OLD MASTER DRAWINGS

OLD MASTER DRAWINGS

from

American Collections

Ebria Feinblatt

Exhibition: April 29 – June 13, 1976

Los Angeles County Museum of Art

Published in association with Allanheld & Schram, New York

PUBLISHED IN THE UNITED STATES OF AMERICA IN 1976
BY THE LOS ANGELES COUNTY MUSEUM OF ART,
5905 WILSHIRE BOULEVARD, LOS ANGELES, CALIFORNIA 90036
IN ASSOCIATION WITH ABNER SCHRAM, DIVISION OF SCHRAM ENTERPRISES LTD.
1860 BROADWAY, NEW YORK, NEW YORK 10023
AND BY ALLANHELD, OSMUN & CO. PUBLISHERS, INC.
19 BRUNSWICK ROAD, MONTCLAIR, NEW JERSEY 07042

PAPERBOUND EDITION:
LIBRARY OF CONGRESS CATALOG CARD NUMBER 76–4185
ISBN 0–87587–067–8

CLOTHBOUND EDITION:
LIBRARY OF CONGRESS CATALOG CARD NUMBER 76–5164
ISBN 0–87663–242–8
DISTRIBUTION BY UNIVERSE BOOKS
381 PARK AVENUE SOUTH, NEW YORK, NEW YORK 10016

PRINTED IN THE UNITED STATES OF AMERICA

LENDERS TO THE EXHIBITION

ABRAMS COLLECTION, *Boston*
DAVID DANIELS
MRS. EDWIN GARVIN FISHER
MICHAEL HALL, ESQ.
ARMAND HAMMER FOUNDATION
MRS. LOIS T. HANDLER
MR. & MRS. JULIUS S. HELD
JOHN AND PAUL HERRING
JOHN MCCRINDLE
DAVID E. RUST
JANOS SCHOLZ
MR. & MRS. GERMAIN SELIGMAN
STEPHEN SPECTOR
ROBERT L. & BETTINA SUIDA MANNING
WOODNER FAMILY COLLECTION
PRIVATE COLLECTORS

ACHENBACH FOUNDATION FOR THE
 GRAPHIC ARTS, *San Francisco*
WILLIAM HAYES ACKLAND MEMORIAL
 ART CENTER, *Chapel Hill, North Carolina*
ADDISON GALLERY OF AMERICAN ART,
 Phillips Academy, Andover
THE ART INSTITUTE OF CHICAGO
THE ART MUSEUM, *Princeton University*
CHRYSLER MUSEUM AT NORFOLK
CLEVELAND MUSEUM OF ART
COOPER-HEWITT MUSEUM OF
 DECORATIVE ARTS AND DESIGN,
 Smithsonian Institution, New York

E. B. CROCKER ART GALLERY, *Sacramento*
DETROIT INSTITUTE OF ARTS
FOGG ART MUSEUM, *Cambridge*
INDIANA UNIVERSITY ART MUSEUM,
 Bloomington
THE METROPOLITAN MUSEUM OF ART,
 New York
THE METROPOLITAN MUSEUM OF ART,
 Robert Lehman Collection, New York
THE PIERPONT MORGAN LIBRARY,
 New York
MUSEUM OF ART, RHODE ISLAND SCHOOL
 OF DESIGN, *Providence*
MUSEUM OF FINE ARTS, *Boston*
NATIONAL GALLERY OF ART,
 Washington, D.C.
NATIONAL GALLERY OF CANADA, *Ottawa*
WILLIAM ROCKHILL NELSON GALLERY
 AND ATKINS MUSEUM OF FINE ARTS,
 Kansas City
THE JANOS SCHOLZ COLLECTION,
 The Pierpont Morgan Library
SEATTLE ART MUSEUM
SMITH COLLEGE MUSEUM OF ART,
 Northampton
THE TOLEDO MUSEUM OF ART
THE UNIVERSITY OF MICHIGAN MUSEUM
 OF ART, *Ann Arbor*
YALE UNIVERSITY ART GALLERY,
 New Haven

ACKNOWLEDGMENTS

In addition to the many lenders whose names are listed separately and to whom deep appreciation is expressed for their generosity and support of the exhibition, personal gratitude is warmly extended to those friends and colleagues who have so kindly assisted in making the exhibition a reality: Clifford Ackley; Dennis Anderson; Jacob Bean; Jean Sutherland Boggs; D. De Grazia Bohlin; James Burke; Fred Cain; Charles Chetham; Frederick J. Cummings; Elaine Dee; Cara D. Denison; Joseph Goldyne; Eleanor Hartman; Phyllis Hattis; Christian Humann; Harold Joachim; Robert Flynn Johnson; Betsy Jones; Frances F. Jones; Martha Kaufman; Sherman Lee; Ruth Fine Lehrer; Agnes Mongan; Elizabeth Mongan; Louise Richards; Franklin Robinson; Andrew Robison; H. Diane Russell; Charles Ryskamp; Eleanor Sayre; Frederick Schab; Janos Scholz; Ellen Sharp; Seymour Slive; Stephen Spector; Felice Stampfle; George Szabò; Ross Taggart; Mary Cazort Taylor; Robert Wark; Richard V. West; Eunice Williams; John Wisdom; and Otto Wittmann.

Very special thanks are due to Joseph E. Young, Assistant Curator of Prints and Drawings, who assumed the unenviable, quasi-collaborative job of editing the first stage of the copy; and to Annette Epstein for typing the material. The Publications Department headed by Jeanne D'Andrea and assisted by Nancy Grubb saw the copy through several stages with exemplary patience. Finally, personal thanks and appreciation are extended to the Director, Kenneth Donahue, and to the Board of Trustees of the Museum for encouraging this undertaking.

EBRIA FEINBLATT
Senior Curator of Prints and Drawings

TABLE OF CONTENTS

Old master drawings have historically been associated chiefly with the Italian Renaissance and its humanist tradition. However, more recently scholars have widened the definition of old master drawings to commence with the dawn of history, continue through the eighteenth century, and conclude with the work of Goya, who heralded the world of modern art. The largest group of drawings in the exhibition is of the Italian school; in the late fourteenth century, Italy became the first real seat of European art, and Italian drawings of the Renaissance have traditionally been the most highly prized. The greater preservation of this graphic heritage meant that early collectors of drawings found Italian works more available than those from countries that had not maintained a similar continuity of drawing production and preservation. In terms of popularity with American collectors, the closest competitor to the Italian school has been the French. In France the production of drawings as preliminary studies and independent works of art, divorced from manuscript illumination, commenced on a truly grand scale only in the seventeenth century. The importance of French drawings for Americans was evidenced by the more than two hundred works included in the exhibition French Drawings from American Collections, *held at The Metropolitan Museum of Art in 1959; it was not surpassed in quantity until the exhibition of* Drawings from New York Collections: The 18th Century in Italy, *at the Metropolitan in 1971. Although other European schools have not been so extensively collected in the United States, individual artists, notably Dürer, Rubens, and Rembrandt are well represented by drawings in American collections.*

From the standpoint of size, the large group of European drawings acquired by E. B. Crocker of Sacramento in 1869–70 appears to have been the first substantial collection of old master drawings to enter the country, but the collecting of master drawings in California has otherwise progressed very slowly. With the notable exception of the early nineteenth-century collector James Bowdoin, III, who left his collection in 1811 to Bowdoin College in Maine, and of Cornelius Vanderbilt, who in 1880 gave the Metropolitan Museum its first group of old master drawings, the collecting of drawings gained momentum only as the new century unfolded. In 1935 an exhibition of Old Master Drawings from American Collections *was held at the Albright Art Gallery in Buffalo, New York. "Never before in this country," wrote Agnes Mongan in her introduction, "has there been shown at one time a group of drawings of greater significance, wider variety or finer quality than those assembled in the present exhibition. Less than a decade ago, it would have been impossible to have held an exhibition of such scope and importance."*

Still, in 1947 Hans Tietze scolded American collectors for their delay in collecting old master

drawings. In his book European Master Drawings, *he claimed that American collectors had tried "to catch up with the famous museums of Europe," thus accumulating paintings which were "pleasant at first glance" as compared to drawings which are "less ostentatious" as well as less "impressive on the wall," requiring "a certain exertion and concentration." "A very rich man can be a successful purchaser of painting," Tietze wrote, but "I do not know of one who became a great collector of drawings without having undertaken more or less serious study." Yet Tietze was forced to acknowledge that American museums in their awakening interest in developing drawing collections were "on the verge of turning from mere repositories into genuine educational institutions." Two years later, in 1949, the Fogg Museum held a major exhibition,* One Hundred Master Drawings, *only coincidentally timed as if to answer Tietze's remarks. In reality, the Fogg exhibition was in honor of the seventieth birthday of Paul J. Sachs, one of America's pioneers in the field of drawing appreciation. Taken from American sources, the exhibition and its catalog revealed that very great treasures indeed were now to be found in both public and private collections in the United States.*

Assembled in the present first extensive survey exhibition of old master drawings organized by the Los Angeles County Museum of Art is a rich sampling of the myriad drawings preserved in public and private American collections. Thanks to many generous loans, we are able to exhibit a large quantity of drawings which have never before been seen in this Museum. However, an exhibition of the scope and variety of the present one must necessarily be limited by the many commitments of the lending institutions. In addition, travel is impossible for drawings of great rarity or fragility and for those that have recently been shown. Bearing this in mind, it is understandable that in a few instances not all the key figures in the long history of European drawings could be represented. Nevertheless, the present assemblage does provide a comprehensive survey of the development of European master drawings from the fourteenth to the close of the eighteenth century, in as many of its important manifestations as circumstances have allowed.

The catalog for Old Master Drawings in American Collections *is designed as a synoptic introductory outline for the general study of old master drawings. It offers a profile of the various European schools and, in addition to the predominant number of well-known published drawings, includes a group of unpublished ones; among them are works by less known figures which are useful for comparison with those by major artists. Hopefully, this effort will lead many in our community to a broader appreciation of this field which for centuries has inspired artists and connoisseurs alike.*

INTRODUCTION

DRAWING connoisseurship is seldom treated in art literature because the discipline is so difficult to master from written discussions. Many people who respond to paintings and prints are diffident about drawings, not from lack of appreciation but from limited knowledge and experience.

Unfortunately, the prospective collector of old master drawings cannot be directed by the same definite guidelines that can be used to determine the authenticity and desirability of a print, guidelines that include printing techniques, states, edition sizes, signatures, quality of impressions, etc. In contrast to other graphic arts such as prints and photographs, drawings are almost always unique and usually cannot be evaluated against other nearly identical examples. The singularity of each drawing largely precludes establishing sure criteria which could be scrupulously followed for the certain judgment of a drawing's authenticity and importance as a work of art. Such clues are not always readily available, even to those whose experience has led to a profound familiarity with various periods and styles of draftsmanship.

But a prospective collector of old master drawings, through diligence and serious study, can learn to recognize old, handmade paper; cultivate his perception to distinguish between a fine drawing and a lesser copy; determine whether a drawing was designed for engraving or is a copy after a print; and, not least of all, can hope to detect the more obvious forgeries. Such knowledge will usually be acquired through both looking and reading. The vast literature on drawings can be of inestimable aid in providing the background for appreciating all aspects of their development. (Many of the more general studies are listed in the bibliography of this catalog.) If consulted attentively, various illustrated texts and numerous published reproductions can provide a basic familiarity with the drawing styles of different centuries and countries. However, of equal benefit to the collector and student alike are repeated visits to exhibitions or collections of drawings, for it is direct contact with a work of art that best trains the eye to see what the mind has already learned to recognize.

In comparison with works in other media, less has been published on the history, techniques, and appreciation of drawings; only in the twentieth century have they begun to enjoy a broad audience of collectors, scholars, and students. If the distinction is made between catalogs and books, it can be said that Bernard Berenson provided the first book devoted to the study, appreciation, and connoisseurship of one great school in his *Drawings of the Florentine Painters*, which was initially published in 1903 and later revised in a definitive 1938 edition. Reitlinger's *Old Master Drawings*, possibly the first general survey in English of the

various schools of old master drawings, was published in 1922, three years after the first edition of Meder's monumental contribution, *Die Handzeichnung*, appeared in Germany. Subsequent publications have included Leporini's *Die Stilentwicklung der Handzeichnung XIV bis XVIII Jahrhundert*, which appeared in 1925; the Mongan–Sachs *Drawings in the Fogg Museum of Art* of 1940, which was the first major catalog of drawings in an American collection; and Charles de Tolnay's *History and Technique of Old Master Drawings*, which was published in 1943. Fourteen years later James Watrous made a substantial contribution to the history of drawing techniques with his *Craft of Old Master Drawing*, and in 1962 Shorewood Publishers Inc. broke ground in the United States with its series, *Great Drawings of All Time*, followed by a group of small volumes, *Drawings of the Masters*. Jacob Rosenberg's *Great Draughtsmen* had appeared in 1959, providing salient insights into connoisseurship which he continued in several chapters on questions of criteria in his 1967 book, *On Quality in Art*.

Over the past two decades the spate of publications on drawings, both at home and abroad, has become too great to enumerate here. Suffice it then to single out only two major publications – the Morgan Library's indispensable periodical, *Master Drawings*, and Degenhart–Schmitt's *Corpus der italienischen Zeichnungen, 1300–1450* (1908) – as advances in the field, before listing some American publications of distinction. The latter include Shoolman–Slatkin's *Six Centuries of French Master Drawings in America* (1951); Wittkower–Ames' *Great Master Drawings of Seven Centuries* (1959); the Metropolitan Museum's extensive *French Drawings from American Collections: Clouet to Matisse*, from the same year; and the numerous exhibition catalogs, beginning in the 1950s, attesting to the great interest and significance of the Janos Scholz collection. More recently, splendid volumes on drawings in New York collections have been issued through the joint effort of the Morgan Library and The Metropolitan Museum of Art. Other major catalogs number among them Jacob Bean's *One Hundred European Drawings in The Metropolitan Museum of Art* (1964); E. Haverkamp-Begemann's *Drawings from the Clark Institute* (1964); Jacob Bean's *Italian Drawings in the Art Museum, Princeton University* (1968); Haverkamp-Begemann's *European Drawings and Watercolors in the Yale University Art Gallery* (1970); P. Rosenberg's *French Master Drawings of the 17th and 18th Centuries in North American Collections* (1972); the catalogs of the expanding Ian Woodner collection (1971, 1973); Harold Joachim's *Helen Regenstein Collection of European Drawings* (1974); and T. Pignatti's *Venetian Drawings from American Collections* (1974). Due to the limitations of space this highly compressed list necessarily omits, among others, catalogs devoted to drawings by individual masters in American collections.

In seeking one of the earliest definitions characterizing the nature of line, we find that in his *Categories* Aristotle distinguishes between discrete and continuous quantity. Number and speech are examples of discrete quantities, he states, while "A line…is a continuous quantity, for it is possible to find a common boundary at which its parts join. In the case of the line, this common boundary is the point.…" In ancient times writing was generally created from lines that were either drawn or incised, and both the Greeks and Romans used the word *orthographia*, or "writing," to designate both drawing and painting. The value of continuous line for indicating form without the aid of color was well appreciated in antiquity. Pliny extolled the ability to convey form and volume merely by outline, and one concludes that the outline drawing that could give an illusion of relief to a flat surface was considered most desirable, a view also held by the first important art theorist of the Renaissance, Leon Battista Alberti.

For millennia, drawings in Egypt were generally first outlined, then filled with color, and for centuries drawings on Greek vases often included lines drawn with a brush as well as incised with a stylus. "Pure" drawing, which traditionally means linear work without color, is known from antiquity chiefly by rare extant graffiti found on papyrus and by engravings on bronze supports such as mirror-backs or vessels like *cistae*. Ancient drawings in western Asia, Egypt, and Greece were done principally in silhouette, and these outlines were the favored as well as the simplest way of rendering form. By the seventh century B.C., Greek vase painters were using incised lines to add interior details to their profile drawings, and on the Attic vases of the sixth and fifth centuries B.C. drawings are already frontal, portraying movement, foreshortening, and intricate overlapping compositions.

The Greco-Roman emphasis on material values was expressed in a prolonged tradition of naturalism, and the re-creation of corporeal solidity and fleshly beauty was the hallmark of the classical world. But, following the rise of Neo-Platonism in the third century A.D., and with the continued growth and prestige of Christianity, the late antique period began stressing schematization in all the arts, including drawing, which had not yet been freed as an independent category of representation. To emphasize a new introspective concern with spiritual values and the transience of earthly life, figures were flattened, crowded, and disembodied or schematized. Abstract, endlessly interweaving lines expressed a new feeling for the eternity of afterlife. Unnaturalistic colors were often used, the most notable being gold leaf in place of blue for the heavens. All of these formal means pictorially subordinated the physical world of nature to an ideal, spiritual space in which the religious soul could approach the freedom of mystical contemplation.

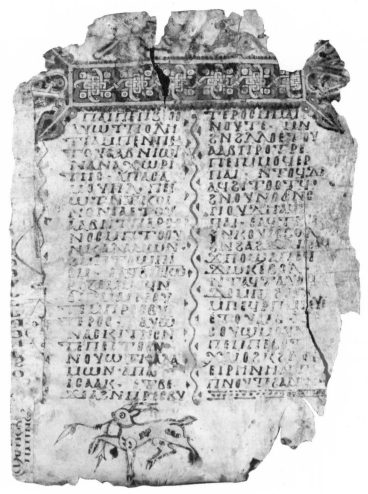

One of the earliest preserved Christian miniatures is a Coptic leaf with a large ansate cross, from the late fourth- or early fifth-century *Acts of the Apostles* codex in the Morgan Library. Its marked importance stems from the fact that its interlace pattern has been advanced as strong evidence for the Coptic origin of the involved interlace component of later Anglo-Irish manuscript illumination. Still another example of interlace is found in the Coptic leaf of about 800 from the *Life of Apa Samuel* (cat. no. 1); its plaited borders exemplify one of the important influences on the Insular style of manuscript illustration. This type of interlace patterning subsequently entered Frankish and Carolingian book art, and together with other motifs from the Christian Middle East it became, after many transformations, part of the fabric of Romanesque drawing in certain parts of Europe. Romanesque drawing, as in the succeeding Gothic period, was largely limited to illustrated manuscripts.

Copies of classical or late antique scientific and literary works, as well as secular and sacred texts enlivened by drawings with scarcely any color, were made in Italy, in Gaul, and in Germanic lands during the Ottonian age.

The first half of the ninth century was distinguished by the production of the great Utrecht Psalter by Benedictine monks near Rheims. Based on Hellenistic models and employing a repertoire of schematic types and motifs, these drawings nevertheless had a vivacity, verve, and delicacy of execution that did not come to life again in the same way until the drawings of Jacques Callot, whose tiny galloping riders appear to have been anticipated by similar springing horsemen in the Psalter.

In addition to illuminated or illustrated manuscripts, drawings from medieval times survived in the form of *exempla*, or pattern books, which provided traditional compositions and motifs for artists to copy. Thus, individual studies or completely realized drawings from early periods are seldom encountered. The earliest known European *exemplum* is the eleventh-century model book by Adémar de Chabannes, preserved in the University Library of Leyden. Probably the most famous of these rare complete model books is that by the thirteenth-century French artist Villard de Honnecourt in the Bibliothèque Nationale, Paris. Villard claimed that he drew to show how geometry underlies all drawing, but different interpretations have been made of his art. De Tolnay proposed that Villard was working in the spirit of the precepts of St. Thomas Aquinas, using geometry to reveal the spiritual nature of things. J. Porcher held that Villard's schematized copies were influenced by the designs of contemporary stained glass and the balanced compositions of illuminations for the *Bible moralisée*. But J. Hubert submitted that Villard, like most medieval artists, was simply incapable of copying antiquity correctly, and that "medieval man had an imperfect vision of the outside world."

While the spirited drawings of the Utrecht Psalter were inspired by Hellenistic tradition, later drawings in the Romanesque period "hardened," so to speak, into a uniformly flat, linear impersonality of rather schematized forms, the unmodeled bodies and objects often seemingly crying out to be filled with color, which was rarely a dominant factor. The generally static, equilibratory stroke of Romanesque drawing was replaced in the Gothic period by a new, rhythmically swinging line which imparted a revived vitality to the graphic arts, particularly that of manuscript illumination.

Despite the emphasis in numerous early medieval drawings on simple forms delineated by continuous, unbroken lines, in some late fourteenth-century manuscript illuminations loose and broken lines, in addition to stressed or accented strokes, can be detected as pre-

liminary sketching underneath the finished work. A similar type of investigative method is evidenced in the complex preparatory sketches or *sinopie* found beneath early Italian wall frescoes, which often demonstrate the artist's deliberation and subsequent changes of composition. De Tolnay and Degenhart discerned even in antiquity and the Middle Ages characteristics of subjective approaches to drawing. This subjective, exploratory impulse required only the subsequent relaxation of the more formalized pattern-book tradition to render the artist's autographic traits more fully operative. One can note in this regard a very fine late ninth-century drawing, *Christ on the Cross*, from a Gospel Book of the Meuse region, in which the form and movement of the figures are indicated clearly through the clinging drapery which is drawn with a rather astonishing looseness and freedom.

Products of the tradition of the anonymous craftsman dedicated chiefly to the art of the church, pre-Renaissance drawings generally were not cherished as they later came to be with the new Renaissance appreciation of man and his individual creativity. Assiduous study and copying of ancient monuments provided the classical form sought both by men of culture and by artists. Artists in the Italian Renaissance, like artists of the Carolingian period and undoubtedly like Villard de Honnecourt, believed that they were copying antiquity "correctly" while actually, consciously or not, they were transforming that heritage into their own terms according to new interpretations and meaning.

The traditions of drawing that developed in the Renaissance affected artists of succeeding centuries in a multitude of ways. The persistent emphasis on the human form in drawing attests to the vitality and meaning that artists throughout Europe found in this heritage. Venice represented the last great stronghold of draftsmanship in Italy, but even while this art ebbed there in the eighteenth century, it continued in France well into the nineteenth. Powerful and individualistic figures appeared in the early part of the century who, like Ingres, used the academic tradition for their own particular modes of expression, while innovators like Delacroix created new styles.

In our own time the radicalization of the concept of drawing has led numerous artists to a multiplicity of often novel approaches and interpretations of this ancient art. Mixed-media studies, engravings on metal plates that are not printed, solvent transfer works in which printed imagery is autographically transferred from one paper support to another, and photographs used as preparatory "sketches" all function to expand, if not explode, long traditional concepts of drawing. While they may seem surprising at first, these aesthetically adventurous creations are actually no more than recent developments and extensions of the ever-changing European tradition of drawing that extends back to antiquity.

The Italian School

A NOTE ON ITALIAN DRAWINGS

ALTHOUGH by the late fourteenth century preparatory as well as more finished drawings were created in several centers in Italy, little tangible evidence remains of such drawings made before the mid-fifteenth century. The scarcity of thirteenth- and fourteenth-century studies on paper and vellum may result from the practice of drawing directly on the wall to prepare for the fresco paintings, as the discovery in past decades of preliminary drawings (*sinopie*) on the rough plaster beneath completed frescoes has caused scholars to believe. But when the demand for frescoes began to dwindle in the fifteenth century, satisfied in part by other forms of painting, preliminary drawings were often executed on various supports, including vellum and paper. These works ranged from the briefest sketches to completed drawings, sometimes finished with color, which, as presentation pieces, might incorporate a variety of media to approximate for a patron the final effect of a proposed painting. It was largely in the quattrocento that such studies, or *modelli*, were first executed and preserved, for it was during this period that the modern appreciation of drawing had its first impulse.

The earliest schools of Italian drawing, dating from the late fourteenth century, were located in the west (Tuscany), the central region (Umbria), and the north (Lombardy as well as Venice and the Veneto). Other schools arose during the High Renaissance, chiefly those of the north Italian province of the Emilia. Subject to considerable foreign influence even up to the Renaissance, Piedmont and Liguria produced fewer notable native artists than other regions. However Genoa, in Liguria, revived in the seventeenth century and became an important center of Baroque art. Rome, on the other hand, was a major center of draftsmanship for at least two centuries, from the time of the Renaissance through the age of the Baroque.

In attempting to identify the drawing styles of these various Italian schools, scholars such as Bernhard Degenhart and Konrad Oberhuber have employed many criteria. In his 1967 graphological study of Italian drawings from the fifteenth to the eighteenth century Dr. Degenhart stressed the regional characteristics of each artist's approach, stating that the lines, brushstrokes, dimensions of forms, simulation of light and shadow, and disposition of the composition on the page are quite distinctive in drawings from different Italian art centers. By analyzing these elements he demonstrated how, for example, the drawings of the Venetian painter Tintoretto differ stylistically from those of his contemporary, the Florentine sculptor Baccio Bandinelli. In fact, the most general categories of Italian drawing styles

have traditionally been Florentine and Venetian, the former noted for a usually emphatic clarity and definition of form, the latter for effects of light and shade. Within these two broad divisions, numerous stylistic variations result from many contributing factors, including strong individual artistic personalities, foreign influences, and native characteristics and traditions that gradually developed within a certain city or region.

In their writings, both Degenhart and Oberhuber appear to proceed on the premise that the graphological facture of every draftsman reflects the style of his region, which remains as a constant element underlying his drawing. Further, this style may be discerned even when the personal characteristics of the artist are quite pronounced. Dr. Oberhuber, in his introduction to a 1973 exhibition of Italian drawings at the National Gallery of Art, Washington, D. C., stated that to individuate the various schools one should observe how artists use the formal qualities of drawings to create space, volume, and the surface textures of objects. For the same reason he proposed studying the relationship of drawings to paintings and sculpture of the same region as a way to understand their underlying aesthetic aims and ideals.

The viewpoints of these scholars are undeniably of great interest and even of fundamental assistance in distinguishing the character of the divers Italian schools, historically regarded as including the Florentine, Venetian, Emilian, Neapolitan, Milanese, Genoese, Piedmontese, and Roman. However, the genesis and subsequent development of the regional drawing styles of Italy are intricate, complex subjects, difficult to categorize, even generally, without producing exceptions. Thus, in keeping with the focus of the entire catalog, the Italian section is limited to a general description of individual drawings by artists from these several regions and schools; the emphasis of the text has necessarily been placed on the works themselves rather than on an historical analysis of Italian draftsmanship. Bearing in mind the complex background and nature of Italian drawing, and comparing works from its schools and periods, one can enjoy the rich variety of interpretations and techniques employed by the Italian masters of the past.

Florence and Siena

ALTHOUGH a school of relatively minor painters existed in thirteenth-century Florence, it was not until the advent of Giotto (*ca.*1277–*ca.*1336) on the brink of the fourteenth century that the significant school of the Giotteschi became established, not only in Florence but throughout Italy. Still, there is a dearth of drawings from the early quattrocento, particularly from the school of Giotto, and the attributions of remaining fourteenth-century Florentine drawings are often contested.

The earliest Florentine drawing in this exhibition, *Studies of St. Francis Kneeling* (cat. no. 2), was attributed by an early collector to Giotto himself; Degenhart and Schmitt later proposed that the work was Florentine, from about 1340. More recently the drawing has been attributed to Giotto's best-known pupil and principal assistant, Taddeo Gaddi (*ca.* 1300–1366), and the painterly freedom of the work reinforces the opinion that it was preparatory to one of Taddeo's paintings. There is, in fact, a painting from Gaddi's shop entitled the *Tree of the Cross* in the refectory of Santa Croce, Florence. Thus, the Woodner drawing provides the only example in America of a drawing either by, or very close to, Taddeo Gaddi. Because the three main fragments of the drawing are mounted on another paper support and surrounded by carefully drawn decorative "frames," in the manner used by Giorgio Vasari, Degenhart and Schmitt suggested that the famous biographer may once have owned the work.

The sheet with *Figures and Decorative Motifs* (cat. no. 3) from the second half of the fourteenth century is the earliest Italian drawing executed in pen and ink in the exhibition. Unlike the other fourteenth-century works, often drawn on paper chiefly with brush or combining pen and brush, this was done with a quill pen on vellum. Degenhart attributed the sheet to a book illuminator who took the motifs of animals and grotesques from illustrated manuscripts or model books. M. W. Evans, noting the irregular disposition of the figures and motifs on the leaf, recently suggested that the drawings might be in the nature of trial sketches rather than repetitions of established types. Among the recognizable images are the stoning of St. Stephen, at the left of the second row; the figures with bellows, at lower left, a reference to the martyrdom of St. Lawrence; and the allegorical figure of Prudence, off center, which Degenhart related iconographically to Andrea Pisano's work in the tower of the Florence Baptistry of 1330 and stylistically to Taddeo Gaddi's allegorical half-figures in the Baroncelli Chapel of Santa Croce.

An example of a drawing that once formed part of a pattern or model book is *St. John the Baptist and Another Saint* (cat. no. 4). Striking in its dignity, monumentality, and clarity of form, the work was done in brown ink and pen over preliminary chalk on light red tinted paper, with long, continuous lines defining the drapery. Also notable is the pathos of the Baptist's face. Opinions vary as to where this work originated: once thought to be either Pisan, Florentine, or Sienese, it appears in the Umbrian section of Degenhart and Schmitt's *Corpus*. The authors related the work to a polyptych of which fragments are now dispersed between the Musée Fesch in Ajaccio; the Fondazione Giorgio Cini, Venice; and a private collection in Lucerne. The polyptych itself was ascribed by both Longhi and Meiss to an Umbrian master of the mid-fourteenth century.

Still unattributed, the *Martyrdom of St. Miniato* (cat. no. 5) also dates from the fourteenth century. Drawn in a highly finished style, it combines brush and pen, heightened with white, with red wash and silverpoint on a brown ground that covers a paper support. An excellent example of a drawing prepared for a patron to suggest the effect of a proposed painting, the Morgan drawing discloses in its careful execution the persistent influence of illuminated manuscripts. Such *modelli* as this famous one apparently became necessary in the latter fourteenth century as painters began departing from strictly traditional compositions. As artists sought more independence from the compositions that had been prescribed by the Church from the time of the Second Nicene Council on, their patrons needed to gauge the artist's intentions before authorizing him to execute a commission. After the fourteenth century, the execution of *modelli* became a frequent practice in Italy.

The Florentine school of the mid-fourteenth century is represented by a rare leaf filled with nine figures from a picture chronicle illustrating famous men in history (cat. no. 8). The most recent research seems to indicate the work was copied from frescoes probably painted by Giottino (Giotto di Maestro Stefano, 1324–1404) in the Casa Orsini at Monte Giordano, in Rome. Thus the sheet, one of eight which are now widely dispersed, may provide a link with work by a follower of Giotto. This drawing in particular reveals the artist's strong feeling for the portrayal of individual personalities. The nascent realism of the figures presents a marked contrast to their miniaturization and to the inscription of their identifications in the background, elements that indicate this quattrocento work was still conceived in the manner of manuscript illumination.

Of the major early Italian schools, that of Siena is probably the least documented by preserved drawings, and examples of Sienese draftsmanship of the latter fourteenth century exist largely in illustrated manuscripts. Since this rarity has so curtailed the appearance of

Sienese drawings in the present exhibition they are included in the Florentine section rather than treated separately. Some Sienese illustrations may, by reason of their technique, be classed as drawings rather than as paintings. For example, two beautiful works by Lorenzo Monaco (1370–after 1422) in the Print Room, Berlin, drawn on parchment in pen and ink with mixed tempera colors and heightened with white, were not included in Berenson's *Corpus* because he considered them manuscript illuminations or paintings; they have now been reappraised and published as drawings.

A particularly rare work, not only in origin but equally in purpose, is the study of the celebrated fountain, the *Fonte Gaia*, in Siena (cat. no. 6). Often considered the most beautiful fountain in Italy, it was designed and executed by Jacopo della Quercia (*ca.* 1374–1438), the principal Sienese sculptor of the early Renaissance. Successor to Nicola and Giovanni Pisano, the forerunners of Michelangelo, Jacopo della Quercia is given credit for effecting the transition from medieval to Renaissance sculpture in Italy. This early fifteenth-century (1409) drawing, in brown ink and wash on parchment, displays the careful attention to fine detail so characteristic of the period. Its expert modeling conveys an extraordinary illusion of relief, particularly evident in the volumetric quality of the robed figures seated in the niches. No less enchanting are the carved details of the architecture with their classical foliate motifs.

With the rebirth of the scientific study of nature and the resulting technical knowledge, Renaissance artists sought to infuse their work with the aspects of realism that were rediscovered in the world around them. In keeping with Renaissance ideals, the accomplished, much traveled Sienese Francesco di Giorgio di Martino (1439–1502) did not allow preoccupation with his duties as architect and civic and military engineer to hinder his career as a painter and draftsman. As shown in his rare figural drawing (cat. no. 10) from the Metropolitan Museum, he was influenced by the Florentine love of line and order. Ascribed to 1475, the work incorporates the Renaissance device of placing figures against a recessed architectural background that creates an illusion of depth from which the figures project in sculptural relief.

While early Sienese drawings manifested a more decorative, curvilinear style of attenuated and flowing lines, Florentine drawings of the second half of the quattrocento reflected the monumental conception that had been introduced into Italian art by Giotto. This monumentality continued in the classical naturalism derived by Masaccio (1401–1428) from his awareness of Roman statuary and from his knowledge of linear perspective. (The foundations of the science of perspective had been laid by the great Florentine architect

Filippo Brunelleschi, whose theories were further developed by Leon Battista Alberti.) Since no drawings by Masaccio are known, one must look to the draftsmanship of another major Florentine sculptor and painter, Antonio Pollaiuolo (1432–1498) (cat. no. 9), for examples of the realistic elements Masaccio had earlier introduced into Florentine painting. By dissecting corpses Pollaiuolo acquired much of the anatomical knowledge he needed to create effortless drawings of nudes by outlining without modeling. Despite the poses that now seem rather exaggerated, Pollaiuolo's drawings, with strokes stressed as they follow the shape of muscles and the articulation of limbs, begin to capture the movement and tangibility of the human form. Taking his cue from Pollaiuolo, Luca Signorelli (1491–1523), who ranks with the powerful draftsmen of the early Renaissance, also concentrated chiefly on the human form, drawing it with a sure structural line and remarkable modeling of musculature that prefigured Michelangelo.

The naturalism introduced by Masaccio, highly personalized in the drawings of Pollaiuolo and still tied in Signorelli's work to the quattrocento style, appeared fully ripened and perfected in the work of Leonardo da Vinci (1452–1519), whose corpus of drawings is incomparable with that of any predecessor. Through Leonardo, who in his art conveyed mystery, the sensuous was combined with science to free anatomical drawing from its purely schematic, medical character, creating a living art with a luxuriant, rhythmic line and modeling of unequaled subtlety (cat. no. 12). Tireless student and experimenter, Leonardo laid down the theories in drawing for form, outline, shading, and movement that captivated artists until the advent of his younger contemporary, Michelangelo.

Second only to Leonardo as a student of Verrocchio, Lorenzo di Credi (1459/60 ?–1537) reflected in his art the languid refinement of Perugino as well as types based on those of Leonardo. Di Credi's silverpoint drawing of the *Madonna and Child* (cat. no. 16) is obviously reminiscent of, and possibly inspired by, Leonardo's Madonna and Child in the cartoon of the *Adoration of the Magi*. Lorenzo nevertheless maintained his own style which stressed perfection of finish. In fashioning his work with such care, he possibly paid too much attention to detail; although often extremely lovely and delicate, his drawings frequently lack originality and vitality.

The double sheet of the *Pietà with Saints and Angels* (cat. no. 13) by Botticelli's pupil Filippino Lippi (1457/58–1504) evidences the influence of Leonardo's sketchy drawings, but is transformed by Filippino's more emotive character. The sheet contains preliminary sketches in which the artist was still deliberating the final arrangement of a composition. The *recto* of the drawing shows alternate positions of the Virgin's head: gazing out at the

spectator and looking down in grief at her son. A still unresolved architectural background appears in the space that is occupied by angels on the *recto*. Filippino, as the examples in this exhibition demonstrate, drew mainly in two styles and techniques. With pen, his lines are fleet, nervous, and sketchy, producing brief compositional notations as found so often in Leonardo's notebooks. In silverpoint, Filippino's work takes on a more deliberate and finished quality, as in the drawing from the Morgan Library (cat. no.14). However, his strokes are consistently angular and cramped as compared to the flowing line and delineation of volume that were never absent from Leonardo's drawings.

Fra Bartolommeo (1472–1517) stands apart from the masters of the High Renaissance because of the exclusively devotional character of his art; like Fra Angelico before him, he painted only religious subjects. Without the wider cultural stimulation experienced by more worldly men like Leonardo and Raphael, his work remained rather narrow in scope but always idealistic and noble. On Fra Bartolommeo's painting style, Leonardo was probably the strongest, most lasting influence with his veiling quality of sfumato and softly graded chiaroscuro. In turn, Fra Bartolommeo had a strong effect upon Raphael, who became a close friend and associate after his arrival in Florence in 1504.

The beautiful Lehman *Virgin with the Holy Children* (cat. no.18) has been assigned to about 1505, soon after Fra Bartolommeo resumed painting following several years of retreat in the cloister of San Marco in Florence. During those non-painting years he executed a large number of drawings on the theme of the Madonna and Child, in many versions and variations. Because of the strong vertical axis of her figure and the large, robust children, the Lehman drawing with its standing Virgin ranks among the most monumental of these works. Another study of the *Holy Family*, dating from 1498 and now in Berlin, shows a profile of the standing Madonna. With this frail figure enveloped in voluminous drapery, the Berlin drawing is strikingly different from the solidity and vitality of the Lehman work.

Although the landscape motifs in Fra Bartolommeo's paintings were already well appreciated, the appearance of a collection of his landscape drawings at a 1957 London sale established this master as an unexpected pioneer in Italy in the field of pure landscape drawing; these works seemingly date from the latter part of his life. Among the most impressive of his landscape studies is the naturalistic treatment of a *Gnarled Tree* (cat. no. 19) with its beautiful view of *A Village on a Hill* on the *verso* (cat. no. 19). The similarity of the tree stumps in the *Gnarled Tree* to those in Dürer's watercolor of 1495, *Rocky Ledge with Tree Stumps*, in Berlin, suggests the extent of the German's influence upon his Italian contemporaries.

Though deeply spiritual like Fra Bartolommeo, Michelangelo (1475–1564) did not assume the usual theological pattern in his religious expression. Influenced by Neo-Platonism, his work in its daemonic force seems indeed to reflect one of the main tenets of that philosophy: the conflict between sense or matter and pure spirit. What was profoundly personal, veiled, and complex in the art of Leonardo became in Michelangelo open, declarative, and sculptural. In the drawings of the latter, forceful movement, the operative element of the Baroque, dominates the other formal values. The plastic form is heroically delineated in dynamic motion and with vibrant energy, even in such passive images as the dead Christ. The nude form achieves perfection in terms of structural solidity and naturalism of the modeling. By whatever means he employed—ink, charcoal, or chalk—Michelangelo molded the human figure as he drew it. The realism of his full-bodied male nudes was controlled to an extent by the idealizing factor he found in classical sculpture; in turn, his drawings, having attained the plane of universality through their perfection of form and action, became the classic norm of human anatomy for centuries of European artists. Whereas Leonardo's influence as a draftsman was mainly limited to his own period, Michelangelo's was the greatest in the history of Western art.

Lacking the incisiveness and torment of Michelangelo, Raphael (1483–1520) achieved harmony. The plasticity of Raphael's drawings is generally less dramatic, his graphic means more economical than those of either Leonardo or Michelangelo. Raphael was the ultimate refiner, embellisher, and distiller of the great contributions of Leonardo, Perugino, and Michelangelo. Fluid movement and dissolution into space through a floating, melodic line are characteristics generally associated with the drawings of Raphael, but there are as many of his works in which the energy of the High Renaissance is expressed by a ripeness and roundness of forms and swelling strokes that almost seem to explode. In his portrait studies he achieved a perfected poise of position and balanced repose, made doubly intriguing by an undercurrent of psychological tension. The recently discovered monumental Hammer drawing (cat. no. 21) is a preparatory study for the frescoes of 1510–11 which Raphael painted in the Chigi chapel of the church of Santa Maria della Pace, in Rome. The concept of the two powerful figures of the prophets derives from his earlier fresco of the *School of Athens*, in the Vatican. *Jonah* recalls the figure of *Aristotle*, while the knotted brow of *Hosea* is an intensification of *Plato's* expression.

After Leonardo, Michelangelo, and Raphael, the most important Florentine draftsmen were Andrea del Sarto (1486–1530) and Jacopo da Pontormo (1494–1557). In the strong, sure strokes that demonstrate his ability to capture the figure from life, Andrea del Sarto

(cat. no. 22) continued the tradition of the large, classic form and measured pose as it was transmitted through the structural proportions and tactile values used by the great Florentine masters before him. At the same time, there are also elements in his work which deviate from those of his predecessors, such as changes from the ideal proportions, a loosening and slight coarsening of the forms, and broader, more abstract modeling. The stockiness of his figures is a token of a certain plebian quality which characterizes his art as compared to the consistently patrician nature permeating all phases of work by Leonardo, Michelangelo, and Raphael.

In del Sarto's pupil Jacopo da Pontormo (cat. no. 25), the standards of the High Renaissance give way to an anti-classicism that is even more evident in the work of his exact contemporary Rosso Fiorentino, discussed in the French section. Pontormo generally drew stressed, strong, and rhythmic contours and articulated musculature, but his nudes, often resembling those of Michelangelo, were delineated with sharper, more angular and accented strokes; their pointed knuckles and tentaclelike fingers seem expressive of the artist's emotional temperament, which has sometimes been termed neurasthenic. What could be called the classical underpinning of form in the High Renaissance began to grow unstable in Pontormo: he renounced the more traditional center of gravity in composition and led the way to Mannerism, which Antal has described as a continuation of the "Quattrocento Gothic style." Indeed, Pontormo's work discloses what can be termed a Gothic pathos, as though the direction of the Renaissance had been different from his own, and the inspiration of classical humanism and antique form had in fact never really touched the deep roots of his unquiet, religious spirit.

The only sixteenth-century drawing in the exhibition that can be connected to a realized sculpture is the splendid double-sided drawing (cat. no. 27, *recto* and *verso*) by Bartolommeo Ammanati (1511–1592). Originally a pupil of Baccio Bandinelli, Ammanati was also strongly influenced by Jacopo Sansovino, with whom he worked in the Libreria di San Marco, Venice, and by Michelangelo's sculpture in the Sacristy of San Lorenzo in Florence. The discovery in 1540 of the famed Farnese *Hercules* further affected the expression of his style. The two monumental figures in Ammanati's drawing have been related to the bronze satyrs grouped around the base of the Neptune Fountain in the Piazza della Signoria, Florence, which was begun by the sculptor about 1560. The figure on the *verso*, justly described as inspired by the Laöcoon, exhibits a discordance between the mature head and the youthful body. That on the *recto* is reminiscent of a Michelangelesque pose and character, comparable to two of the *Ignudi* from the Sistine ceiling–one on the left plinth above the *Prophet*

Joel, the other, on the right plinth over the *Persian Sibyl*–as well as to Michelangelo's very damaged *River God*, in the Accademia, Florence.

An element of rusticity began to characterize the painting of Florence in the seventeenth century as the ideals and canons of the High Renaissance receded and those of Mannerism waned. Florentine draftsmanship was, on the whole, less adversely affected than painting by this change, and individual designers of much distinction still flourished. Among them, Francesco Montelatici (1607–1661), called Cecco Bravo because of the spirited intensity of his work, occupies a special place with his highly individual style and unusual imagination. His free, romantic handling of the figure has caused some of his works to be confused with those of a Venetianizing Florentine contemporary, Sebastiano Mazzoni. However, the facture of Cecco's drawing was basically Florentine, reminiscent of the aerial treatment in chalk studies by Fra Bartolommeo and Andrea del Sarto, but with the effects of atmospheric lightness emphasized to a new extent. As seen in his *Male Nude Bending* (cat. no. 32), he infused his drawings with a vibrating dynamism, the light bouncing off the sculpturally modeled form as the deft shading veils the body with shimmering transparency.

In addition to Cecco Bravo, there were other notable Florentine draftsmen of the seicento, including Stefano della Bella, Baldassare Franceschini, called Il Volterrano, and Francesco Furini. But in the following century, it was the city of Venice that once again became the center of great draftsmanship in Italy.

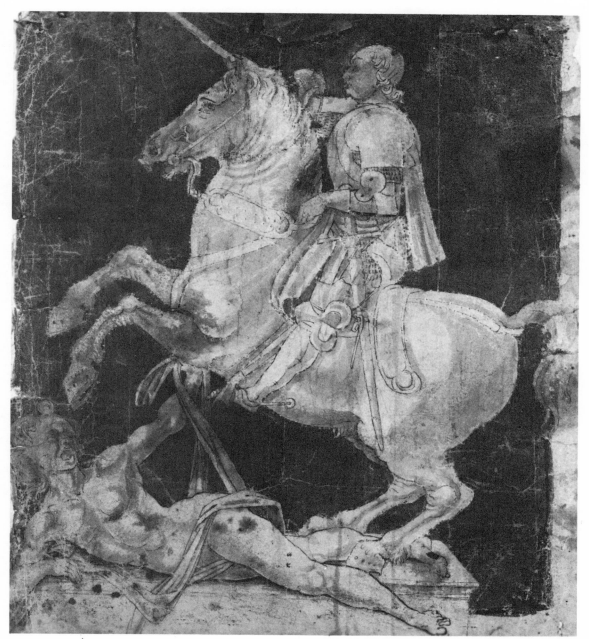

Catalog

1. COPTIC, 8th or 9th century
The Life of Apa Samuel
Ink and tempera on vellum
13¾ x 10 in. (34.9 x 25.4 cm.)
Mark Lansburgh

Literature: Unpublished
 In its borders and stylized animal motif
this leaf can be compared to the ninth-century
Synaxary Fragment from Fayum, in The
Pierpont Morgan Library.
Reproduced page xiv

2. TADDEO DI GADDO GADDI,
attributed (Italian, *ca.*1300–1366)
*Studies of St. Francis Kneeling and of Another
Figure, and Studies of Three Seated Mourners,
of St. Francis Kneeling, of a Woman and of an
Angel in Flight*
Brush and brown ink, heightened with white
on green prepared paper
Upper panel: 7⅛ x 5⅝ in. (18.1 x 14.3 cm.);
lower panel: 8¹⁵⁄₁₆ x 10¼ in. (22.8 x 24.8 cm.)
Woodner Family Collection

Collections: Unidentified 16th-century
Florentine collector who mounted the two por-
tions of a larger sheet with two console panels,
inscribed respectively: "Giotto/fiorent/no" and
"Mori l'anno 1336, e sepol/to in Santa Maria/di
fiore"; Lord Eldin (1757–1832) as Giotto;
(Sale, Christie's, London, Mar. 26, 1974, no.54,
as attributed to Taddeo Gaddi), acquired by
Ian Woodner
Literature: B. Degenhart, A. Schmitt. *Corpus
der italienischen Zeichnungen, 1300–1450.* 4 vols.
Berlin,1968. vol. 1, pt.1, p. xxiv, no.25, pt.3,
pl. 50, as Florentine school, *ca.* 1340.

3. ANONYMOUS TUSCAN ARTIST,
ca. 1350–1375
Figures and Decorative Motifs
Verso: Deed of sale, dated 1321
Ink on vellum
29⅞ x 12 in. (75.9 x 30.5 cm.)

The Janos Scholz Collection
The Pierpont Morgan Library

Collection: Private collection, Los Angeles
Literature: A. Neumeyer. *Drawings from
Tuscany and Umbria, 1350–1700.* Mills College
Art Gallery, Oakland, 1961. no.86; W. Stubbe.
*Italienische Meisterzeichnungen von 14. bis 18.
Jahrhundert aus amerikanischen Besitz: Die
Sammlung Janos Scholz.* Hamburger Kunst-
halle, 1963. no.4; E. Haverkamp-Begemann,
E. Sharp. *Italian Drawings from the Collection
of Janos Scholz.* Yale University Art Gallery,
1964. no.1; *Tuscan and Venetian Drawings of the
Quattrocento from the Collection of Janos Scholz.*
Los Angeles County Museum of Art, 1967.
no. 1; B. Degenhart, A. Schmitt. *Corpus der
italienischen Zeichnungen, 1300–1450.* 4 vols.
Berlin, 1968. vol. 1, no. 47, vol. 2, pl. 52d;
M. W. Evans. *Medieval Drawings.*
New York, 1969. pl. 129.

4. UMBRIAN, third quarter of the 14th century
St. John the Baptist and Another Saint
Brown ink and pen over chalk on light
red tinted paper
9¾ x 4⅞ in. (24.8 x 12.4 cm.)
The Janos Scholz Collection
The Pierpont Morgan Library

Collection: Savoy-Aosta
Literature: *Great Master Drawings of Seven
Centuries.* M. Knoedler & Co., New York, 1959.
no.2; A. Neumeyer. *Drawings from Tuscany and
Umbria.* Mills College Art Gallery, Oakland,
1961. no.89; I. Moskowitz, ed. *Great Drawings
of All Time.* 4 vols. New York, 1962. vol. 1, as
Tuscan, early fifteenth century; W. Stubbe.
*Italienische Meisterzeichnungen von 14. bis 18.
Jahrhundert aus amerikanischen Besitz: Die
Sammlung Janos Scholz.* Hamburger Kunst-
halle, 1963. no.5; *Tuscan and Venetian Draw-
ings of the Quattrocento from the Collection of
Janos Scholz.* Los Angeles County Museum of
Art, 1967. no.3, as Sienese, about 1400; B. De-
genhart, A. Schmitt. *Corpus der italienischen
Zeichnungen, 1300–1450.* 4 vols. Berlin, 1968.
vol.1, no. 73, vol. 3, pl. 117c.

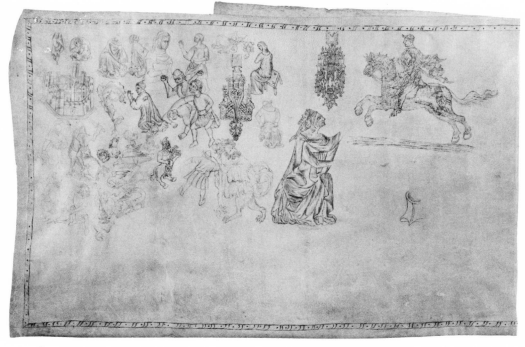

3

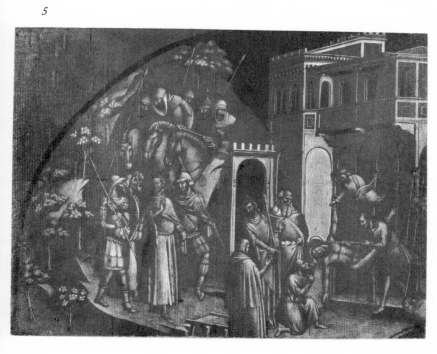

5

4

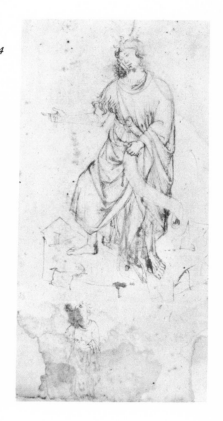

5. FLORENTINE SCHOOL, late 14th century
Martyrdom of St. Miniato
Ink, brush, heightened with white on brown
paper, red wash, traces of silverpoint in the
architecture
11½ x 15¹¹⁄₁₆ in. (29.2 x 39.8 cm.)
The Pierpont Morgan Library

Collections: Skene; J. C. Robinson;
C. Fairfax Murray
Literature: C. Fairfax Murray. *Drawings by the
Old Masters: Collection of J. Pierpont Morgan.*
4 vols. London, 1905–12. vol. 1, no.1: J. Meder.
Die Handzeichnung. Vienna, 1923. p.150, under
footnote no.1; B. Berenson. *The Drawings of the
Florentine Painters.* 3 vols. Chicago, 1938.
I:324, II:353, no. 2756C; A. Mongan. *One Hun-
dred Master Drawings.* Cambridge, Mass., 1949.
pp. 2, 3; *Great Master Drawings of Seven
Centuries.* M. Knoedler & Co., New York, 1959.
no. 1; L. Tintori, M. Meiss. *The Painting of the
Life of Saint Francis in Assisi.* New York, 1962.
p.26; I. Moskowitz, ed. *Great Drawings of All
Time.* 4 vols. New York, 1962. vol. 1, pl. 5; B.
Degenhart, A. Schmitt. *Corpus der italienischen
Zeichnungen, 1300–1450.* 4 vols. Berlin, 1968.
vol. 1, no. 30, fig. 58c, as Circle of Bernardo
Daddi; M. F. Todorow. *L'Italia dalle Origini
a Pisanello.* Milan, 1970. p. 81, pl. V, as Master
of the Circle of Orcagna.

6. JACOPO DELLA QUERCIA
(Italian, *ca.* 1374–1438)
Study for the Fonte Gaia, Siena, 1409
Brown ink and wash on parchment
7¹⁵⁄₁₆ x 8⁷⁄₁₆ in. (20.2 x 21.4 cm.)
The Metropolitan Museum of Art
Harris Brisbane Dick Fund

Collections: E. Philipps; R. Philipps,
1st Lord Milford; Sir J. Philipps;
purchased by the Metropolitan Museum, 1949
Literature: R. Krautheimer. "A Drawing for
the Fonte Gaia in Siena." *Metropolitan Museum
of Art Bulletin,* June 1952, pp.265-74; J. Pope-
Hennessey. *Italian Gothic Sculpture,* 1955.

p.214; J. Bean. *100 European Drawings in the
Metropolitan Museum of Art.* New York, 1964.
no. 1; B. Degenhart, A. Schmitt. *Corpus der ital-
ienischen Zeichnungen, 1300–1450.* 4 vols.
Berlin, 1968. no.112, fig. 161a; A. C. Hanson.
Jacopo della Quercia's Fonte Gaia. Oxford, 1965.
pp. 11-14, pl. 4.

7. FLORENTINE SCHOOL, 15th century
Two Male Nudes, One Playing a Violin
Silverpoint, heightened with white,
on gray prepared paper
7¾ x 8¹³⁄₁₆ in. (19.8 x 22.3 cm.)
The Pierpont Morgan Library

Collections: Arundel; Tighe
Literature: C. Fairfax Murray. *Drawings by the
Old Masters: Collection of J. Pierpont Morgan.*
4 vols. London, 1905–12. IV: 2; B. Berenson.
The Drawings of the Florentine Painters. 3 vols.
Chicago, 1938. vol. 3, no. 852B.

8. FLORENTINE SCHOOL,
about mid-15th century
Nine Famous Men
(*Six Prophets and Three Kings*)
Brown ink and watercolor on parchment
12¼ x 7¾ in. (31.2 x 19.7 cm.)
National Gallery of Canada, Ottawa

Collection: French Collection (?);
Quaritch, London; William Morris, 1894;
C. Fairfax Murray (Sale, Sotheby's, July 18,
1919, lot no.50); Sir Sidney Cockrell (Anony-
mous Sale, Sotheby's, July 2, 1958, lot 18); Dr.
and Mrs. Francis Springell (Sale, Sotheby's,
June 28, 1962)
Literature: U. Hoff. "Meditations in Solitude."
Journal of the Warburg Institute I (1937–38):
292-94; B. Berenson. *Drawings of the Florentine
Painters.* 3 vols. Chicago, 1938. p.17, no.164c
(3rd ed., 1961, p. 35, no. 164c); I. Toesca.
"Gli uomini famosi della Biblioteca Cock-
erell." *Paragone, disegno italiano dal trecento al
seicento.* Rome, 1956. p. 86; *Arte Lombarda
dai Visconti agli Sforza.* Milan, 1958. p. 64,

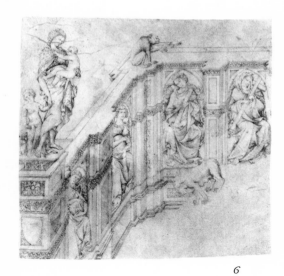

6

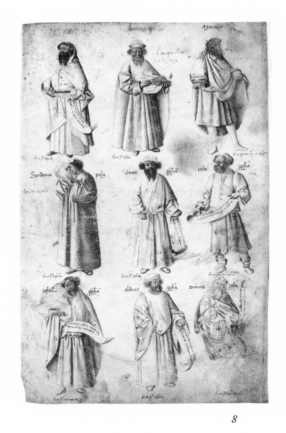

8

11

7

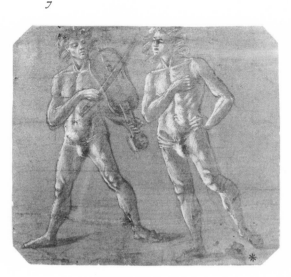

no. 202 (entry by R. Cipriani); *Drawings by Old Masters from the Collection of Dr. and Mrs. Springell*. Colnaghi's, London, 1959. no. 4; R. W. Scheller. "Uomini famosi." *Bulletin van het Rijksmuseum*. Amsterdam, 1962. X: 56-57; C. Virch. *Master Drawings in the Collection of Walter C. Baker*. New York, 1962. pp.11-12, no. 1; *Annual Report by the Trustees of the National Gallery of Canada 1962/63*. repr.; R. W. Scheller. *A Survey of Medieval Model Books*. Haarlem, 1963. p. 206; K. M. Fenwick. "The Collection of Drawings." *The National Gallery of Canada Bulletin*, II, no. 2 (1964): 2, 4, fig. 2; A. E. Popham, K. M. Fenwick. *European Drawings in the Collection of the National Gallery of Canada*. Toronto, 1965. p.3, no.1; C. Gómez-Moreno. *Medieval Art from Private Collections*. The Cloisters, New York, 1968–69. no.19.

9. ANTONIO POLLAIUOLO
(Italian, 1432-1498)
Study for a Projected Equestrian Monument to Francesco Sforza
Brown ink with light brown wash; dark brown wash in the background. The outlines of the horse and rider are pricked for transfer; various abrasions and losses, irregular margins
11 3/16 x 9 5/8 in. (28.5 x 24.4 cm.)
The Metropolitan Museum of Art
Robert Lehman Collection

Collections: G. Vasari (?); S. Meller; P. Hofer
Literature: G. Vasari. *Le Vite....* Edited by Milanesi. Florence, 1880. p.297; R. van Marle. *The Development of the Italian Schools of Painting*. 19 vols. The Hague, 1923–36. XI :370; S. Meller. "Pollaiuolo tervajzai Francesco Sforza lovasszo-brahoz." *Hommage à Alexis Petrovich*. Budapest, 1934. p. 204; O. Kurz. "Giorgio Vasari's 'Libro de Disegni.'" *Old Master Drawings*, II, no. 45 (1937): 13; B. Berenson. *The Drawings of the Florentine Painters*. 3 vols. Chicago, 1938. p. 27, no. 4, no. 1908A, fig. 78; C. de Tolnay. *History and Technique of Old Master Drawings*. New York, 1943. p. III, pl. 42; G. Colacicchi. *Antonio del Pollaiuolo*. Florence, 1945. pl. 77; H. Tietze. *European Master Draw-*

ings in the United States. New York, 1947. no.13, repr.; S. Ortolani. *Il Pollaiuolo*. Milan, 1948. pp. 169, 220–21, pl. 134 (with useful summary of previous opinions); P. Halm, B. Degenhart, W. Wegner. *Hundert Meisterzeichnungen aus der staatlichen graphischen Sammlung Munchen*. Munich, 1958. p. 56; B. Berenson. *I disegni dei pittori fiorentini*. 3 vols. Milan, 1961. p. 59, no. 1908A, fig. 75; B. Degenhart, A. Schmitt. "Methoden Vasaris bei der Gestaltung seines 'Libro.'" *Studien zur toskanischen Kunst, Festschrift für L. H. Heydenreich*. Munich, 1964. p. 58, fig.12; J. Bean, F. Stampfle. *Drawings from New York Collections I: The Italian Renaissance*. The Metropolitan Museum of Art and The Pierpont Morgan Library, New York, 1965. no. 6, p. 21, pl. 6.

10. FRANCESCO DI GIORGIO DI MARTINO
(Italian, 1439–1502)
A Kneeling Humanist Presented by Two Muses, 1475, Brown ink and wash and blue gouache, on vellum, 7¼ x 7⅝ in. (18.4 x 19.4 cm.)
Inscribed in brown ink at lower left: *Franco Francia;* in the cartouche: Franco/Francia Bolognese
The Metropolitan Museum of Art
Robert Lehman Collection

Collection: The Misses M. H., L. E., and M.D. Le Hunte (Sale, "Important Old Master Drawings and Paintings [including Le Hunte]," London, Sotheby's, June 9, 1955, no. 42, repr.)
Literature: *Exposition de la Collection Lehman de New York*. Galerie de l'Orangerie, Paris, 1957. no. 98, pl. XLIX; *Great Master Drawings of Seven Centuries*. M. Knoedler & Co., New York, 1959. no. 7, pl. III; J. Bean, F. Stampfle. *Drawings from New York Collections I: The Italian Renaissance*. The Metropolitan Museum of Art and The Pierpont Morgan Library, New York, 1965. no. 10, p. 23.

11. FRANCESCO DI STEFANO
called Pesellino (Italian, *ca.*1422–1457)
St. Philip Seated, Holding Book and Cross
Brush and brown wash, heightened with white,

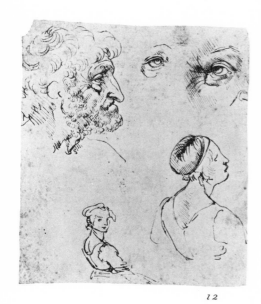

12

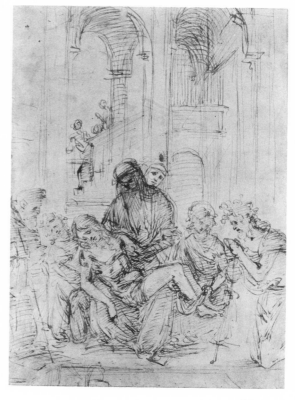

13

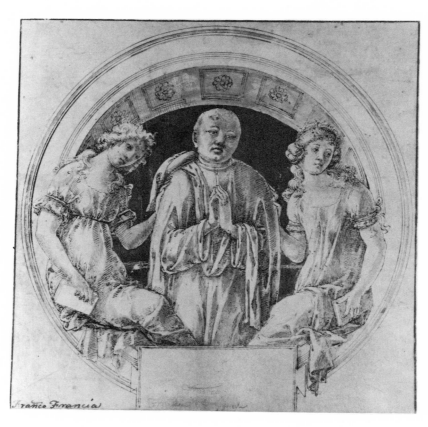

10

over black chalk, 10¾ x 7½ in. (27.3 x 19.0 cm.)
Watermark: Briquet 6062, *Star*
The Metropolitan Museum of Art
Rogers Fund

Collection: V. Bloch (Sale, London, Sotheby's
part 3, Nov. 12, 1964, no. 4); Metropolitan
Museum, 1965
Literature: J. Bean, F. Stampfle. *Drawings from
New York Collections I: The Italian Renais-
sance.* The Metropolitan Museum of Art and
The Pierpont Morgan Library, New York, 1965.
no. 2, p. 19; B. Degenhart, A Schmitt. *Corpus
der italienischen Zeichnungen, 1300–1450.* 4 vols.
Berlin, 1968. vol. I, no. 551, fig. 371d, as copy
of a much damaged drawing in the Uffizi.

12. LEONARDO DA VINCI
(Italian, 1452–1519)
Sheet of Studies
Verso: Study of a Madonna
Brown ink over traces of black chalk
6⁷⁄₁₆ x 5⁷⁄₁₆ in. (16.4 x 13.8 cm.)
Watermark: Tulip (close to Briquet 6645–6659)
The Armand Hammer Foundation

Collection: Colnaghi's, London
Literature: *Recent Acquisitions and Promised
Gifts.* National Gallery of Art, Washington,
D.C., 1974. no. 65. Dr. Oberhuber dates this
drawing to around 1478–80.

13. FILIPPINO LIPPI (Italian, 1457/58-1504)
Pietà with Saints and Angels, after 1495
Brown ink
9⅞ x 7⅛ in. (25.1 x 18.1 cm.)
Watermark: Greek cross in circle
Fogg Art Museum
Bequest of Charles Alexander Loeser

Collection: Charles Alexander Loeser
Literature: J. Meder. *Die Handzeichnung.*
Vienna, 1919. p.36, fig. II; H. Leporini. *Die
Kunstlerzeichnung.* Berlin, 1928. p.174, fig. 73;
R. van Marle. *The Development of the Italian
Schools of Painting.* 19 vols. The Hague,
1923–36. XII: 362; A. Scharf. "Studien zu eini-

gen Spätwerken des Filippino Lippi." *Jahrbuch
der preussischen Kunstsammlungen* LII (1931):
209–13, figs. 8, 9; A. Mongan. "The Loeser
Collection of Drawings." *Bulletin of the Fogg
Museum* II, no. 2 (Mar.1933): 22–24, frontis-
piece; A. Scharf. *Filippino Lippi.* Vienna,1935.
pp. 48, 120, figs.172,173; B. Berenson. *Draw-
ings of the Florentine Painters.* 3 vols. Chicago,
1938. no. 1271G; K. B. Neilson. *Filippino Lippi.*
Cambridge, Mass.,1938. pp.107–109; A. Mon-
gan, P. J. Sachs. *Drawings in the Fogg Museum
of Art.* 3 vols. Cambridge,1940. vol. I, no. 22,
vol. II, figs. 21, 22; H. Tietze. *European Master
Drawings in the United States.* New York,1947.
p. 34, fig.17; I. Moskowitz, ed. *Great Drawings
of All Time.* 4 vols. New York, 1962.
vol. I, pl. 116.

14. FILIPPINO LIPPI (Italian,1457/58-1504)
Seated Youth
Silverpoint and leadpoint
7⅛ x 4¾ in. (18.1 x 12.2 cm.)
The Pierpont Morgan Library

Collections: Duke of Cambridge;
C. Fairfax Murray
Literature: C. Fairfax Murray. *Drawings by the
Old Masters: Collection of J. Pierpont Morgan.*
4 vols. London, 1905–12. vol. I. (appendix 4a,
46); *Master Drawings Selected from the Muse-
ums and Private Collections of America.* The
Buffalo Fine Arts Academy,1935. no.17, repr.;
B. Berenson. *Drawings of the Florentine Paint-
ers.* 3 vols. Chicago, 1938. vol. II, no. 1353D;
Italian Drawings, 1330-1780. Smith College
Museum of Art, Northampton, Mass.,1941.
no. 21; I. Moskowitz, ed. *Great Drawings of All
Time.* 4 vols. New York,1962. vol. I, pl. 121.

15. SCHOOL OF FILIPPINO LIPPI*
(Italian, 1457/58-1504)
Youth Seated on a Stool
Silverpoint on prepared yellow brown paper
8⁹⁄₁₆ x 6⁹⁄₁₆ in. (21.7 x16.7 cm.)
The Museum of Fine Arts, Boston
Harriet Otis Cruft Fund

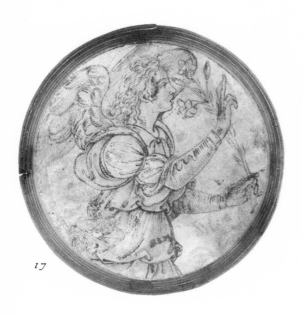

17

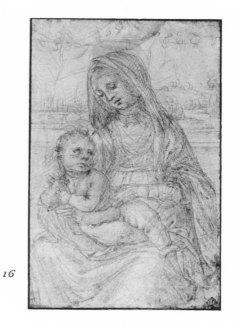

16

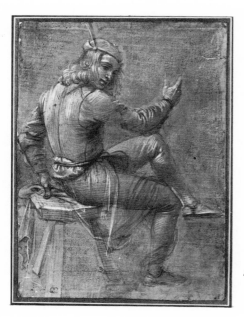

15

14

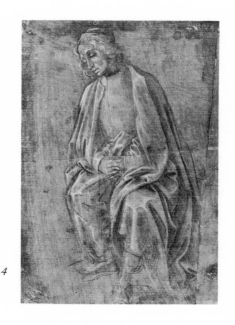

Collection: Argoutinsky-Dologoroukow
Literature: *Boston Museum of Fine Arts Bulletin* XXXIV (1936): 95; B. Berenson. *Drawings of the Florentine Masters*. 3 vols. Chicago, 1938. II: 155, no. 1369A; *Master Drawings of the Italian Renaissance*. Detroit Institute of Arts, 1960. p. 12, no. 5, repr. on cover.

*Withdrawn from exhibition because of its condition.

16. LORENZO DI CREDI
(Italian, 1459/60?-1537)
Madonna and Child
Silverpoint (with touches of oxidized white on right sleeve?) on paper prepared with thin gesso ground
5 11/16 x 3 11/16 in. (14.4 x 9.3 cm.)
Cleveland Museum of Art
John L. Severance Fund

Collections: E. Desperet; E. and L. Galichon; J. P. Heseltine; Henry Oppenheimer; Sir T. D. Barlow; Dr. F. Springell
Literature: *Drawings by Old Masters*. London, Royal Academy of Arts, 1953. no. 33; "Year in Review." *Cleveland Museum of Art Bulletin* LI (Oct.1964): 189–95, repr. p.190; *Handbook*. Cleveland Museum of Art, 1966. p. 80.

17. RAFFAELLINO DEL GARBO
(Italian, ca. 1466-1524)
The Angel of the Annunciation
Brown ink and wash, heightened with white on brown washed paper; a probable design for an embroidery, pricked for transfer
diam: 3 ¾ in. (9.7 cm.)
The Metropolitan Museum of Art
Rogers Fund

Collections: Sir C. Eastlake; J. P. Richter; Metropolitan Museum purchase, 1912
Literature: B. Berenson. *The Drawings of the Florentine Painters*. 3 vols. Chicago, 1938. no. 766A; *European Drawings*. The Metropolitan Museum of Art, New York, 1942. vol. I, no. 12; B. Berenson. *I disegni dei pittori fiorentini*. Milan, 1961. no. 766E; J. Bean. *100 European*

Drawings in The Metropolitan Museum of Art. New York, 1964. no. 8; J. Bean, F. Stampfle. *Drawings from New York Collections I : The Italian Renaissance*. The Metropolitan Museum of Art and The Pierpont Morgan Library, New York, 1965. no. 25.

18. BACCIO DELLA PORTA,
called Fra Bartolommeo (Italian, 1472–1517)
Virgin with the Holy Children
Verso: child at extreme right on *recto* traced through; sketch of a child
Brown ink over black chalk
7 ¼ x 6 ¼ in. (18.4 x 15.9 cm.)
The Metropolitan Museum of Art
Robert Lehman Collection

Collections: Count Ottolini; J. P. Heseltine; H. Oppenheimer (Sale, London, Christie's, July 10, 1936, no. 31, pl. 6)
Literature: F. Knapp. *Fra Bartolommeo....* 1903. p. 314, no. 4; B. Berenson. *The Drawings of the Florentine Painters*. 2 vols. London, 1903. no. 430; H. von der Gabelentz. *Fra Bartolommeo....*Leipzig, 1922. II: 133, no. 307; B. Berenson. *The Drawings of the Florentine Painters*. 3 vols. Chicago, 1938. no. 459G; A. Popham, J.Wilde. *Italian Drawings of the XV and XVI Centuries at Windsor Castle*. London, 1949. p. 193, no. 113; *Exposition de la Collection Lehman de New York*. Galerie de l'Orangerie, Paris, 1957. p. 64. no. 86, pl. LII; B. Berenson. *I disegni dei pittori fiorentini*. 3 vols. Milan, 1961, no. 459G; J. Bean, F. Stampfle. *Drawings from New York Collections I : The Italian Renaissance*. The Metropolitan Museum of Art and The Pierpont Morgan Library, New York, 1965. p. 32, no. 28, pl. 28.

19. BACCIO DELLA PORTA,
called Fra Bartolommeo (Italian, 1472–1517)
A Gnarled Tree Verso: A Village on a Hill
Brown ink, 11⅜ x 8⅞ in. (28.9 cm. x 21.6 cm.)
Stephen Spector

Collections: Fra Paolina da Pistoia; Suor Plautilla Nelli; Convent of St. Catherine, Florence; F.M.N.Gabburi, Florence; "Mr. Kent;"

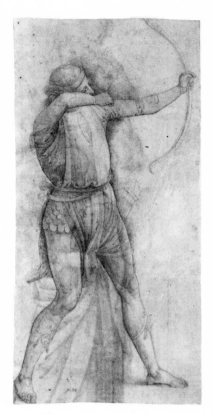

20

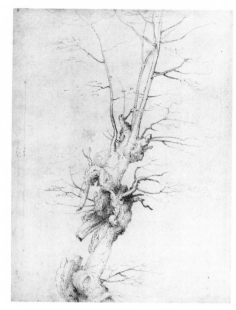

19

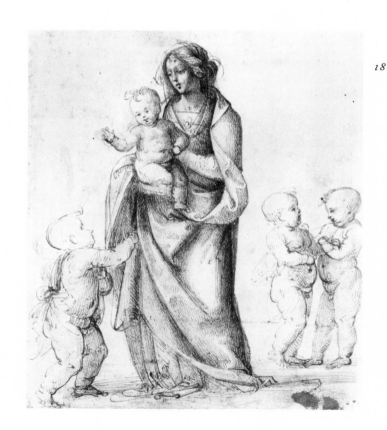

18

Collector, Southern Ireland, 1925; (Sale, London, Sotheby's, Nov. 20, 1957, no. 29) P.W. Josten Literature: C. Gronau. *Catalogue of Drawings of Landscapes and Trees by Fra Bartolomeo.* Sotheby's, London, Nov. 20, 1957. no. 29; W.R. Jeudwine. "A Volume of Landscape Drawings by Fra Bartolomeo." *Apollo* LXVI (Nov. 1957): 135; E. van Schaack. *Master Drawings in Private Collections.* New York, 1962. p. 69, nos. 2–3, pls. 2–3.

20. WORKSHOP OF PIETRO PERUGINO
(Italian, *ca.* 1500)
Figure of an Archer Verso: Rider and Standing Draped Man, from the Antique
Brown ink, 6¹¹⁄₁₆ x 5³⁄₁₆ in. (16.9 x 13.2 cm.)
National Gallery of Art, Washington, D.C.
The Pepita Milmore Fund

Collections: Padre Sebastiano Resta; G.M. Marchetti; Bishop of Arezzo; Cavalier Marchetti of Pistoia; John Lord Somers; The Marquis of Tweeddale; Schaeffer Galleries
Literature: *Recent Acquisitions and Promised Gifts.* National Gallery of Art, Washington, D.C., 1974. no. 14.

21. RAFFAELLO SANZIO, called Raphael
(Italian, 1483–1520)
Study for the Prophets Hosea and Jonah
Brown ink and wash, heightened with white over black chalk and stylus, squared with stylus and red chalk, 10⁵⁄₁₆ x 7¹³⁄₁₆ in. (26.2 x 19.8 cm.)
The Armand Hammer Foundation

Collections: Jonathan Richardson, Sr.; Jonathan Richardson, Jr.; P.–J. Mariette; H.C. Jennings; P. Payne Knight; Baron H. de Triquety; E. Colando; Major S.V. Christie-Miller; Colnaghi's, London
Literature: C. Metz. *Imitations of Ancient and Modern Drawings.* London, 1798. pl. 34; C. Ruland. *The Works of Raphael Santi da Urbino as Represented in the Raphael Collection in the Royal Library in Windsor Castle.* London, 1876. III: 4, 271; J.A. Crowe, G.B. Cavalcaselle. *Raphael, Life and Works.* London, 1882-85. 2: 216, n.; G.E. Lafenestre, W. Richtenberger. *Rome, le Va-*

tican et les églises. Paris, 1903. p. 263; O. Fischel. "Some Lost Drawings by or near Raphael." *Burlington Magazine* 20 (1912): 299, pl. II, fig. 12; idem. "Santi." in Thieme-Becker, vol. XXIX, p. 438; O. Fischel. *Raphael.* London, 1948. 1:364; F.A. Gruyer. *Raphael et l'antiquité.* Paris, 1946. L:379, no. 1; J. Richardson. *An Account of the Statues, Bas-Reliefs, Drawings and Pictures in Italy, France, …with remarks by Mr. Richardson, Sen. and Jun.* 2nd ed. London, 1954, p. 104; J.D. Passavant. *Raphael d'Urbin.* Paris, 1960. 2:142; L. Dussler. *Raphael, A Critical Catalogue of His Pictures, Wall-Paintings and Tapestries.* London, 1971. p. 94; *The Armand Hammer Collection.* Los Angeles, 1971. no. 61; C. White. "The Armand Hammer Collection: Drawings." *Apollo* LXXXXV (1972): 456-57, fig. 1; *Recent Acquisitions and Promised Gifts.* National Gallery of Art, Washington, D.C., 1974. no. 67.

22. ANDREA DEL SARTO (Italian, 1486–1530)
St. Michael
Red chalk, 10⅝ x 5⁵⁄₁₆ in. (27.0 x 13.5 cm.)
The Pierpont Morgan Library

Collections: F. Renaud; Earl of Aylesford; C. Fairfax Murray
Literature: C. Fairfax Murray. *Drawings by the Old Masters: Collection of J. Pierpont Morgan.* 4 vols. London, 1905-12, vol. I. no. 31; *Italian Drawings, 1330–1780.* Smith College Museum of Art, Northampton, 1941. no. 18; B. Berenson. *Drawings of the Florentine Painters.* 3 vols. Chicago, 1938. vol II, no. 141F; S.J. Freedberg. *Andrea del Sarto, Catalogue Raisonné.* Cambridge, Mass., 1963. p. 170, no. 75, fig. 130; J. Shearman. *Andrea del Sarto.* Oxford, 1965. vol. I, pl. 156b, II:366.

23. DOMENICO BECCAFUMI
(Italian, 1486?–1551)
St. Matthew
Tempera and emulsion
15⅜ x 8⅝ in. (39.8 x 22.0 cm.)
The Metropolitan Museum of Art
Gift of Mrs. Edward Fowles, in memory of R. Langton Douglas

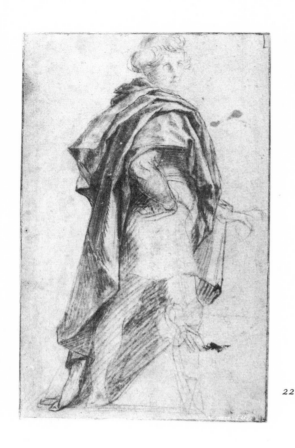

22

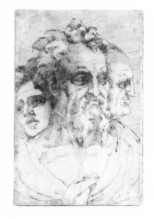

24

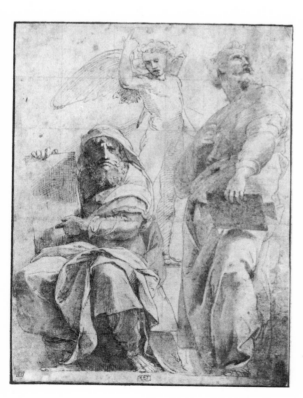

21

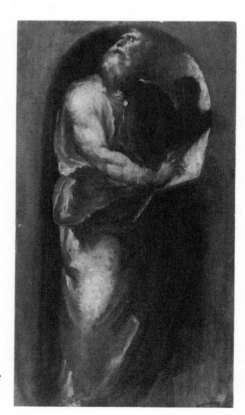

23

Collections: H. S. Reitlinger;
Mrs. Edward Fowles
Literature: D. Sanminiatelli. "The Sketches of Domenico Beccafumi." *Burlington Magazine*, 1955. p. 35, n. 5; J. Bean, F. Stampfle. *Drawings from New York Collections I: The Italian Renaissance*. The Metropolitan Museum of Art and The Pierpont Morgan Library, New York, 1965. no. 63.

The drawing for the apostle Mark, related to the present work and also from the Reitlinger Collection, is now in the Metropolitan Museum.

24. BACCIO BANDINELLI (Italian, 1493–1560)
Three Male Heads
Brown ink, 12⅝ x 8³⁄₁₆ in. (32.1 x 20.8 cm.)
The Metropolitan Museum of Art
Rogers Fund

Collections: Dr. F. Springell (Sale, London, Sotheby's, June 28, 1962, no. 18); Metropolitan Museum, 1963
Literature: J. Bean, F. Stampfle. *Drawings from New York Collections I: The Italian Renaissance*. The Metropolitan Museum of Art and The Pierpont Morgan Library, New York, 1965. no. 75.

25. JACOPO DA PONTORMO
(Italian, 1494–1557)
Standing Male Nude and Two Seated Nudes
Verso: Striding Nude with Upraised Arms
Red chalk, 16 x 8⅞ in. (40.6 x 22.5 cm.)
The Pierpont Morgan Library

Collections: P. Crozat; H. Reitlinger
(Sale, London, Sotheby's, Dec. 9, 1953, no. 84); purchased by the Pierpont Morgan Library, 1954
Literature: A. Scharf. "The Exhibition of Old Master Drawings at the Royal Academy." *Burlington Magazine* 95 (1953): 352, fig. 3; *Fifth Fellows Report*. The Pierpont Morgan Library, New York, 1954. pp. 65–68, repr.; C. Gamba. *Contribuito all conoscenza del Pontormo*. Florence, 1956. p. 11, fig. 12; B. Berenson. *I disegni dei pittori fiorentini*. 3 vols. Milan, 1961. no. 2256H, fig. 905; J. Cox Rearick. *The Drawings of Pontormo*. Cambridge, Mass., 1964. nos. 188, 189, figs.

172, 178; J. Kramer. *Human Anatomy and Figure Drawing*. New York, 1972. p. 79, fig. 5-4; J. Bean, F. Stampfle. *Drawings from New York Collections I: The Italian Renaissance*. The Metropolitan Museum of Art and The Pierpont Morgan Library, New York, 1965. no. 76; F. Stampfle. *Drawings: Major Acquisitions of The Pierpont Morgan Library, 1924–74*. New York, 1974. no. 4.

26. BENVENUTO CELLINI (Italian, 1500-1571)
Standing Male Nude with a Club
Brown ink and wash
16⅛ x 7¾ in. (41.5 x 20.2 cm.)
Woodner Family Collection

Collections: J. Barnard; T. Lawrence
Literature: *Old Master Drawings*. The Newark Museum, 1960. no. 25; J. Bean, F. Stampfle. *Drawings from New York Collections I: The Italian Renaissance*. The Metropolitan Museum of Art and The Pierpont Morgan Library, New York, 1965. no. 82; A. Parroncchi. "Une tête de satyre de Cellini." *Revue de l'Art*, 1969; *Woodner Collection I: A Selection of Old Master Drawings before 1700*. New York, 1971. no. 14; C. Monbeig-Goguel. *Vasari et son temps*. Paris, 1972. p. 45; *L'école de Fontainebleau*. Grand Palais, Oct. 17–Jan. 15, 1973. p. 51, no. 51, fig. 51.

Alessandro Parroncchi has compared the head of the Woodner satyr with a marble head in a Swiss private collection, which he attributes to Cellini after the artist returned to Florence from France.

27. BARTOLOMMEO AMMANATI
(Italian, 1511–1592)
Young Male Figure Seated on Drapery
Verso: Bearded Male Figure Holding Drapery
Dark brown ink, 16⁷⁄₁₆ x 10¼ in. (41.7 x 26.0 cm.)
Michael Hall, Esq.

Collection: Earl of Warwick
Literature: S. J. Pope-Hennessey. *Italian High Renaissance and Baroque Sculpture*. London, 1963. 1:75; *The Male Nude*. The Emily Lowe Gallery, Hofstra University, Hempstead, N.Y., Nov. 1–Dec. 2, 1973. no. 1.

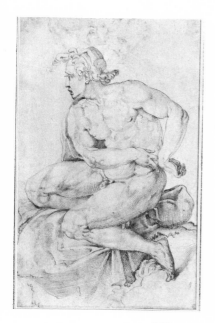

27R

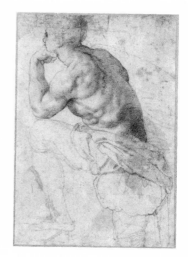

29

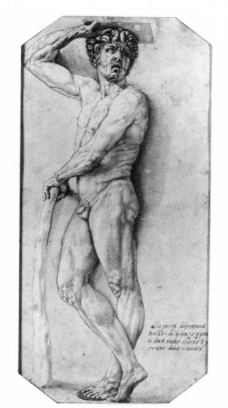

26

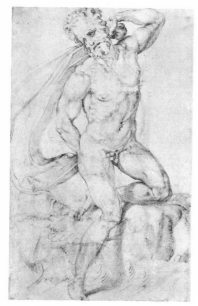

27V

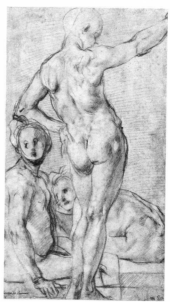

25

28. MARCO PINO (Italian, *ca.* 1525–after 1579/87/88)
The Battle of Anghiari
Brown ink and wash, heightened with white
11 x 16¼ in. (27.9 x 38.7 cm.)
Los Angeles County Museum of Art
Los Angeles County Funds

Collections: Vallardi; B. Anthon
Literature: Unpublished
 Originally attributed to Taddeo Zuccaro, the drawing was identified as Marco Pino by Philip Pouncey and by John Gere.

29. ALESSANDRO ALLORI
(Italian, 1535–1607)
Study of Male Figure Seated towards the Left
Black chalk, 11¾ x 8¼ in. (29.8 x 20.9 cm.)
David E. Rust

Collections: F. J. Gesell; S. de Festetits
(Graf von Festetits); H. M. Calmann
Literature: Unpublished
 This appears to be an earlier version than the chalk drawing in the Philadelphia Museum (see *The Age of Vasari* [University of Notre Dame, Ind.,1970], p. 72, D.2, repr. p. 92) for the figure at the upper right of Allori's painting *The Pearl Divers*, painted *ca.*1570–72 for the *studiolo* of Francesco I in the Palazzo Vecchio, Florence.

30. MASO DA SAN FRIANO
(Italian, 1536–1571)
Three Standing Soldiers
Black chalk, 8¼ x 9½ in. (20.9 x 24.1 cm.)
Inscribed in a later hand at lower right:
Federico Zuccaro
Los Angeles County Museum of Art
Gift of the Graphic Arts Council

Literature: Unpublished
 Although the drawings of Maso da San Friano (Tommaso Manzuoli) have not been definitively

assorted, a certain number of them are securely attributed. In the past some have been attributed to artists by whom he was conspicuously influenced, for example, Andrea del Sarto, Rosso Fiorentino, and Jacopo da Pontormo. The present work shows a predominant influence of Pontormo, as can be seen in the striking similarity of the gesturing soldier at the left to Pontormo's *Seated Nude* in the Uffizi (J. Cox Rearick, *The Drawings of Pontormo* [Cambridge, 1964], 2 vols., vol. II, fig. 291). The looser, more decorative quality of Maso's line is, however, apparent. The helmeted soldier with the curvilinear, ornamented shield at the left should be compared with the warrior at the lower left in Maso's drawing *Ecce Homo*, in the Uffizi (n. 999 s).

31. RUTILIO MANETTI (Italian, 1571–1637)
Scene from the Life of a Saint
Oil on paper, 16½ x 11½ in. (41.9 x 29.2 cm.)
Los Angeles County Museum of Art
Los Angeles County Funds

Collection: H. Voss
Literature: Unpublished
 The name of Francesco Rustici (A. Moir), and the suggestion that the drawing is close to Francesco Vanni (H. Röttgen) have also been proposed for the work.

32. FRANCESCO MONTELATICI,
called Cecco Bravo (Italian, 1607–1661)
Male Nude Bending
Red chalk, 15⅛ x 9¾ in. (38.4 x 24.8 cm.)
David E. Rust

Collection: J. Reynolds
Literature: Unpublished
The drawing appears to be a variant of the *Nude Bending with Sword in Left Hand*, in the Uffizi (repr. in A. R. Masetti, *Cecco Bravo, Pittore Toscano del seicento* [Venice, 1962], p. 119, no. 117, fig. 83.).

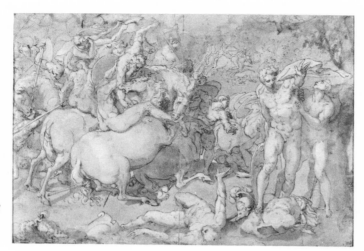

28

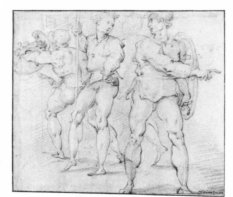

30

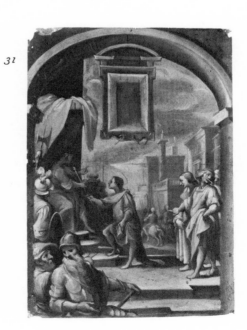

31

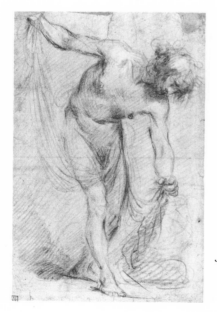

32

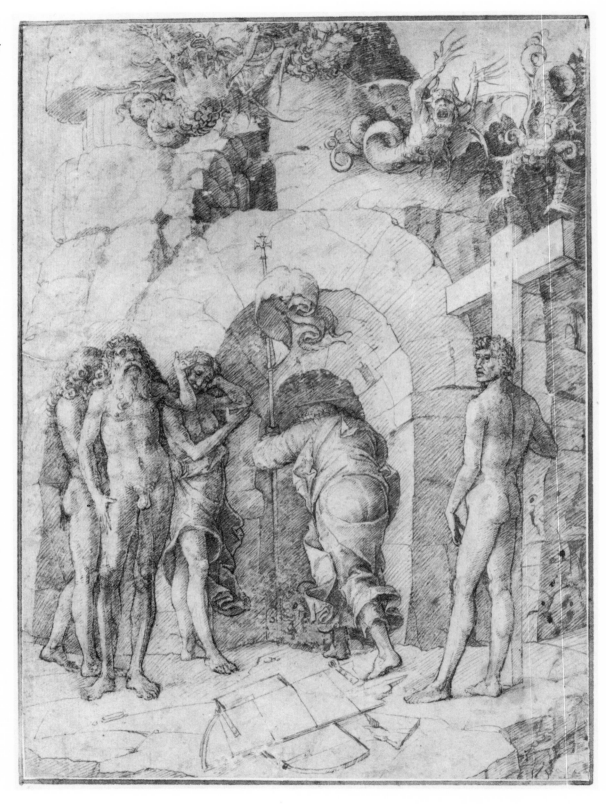

Venice and the Veneto

ᗷECAUSE of her historically close connections with Constantinople and the East through politics and trade, Venice maintained a tradition of Byzantine art longer than other Italian cities. Even when Giottesque influences were taking hold in nearby Padua, Venice continued the Byzantine style, only gradually freeing herself from that influence by the middle of the quattrocento. Toward the second half of the fifteenth century, the area of the Veneto reflected the style of the International Gothic, which had a principal center in the city of Verona, then under the domination of Venice.

Among the first artists of the Veneto to free himself from the older tradition of drawing with unbroken contour lines was Stefano da Zevio (*ca.* 1374/75–after 1438), also called Stefano da Verona after his native city. Departing from the miniature-related method of depicting form by carefully contained outlines, Stefano used straight or gently curving parallel lines to create free-flowing, rhythmic, and completely individual drawings (cat. no. 33) that no longer observed the conventions of outline and modeling. The vibrant new energy seen in his work has also been found occasionally in *sinopie*, which were, of course, intended to be covered by the finished frescoes. Roughly contemporary with Stefano da Zevio, the Aretine artist Parri Spinelli (*ca.* 1387–1453) produced many drawings that also indicate a new relaxation of technique, noticeable in the loose nets of hatching and cross-hatching that play a large role in his graphic style.

The most important draftsman in fifteenth-century Verona was Antonio Pisanello (before 1395–before 1455). Equally famous as painter and medallist, he moved among many Italian courts, both in the north and in the south, perfecting a style that united the refined elegance of the late Gothic world with the dawning age of naturalism. Pisanello was born at about the same time that Milan became the seat of the Visconti duchy and having worked for that family in Pavia he could profit from their support and encouragement of the rising interest in humanism with its new awareness and observation of natural form. His exquisite sensibility and attention to the finest detail resulted in a quality of design so true and controlled that his drawings assume an almost carved relief appearance.

In keeping with the standard procedures of the period, Pisanello's drawings fall into two broad categories–the sketch and the study. The former, in which he used pen or graphite, was generally for rapid notemaking, and in such studies as found, for example, in Pisanello's sketchbook in the Louvre, the freely drawn parallel lines and stressed strokes create a sense

of swinging motion upon the page. When he sought a highly finished accuracy in a drawing, Pisanello often used metalpoint to produce punctiliously fine and graded hatching for a subtle modeling of form. Predating Pollaiuolo and apparently without the benefit of anatomical knowledge derived from dissecting corpses, Pisanello's delicately modeled drawing of female nudes in the Boymans-Van Beuningen Museum, Rotterdam achieves a striking re-creation of the solidity of flesh and muscle. This may be due in part to his following the practice of his Umbrian collaborator, Gentile da Fabriano (1360–1427), in copying antique sculpture, both free-standing and relief, thereby gaining a mastery over roundness of form.

Among the most important bodies of work for the history of fifteenth-century drawing in northern Italy are the two pattern books of Jacopo Bellini (*ca.*1400–1470). The earlier one (*ca.*1450–55, in the British Museum) is comprised of drawings executed in chalk and leadpoint. They are characterized by a pictorial style with contouring chiefly by softly accented delicate flecks rather than by continuous lines. Interior modeling of form is absent, and the effect thus suggests light-suffused shapes, which nevertheless do not lack substantiality. The drawings in the second sketchbook in the Louvre, executed almost exclusively with pen on parchment, display a more developed style than those in the earlier one and evidence a broader compass that includes architectural and landscape backgrounds as well as the study of anatomy and perspective. Jacopo Bellini was influenced by many sources: antiquity, illuminated manuscripts, Gentile da Fabriano, and Donatello. In turn, he provided a mine of models and ideas for his two sons, Giovanni and Gentile, as well as for their brother-in-law Andrea Mantegna.

The art of Andrea Mantegna (1431–1506) (cat. no.35) affords a prime example of the early Renaissance influence of sculpture upon painting, which imparted the suggestion of a carved linear quality to two-dimensional surfaces. Roman statuary and the later works of Donatello, who came from Florence to work in Padua, were among Mantegna's chief inspirations. In turn, Mantegna's compositions, thoroughly impregnated with classical themes and spirit, were highly influential upon the art of northern Italy. Mantegna's drawings, which are occasionally difficult to segregate from those of Giovanni Bellini (*ca.*1431–1516), are of two categories. One type is sketchy, identifiable by Mantegna's distinctive system of parallel hatching and the long contour lines he also employed in his engravings. His other style is highly finished, with naturalistic modeling that reflects this artist's profound attachment to ancient sculpture. Although he was indisputably a major factor in the formation of a score of painters, from those of the Venetian school to artists like Bramantino of Milan and the early Correggio, Mantegna's use of a severely lineal style to suggest sculptural

form did not noticeably affect the current of sixteenth-century Venetian draftsmanship.

The Lehman collection's drawing of *Christ's Descent into Limbo* (cat. no. 36) exemplifies the proximity of Giovanni Bellini's style to that of his brother-in-law Andrea Mantegna. (A summary of the latest opinion on the authorship of the work is found in the catalog section.) Regardless of its authorship, the technical character of the drawing is arresting, contrasting with another drawing from the same collection, *St. Jerome in a Landscape* (cat. no. 37), which has also been attributed to Giovanni Bellini, Piero di Cosimo, and, most recently, to Giulio Campagnola. The first drawing typifies the Paduan style with its lean, hard figures, intensely expressive faces, sharply outlined draperies clinging to the form, and fine, straight parallel lines employed for modeling. Inspired by classical art, the use of drapery to outline the forms, as in the back of the figure of Christ, is here given a distinguishing crispness by the lineal patterning and the emphasized areas of light.

The second drawing is of great importance as one of the earliest examples of Italian landscape that has been preserved, indicating the significant part Venice played in the development of the art of Italian landscape. One of the reasons that Pignatti declined to ascribe the drawing to Giovanni Bellini is the presence of the half-timbered buildings at the right. Such clusters of northern type architecture are well known from drawings by the German-descended, Venetian-born Domenico Campagnola (cat. no. 45) but to date have not been found in the work of Giovanni Bellini.

It is now almost commonplace to state the polarity of aesthetic views held by Florentine and Venetian artists in the sixteenth century. Whereas in Florence artists generally emphasized line as a means to create and clarify form, and stressed modeling with light and dark or with hatching, the Venetians were usually engrossed by a more painterly approach to the delineation of form. This latter approach was stimulated in the sixteenth century by the contribution of Titian (1485/88?–1576) to developing the potentials of oil painting, particularly evident in his employment of the broken highlights that so enliven the surfaces of his canvases. Wholly opposite to the sculptural orientation that marks the sharply contoured linear forms of Mantegna, Titian's drawing style presents mass and coloristic effects through his broad modeling and portrays planes dissolving beneath light or shadow.

A beautiful example of Titian's landscape drawing is the Metropolitan Museum's *A Group of Trees* (cat. no. 42), which the artist prepared as the model for the background of the woodcut *The Sacrifice of Abraham*. The noble, almost romantic rendering of the picturesque clump of trees in this drawing introduced an interpretation of landscape into this

branch of art that has remained a touchstone for artists over the centuries. Another aspect of Titian's landscape style, more linear and expansive in composition, is found in his late work *St. Theodore and the Dragon* (cat. no.43). The landscape approach of Agostino and Annibale Carracci was originally based on background compositions of this type which were created by Titian and followed by Domenico Campagnola.

A contemporary of Titian's, Giovanni Antonio de'Sacchis (1484–1539), called Giovanni Antonio da Pordenone after his birthplace, was one of the most interesting and spirited masters of the Veneto before Tintoretto. A very active painter and frescoist, Pordenone worked in many cities of the north, including Mantua and, at the end of his career, Ferrara, where he died. Two brilliant compositions illustrate Pordenone's bold, decorative style. Bean and Stampfle have pointed out that *The Conversion of St. Paul* (cat. no.39) has no connection with the organ wing of the same subject, in the cathedral at Spilimbergo, near Udine, which Pordenone painted in 1524.

Instead, these two scholars suggest that the drawing may in fact be a study for a possibly later painting of the same theme. The drawing may antedate the *Adoration of the Magi* (cat. no.40), which C. Cohen considers to be possibly related to Pordenone's 1529 frescoes in the church of Santa Maria di Campagna, in Piacenza. Both drawings are executed in an identical technique: brown ink and wash, heightened with white, on colored paper. Whereas the study of the *Conversion* is light and delicate, with the highlighting restrained, in the *Adoration* the figures are delineated with greater solidity and the white is added to make more forceful accents. It should be mentioned that Pordenone also excelled in the use of red chalk, as can be seen in his drawings in the Chatsworth collection and elsewhere.

Like Titian, Jacopo Robusti (1518–1594), called Jacopo Tintoretto, used drawing in a personal way, seeking to capture the movement of figures by flowing and broken curves, a method that also admitted the full play of light upon the interrupted contours of his figures (cat. no.49). Like Mantegna, Tintoretto was strongly attracted to sculpture but used it for an entirely different point of departure. He was greatly given to copying plaster casts of the antique, and also to the copying of Michelangelo's sculpture (cat. no.48) which he observed from various angles, chiefly for the purpose of drawing the figures in sharp foreshortening. Thus it is not surprising that Tintoretto prepared clay models to guide him in the arrangement of his compositions.

For the greater part, Tintoretto's studies are all of the same nature, being chiefly exercises for studying the figure in movement. Nearly always using charcoal, which he sometimes heightened with white, Tintoretto evolved an impressive drawing style which neither

varied greatly over the years nor ever diminished in its intensity. Developing from his father's style, Tintoretto's son and assistant, Domenico (*ca.*1560–1635), created oil sketches with free, impressionistic strokes in which form and background merge into an almost monochromatic unity (cat. no.53).

Paolo Caliari, called Veronese (1528–1588), ten years younger than Tintoretto, was his antipode. While the impassioned energy and spiritualized light effects of Tintoretto's paintings heralded the world of the Baroque, Veronese still belonged to the world of the classical Renaissance. His drawings, which became the subject of study much later than those of Titian and Tintoretto, range from sketches with exploratory, repeating, threadlike lines which intensify the light of the paper (cat. no.50) to completely finished, chiaroscuro compositions on blue paper, shimmeringly highlighted with white (cat. no.51). Unlike Tintoretto, Veronese is only rarely known to have used chalk for his drawings.

A contemporary of the three major Venetian masters of the Renaissance, Jacopo da Ponte (*ca.* 1516–1592), called Jacopo Bassano, can be termed the father of Italian genre painting. In contrast to the historical and heroic themes of Titian, Tintoretto, and Veronese, Jacopo chose to depict scenes of country life and to set many of his compositions in such surroundings. A fine colorist in the native tradition, Bassano used different colors of chalk to execute drawings of great pictorial vividness, sometimes heightened with wash to increase their effectiveness. His drawing on blue paper (cat. no.47) combines black chalk with brown wash heightened with white. The large, powerfully drawn figure of the woman on the horse appears in four paintings of the *Departure for Canaan*, of which only one is by Jacopo himself, two by his son Francesco, and another signed by both father and son. Since conjunctive work was common in Jacopo Bassano's workshop, opinion has been divided as to the nature of the Crocker drawing; but according to Pignatti, the latest authority to study this drawing, the monumental quality of the work transcends the level of a typical drawing executed in the shop by assistants as a *ricordo*.

In keeping with the tradition of his school, Jacopo Negretti, called Palma Giovane (1544–1628), the last important exponent of the Venetian High Renaissance, flooded his drawings (cat. no.52) with a brilliant light against which figures created by broken and patchy lines seem to palpitate with life. With Palma the curtain is considered to have dropped upon the great centuries of Venetian art. Throughout the sixteenth century, the Venetian Republic struggled to maintain her possessions and power despite the forces aligned against her, from the League of Cambrai to the combative Turks. Paradoxically, this trying period marked the Golden Age of Venetian art. The next century saw the nadir of Venetian artistic

effulgence. The important draftsmen who worked in Venice during the seventeenth century were mainly artists from other cities: Strozzi came from Genoa, Domenico Feti came from Rome, and Giovanni Lys came from Oldenburg. Not until the early eighteenth century did Venice once more spawn major artists that were truly her own.

One of the Venetians who attained universal fame in Europe in the first quarter of the eighteenth century was Rosalba Carriera (1675–1757), long considered the most important miniaturist and portrait painter of her school and the greatest pastellist of her day. Originally a lace maker and decorator of snuff boxes, she turned to the medium of pastel with such success that when she went to Paris in 1720 she was elected a member of the Academy by acclamation. The melting, limpid delicacy and atmospheric effect of her color; her graceful design; and the vivacity of her draftsmanship sometimes camouflage the occasional weakness and inaccuracy in her drawing. Still, her pastel portraits (cat. no.55) with the soft, velvety bloom of their surfaces could hardly be surpassed, and they remain admirable documents of the charm and loveliness so enthusiastically received by the sensibility of Rosalba's time.

As in the High Renaissance, four major artists dominated Italian art in the eighteenth century. Tiepolo, Canaletto, Guardi, and Piranesi were the four lights among the draftsmen of this final century of greatness in Italy. With ceiling frescoes figuring among his most significant contributions, Giovanni Battista Tiepolo (1696–1770) worked in the great decorative tradition of Paolo Veronese. As the last important artist in the monumental Italian style, Tiepolo assimilated a myriad of influences in his draftsmanship. His early sources included Piazzetta, Bencovich, Magnasco, Rembrandt, Salvator Rosa, and artists like Guercino and Canuti of the nearby Bolognese school. The latter two particularly influenced him with their dynamic chiaroscuro effects and graceful power. From such varied influences Tiepolo evolved a completely individual, sparkling, and "musical" style which places him among the foremost draftsmen in history. His development can be traced from an example of his early style (cat. no.57) through a work such as *St. Jerome in the Desert Listening to the Angels* (cat. no.58) which probably dates from the 1730s since the composition is known to have been engraved by 1740.

A splendid example from the celebrated Orloff album of Tiepolo drawings, *Christ Calling the Fishermen* ("Follow me, I will make you fishers of men!") (cat. no.59) belongs, as suggested by Pignatti, to the period around the mid-1740s. Suffused with a radiant light are the shimmering golden brown shadows accented in Tiepolo's inimitable way by his calligraphic use of the brush point.

A greater sketchiness, reminiscent of Guercino, characterizes Tiepolo's powerful *Cruci-fixion* of about 1745–50 (cat. no.60), while more solid forms and painterly values appear in the *Adoration of the Magi* of around 1753 (cat. no.62). His prowess in chalk drawing is evidenced by his study for a figure (cat. no.61) from *The Fall of the Rebel Angels*, an altarpiece painted in 1752 for the chapel of the Residenz in Wurzburg. The red chalk heightened with white on blue paper creates a brilliant coloristic effect. Typical of Tiepolo's style of drawing is his individualistic contouring by means of a fairly thin, often trembling line that he sometimes even re-drew. In this work, the fine, undulating outline on the left side of the male torso contrasts with the plasticity and solidity of the figure's musculature, whereas *The Holy Family* (cat. no. 63) typifies Tiepolo's freer style of the early sixties.

The contrast between the work of the elder Tiepolo and that of a contemporary draftsman like Antonio Canaletto (1697–1768), who was primarily a view painter, is striking. The distinguishing feature of the bulk of Canaletto's drawings is their calm regularity, serene clarity, and even precision of line. Generally detached, detailed, faithful visual transcriptions, his drawings were created to meet an independent commercial demand rather than specific commissions. With a system of spaced parallel lines, both slanting and hatched, Canaletto created graphic equivalents of light and shade which he blended with suggestions of great atmospheric effects. His scenes and views were most often taken directly from nature, but he also created *vedute ideate*, the imaginary or created view known as the *capriccio*. Canaletto is represented in the exhibition by a splendid example of each type of drawing. The monumental *Doge Attending the Giovedi Grasso Festival in the Piazzetta* (cat. no. 64) ranks among the artist's most majestic, populous scenes, overpowering the viewer in its fidelity to nature and its immediacy of delineation. At the other end of the spectrum of Canaletto's draftsmanship stands the romanticism of *Capriccio with an Arch in Ruins* (cat. no.65) in which a gently decaying ruin is juxtaposed with a late Gothic building on the edge of a Venetian lagoon. Even here one finds the cool detachment and tranquility that keep his work "classical" even when he would be "capricious." The drawing was probably executed in England, where Canaletto went in 1746 and remained, with a brief return to Venice, until at least 1755.

Francesco Guardi (1712–1793), partly of Austrian descent, was born in Venice and became Giovanni Battista Tiepolo's brother-in-law at the age of seven. When he began to work in Canaletto's studio, sometime around 1760, Guardi was already middle-aged, having spent long years painting historical and religious works which brought him little renown. Thus he was eager to follow in the footsteps of the celebrated painter Canaletto

whose views of Venice were so assiduously sought by foreign visitors. Guardi became noticeably indebted to the older artist, chiefly through his borrowing of subjects, but this dependence diminished with the passage of time, and, ultimately, few drawings could be more dissimilar than those of Canaletto and Guardi. The opposite of Canaletto's measured calm is Guardi's impressionistic approach with his changing, graphlike lines that suggest charts of irregular wave lengths. Instead of shading with parallel strokes, as Canaletto did, Guardi chose the more spontaneous and painterly effect of wash. Nor does any resemblance in their figures link Canaletto and Guardi. The latter's figure drawings seem to relate more directly to drawings by Canaletto's short-lived pupil, Michele Marieschi (1696–1743). Guardi's bulging loops and the sometimes zigzag scrawl with which he rendered the contours of his fantastic *staffage* are uniquely personal characteristics which quickly foil the would-be imitator of his style.

Capricci, of which Guardi became the past master, were almost improvisations from motifs borrowed not only from other artists but also from diverse architectural forms, then mixed and recombined. This can be seen in the splendid *Decorative Cartouche with a Lagoon Capriccio* from the Cooper-Hewitt Museum (cat. no.66) in which Guardi used the composition of Canaletto's etching *La Torre di Malghera* for the central motif but transformed the tranquil geometric composition into a poetic dream of the picturesque. The Los Angeles *Architectural Capriccio* (cat. no. 67) dated by J. Byam Shaw to the 1780s, belongs to the period when Guardi produced a host of romantic *capricci*. While many of these late *capricci* are in the Museo Correr, the Los Angeles drawing is a more finished and imposing composition than the majority in the Venetian museum.

Giovanni Battista Piranesi (1720–1778), the so-called Rembrandt of Architecture, has always been one of the world's most popular etchers. For centuries the range of his prints, from the most topographically accurate to the most conceptually free, has satisfied a whole spectrum of tastes and purposes. Piranesi studied architecture, perspective, stage design, and Roman history. To become a graphic artist he studied with Giuseppe Vasi, an important topographical etcher; but more importantly, he worked with Giovanni Battista Tiepolo. These various disciplines and masters to which he subjected himself prepared Piranesi to create the most striking views of ancient and modern monuments and interiors in the history of printmaking. Love for architectural construction *per se* and admiration for the grandeur of Roman building were the principles that animated his entire career. Trained in the classical manner of Palladio, Piranesi followed the models of the antique, not in imitation, but to use their examples for his grand conception of line and composition.

Because Roman ruins endlessly inspired him, he avoided falling into the sterility of mere reconstruction. Piranesi's entire *oeuvre* was the epitome of the picturesque, as is especially conspicuous in his drawings in which he could be freer than in his etchings. While his prints, because of their heavy blacks, often could be more dramatic than his pen and ink drawings, nevertheless, the impetuous calligraphy of his pen strokes and the boldness of the washes combined in many of his works (cat. nos. 68–72) to form a range of graphic scenography quite unparalleled in the history of graphic art.

With the deaths of Canaletto, Piranesi, and Guardi, Giovanni Battista Tiepolo's son and assistant, Giovanni Domenico (1727–1804), remained as the chief draftsman of the late eighteenth-century Venetian school. Though Domenico is perhaps best known for his many diverting Pulcinello drawings, which revived this very popular figure of the Italian *Commedia dell'arte*, his fantastic drawings of centaurs (cat. no. 73) are equally appreciated. Toward the end of his life, Domenico executed a series of over two hundred drawings on religious subjects which are complete and monumental enough (cat. no.74) to stand as finished works of art. It was not until his death that the great tradition of Venetian drawing essentially ended.

Catalog

33. STEFANO DA ZEVIO, called Stefano da
Verona (Italian, *ca.* 1374/75–after 1438)
Five Figures
Brown ink
7¾ x 5¾ in. (19.6 x 14.7 cm.)
Janos Scholz

Collection: Triqueti
Literature: B. Degenhart. "Di una publicazione su
Pisanello e di altri fatti." *Arte Veneta* II, no. 8
(1954): 106, fig. III; L. Grassi. *Il disegno italiano
del trecento al seicento.* Rome, 1956. p. 88, fig. 55;
M. Muraro. *Disegni veneti della collezione Janos
Scholz.* Venice, 1957. no. 1, fig. 1; *Venetian
Drawings, 1400–1630,* Mills College Art Gallery,
Oakland, 1959. no. 67, repr.; *Italienische Meister-
zeichnungen von 14. bis 18. Jahrhundert aus ameri-
kanischen Besitz: Die Sammlung Janos Scholz.*
Hamburger Kunsthalle,1963. no.150; *Tuscan and
Venetian Drawings of the Quattrocento from the
Collection of Janos Scholz.* Los Angeles County
Museum of Art, 1967. no. 58.

34. GENTILE BELLINI (Italian, 1429–1507)
Camel in a Landscape
Brown ink, 6¹⁄₁₆ x 8⅜ in. (15.8 x 21.4 cm.)
The Janos Scholz Collection
The Pierpont Morgan Library

Collections: Gardon; H. M. Calmann
Literature: E. Haverkamp-Begemann, E. Sharp.
Italian Drawings from the Collection of Janos Scholz.
Yale University Gallery,1964. no. 3; W. Stubbe.
*Italienische Meisterzeichnungen von 14. bis 18.
Jahrhundert aus amerikanischen Besitz: Die Samm-
lung Janos Scholz.* Hamburger Kunsthalle,1963.
no. 15; *Tuscan and Venetian Drawings of the Quat-
trocento from the Collection of Janos Scholz.* Los
Angeles County Museum of Art, 1967. no. 6;
Italian Drawings from the Collection of Janos Scholz.
Arts Council, London, 1968. no. 8, as attributed
to Gentile Bellini.

Once given to Dürer, and also published in 1965
as Pisanello, the work is ascribed to Gentile Bellini
on the basis of its similarity to two of his draw-
ings of *Seated Orientals,* in the British Museum.
It is suggested that the study of the camel was done
on Bellini's journey to Constantinople in 1479.

35. ANDREA MANTEGNA, attributed
(Italian, 1431–1506)
Ganymede Carried by the Eagle over a Landscape
Reddish brown ink
6 x 4½ in. (15.3 x 11.5 cm.)
Anonymous

Collections: Suermondt; Stroganoff; A.
de Hevesy; E. Holland-Martin; Sale, London,
Christie's, May 20, 1966, no.103; I. Gale
Literature: H. Tietze, E. Tietze-Conrat. "Giulio
Campagnola's Engravings." *Print Collector's
Quarterly* 26 (1942): 184–87; idem. *The Draw-
ings of the Venetian Painters of the 15th and 16th
Centuries.* New York, 1944. p. 87, A320; E. Tietze-
Conrat. *Mantegna, Paintings, Drawings, Engrav-
ings.* London, 1955. p. 207, fig. 32; K. Oberhuber.
*Early Italian Engravings from the National Gallery
of Art.* Washington, D.C.,1973. p. 392, n.12.

Originally attributed to Giovanni Bellini by
Detlev von Hadeln and exhibited as such at the
Matthiesen Gallery, London, in 1930 (no.77), it
was reattributed to Mantegna by the Tietzes (see
Literature), then re-ascribed to Bellini in the 1966
Christie's sale. Oberhuber has questioned both
names (see Literature), suggesting instead the pos-
sibility that it is an early drawing by Giulio Cam-
pagnola for his engraving of this subject, in which
he replaced the Bellinesque landscape of the
drawing with one copied directly from Dürer's
engraving *Madonna with the Monkey.*

36. GIOVANNI BELLINI (Italian, *ca.*1431–1516)
or Andrea Mantegna (Italian,1431–1506)
Christ's Descent into Limbo
Brown ink, 10½ x 7⅞ in. (27.0 x 20.0 cm.)
The Metropolitan Museum of Art
Robert Lehman Collection

Collections: J. P. Zoomer; J. Skippe; his
descendants, the Martin family, including Mrs.
A. C. Rayner-Wood; E. Holland Martin; Skippe

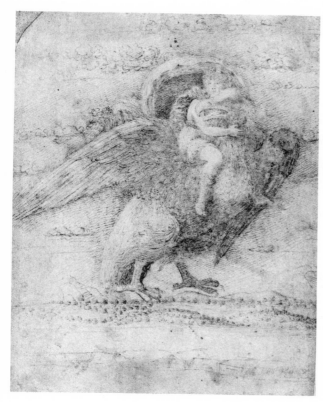

35

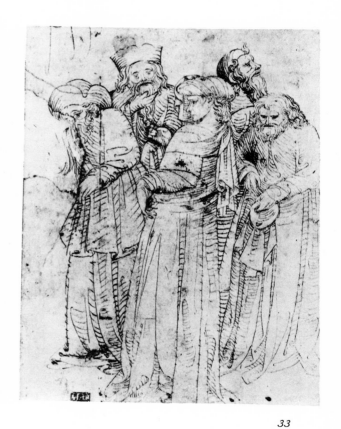

33

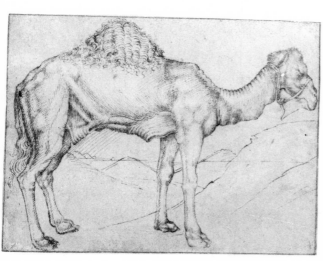

34

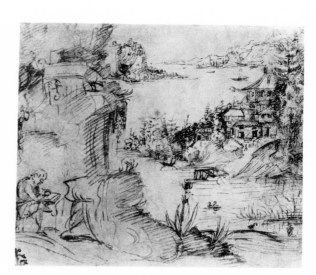

37

Sale, London, Christie's, Nov. 20-21, 1958, no. 37, pl. 5
Literature: F. Heinemann. *Giovanni Bellini e I Belliniani*. Venice, 1962. p. 54, no. 179; J. Bean, F. Stampfle. *Drawings from New York Collections I: The Italian Renaissance*. The Metropolitan Museum of Art and The Pierpont Morgan Library, New York, 1965. no. 3; *Early Italian Engravings*. Washington, D.C., 1973. p. 210, fig. 9-3; T. Pignatti. *Venetian Drawings from American Collections*. National Gallery of Art, Washington, D.C., 1974. no. 2.

Like cat. no. 35, the present drawing has been attributed over the years to both Bellini and to his son-in-law, Mantegna. The reciprocal use of works in families of artists seems responsible for some of the uncertainty that at times hangs over their authorship. In the present case, the subject of *Christ in Limbo* first appeared in an engraving after a drawing by Mantegna, was then used by Bellini for a painting (now in Bristol), and was later used by Mantegna in different versions, now known only through copies.

While Byam Shaw favors Bellini as the author of the drawing, Levenson, Oberhuber, and, more recently, Pignatti, seem more inclined to see it as the work of Mantegna. On the basis of style, the drawing is so close to Mantegna's engravings that the reversion of authorship to him seems justified.

37. GIOVANNI BELLINI (?) (Italian, *ca*. 1431–1516)
St. Jerome in a Landscape
Brown ink, 7 x 8⅜ in. (17.8 x 21.3 cm.)
The Metropolitan Museum of Art
Robert Lehman Collection

Collections: L. Grassi; Sale, under the initials G. L. (Grassi), London, Sotheby's, May 13, 1924, no. 147, repr.
Literature: B. Berenson. *The Drawings of the Florentine Painters*. 3 vols. Chicago, 1938. no. 1859 J, fig. 429, as Piero di Cosimo; R. Langton Douglas. *Piero di Cosimo*. Chicago, 1946. p. 128, pl. LXXX; J. Bean. *Bayonne, Musée Bonnat,*

Les dessins italiens de la collection Bonnat. Paris, 1960. no. 110; B. Berenson. *I disegni dei pittori fiorentini*. 3 vols. Milan, 1961. no. 1859 J, fig. 346, as Piero di Cosimo (?); F. Heinemann. *Giovanni Bellini e I Belliniani*. Venice, 1962. p. 286, no. v, 467; L. Puppi. *Bartolomeo Montagna*. Venice, 1962. p. 148, fig. 107; J. Bean, F. Stampfle. *Drawings from New York Collections I: The Italian Renaissance*. The Metropolitan Museum of Art and The Pierpont Morgan Library, New York, 1965. no. 4; T. Pignatti. *Venetian Drawings from American Collections*. National Gallery of Art, Washington, D.C., 1974. no. 7, as circle of Giorgione.

38. BARTOLOMMEO MONTAGNA (Italian, *ca*. 1450–1523)
Nude Man Standing beside a High Pedestal
Brush and black pigment, heightened with cream white, 15¾ x 10 3/16 in. (40.0 x 25.8 cm.)
The Pierpont Morgan Library

Literature: J. Bean, F. Stampfle. *Drawings from New York Collections I: The Italian Renaissance*. The Metropolitan Museum of Art and The Pierpont Morgan Library, New York, 1965. no. 14, repr.; W. Vitzhum. "Drawings from New York Collections." *Burlington Magazine* 108 (1966): 110; *Gifts in Honor of the Fiftieth Anniversary*. The Pierpont Morgan Library, New York, 1974. pp. 42–43.

39. GIOVANNI ANTONIO DA PORDENONE (Italian, 1484–1539)
The Conversion of St. Paul
Brown ink, heightened with white on gray green paper, 10¾ x 16⅛ in. (27.2 x 41.0 cm.)
The Pierpont Morgan Library

Collections: E. Jabach; W. Esdaile; T. Thane; J. C. Robinson; C. Fairfax Murray
Literature: C. Fairfax Murray. *Drawings by the Old Masters: Collection of J. Pierpont Morgan*. 4 vols. London, 1905–12. vol. I, no. 70; L. Fröhlich-Bum. "Beitrage zum Werke des Giovanni Antonio Pordenone." *Müncher Jahrbuch der bildenden Kunst* n.s. II (1925): 85, 86; G. Fiocco. *Giovanni Antonio Pordenone*. Padua, 1943. pp. 86,

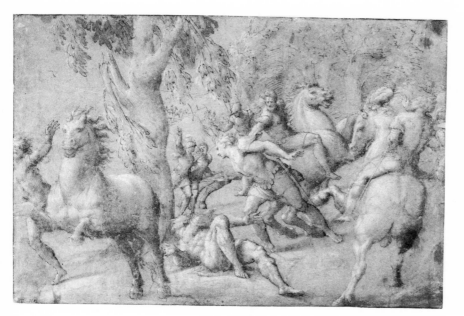

39

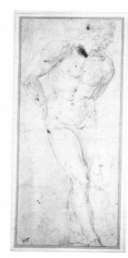

44

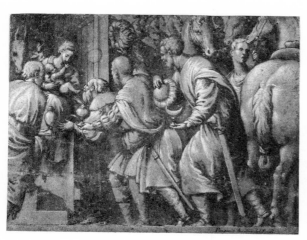

40

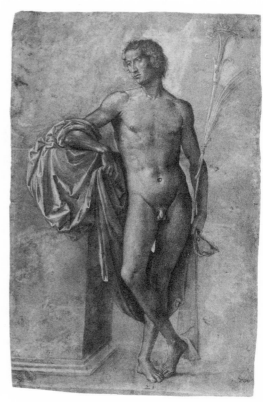

38

90, 154, pl. 180; H. Tietze, E. Tietze-Conrat. *The Drawings of the Venetian Painters of the 15th and 16th Centuries.* New York, 1944. no.1341; A. E. Popham, J. Wilde. *The Italian Drawings of the XV and XVI Centuries...at Windsor Castle.* London,1949. p.302, under no. 749; J. Bean, F. Stampfle. *Drawings from New York Collections I: The Italian Renaissance.* The Metropolitan Museum of Art and The Pierpont Morgan Library, New York, 1965. no. 53.

40. GIOVANNI ANTONIO DA PORDENONE
(Italian, 1484–1539)
Adoration of the Magi
Brown ink and wash, heightened with white on blue gray paper, 9¹¹⁄₁₆ x 13⅛ in. (24.6 x 33.3 cm.)
Janos Scholz

Collections: A. M. Zanetti (?); Benjamin West
Literature: *Venetian Drawings, 1400–1630, from the Collection of Janos Scholz.* Mills College Art Gallery, Oakland,1959. no. 3, as Pomponio Amalteo; *Sixteenth Century Italian Drawings from the Collection of Janos Scholz.* National Gallery of Art, Washington, D.C.,1973, no. 99, as attributed to Pomponio Amalteo.

41. GIROLAMO ROMANI, called Romanino
(Italian, *ca.*1485–1559/61)
Nude Male Figure
Brush and brown wash over slight traces of black chalk, 11⁹⁄₁₆ x 6⁹⁄₁₆ in. (29.4 x 16.7 cm.)
The Metropolitan Museum of Art
Rogers Fund

Literature: A. Morazzi. "Alcuni disegni inediti del Romanino." *Festschrift Karl M. Swoboda.* Vienna,1959. p.190, fig. 39; J. Bean. *Metropolitan Museum of Art Bulletin.* Jan.1962. p.163, fig. 6; C. Gilbert. "Una monografia sul Romanino." *Arte Veneta* XVI (1962): 201, fig. 232; F. Kossoff. "A New Book on Romanino." *Burlington Magazine* CV (1963): 77, fig. 52; J. Bean, F. Stampfle. *Drawings from New York Collections I: The Italian Renaissance.* The Metropolitan Museum of Art and The Pierpont Morgan Library, New York, 1965. no. 56.

42. TIZIANO VECELLIO, called Titian
(Italian, 1485/88?–1576)
A Group of Trees
Brown ink on brownish paper
8⁹⁄₁₆ x 12⁹⁄₁₆ in. (21.7 x 31.9 cm.)
The Metropolitan Museum of Art
Rogers Fund

Collections: C. Sackville Bale (Sale, London, Christie's, June 9, 1881, no. 2298, as Giorgione); Sir J. Knowles, London (Sale, London, Christie's, May 27,1908, no.181, as Titian), purchased by the Metropolitan Museum
Literature: S. Colvin. *Vasari Society.* 1st series, 1909–10. vol. V, no. 9, repr.; D. von Hadeln. *Titian's Drawings.* London,1927. pp.15-16, 24, pl. 45; L. Frölich-Bum. "Die Landschaftszeichnungen Tizians." *Belvedere* VIII (1929): 77; H. Tietze, E. Tietze-Conrat. "Titian-Studien." *Jahrbuch der kunsthistorischen Sammlungen in Wien,* n.s., X (1936): 167,191, no. 7, fig.145 (related woodcut, fig.143); *European Drawings from the Collection of The Metropolitan Museum of Art.* New York,1943. vol. I, fig.14; H. Tietze, E. Tietze-Conrat. *The Drawings of the Venetian Painters of the 15th and 16th Centuries.* New York, 1944. no. 1943, pl. LXIII, 2; H. Tietze. *European Master Drawings in the United States.* New York, 1947. p. 54, no. 27, fig. 55; A. Mongan. *One Hundred Master Drawings.* Cambridge, Mass.,1949. p. 48, repr. 49; H. Tietze. *Titian.* n.p.,1950. p. 404, pl. 47; J. Bean. *100 European Drawings in The Metropolitan Museum of Art.* New York, 1964. no.15, repr.; J. Bean, F. Stampfle. *Drawings from New York Collections I: The Italian Renaissance.* The Metropolitan Museum of Art and The Pierpont Morgan Library, New York, 1965. no. 58.

43. TIZIANO VECELLIO, called Titian
(Italian, 1485/88?–1576)
St. Theodore and the Dragon
Brown ink
7¾ x 11¹¹⁄₁₆ in. (19.6 x 29.7 cm.)
Janos Scholz

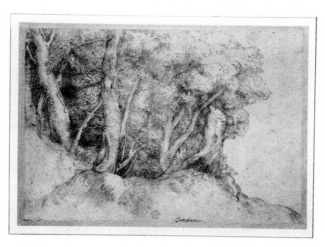

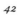

42

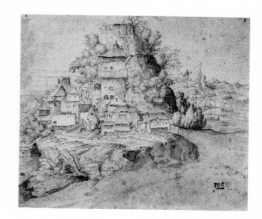

45

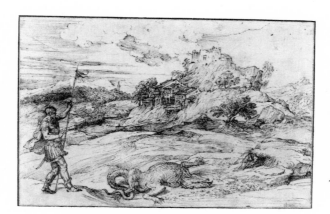

43

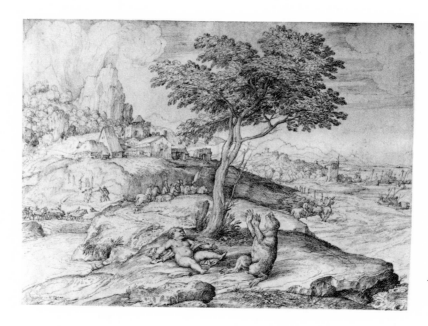

46

Collections: P. Sylvester; P. G. Berthauldt (?);
R. C. Jackson; Dr. M. Goldstein
Literature: A. Chatelet. "Notes on Old and
Modern Master Drawings from the Janos Scholz
Collection at the Cini Foundation." *Art Quarterly*
XXI (1958): 193; K. Oberhuber, D. Walker.
*Sixteenth Century Drawings from the Collection
of Janos Scholz*. National Gallery of Art, Wash-
ington, D.C., and The Pierpont Morgan Library,
New York, 1973–74. no. 93.

44. GIOVANNI BATTISTA FRANCO
(Italian, 1498–1561)
Standing Male Nude
Red chalk
15 ¼ x 6⅝ in. (38.7 x 16.8 cm.)
The Metropolitan Museum of Art
Rogers Fund

Collections: Jonathan Richardson, Sr.;
Mrs. E. E. James, London; Sale, Sotheby's,
London, May 16, 1962, no. 158; Metropolitan
Museum
Literature: J. Bean, F. Stampfle. *Drawings from
New York Collections I: The Italian Renaissance*.
The Metropolitan Museum of Art and
The Pierpont Morgan Library, New York,
1965. no. 78.

According to information kindly supplied by
Jacob Bean, in 1967 James David Draper pointed
out that the present study was made by Franco
for the figure of Christ that appears in reverse in
his engraving *The Flagellation* (Bartsch, XVI, 122,
10). A red chalk study for one of the male figures
beating Christ is at Windsor (A. E. Popham,
J. Wilde, *The Italian Drawings of the XVth and
XVIth Centuries at Windsor Castle* [London,
1949], no. 329, pl. 171).

45. DOMENICO CAMPAGNOLA
(Italian, 1500–*ca.* 1581)
Buildings in a Rocky Landscape
Verso: Sketches of Figures and Legs
Brown ink (*verso:* black chalk)
8⅜ x 7 9/16 in. (21.4 x 18.7 cm.)
Woodner Family Collection

Collection: Maurice and Marie Marignane
Literature: *Woodner Collection I: A Selection of
Old Master Drawings before 1700*. New York,
1971. no. 29a–29b, repr.

46. DOMENICO CAMPAGNOLA
(Italian, 1500–*ca.* 1581)
*Callisto's Transformation into a Bear
after Giving Birth to Arcas*
Brown ink
13⅜ x 18⅜ in. (34.1 x 46.7 cm.)
Detroit Institute of Arts
Elliot T. Slocum Fund

Literature: H. Tietze, E. Tietze-Conrat. *The
Drawings of the Venetian Painters of the 15th and
16th Centuries*. New York, 1944. no. 455;
T. Pignatti. *Venetian Drawings from American
Collections*. National Gallery of Art, Washing-
ton, D.C., 1974. no. 10, pl. 10.

47. JACOPO DA PONTE, called Jacopo Bassano
(Italian, *ca.* 1516–1592)
Woman on Horseback
Black chalk, brown wash, heightened with
white on blue paper
14⅛ x 10½ in. (36.0 x 26.5 cm.)
E. B. Crocker Gallery

Collections: A. J. Dezallier d'Argenville;
Destouches; E. B. Crocker
Literature: A. Neumeyer. "A Bassano Drawing."
Old Master Drawings 13 (1939): 61; H. Tietze,
E. Tietze-Conrat. *The Drawings of the Venetian
Painters of the 15th and 16th Centuries*.
New York, 1944. no. 195; W. Arslan. *Il Bassano*.
Milan, 1960. 1:176; *Master Drawings from Cali-
fornia Collections*. University Art Museum,
Berkeley, 1968. no. 46: 128 (as Francesco Bas-
sano); T. Pignatti. *Venetian Drawings from
American Collections*. National Gallery of Art,
Washington, D.C., 1974. no. 17, repr.

48. JACOPO ROBUSTI, called Jacopo Tintoretto
(Italian, 1518–1594)
Study after Michelangelo's "Il Giorno"
Black and white chalk on blue paper

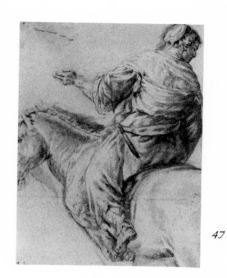

47

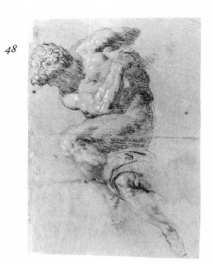

48

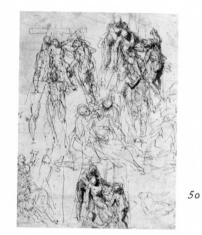

50

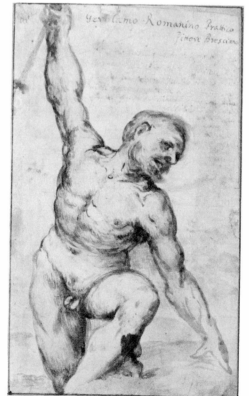

41

49

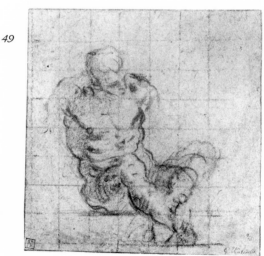

13¾ x 19⅞ in. (34.9 x 50.5 cm.)
The Metropolitan Museum of Art
Rogers Fund

Literature: C. Virch. "A Study by Tintoretto after Michelangelo." *Metropolitan Museum of Art Bulletin*. Dec. 1956. pp. 111–16, repr.

49. JACOPO ROBUSTI, called Jacopo Tintoretto (Italian, 1518–1594)
Study of a Seated Male Nude, His Legs Crossed Verso: Rapid Sketch of the Same Figure
Black chalk on gray paper, squared
8⅞ x 8⁹⁄₁₆ in. (22.6 x 21.3 cm.)
Inscribed: G. Tintoretto
Anonymous

Collections: J. Reynolds; Sale, London, Christie's, Mar. 26, 1974, no. 25; W. Schab
Literature: *Highly Important Old Master Drawings*. Christie's, London, Mar. 26, 1974. no. 25, pl. 11.

Originally this work was suggested as a possible study for the old man seated on the top step, to the left of the feet of the High Priest, in Tintoretto's painting *The Presentation of the Virgin*, of about 1552, in the Church of the Madonna dell'Orto, Venice. However, Frederick Schab has proposed that it is rather a preliminary drawing for Isaac in the *Abraham and Isaac* panel in the Scuola di San Rocco. This proposal seems wholly convincing even though Tintoretto changed the position of Isaac's legs in the painting.

50. PAOLO CALIARI, called Veronese (Italian, 1528–1588)
Sheet of Studies for a Descent from the Cross Verso: Reclining Figure
Brown ink, with washes of gray brown and faint traces of black chalk
11⅛ x 8⅛ in. (28.3 x 20.7 cm.)
Art Institute of Chicago
The Robert A. Waller Memorial Fund

Collection: L. van Anhalt

Literature: H. Tietze. "Nuovi disegni veneti del cinquecento in collezioni americane." *Arte Veneta*, 1948. pp. 56-66; H. Joachim. *Master Drawings from the Art Institute of Chicago*. Chicago, 1963. no. 6, fig. 5; D. Rosand. *Veronese and His Studio*. Birmingham, Ala., 1972. p. 59, as Circle; T. Pignatti. *Venetian Drawings from American Collections*. National Gallery of Art, Washington, D.C., 1974. no. 23.

51. PAOLO CALIARI, called Veronese (Italian, 1528–1588)
Allegory of the Redemption of the World
Black ink and gray wash, heightened with white
24⅛ x 16⁹⁄₁₆ in. (61.4 x 42.1 cm.)
The Metropolitan Museum of Art
Rogers Fund

Collection: C. and F. Muselli, Verona (?); Sir Peter Lely; Jonathan Richardson, Jr.; Norblin *fils*, Paris (Norblin *fils* Sale, Paris, Jan. 30, 1863, no. 12); Metropolitan Museum purchase, 1961
Literature: J. Bean. *Metropolitan Museum of Art Bulletin*. Jan. 1962, repr. p. 164, fig. 8; J. Bean. *100 European Drawings in the Metropolitan Museum of Art*. New York, 1964. no. 25, repr. p. 164, fig. 8; J. Bean, F. Stampfle. *Drawings from New York Collections I: The Italian Renaissance*. The Metropolitan Museum of Art and The Pierpont Morgan Library, New York, 1965, no. 129.

52. JACOPO NEGRETTI, called Palma Giovane (Italian, 1544–1628)
Sketch for the "Paradiso"
Brown ink and wash on paper
7¼ x 22¼ in. (18.5 x 56.5 cm.)
Anonymous

Collection: Dimier
Literature: S. Rinaldi Mason. "Disegni preparatori per di dipinti di Jacopo Palma il Giovane." *Arte Veneta*, 1972. pp. 91–110; T. Pignatti. *Venetian Drawings from American Collections*. National Gallery of Art, Washington, D.C., 1974. no. 32.

54

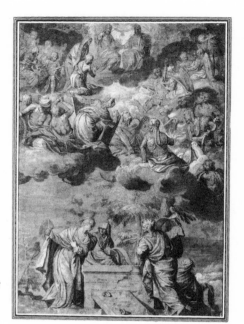

51

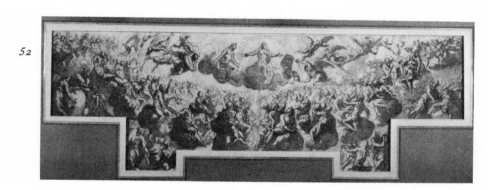

52

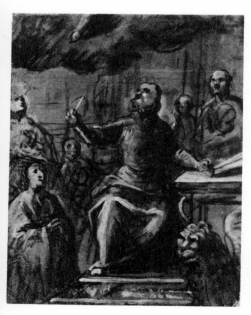

53

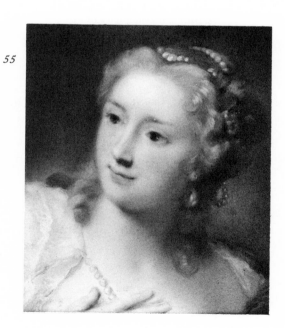

55

53. DOMENICO TINTORETTO (Italian, *ca.* 1560–1635)
St. Mark Enthroned and Worshipped by a Kneeling Donor
Oil on paper
12 3/16 x 9 3/4 in. (30.9 x 24.8 cm.)
Los Angeles County Museum of Art
Gift of the Graphic Arts Council

Collections: Cardinal Albani; Schaeffer Galleries
Literature: R. Tozzi Pedrazzi. "Le Storie di Domenico Tintoretto per la Scuola di S. Marco." *Arte Veneta* XVIII (1964): 86, fig. 90.

54. CARLETTO CALIARI (Italian, 1570–1596)
Head of a Bearded Man with a Ruff
Black chalk, colored chalk on blue faded paper
11 3/4 x 7 7/8 in. (30.0 x 20.0 cm.)
David Daniels

Collections: H. Marignane; H. M. Calmann; Charles E. Slatkin
Literature: H. Tietze, E. Tietze-Conrat. *The Drawings of the Venetian Painters of the 15th and 16th Centuries.* New York, 1944. no. 235; E. Arslan. *I Bassano.* 2 vols. Milan, 1960. II: 239, 263, pl. 294; A. Mongan. *Selections from the Drawing Collection of David Daniels.* The Minneapolis Institute of Arts, Feb. 22–Apr. 21, 1968. no. 1 (as Leandro Bassano).

55. ROSALBA CARRIERA (Italian, 1675–1757)
Portrait of a Young Woman
Pastel
13 7/8 x 11 3/4 in. (35.2 x 29.8 cm.)
Anonymous

Literature: Unpublished
 According to the owner, the drawing was purchased in 1936 at a sale either at Christie's or Sotheby's in London.

56. GASPARE DIZIANI (Italian, 1689–1767)
The Fall of Phaeton
Brown ink over red chalk with gray wash on cream-colored paper
15 7/8 x 12 3/4 in. (40.5 x 32.4 cm.)
David Daniels

Collections: A. L. de Mestral de Saint Saphorin; Marguerite and Madeline de Mestral; R. de Cerenville; Nathan Chaikin
Literature: *Drawings and Watercolors from Minnesota Private Collections.* Minneapolis Institute of Arts, 1971. no. 11, repr.; T. Pignatti. *Venetian Drawings from American Collections.* National Gallery of Art, Washington, D.C., 1974. no. 56, repr.

57. GIOVANNI BATTISTA TIEPOLO (Italian, 1696–1770)
The Brazen Serpent, ca. 1725
Brown ink and wash
5 3/4 x 8 1/16 in. (14.6 x 20.5 cm.)
Mr. and Mrs. Lorser Feitelson

Collections: Schwabacher; acquired by Lorser Feitelson, 1966
Literature: E. Feinblatt. "More Early Drawings by Giovanni Battista Tiepolo." *Master Drawings* V, no. 4 (1967): 400–403, pl. 36; G. Knox. *Tiepolo, A Bicentenary Exhibition,* 1770–1970. Fogg Art Museum, 1970. no. 4, repr.
 Additional studies for the *Brazen Serpent* that have come to light in recent years have been published by C. von Prybram-Gladona, *Unbekannte Zeichnungen alter Meister aus europäischem Privatbesitz* (Munich, 1969), nos. 79-83.

58. GIOVANNI BATTISTA TIEPOLO (Italian, 1696–1770)
St. Jerome in the Desert Listening to the Angels
Brown ink and wash, heightened with white, over black chalk on buff paper
16 3/4 x 10 7/8 in. (42.5 x 27.6 cm.)
Armand Hammer Foundation

Collections: P. Monaco (1707–1772); engraved by him and published in his *Raccolta di centododici stampe di pitture della storia sacra,* 1743, and then re-issued with additional plates in 1763; A. P. Robertson (on loan to the Metropolitan Museum); Sale, London, Sotheby's, Nov. 26, 1970, no. 71
Literature: *Important Old Master Drawings.* Sotheby's, London, Nov. 26, 1970. no. 71, p. 113,

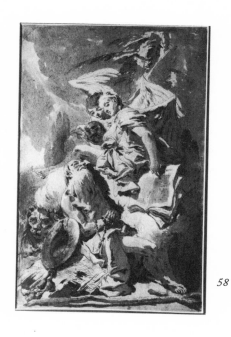

58

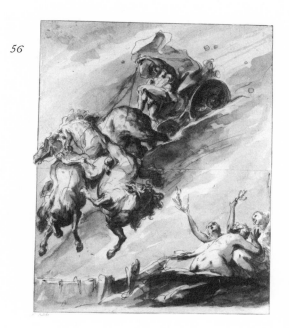

56

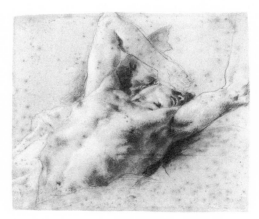

61

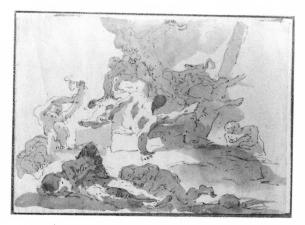

57

repr. opp: *The Armand Hammer Collection.* Los Angeles, 1971. no. 67; T. Pignatti. *Venetian Drawings in American Collections.* National Gallery of Art, Washington, D.C., 1974. no. 68, p. 68

59. GIOVANNI BATTISTA TIEPOLO
(Italian, 1696–1770)
Christ Calling the Fishermen, mid-1740s
Brown ink and wash
16½ x 11¼ in. (41.9 x 28.6 cm.)
John and Paul Herring

Collection: Prince Orloff
Literature: Unpublished
This is one of two drawings dealing with the "Calling of the Apostles" that were previously in the Orloff Collection, numbered 93 and 94 in the catalogue for the 1920 sale at the Galerie Georges Petit. No. 93, later in the collection of Irma N. Straus, has been published by T. Pignatti in *Venetian Drawings from American Collections*, National Gallery of Art, Washington, D.C., 1974, no. 75. The present drawing, which was no. 94 in the Petit sale, has not previously been reproduced.

60. GIOVANNI BATTISTA TIEPOLO
(Italian, 1696–1770)
The Crucifixion of Christ between Two Thieves, ca. 1745–1750 *Verso: Sketch, Upper Half of Body of Christ Crucified*
Black crayon (or chalk) under pen and brown ink with brown ink wash on cream paper
14⁵⁄₁₆ x 10 in. (36.3 x 25.4 cm.)
Achenbach Foundation for the Graphic Arts, California Palace of the Legion of Honor

Collections: Prince Alexis Orloff; Marquis de Biron: M. Knoedler; W. H. Crocker; Mrs. Diana Crocker Redington
Literature: *Catalogue des tableaux anciens… dessins par G. B. Tiepolo composant la collection de son excellence feu le Prince Alexis Orloff.* Galerie Georges Petit, Paris, Apr. 29-30, 1920. no. 97, repr.; D. von Hadeln. *Handzeichnungen von Giovanni Battista Tiepolo.* Munich, 1927. no. 96. repr.; idem. "The Drawings of G. B. Ti-

epolo." Paris and New York, 1928. vol. II, pl. 96; G. Knox. "The Orloff Album of Tiepolo Drawings." *Burlington Magazine* 103 (1961): 275, no. 57, p. 699; *Master Drawings from California Collections.* University Art Museum, Berkeley, 1968. no. 56: 138, repr.; G. Knox. *Tiepolo.* Fogg Art Museum, Cambridge, 1970. no. 59.

61. GIOVANNI BATTISTA TIEPOLO
(Italian, 1696–1770)
Study of a Reclining Male Figure, 1752
Red chalk, heightened with white, on blue paper
10½ x 12¼ in. (26.7 x 31.1 cm.)
Anonymous

Literature: Unpublished
This is a preliminary study for one of the two rebel angels represented in Tiepolo's altarpiece *The Fall of the Rebel Angels* which he painted in 1752 for the Chapel of the Residenz in Wurzburg. For the altarpiece, see A. Morassi, *A Complete Catalogue of the Paintings of G. B. Tiepolo* (Greenwich, 1962), pp. 68-69, fig. 224.

62. GIOVANNI BATTISTA TIEPOLO
(Italian, 1696–1770)
Adoration of the Magi, 1753
Black chalk, brown ink, and wash
15⅞ x 11⁹⁄₁₆ in. (40.4 x 29.4 cm.)
San Francisco Museum of Art
Gift of Mrs. Charles Templeton Crocker

Collection: Mrs. Charles Templeton Crocker
Literature: *Master Drawings from California Collections.* University Art Museum, Berkeley, 1968. no. 55: 60, repr.

63. GIOVANNI BATTISTA TIEPOLO
(Italian, 1696–1770)
The Holy Family, ca. 1759–1760
Brown ink and wash
12 x 8½ in. (30.5 x 20.6 cm.)
Los Angeles County Museum of Art
Gift of Cary Grant

Collections: R. Owen; Barbara Hutton; Cary Grant

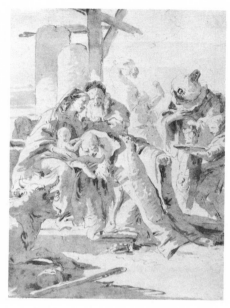

62

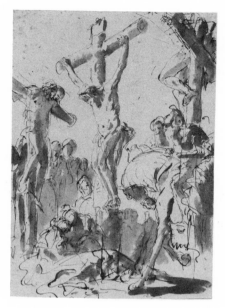

60

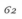

64

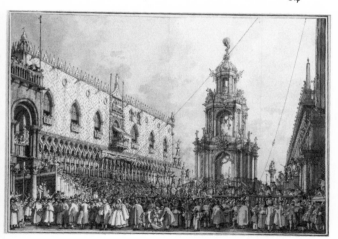

65

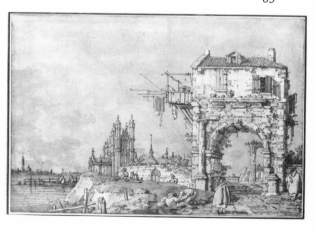

Literature: T. Pignatti. *Venetian Drawings from American Collections*. National Gallery of Art, Washington, D.C., 1974. no. 80, repr.

64. ANTONIO CANALETTO
(Italian, 1697–1768)
The Doge Attending the Giovedi Grasso Festival in the Piazzetta
Brown ink and two shades of gray wash heightened with white over black chalk
15½ x 22 in. (38.6 x 55.5 cm.)
Anonymous

Collections: L. Furlanetto; Sir Richard Colt Hoare; Sir Henry Hugh Hoare; Sir Hugh Richard Hoare; Sir Henry Ainslie Hoare (Sale, London, Christie's, June 2, 1883, no. 32); purchased by Baron Meyer de Rothschild; Earl of Roseberry; Sale, London, Sotheby's, Dec. 11, 1974, no. 10
Literature: Sir R. C. Hoare, Bart. *Modern Wilts-Hundred of Mere*. London, 1822. p. 75; F. J. B. Watson. *Canaletto*. London, 1949. fig. 29; V. Moschini. *Canaletto*. London and Milan, 1954. pp. 48-50, pl. 275; W. G. Constable. *Canaletto*. Oxford, 1962. no. 636, pl. 116.
The drawing was engraved by Giovanni Brustoloni.

65. ANTONIO CANALETTO
(Italian, 1697–1768)
Capriccio with an Arch in Ruins
Brown ink and gray wash
10 1/16 x 15¼ in. (25.7 x 38.5 cm.)
Detroit Institute of Arts
Bequest of John S. Newberry

Collections: Marquis of Lansdowne; P. Hofer; John S. Newberry
Literature: W. G. Constable. *Canaletto*. Oxford, 1962. no. 790; T. Pignatti. *Venetian Drawings from American Collections*. National Gallery of Art, Washington, D.C., 1974. no. 101.

66. FRANCESCO GUARDI
(Italian, 1712–1793)
Decorative Cartouche with a Lagoon Capriccio

Black ink, watercolor, over black chalk; composed of two sheets joined vertically at right of center
16½ x 27⅛ in. (41.9 x 68.8 cm.)
The Cooper-Hewitt Museum, Smithsonian Institution
Bequest of Erskine Hewitt

Collections: G. Guy, 4th Earl of Warwick (sale, London, Christie's, May 20-21, 1896, no. 164); R. de Madrazo; S. Cooper and Erskine Hewitt
Literature: G. A. Simonson. "Skizzen und Zeichnungen des Francesco Guardi." *Zeitschrift fur bildende Kunst* XVIII (1907): 268, repr.; *Chronicle of the Museum for the Arts of Decoration of Cooper Union*. n.p., 1939. 1: 198, repr.; O. Benesch. *Venetian Drawings of the Eighteenth Century in America*. New York, 1947. no. 62, repr.; R. Berliner. "Two Contributions to Criticism of Drawings Related to Decorative Art-II." *Art Bulletin* XXXIII (1951): 53-55; J. Byam Shaw. *The Drawings of Francesco Guardi*. London, 1951. p. 77, no. 68; idem. "A Sketch for a Ceiling by Francesco Guardi." *Burlington Magazine* CIV (1962):73; R. Wunder. *Extravagant Drawings of the Eighteenth Century from the Collection of the Cooper Union Museum*. New York, 1962. no. 46, repr.; T. Pignatti. *Disegni di Guardi*. Florence, 1967. no. XLVI; J. Bean, F. Stampfle. *Drawings from New York Collections III: The Eighteenth Century in Italy*. The Metropolitan Museum of Art and The Pierpont Morgan Library, New York, 1971. no. 212; J. Bean. "Venise, quelques dessins exceptionnels." *Connaissance des Arts*, Feb. 1971. repr. p. 79; *An American Museum of Decorative Arts and Design, Designs from the Cooper-Hewitt Collection, New York*. Victoria and Albert Museum, London, 1973. no. 100, repr. in color on cover.

67. FRANCESCO GUARDI
(Italian, 1712–1793)
Architectural Capriccio, ca. 1780
Brown ink and wash on dark gray paper
15 x 12¼ in. (38.1 x 30.5 cm.)
Los Angeles County Museum of Art
Los Angeles County Funds

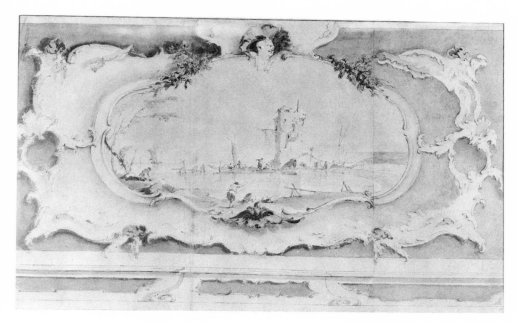

66

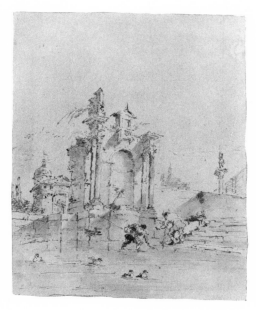

67

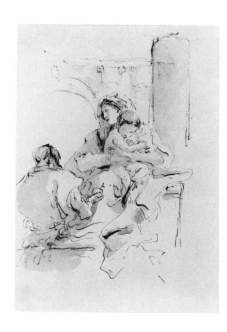

63

Collections: Eugene V. Thaw; Paul Kantor
Literature: "A Romantic Capriccio by Guardi."
*Bulletin of the Art Division. Los Angeles County
Museum* IX, no. 3 (1957): 3–5; *Drawings of the
Masters. Italian Drawings from the 15th to the
19th Century.* New York, 1963. pl. 94; *Master
Drawings from California Collections.* University
Art Museum, Berkeley, 1968. no. 38: 119.

68. GIOVANNI BATTISTA PIRANESI
(Italian, 1720–1778)
Architectural Interior with Staircases
Dark brown ink
7¹⁄₁₆ x 8¹⁄₁₆ in. (17.9 x 20.5 cm.)
Anonymous

Collection: Sale, Bern, Klipstein and Kornfeld,
June 16, 1960, no. 202
Literature: Unpublished

69. GIOVANNI BATTISTA PIRANESI
(Italian, 1720–1778)
Studies of Four Men
Brown ink
8⅞ x 5⁵⁄₁₆ in. (22.5 x 13.5 cm.)
The Janos Scholz Collection
The Pierpont Morgan Library

Collection: J. A. Duval le Camus
Literature: A. Hyatt Mayor. *Giovanni Battista
Piranesi.* New York, 1952. p. 39, pl. 41;
H. Thomas. *The Drawings of Giovanni Battista
Piranesi.* New York, 1954. no. 70, repr.; "Italian
Drawings from the Collection of Janos Scholz."
Metropolitan Museum of Art Bulletin, May 1965.
Part II, p. 343, repr.; J. Bean, F. Stampfle.
*Drawings from New York Collections III: The
Eighteenth Century in Italy.* The Metropolitan
Museum of Art and The Pierpont Morgan
Library, New York, 1971.

70. GIOVANNI BATTISTA PIRANESI
(Italian, 1720–1778)
Triumphal Arch, ca. 1750
Brown ink and wash over black chalk

7¼ x 10¹⁄₁₆ in. (18.5 x 25.6 cm.)
Signed lower left: Piranesi
Museum of Fine Arts, Boston
Harvey D. Parker Collection and Babcock
Bequest, by exchange

Literature: H. Thomas. *The Drawings of Gio-
vanni Battista Piranesi.* New York, 1954. no. 33;
A. Mongan. "Italian Drawings, 1330–1780:
An Exhibition at the Smith College Museum of
Art." *The Art Bulletin*, Mar. 1942. p. 93;
G. B. Piranesi. Galleria Civica d'Arte Moderna,
Turin, Dec. 1, 1961–Jan. 21, 1962. no. 187, repr.

71. GIOVANNI BATTISTA PIRANESI
(Italian, 1720–1778)
Fantastic Monument, ca. 1750
Brown ink and wash over red chalk over black
chalk, 6¹⁄₁₆ x 8½ in. (21.6 x 15.4 cm.)
Museum of Fine Arts, Boston
Gift of Dr. Timothy Leary, 1917

Literature: H. Thomas. *The Drawings of
Giovanni Battista Piranesi.* New York, 1954.
no. 23, repr.

72. GIOVANNI BATTISTA PIRANESI
(Italian, 1720–1778)
Architectural Fantasy
Brown ink and wash
12¹⁵⁄₁₆ x 19⁵⁄₁₆ in. (32.9 x 49.1 cm.)
The Janos Scholz Collection
The Pierpont Morgan Library

Literature: G. Freedley. *Theatrical Designs.*
New York, 1940. vol. I, pl. 9; C. de Tolnay.
History and Technique of Old Master Drawings.
New York, 1943. no. 142, repr.; H. Tietze. *Euro-
pean Master Drawings.* New York, 1944. p. 202,
pl. 101; J. Scholz. *Baroque and Romantic Stage
Design.* New York, 1949. p. 14, pl. 68; A. Hyatt
Mayor. *Giovanni Battista Piranesi.* New York,
1952. p. 38, pl. 24; J. Bean, F. Stampfle.
*Drawings from New York Collections III: The
Eighteenth Century in Italy.* The Metropolitan
Museum of Art and The Pierpont Morgan
Library. New York, 1971. no. 226, fig. 226.

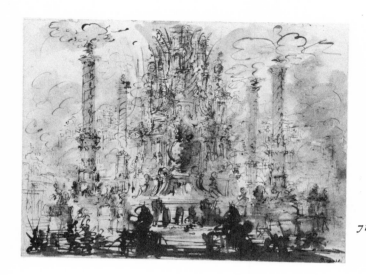

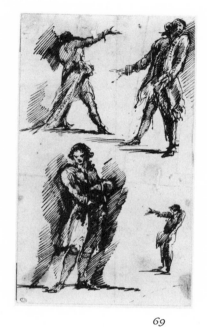

71

69

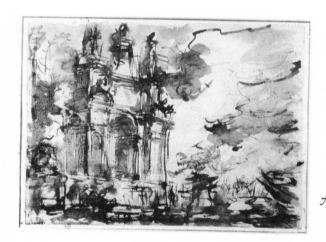

70

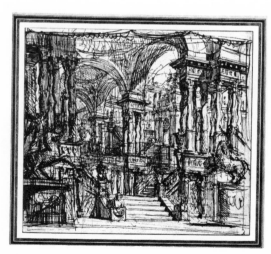

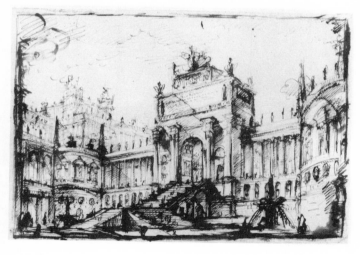

72

68

73. GIOVANNI DOMENICO TIEPOLO
(Italian, 1727–1804)
Centaur Arrested in Flight, a Female Faun on His Back
Brown ink and wash
7⅝ x 10⅞ in. (19.3 x 27.6 cm.)
Los Angeles County Museum of Art
Museum Purchase, 1965

Collections: Rudolf; Drey Gallery
Literature: J. Byam Shaw. *Drawings of Domenico Tiepolo*. London, 1962. p. 42, no. 2; J. Cailleux. "Centaurs, Fauns...among the Drawings of Domenico Tiepolo." *Burlington Magazine*, July 1974. no. 53, fig. 48; *A Decade of Collecting*. Los Angeles County Museum of Art, 1975. pp. 86-87, 193–94, no. 81, repr.

74. GIOVANNI DOMENICO TIEPOLO
(Italian, 1727–1804)
The Raising of Tabitha, ca. 1780–1790
Pen and brush in brown ink and wash
18³⁄₁₆ x 14³⁄₁₆ in. (46.2 x 36.0 cm.)
Woodner Family Collection

Literature: *Woodner Collection II: Old Master Drawings from the XV to the XVIII Century*. New York, 1973. no. 73, repr.

73

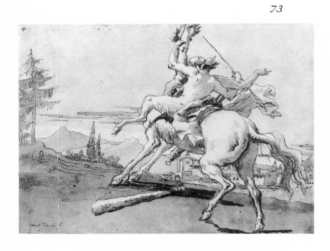

74

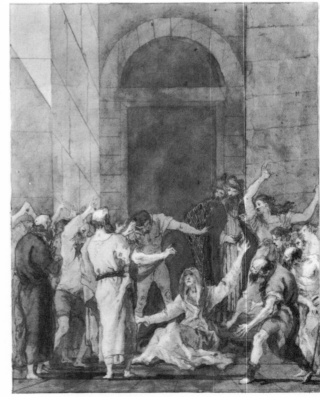

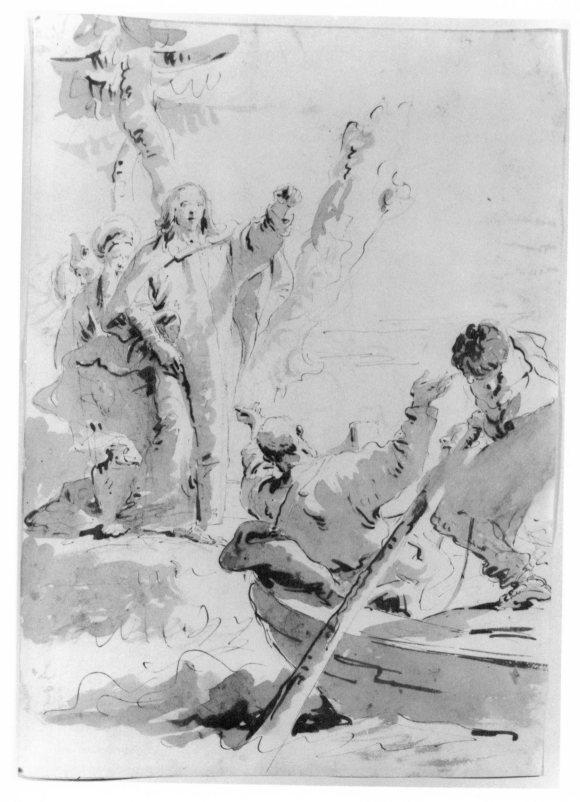

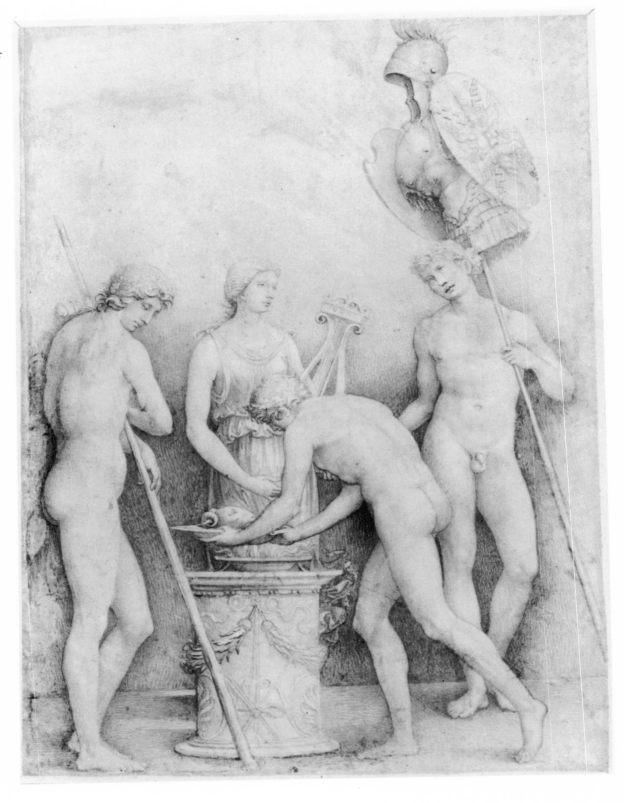

The Emilia

EXTENDING from the cities of Piacenza and Reggio Emilia in the north to Ravenna and Forlì in the south, the region of the Emilia encompassed several noteworthy art centers–Modena, Bologna, Ferrara, and Parma–during its long history. One of Modena's greatest glories was her late twelfth-century cathedral; in painting after the fourteenth century she was largely indebted to foreign and Bolognese artists. Bologna was artistically important in the fourteenth century and again in the late sixteenth and throughout the seventeenth centuries, while Parma became significant in the sixteenth century. Ferrara was particularly fertile during the Renaissance, producing at least four major artists whose influence was felt throughout the Emilia in the fifteenth century. The most outstanding among them was Cosimo Tura (ca.1430–1495) whose highly expressive drawings, like those of his Ferrarese contemporaries, are exceedingly rare, preventing their inclusion in this exhibition. Fortunately, a drawing generally accredited to his closest pupil, Francesco del Cossa (ca. 1435–1477), was obtained (cat. no.75). Some scholars have not accepted this work as Emilian, believing it more characteristic of the Venetian school and suggesting the names of either Jacopo or Giovanni Bellini as its author. However, though no drawings securely attributed to Cossa are known, until evidence appears to the contrary it seems reasonable to maintain the ascription to him, or to his school, based on the stylistic resemblance of the drawing to his Palazzo Schifanoia frescoes in Ferrara.

An equally disputed question of authorship applies to the beautiful drawing (cat. no.77) attributed for at least a century to the Mantegnesque artist and *cassone* painter of Ferrara, Ercole de' Roberti (ca.1456–1496); when the drawing was exhibited at the Metropolitan Museum in 1965, it was suggested that further investigation might identify it as Milanese rather than Emilian.

Giovanni Luteri (1479–1542), called Dosso Dossi, is considered the most important Ferrarese master after Cosimo Tura. A pupil of Lorenzo Costa (1460–1535) and also inspired by Giorgione and Titian, Dossi stands out among the Ferrarese for his contributions to landscape and portrait painting. Dosso was one of the group of artists who executed the frescoes at the Villa Imperiale at Pesaro, and the drawing of this villa (cat. no.79) takes on significance as a possible work by this master whose drawings are so rare.

The close artistic ties between Ferrara and nearby Bologna that developed during the Renaissance are personified in the relationship of two of their leading artists: Lorenzo Costa

and Francesco Raibolini (*ca.*1450–1517), called Francia. Originally Costa's pupil, Francia was Bologna's first important Renaissance artist. Later the pair collaborated in Bologna, not only in conducting a studio but also in executing commissions. Nevertheless, Francia's indolent figures, although reflecting the influence of Costa to a certain extent, more obviously resemble the figures of the leading Umbrian master of the period, Pietro Perugino (1466–1542). The high degree of finish of Francia's drawings, as seen in the Morgan Library's *Scene of Classical Sacrifice* (cat. no.76), executed in a flawless technique with brush on vellum, bespeaks the painstaking skill to be expected from an artist who was also a goldsmith, an important medallist, and a worker in *niello*. With its serene sentiment and poetic charm, the present work epitomizes this Bolognese artist's lyrical expression; in the graceful poses of the classical figures and in its harmonious composition the drawing exemplifies the Renaissance re-creation of the antique.

In striking contrast to Francia's classical style is the work of another Bolognese Renaissance artist, Amico Aspertini (1475–1552). If Vasari's anecdotes are accurate, Aspertini was one of the most amusingly eccentric artists in history. For example, Amico, who died mad, is described as painting with both hands at the same time; after he had copied pieces of ancient sculpture he would attempt to destroy them to prevent their usefulness to other artists. Emulator of the antique and of Raphael, Amico produced eclectic work that at times reflects in a singularly imaginative if not bizarre way, something of the robust, earthy humor of his native city. Found again later in the work of Pellegrino Tibaldi, this Bolognese humor culminated in the creation of caricature by Annibale Carracci, possibly in conjunction with his brother Agostino. Aspertini's powerful *River God* (cat. no. 78) is drawn with a face that is, if not quite a caricature, then at least unidealized, although possibly based on a Roman portrait.

Antonio Allegri (1489/94–1534), called Correggio after the township of his birth in the duchy of Parma, was one of the greatest and most influential artists of the Emilia. Although neither early sources for Correggio's art nor the influences upon it are documented, his work indicates knowledge of Leonardo and Raphael, and he is now believed by Sidney Freedberg to have made a trip to Rome in 1514 rather than in 1518. However, unlike the two Florentine masters, Correggio seemingly never drew from life or models; in his use of drawing he appears to have been a basically self-trained artist, of whom it was said figuratively that he "drew" with the brush. Evidence of his use of pen and ink for studies is rare, but numerous examples attest to his employment of red chalk, a medium then newly introduced, which particularly suited his painterly style with its aerial perspective, flowing

rhythm, and magnificent distribution of light and shade (cat. no.80). The use of colored chalks (*pastelli*) is also attributed to Correggio, but drawings in this medium are not now known by him. However, it is reputed that on the strength of such drawings, Federico Barocci (1526–1612) adopted *pastelli* with great success, especially in preparatory studies for components of his paintings.

Unlike Correggio, who was his chief source of inspiration, Parmigianino (1503–1540), the second major artist of Parma, drew constantly. The joyous distillation of beauty and the billowing forms of Correggio's art are transformed in many of Parmigianino's paintings to an extremely mannered gracefulness and exaggeratedly elongated forms. A suave remoteness and coldness encase Parmigianino's painted figures with their torsional bodies, weighty hands, and frozen gestures. His drawings, on the other hand, with their freedom and dynamic rhythms reminiscent of Correggio and Raphael, exhibit qualities not found in his canvases. By comparing the preliminary chalk studies in the Louvre and the Morgan Library for Parmigianino's famous painting of the *Madonna dal Collo Lungo* with the painting itself one sees the contrast between the free execution of the shimmering, flowing draperies in the drawings and the marmoreal finish of the canvas.

The Metropolitan Museum's *Studies for the Figure of Moses* (cat. no.82) shows many of the forceful poses that Parmigianino attempted before deciding on a final solution for part of the decoration of the eastern apse and vaulting he planned for Santa Maria della Steccata but never completed. The studies reveal an artist of dramatic power who apparently chose to restrain that strength in favor of a sinuous, hyperbolic elegance. It was this undulating gracefulness that captured the imagination of scores of artists, native and foreign, and became one of the most influential factors in the formation of Mannerism.

A strikingly original Emilian painter whose strong sculptural illusionism distinguishes his drawings from those of his Mannerist contemporaries, Lelio Orsi (*ca.*1511–1587) was a façade decorator in his native Novellara as well as in the city of Reggio Emilia. The present sheet of studies for such a decoration (cat. no.86) is less characteristic than some of his better-known drawings. In this instance, the careful, delicate hatching of the lines seems to reflect knowledge of contemporary northern engravings such as those executed after the designs of Marten van Heemskerk.

Like many Bolognese artists of the latter sixteenth century, Pellegrino Tibaldi (1527–1596), the most powerful Mannerist in Bologna, was affected by the refined and decorative style of Parmigianino. This can be seen in some of Pellegrino's drawings which show their indebtedness to the great Mannerist of Parma in their swelling, dissolving forms which the

Bolognese carried to grotesque and bizarre extremes. Pellegrino further emphasized the pictoriality of these drawings by profusely heightening them with white. The other major influence upon Tibaldi was Michelangelo, as the heroic proportions and heavy limbs of Pellegrino's figures make manifest. His assiduous disciples, the Carracci, called Pellegrino their "Michelangelo riformato," as he had imported into Bologna a "domesticated" adaptation of the master's *terribile maniera*.

In addition to these influences, Pellegrino's work also reveals the effect of Perino del Vaga's frescoes in Castel Saint'Angelo, Rome. But as shown in the linear quality of the figures in the Los Angeles double-sheet (cat. no.87, *recto* and *verso*), Pellegrino's strokes are nervously energetic as compared to the supple character of the line that flows more regularly in drawings by Perino del Vaga (cat. no.108). The Los Angeles drawing was executed in the early 1550s for one of the female figures of the ceiling fresco of the audience hall in the Palazzo Poggi, Bologna.

Coincident with the declining influence of great art centers like Florence and Venice toward the end of the sixteenth century, Bologna revived. An important papal city whose artistic accomplishments had not yet reached major proportions, Bologna gave rise in the later sixteenth century to the Carracci, a family of artists who succeeded in making the city the most important artistic center, after Rome, in creating the seventeenth century's classical ideal.

Annibale Carracci (1560–1609), the major figure of this family of artists, sought to rebuild the high classical standards of the Renaissance. As a young artist, he was likely familiar with only those few great master works that could be seen in Bologna and its environs. The effect of his encounter with Correggio's works in Parma and those of Paolo Veronese in Venice is well known, not only in Annibale's earlier paintings but also from his correspondence with his cousin Lodovico Carracci (1555–1619), who was the first guide and mentor in art to Annibale and his older brother Agostino. Eventually Annibale broke away entirely from the earlier influences upon him by the Bolognese Mannerists. He went to Rome toward the end of 1594, came home by the summer of the following year, and after a few months returned to Rome to undertake the decoration of the Camerino and Galleria Farnese. During his last years in the capital Annibale shared the position of leading painter with a meteoric young talent, Michelangelo da Caravaggio.

Throughout Annibale's various styles and periods–his early genre works, his Correggiesque and Venetian-inspired paintings, his decorative work executed in Bologna, and his great classicist frescoes in Rome–there continues the common purpose of conveying a

greater humanization of his subjects in accordance with the prevailing religious and cultural beliefs. Nevertheless, Annibale never abandoned the Renaissance principles of form and technique which he considered fundamental to the art of painting. This interpretation, one of the most recent re-evaluations of Annibale's work, expresses the current estimation of the Carracci. It sharply contradicts the sentiments voiced exactly a century ago by the English critic J. A. Symonds, who wrote, "The founders of the Bolognese Academy… chopped up the limbs of painting, which had ceased to throb with organic life, recombined them by an act of intellect and will, and having pieced them together, set the composite machine on the path of studied method."

While the Carracci paintings once stimulated such negative reaction, the drawings have consistently maintained a place among the illustrious creations of the Bolognese school. This appreciation for their drawings has been enhanced in recent years by the renewed study of the numerous facets of their work. One of their chief contributions to the art of draftsmanship was the re-institution of life drawing and the study of anatomy as prerequisites to painting. This approach, adopted by the pupils of the Carracci, led to the formation of a recognizable Bolognese school of draftsmen. Prior to the accomplishments of the Carracci, no independent drawing tradition had existed in Bologna, despite its important school of manuscript illumination, dating from the trecento, and the presence of outstanding individual artists from Gothic through Renaissance times. Returning to the direct study of nature as a source for their art the Carracci, particularly Annibale and Agostino, produced drawings that were rich in fresh and vital expression. Their life studies simplified the human figure and gave it a greater freedom of form; yet while broadly sketching the essential structure of the nude, they nevertheless maintained monumental proportions (cat. no.90). This classical approach was in opposition to the exaggerated proportions and decorative effects of the Mannerist style.

Even at their most Michelangelesque, Annibale's figure drawings have their own robust energy and animation which combine with rhythmic contours softer than those found in Michelangelo's own drawings. At Windsor Castle there is a study by Annibale in black chalk heightened with white on gray blue paper that is preparatory for one of the female figures in the frescoes of the Farnese Gallery in Rome. This remarkable drawing has a unity of form and movement, degree of plasticity, immediacy of presence, and an overall abstract quality that one would not be astonished to find in a fourth-century Greek drawing on paper, if such a phenomenon existed, so well had the tailor's son from Bologna assimilated the spirit of the antique.

From another sphere of Annibale's production, two beautiful landscape drawings (cat. nos.91, 92) reveal that his contribution to this genre was also of great significance. Indeed, the landscapes he painted in Rome for the Doria-Pamphili Gallery in the first years of the seventeenth century provided the inspiration and direction for many important landscapists ranging from Adam Elsheimer and Paul Bril to Claude Lorrain and Nicolas Poussin. Yet, on the whole, the relationships among the various landscape drawings of the Carracci and with those of their followers, have still to be extensively explored.

The monumental *Eroded River Bank with Trees and Roots* (cat. no.91) by Annibale is dated to around 1590–92 by Denis Mahon and thus belongs to Annibale's first Bolognese period. The extremely dramatic, picturesque cliff which projects like a *coulisse* before the lightly sketched river background of this drawing has no exact counterpart in Annibale's paintings; it is also apparently unique among his landscape drawings. But an eroding, cavernous, overgrown cliff does appear in his *Landscape with Diana and Callisto* (Duke of Sutherland), painted in Rome, and the *Landscape with the Sacrifice of Isaac* (Louvre) contains a cliff with a towering tree, decaying trunks, exposed roots, and fallen limbs. Such pointedly realistic motifs later gave way to more classically conceived landscapes, as can be seen in the beautiful double-sided drawing (cat. no.92, *recto* and *verso*), also formerly in the Ellesmere collection. Drawn a few years after the *Eroded River Bank*, as the old inscribed date of 1595 records, the *recto* of this drawing is a powerful study in forceful, rhythmic line and form while the *verso*, as noted by Denis Mahon, already indicates in its expansive, balanced composition the direction that seventeenth-century Roman landscape was to take, a forerunner of which could be seen in a fresco, *Gideon and the Angel*, by the Florentine Mannerist Giovanni de'Vecchi (1536–1614) in the Sala degli Angeli of the Palazzo Farnese at Caprarola.

Annibale Carracci's elder brother Agostino (1557–1602) is less known as a painter than as an engraver and draftsman. The *recto* of the present double-sided red chalk drawing (cat. no.89) is more softly modeled than is typical of Annibale; the head of the wind god on the *verso* is a marvel of foreshortening, and suggests an admirable deftness and assurance of contour. Often Agostino's drawings have been confused with those of his more celebrated brother, but his landscape drawings can be distinguished from Annibale's by a precise linear quality that is more regular and more obvious in the neat evenness of the crosshatching, reflecting Agostino's training and profession as an engraver. This methodical approach is evident in the beautiful oval drawing (cat. no.88) of about 1590 which is as clear and fine as an engraved print, but tends more to decorative effect. This drawing is

similar to another by Agostino, previously in the Ellesmere collection: *River Landscape with a Small Boat*, dated by Denis Mahon to the second half of the 1590s.

The three leading pupils of the Carracci were Guido Reni (1575–1642), their most famous student; his arch-rival, Francesco Albani (1578–1660); and Domenichino Zampieri (1581–1641). Though somewhat less forceful, more languid and classical than those of the Carracci, Reni's figure drawings (cat. no.93) nevertheless continued in the monumental tradition created by his masters. Francesco Albani simplified Annibale's manner of drawing, following his own bent toward mythological and idyllic themes. The closest adherent to the classicism created by the Carracci was Domenichino; in some of his figural drawings the modeling is more sculptural than any found in Annibale. The classicism of Domenichino's compositions directly inspired Poussin, who came to his studio in Rome to draw after nature and esteemed the Bolognese artist as highly as he did Raphael.

The most individual and effective draftsman of the Bolognese school after Annibale was Giovanni Francesco Barbieri, called Guercino (1591–1666). Unlike Annibale, who worked greatly with chalk, Guercino drew mainly in brown ink with a scintillating brown wash that makes his draftsmanship one of the most painterly of the Emilian artists'. Guercino's intense, vibrant calligraphy ranged from free-flowing, crisscrossing, tangled threads to a more controlled regularity of line; and when he chose to use it, his brilliant application of wash was original and dramatic (cat. no.96). Guercino's less-frequent black (cat. no.97) or red chalk studies reveal a luministic modeling that places him in the forefront of seventeenth-century draftsmen. While many features in his drawings suggest a likely knowledge of Rembrandt's etchings, the pure sensuous beauty of Guercino's drawings is antipodal to the un-idealizing, penetrating characterizations of his Dutch contemporary.

In addition to the foregoing artists, a great many other illustrious draftsmen made Bologna their home in the seventeenth and eighteenth centuries, of whom only a few of the better known can be listed here, including Giacomo Cavedone, Simone Cantarini, Donato Creti, Marcantonio Franceschini, and Ubaldo and Gaetano Gandolfi. In a different genre, that of decorative and scenographic fresco, for which the area was justly celebrated, Bolognese artists made a significant contribution, which also extended to the area of *quadratura* or architecturally illusionistic ceiling drawings, notably from the hands of Agostino Mitelli (1609–1660), Angelo Michele Colonna (1604–1687), and Mauro Tesi (1730–1766).

These *quadratura* designs and frescoes prepared the way for the grand scenic art of the Bibiena family, whose stage sets graced most of the great courts of Europe. Specializing in illusionistic architecture, the Bibiena created the most ambitious and magnificent theatri-

cal environments that had yet been seen in Italy. Public and private festivals and triumphal entries all profited from their grandiose sets and illusionistic decorations. The achievements of Ferdinando Galli Bibiena (1657–1743), founder of the school, replaced the strict frontality of stage sets with the *scena per angola* (oblique view) (cat. no. 100), which varied and deepened the more traditional stage presentation. Ferdinando's second son, Giuseppe Galli Bibiena (1696–1757), is represented by a splendid sheet (cat. no. 101) that is so complete in detail it can stand as an independent work of art. The activity of this famous family, whose drawings have long presented seemingly insoluble problems of individuation, continued until almost the close of the eighteenth century. By that time the ascendant art style was Neoclassicism, a movement in which Bologna, the original home of academic classicism, played no important part.

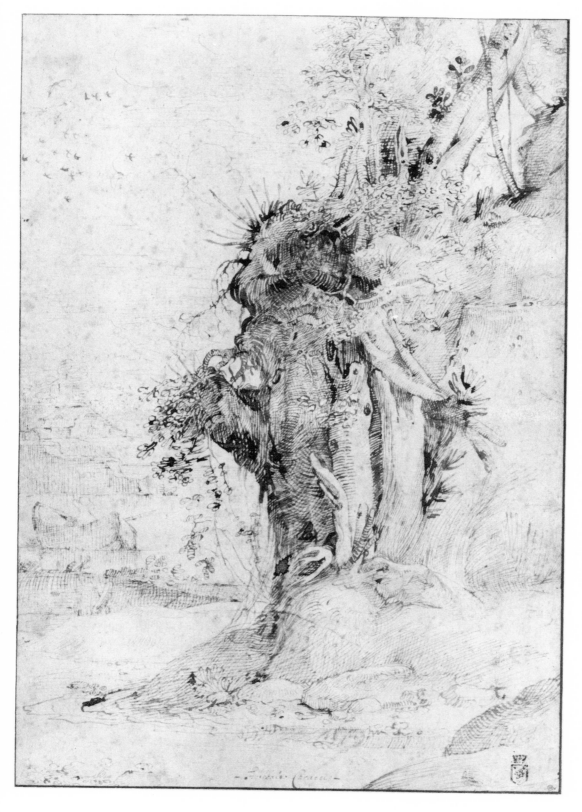

Catalog

75. FRANCESCO DEL COSSA (Italian, *ca.* 1435–1477)
Venus Embracing Cupid at the Forge of Vulcan
Brown ink, 11 x 15⅞ in. (28.0 x 40.7 cm.)
The Metropolitan Museum of Art
Robert Lehman Collection

Collections: J. P. Zoomer; J. Skippe; his descendants, the Martin family, including Mrs. A. C. Rayner-Wood; E. Holland Martin; Skippe Sale, London, Christie's, Nov. 2-21, 1958, no. 81, pl. 12
Literature: R. E. Fry. *The Vasari Society for the Reproduction of Drawings by the Old Masters.* first series, 10 pts., London, 1905-15, and second series, 16 pts., London, 1920–35. first series, vol. II, 1906–07, no. 14, as Ferrarese school; K. T. Parker. *North Italian Drawings.* London, 1927. no. 24, repr., as style of Francesco Cossa; E. Ruhmer. "Bernardo-Parentino und der Stecher P. P." *Arte Veneta* XII (1958): 40-41, fig. 35, as Parentino (?); I. Moskowitz, ed. *Great Drawings of All Time.* 4 vols. New York, 1962, vol. I, no. 63, repr.; W. Ames. *Drawings of the Masters: Italian Drawings from the 15th to the 19th Century.* New York, 1963. p. 62, pl. 30; J. Bean, F. Stampfle. *Drawings from New York Collections I : The Italian Renaissance.* The Metropolitan Museum of Art and The Pierpont Morgan Library, New York, 1965. no. 8.

76. FRANCESCO RAIBOLINI, called Francia (Italian, *ca.* 1450–1517)
Scene of Classical Sacrifice
Brush with brown ink on vellum
11⁷⁄₁₆ x 8⅜ in. (29.2 x 22.3 cm.)
The Pierpont Morgan Library

Collections: W. Y. Ottley; Sir Thomas Lawrence; J. C. Robinson; C. Fairfax Murray
Literature: C. Fairfax Murray. *Drawings by the Old Masters: Collection of J. Pierpont Morgan.* 4 vols. London, 1905-12. I : 95.

77. ERCOLE DE' ROBERTI (Italian, *ca.* 1456–1496)
The Flagellation
Brown ink, minutely worked with point of brush, and brown wash, heightened with white
14¾ x 9¼ in. (38.5 x 23.5 cm.)
The Metropolitan Museum of Art
Robert Lehman Collection

Collections: A. Grahl; M. de Zayas; A. Kann
Literature: *Grahl Collection.* Leipzig, n.d. pl. 340.

78. AMICO ASPERTINI (Italian, 1475–1552)
River God
Black chalk and brown wash, heightened with white; all four corners trimmed
9⅝ x 14⁵⁄₁₆ in. (24.4 x 38.0 cm.)
The Metropolitan Museum of Art
Purchase, Walter C. Baker Gift

Collection: Jonathan Richardson, Sr.
Literature: J. Bean. "The Drawings Collection." *Metropolitan Museum of Art Bulletin* 28 (Oct. 1969): 65-67, repr.

79. NORTH ITALIAN ARTIST (Dosso Dossi?, 1479–1542)
Villa Imperiale, Pesaro
Brown ink with touches of wash in the landscape; indented lines for perspective construction of the column base receding toward the right-hand side, 11⁷⁄₁₆ x 8½ in. (29.1 x 21.6 cm.)
Stephen Spector

Collection: A. Grahl; private collector
Literature: E. van Schaack. *Master Drawings in Private Collections.* New York, 1962. p. 77, no. 30, fig. 30; A. Pinelli, O. Rossi. *Genga Architetto.* Bulzoni Editore, n.p., n.d. unnumbered plate.

Van Schaack has suggested this drawing may have been intended as a title page for a description of the villa. The Villa Imperiale dates from the fifteenth century but, after it was damaged in 1517, additions were made in the early sixteenth century. The architect engaged for this work was the Umbrian Girolamo Genga (*ca.* 1476–1551), also noted as a stage designer. Among the

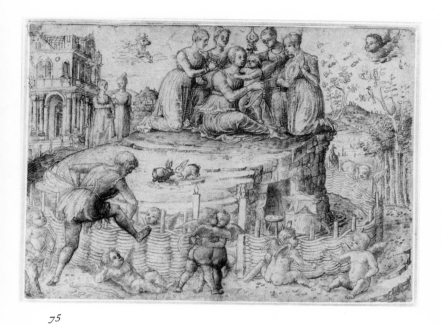

75

77

79

78

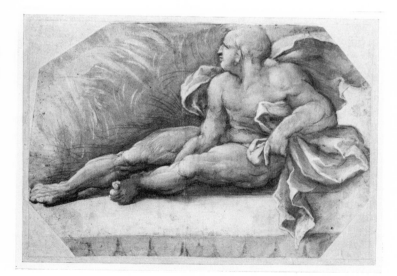

artists who worked on the decoration of the new rooms was Dosso Dossi, to whom Pinelli and Rossi ascribe, with question, the present drawing. According to van Schaack, the drawing dates from between 1530 and 1534, when construction of the villa's new wing was in progress.

80. ANTONIO ALLEGRI, called Correggio
(Italian, 1489/94–1534)
The Adoration of the Magi
Red chalk heightened with white
11½ x 7¾ in. (29.2 x 19.7 cm.)
The Metropolitan Museum of Art
Hewitt Fund

Collections: Sir Peter Lely; Earls of Pembroke; Pembroke Sale, London, Sotheby's, July 5-10, 1917, no. 464; Metropolitan Museum purchase, 1917
Literature: S. A. Strong. *Wilton House Drawings.* n.p., 1900. pt. III, no. 14; S. Moore. *Correggio.* London, 1906. pp. 215, 262; C. Ricci. *Correggio.* London, 1930. p. 184; *European Drawings.* The Metropolitan Museum of Art, New York, n.d. vol. I, no. 20; C. Heaton-Sessions. "Drawings Attributed to Correggio at The Metropolitan Museum of Art." *Art Bulletin* XXXVI (1954) no. 3, pp. 224-28; A. E. Popham. *Correggio's Drawings.* London, 1957. pp. 16, 56, 150, no. 5, pl. VI; J. Bean. *100 European Drawings in the Metropolitan Museum of Art.* New York, 1964. no. 16; J. Bean, F. Stampfle. *Drawings from New York Collections I : The Italian Renaissance.* New York, 1965. no. 66.

81. MICHELANGELO ANSELMI
(Italian, 1491–1555/56)
The Young David Playing the Harp
Black chalk, gray wash, heightened with white, on blue paper, squared in pen and brown ink
15³⁄₁₆ x 5⁷⁄₁₆ in. (38.6 x 14.1 cm.)
The Metropolitan Museum of Art
Rogers Fund

Collection: Metropolitan Museum purchase, 1961
Literature: J. Bean. "The Drawings Collection."
Metropolitan Museum of Art Bulletin 20

(Jan. 1962): 157-75, fig. 3; J. Bean, F. Stampfle. *Drawings from New York Collections I : The Italian Renaissance.* New York, 1965. no. 74.

82. FRANCESCO MAZZOLA, called Parmigianino
(Italian, 1503–1540)
Studies for the Figure of Moses
Verso: Studies for the Figure of Eve and Architectural Studies
Brown ink and wash, over slight traces of black chalk, on light brown paper
8¼ x 6¹⁄₁₆ in. (21.0 x 15.4 cm.)
The Metropolitan Museum of Art
Gustavus A. Pfeiffer Fund

Collections: Earl of Arundel; A. M. Zanetti; Baron D. Vivant-Denon; Sir Thomas Lawrence; R. Ford (Sale, London, Sotheby's, Apr. 25, 1934, no. 29); Sir B. Ingram; Metropolitan Museum purchase, 1962
Literature: Baron D. Vivant-Denon. *Monuments des arts du dessin chez les peuples tant anciens que modernes.... 4* vols. Paris, 1829. vol III, pl. 157; A. E. Popham. *The Drawings of Parmigianino.* London, 1953. pp. 21, 40, 64, pls. LVI–LVII; J. Bean. *Metropolitan Museum of Art Bulletin,* Mar. 1963. pp. 231–32; J. Bean. *100 European Drawings in The Metropolitan Museum of Art.* New York, 1964. no. 21; J. Bean, F. Stampfle. *Drawings from New York Collections I : The Italian Renaissance.* The Metropolitan Museum of Art and The Pierpont Morgan Library, New York, 1965. no. 94; A. E. Popham. *Catalogue of the Drawings of Parmigianino.* New Haven, 1971. no. 301, pl. 330.

83. FRANCESCO MAZZOLA, called Parmigianino
(Italian, 1503–1540)
Nude Figure among Foliage Holding a Globe, and Two Putti
Brown ink
4½ x 5⅛ in. (11.5 x 13.0 cm.)
Mrs. Lois T. Handler

Collections: Sir Joshua Reynolds; B. Delaney; P. Prouté et Fils
Literature: P. Prouté et Fils. *Grand Siècle* (sale

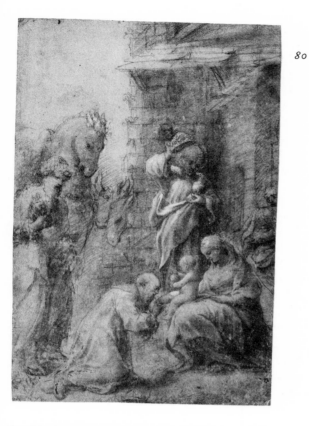

80

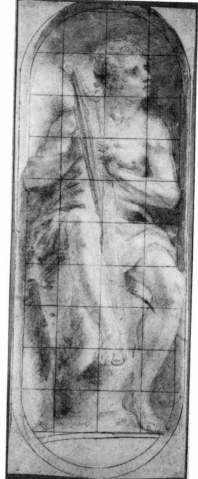

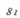

81

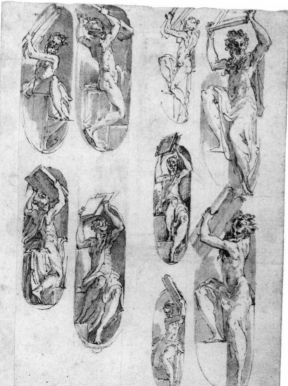

82

83

catalog). Paris, 1965. no. 2; A. E. Popham. *Catalogue of the Drawings of Parmigianino.* Yale University Art Gallery, New Haven, 1971. vol. I, no. 750, vol. III, pl. 269.

84. FRANCESCO MAZZOLA, called Parmigianino
(Italian, 1503–1540)
Study for a Marriage of the Virgin
Brown ink, red chalk, and pale brown wash
7 x 9 3/16 in. (17.8 x 23.1 cm.)
The Pierpont Morgan Library

Collections: Baron D. Vivant-Denon; C. Fairfax Murray; purchased by J. Pierpont Morgan in London, 1910
Literature: D. Vivant-Denon. *Monuments des arts du dessin chez les peuples tant anciens que modernes.* 4 vols. Paris, 1829. III : 163; C. Fairfax Murray. *Drawings by the Old Masters: Collection of J. Pierpont Morgan.* 4 vols. London, 1905–12. vol. I, no. 48; F. Antal. "Un capolavoro inedito del Parmigianino." *Pinacoteca* I (1928): 52; A. O. Quintavalle. *Il Parmigianino.* Milan, 1948. pp. 66, 82, no. 42, p. 196; S. Freedberg. *Parmigianino : His Works in Painting.* Cambridge, Mass., 1950. pp. 65, 174, pl. 40; A. E. Popham. *The Drawings of Parmigianino.* London, 1953. p. 58, no. 26; *Old Master Drawings from Chatsworth.* Smithsonian Institution, 1962. p. 25, no. 42; J. Bean, F. Stampfle. *Drawings from New York Collections I : The Italian Renaissance.* The Metropolitan Museum of Art and The Pierpont Morgan Library, New York, 1965. no. 92; *Drawings and Prints of the First Maniera, 1515–1535.* Museum of Art, Rhode Island School of Design, Providence, 1973. no. 34, repr.

85. FRANCESCO PRIMATICCIO
(Italian, ca. 1504–1570)
Vulcan Forging the Darts of Cupid
Red chalk, heightened with white, on brownish paper, 13 3/8 x 17 3/16 in. (35.0 x 43.7 cm.)
The Metropolitan Museum of Art
Hewitt Fund

Collections: P. H. Lankrink; Earls of Pembroke (Sale, London, Sotheby's, July 5–10, 1917, no. 500)

Literature: S. A. Strong. *Reproductions in Facsimile of Drawings by the Old Masters in the Collection of the Earl of Pembroke.* . . . London, 1900. pt. V, no. 52; *European Drawings.* The Metropolitan Museum of Art, New York, 1942. vol. I, no. 25; J. Bean. *100 European Drawings in The Metropolitan Museum of Art.* New York, 1964. no. 22; J. Bean, F. Stampfle. *Drawings from New York Collections I : The Italian Renaissance.* The Metropolitan Museum of Art and The Pierpont Morgan Library, New York, 1965, no. 97.

86. LELIO ORSI (Italian, *ca.* 1511–1587)
Design for a Facade Decoration Verso: Studies for the Dead Christ, Architecture and Drapery
Brown ink
8 5/16 x 11 1/16 in. (21.2 x 28.1 cm.)
Janos Scholz

Collection: H. Beckmann
Literature: W. Stubbe. *Italienische Meisterzeichnungen von 14. bis 18. Jahrhundert aus amerikanischen Besitz: Die Sammlung Janos Scholz.* Hamburger Kunsthalle, 1963. no. 103, pl. 21; J. Bean, F. Stampfle. *Drawings from New York Collections I : The Italian Renaissance.* The Metropolitan Museum of Art and The Pierpont Morgan Library, New York, 1965. no. 106, fig. 106. *Sixteenth Century Italian Drawings from the Collection of Janos Scholz.* National Gallery of Art, Washington, D. C., and The Pierpont Morgan Library, New York, 1973. no. 61.

87. PELLEGRINO TIBALDI (Italian, 1527–1596)
Dancing Figure
Verso: Dancing Figure and Studies
Brown ink and wash
13 x 10 3/4 in. (33.0. x 27.3 cm.)
Los Angeles County Museum of Art
Los Angeles County Funds

Collections: Count Rey de Villette; Schaeffer Galleries
Literature: Hollstein and Puppel catalog. Berlin, May 6, 1931. no. 1177 (repr.); *Los Angeles County Museum Bulletin of the Art Division* XIII, no. 2 (1961): 3-12; *Emporium*, Feb. 1962. p. 94;

85

84

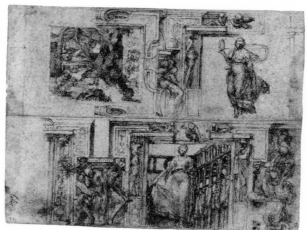

86

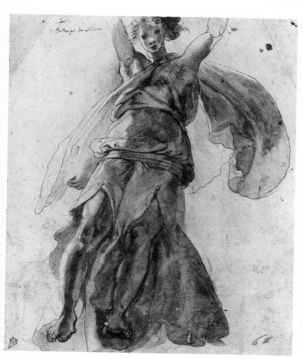

87R

87V

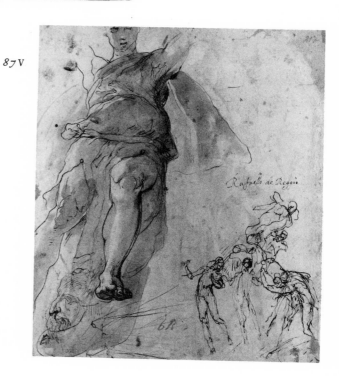

W. Ames. *Drawings of the Masters: Italian Drawings from the 15th to the 19th Century*. New York, 1963. p.110; *European Master Drawings, 1450–1900*. Santa Barbara Museum of Art, 1964. no. 8; *Master Drawings from California Collections*. University Art Museum, Berkeley, 1968. 53:58, pl. 134.

88. AGOSTINO CARRACCI (Italian, 1557–1602)
The Rest on the Flight into Egypt
Brown ink over red chalk
12 1/16 x 16 1/8 in. (30.7 x 40.9 cm.)
Anonymous

Collections: Lord Hampden; Sir Thomas Lawrence; Lord Francis Egerton, 1st Earl of Ellesmere (Sale, London, Sotheby's, July 11, 1972, no. 39)
Literature: *Catalogue of the Ellesmere Collection of Drawings at Bridgewater House*. London, 1898. no. 114; P. A. Tomory. *The Ellesmere Collection of Old Master Drawings*. Leicester, 1954. no. 38, dated to around 1590; *Catalogue of the Ellesmere Collection of Drawings by the Carracci and Other Bolognese Masters Collected by Sir Thomas Lawrence*. Part I, Sale, London, Sotheby's, July 11, 1972. no. 39.

89. AGOSTINO CARRACCI (Italian, 1557–1602)
A Study of a Reclining Male Nude
Verso: The Head of a Wind God
Red chalk, 14 15/16 x 9 3/16 in. (37.9 x 23.4 cm.)
Fogg Art Museum

Collections: Duke of Devonshire; Mrs. D. Fenwick-Owen (Sale, London, Sotheby's, Dec. 4, 1969, no. 89)
 The *recto* is similar to the figure (in reverse direction) of Tithonus, in the Louvre, dated by Denis Mahon around 1599.

90. ANNIBALE CARRACCI (Italian, 1560–1609)
A Study of a Seated Male Bather Seen from Behind, a Clump of Trees to the Right
Brown ink and wash over black chalk
9 1/8 x 6 3/4 in. (23.2 x 17.2 cm.)
Anonymous

Collection: Hardy Amies, Esq.
Literature: *Fine Old Master Drawings*. Sale, London, Sotheby's, Dec. 8, 1972. no. 53, repr. p. 55.

91. ANNIBALE CARRACCI (Italian, 1560–1609)
Eroded River Bank with Trees and Roots
Brown ink, 15 13/16 x 11 1/16 in. (38.6 x 28.1 cm.)
The Pierpont Morgan Library

Collections: Pierre Jean Mariette; Count Moriz von Fries; Sir Thomas Lawrence; Lord Francis Egerton, 1st Earl of Ellesmere (Sale, London, Sotheby's, July 11, 1972)
Literature: *Catalogue of the Ellesmere Collection of Drawings at Bridgewater House*. London, 1898. no. 74; H. Bodmer. "Drawings by the Carracci." *Old Master Drawings* (Mar. 1934), pl. 63, as Agostino; P. A. Tomory. *The Ellesmere Collection*. Leicester, 1954. no. 65, pl. XIX; *Antichità Viva*. 1972. vol. XI, no. 3, repr. p. 67; *Catalogue of the Ellesmere Collection of Drawings by the Carracci and Other Bolognese Masters Collected by Sir Thomas Lawrence*. Part I, Sotheby's, London, July 11, 1972; *Art at Auction, 1971–1972*, Sotheby's, New York, 1973. repr. p. 34; "La chronique des arts." *Gazette des Beaux-Arts*. Mar. 1973. pp. 9–10; F. Stampfle. *Drawings: Major Acquisitions of The Pierpont Morgan Library, 1924–1974*. New York, 1974. no. 8.

92. ANNIBALE CARRACCI (Italian, 1560–1609)
Landscape with a Man Sleeping beneath a Tree, His Dog to the Right
Verso: An Extensive Landscape with a Horseman
Brown ink (*verso*: brown and violet ink)
11 15/16 x 8 3/4 in. (30.4 x 22.4 cm.)
Anonymous

Collections: Verstegh; Sir Thomas Lawrence; Lord Francis Egerton, 1st Earl of Ellesmere (Sale, London, Sotheby's, July 11, 1972, no. 58)
Literature: *Catalogue of the Ellesmere Collection of Drawings at Bridgewater House*. London, 1898. no. 76; P. A. Tomory. *The Ellesmere Collection of Old Master Drawings*. Leicester, 1954. no. 64, *recto* and *verso*, pls. XV, XIII; *Catalogue of the Ellesmere Collection of Drawings by the Carracci*

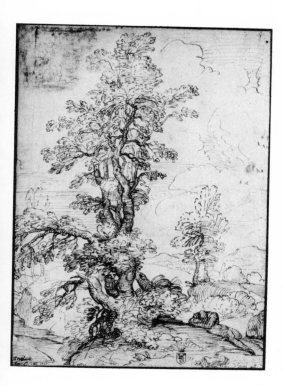

92R

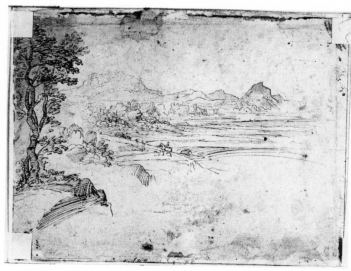

92V

88

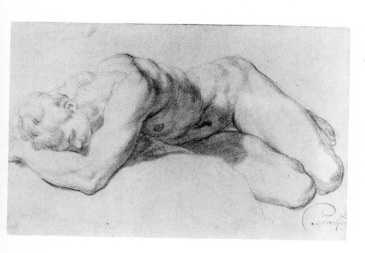

89

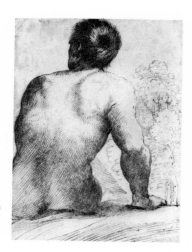

90

and Other Bolognese Masters Collected by Sir Thomas Lawrence. Part 1, Sale, London, Sotheby's, July 11, 1972. no. 58.

93. GUIDO RENI (Italian, 1575–1642)
Liberality
Red chalk
14⅜ x 10⅛ in. (36.5 x 24.5 cm.)
Woodner Family Collection

Collections: E. Lelli: R. Udney; T. Banks; Sir E. J. Poynter; Viscount Lascelles; Earl of Harewood (Sale, Christie's, London, 1965, no. 136)
Literature: *Woodner Collection I : A Selection of Old Master Drawings before 1700.* New York, 1971. no. 44, repr.; *England and the Seicento: A Loan Exhibition of Bolognese Paintings....* Nov. 6–Dec. 7, 1973, London. no. 49; D. S. Pepper. Review of the "England and the Seicento" exhibition. *Burlington Magazine* CXV (Dec. 1973): 824.

According to Pepper, this study is for the figure in the painting *Liberality and Modesty*. The painting was begun around 1635–37, left incomplete at Reni's death, and finished by his pupil–assistant, Giovanni Andrea Sirani (1610–1670). The painting is in the collection of the Earl of Spencer.

94. GIOVANNI FRANCESCO BARBIERI, called Guercino (Italian, 1591–1666)
Study for Christ before the Doctors
Brown ink and wash
10⅜ x 15¼ in. (26.4 x 38.9 cm.)
Los Angeles County Museum of Art
Los Angeles County Funds

Collection: P. Brandt
Literature: W. Vitzthum. *A Selection of Italian Drawings from North American Collections.* Norman Mackenzie Art Gallery, Regina, Saskatchewan, and Montreal Museum of Fine Art, Quebec, 1970. no. 34.

As Vitzthum pointed out, Denis Mahon has indicated that the drawing was probably part of a larger sheet representing *Christ Teaching in the Temple*. A complete drawing of the subject by

Guercino, previously in the H. de Marignane collection and now belonging to Jacques Petit Horry, has been published by J. Bean (*Master Drawings*, 1967, vol. V, no. 3, pl. 50). Another of his drawings of the same subject is in the collection of The Mount Holyoke College Museum of Art (*Five College Roman Baroque Festivals*: "Drawings by Guercino and His Followers," Mount Holyoke College, 1974, no. 6, repr.).

95. GIOVANNI FRANCESCO BARBIERI, called Guercino (Italian, 1591–1666)
Two Warriors
Brown ink and wash
7¹³⁄₁₆ x 5⅛ in. (20.1 x 13.1 cm.)
David Daniels

Collections: Baron D. Vivant-Denon (Sale, Paris, May 1, 1826); Baronne de Conantre, *ca.* 1850; Baronne de Ruble; Mme. de Witte; Marquise de Bryas (until 1958); Stephen Spector
Literature: D. Vivant Denon. *Monuments des arts du dessin chez les peuples tant anciens que modernes....* 4 vols. Paris, 1829. repr. pl. 197 (in reverse); L. J. J. Dubois. *Description des objets d'art qui composent le cabinet de feu de M. le Baron V. Denon.* Paris, 1926. p. 135, no. 463; E. van Schaack. *Master Drawings in Private Collections.* New York, 1962. p. 80, no. 38, pl. 38, and cover; A. Mongan. *Selections from the Drawing Collection of David Daniels.* The Minneapolis Institute of Arts, Feb. 22–Apr. 21, 1968. no. 8; *Five College Roman Baroque Festivals*: "Drawings by Guercino and His Followers." Mount Holyoke College, 1974. no. 45.

96. GIOVANNI FRANCESCO BARBIERI, called Guercino (Italian, 1591–1666)
Landscape with a Volcano
Brush, brown ink, and wash on blue paper
10³⁄₁₆ x 14⅝ in. (27.7 x 37.1 cm.)
Janos Scholz

Collections: B. and C. Gennari (?); Lord Northwick (according to Russell)
Literature: A. G. B. Russell. *Drawings by Guercino.* London, 1923. pl. XIV; Burlington Fine Arts

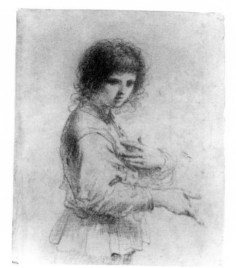

97

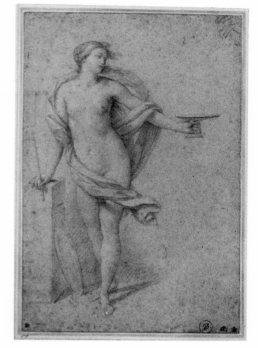

93

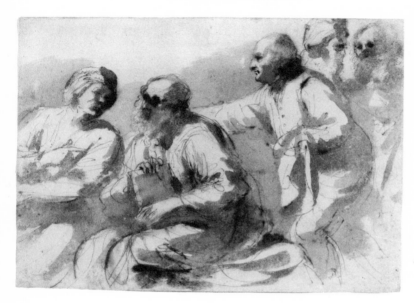

94

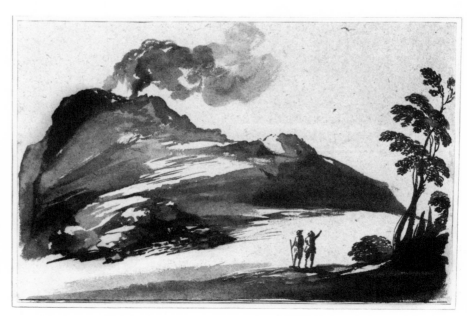

96

Club. London, 1923. no. 3; Magnasco Society. London, 1927; *Drawings from Bologna, 1520–1800*. Mills College Art Gallery, Oakland, 1957. no. 75; *Italian Baroque Drawings from the Janos Scholz Collection*. Columbia Museum of Art, North Carolina, n.d. no. 44; *Italienische Meisterzeichnungen von 14. bis 18. Jahrhundert aus amerikanischen Besitz: Die Sammlung Janos Scholz*. Hamburger Kunsthalle, 1963. no. 79; *Italian Drawings from the Collection of Janos Scholz*. Yale University Art Gallery, 1964. no. 65; "Italian Drawings from the Collection of Janos Scholz." *Metropolitan Museum of Art Bulletin* II (May 1965); J. Bean, F. Stampfle. *Drawings from New York Collections II : The Seventeenth Century in Italy*. The Metropolitan Museum of Art and The Pierpont Morgan Library, New York, 1967. no. 50; *Italian Drawings from the Collection of Janos Scholz*. British Arts Council, London, n.d. no. 52; *Thirty Italian Landscape Drawings from the Collection of Janos Scholz*. Trinity College, Hartford, Conn., 1969–70; *Drawings by Seventeenth Century Italian Masters from the Collection of Janos Scholz*. The Art Galleries, University of California, Santa Barbara, 1974. no. 57, fig. 57.

97. GIOVANNI FRANCESCO BARBIERI, called Guercino (Italian, 1591–1666)
Study of a Young Man
Black chalk, 8¾ x 7 in. (22.2 x 17.8 cm.)
Woodner Family Collection

Literature: *Woodner Collection I : A Selection of Old Master Drawings before 1700*. New York, 1971. no. 43, repr.

98. GIOVANNI FRANCESCO GRIMALDI (Italian, 1606–1680)
Landscape with River and Figures
Brown ink, 9½ x 10 in. (24.1 x 25.4 cm.)
Los Angeles County Museum of Art
Los Angeles County Funds

Collection: O. Salzer
Literature: "Two Seventeenth-Century Drawings." *Los Angeles County Museum Bulletin of the Art Division* VIII, no. 3 (1956): 6.

99. DOMENICO MARIA CANUTI (Italian, 1626–1684)
Studies for Heads and Figures
Brown ink, 6⅝ x 8¾ in. (16.8 x 22.2 cm.)
Detroit Institute of Arts

Collection: Count A. G. P. de Bizemont Prunele
Literature: Unpublished

This interesting sheet, originally attributed to Guercino, contains two Guercinesque heads at the left and two studies for the standing figure of Venus in the ceiling fresco *The Apotheosis of Romulus*, painted by Domenico Maria Canuti in 1675 for the Palazzo Altieri in Rome. After the death of Guido Reni, the youthful Canuti studied for a short period under Guercino, whose influence is very pronounced in these heads, and continued in varied degrees throughout Canuti's life.

A study for the figure of Jupiter in the fresco is in the Morgan Library.

100. FERDINANDO GALLI BIBIENA (Italian, 1657–1743)
Portico and Staircase
Brown ink with watercolors
10⁷⁄₁₆ x 8⅛ in. (26.5 x 20.6 cm.)
The William Hayes Ackland Memorial Art Center, University of North Carolina, Chapel Hill

Collection: E. Fatio
Literature: D. Kelder. *Drawings by the Bibiena Family*. The Philadelphia Museum, Jan. 10–Feb. 28, 1968. no. 14, fig. 14.

101. GIUSEPPE GALLI BIBIENA (Italian, 1696–1757)
Opera Setting: A Fantastic Interior with Figures
Black ink with gray wash
14⅞ x 20¹⁄₁₆ in. (37.8 x 51.0 cm.)
Stephen Spector

Literature: Museum of the Rhode Island School of Design, *Italian Drawings*, 1965; University of Milwaukee, *Drawings from the Collection of Stephen Spector*, 1967; *Drawings by the Bibiena Family*, The Philadelphia Museum of Art, 1968, cat. no. 49, not illustrated.

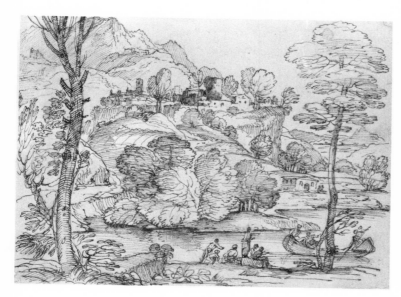

98

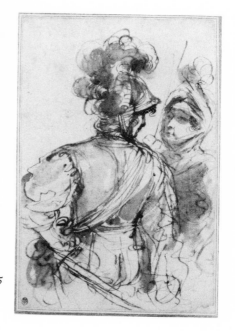

95

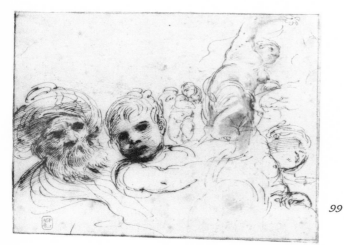

99

101

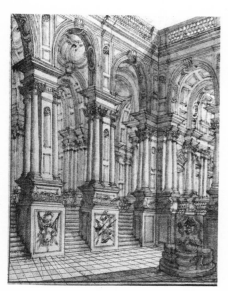

100

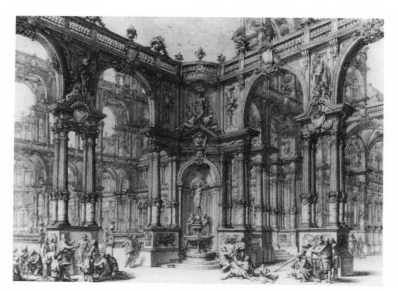

Rome

AFTER Raphael's death in 1520 his chief follower and assistant, the Roman-born Giulio Romano (1499–1546), became the acknowledged head of the master's school. Giulio's work is divided between his Roman *oeuvre* and his commissions later in Mantua where he supervised all artistic and engineering projects for Duke Federigo Gonzaga. Under the influence of his study of the antique, particularly Roman reliefs, Giulio's drawings assumed a planar, plastic character that gave way in Mantua to a more freely rhythmic linear inflection, approaching that of Raphael, as seen in the beautiful *St. Michael and the Devil* (cat. no. 107). Giulio's more solidly modeled *Daedalus Warning Icarcus* (cat. no.106A) is juxtaposed in the exhibition with a later nearly identical drawing that was made through a transfer method (cat. no.106B) to serve the artist as a composition for further development.

Among the significant disciples of the Raphael-Giulio Romano circle and also the most important painter to work on the frescoes in the Vatican Logge, Perino del Vaga (1501–1547) was one of the circle's most productive draftsmen. Born in Florence and trained there early in his youth, he plunged into the Roman world of Michelangelo, Raphael, Giulio Romano, and their followers while still a very young man. He transmuted the monumental aesthetic qualities he absorbed into largely decorative works of many graphic styles which, for the most part, no longer reflected the greater masters. Taken prisoner during the Sack of Rome, Perino finally escaped to Genoa where he decorated the palace of the prince Andrea Doria, introducing a style of fresco painting that was later influential in moderating Luca Cambiaso's Michelangelesque manner.

In addition to his more classical studies in chalk, Perino's drawings were chiefly in ink and wash. On occasion his use of white lead for highlighting lent his fluid, graceful drawings a heightened dramatic quality, as seen in a study (cat. no.108) for a vault fresco of the Pucci Chapel in the church of the Trinità dei Monti, Rome. When Perino fled to Genoa the fresco was left incomplete and was later finished by Taddeo and Federico Zuccaro.

Second in importance only to Perino del Vaga as a decorator of the Vatican Logge was Polidoro Caldara, called Polidoro da Caravaggio (1490/1500–1543?) after the city of his birth in the Milanese region of Lombardy. According to Vasari, Polidoro came as a poor youth to Rome where he was hired to carry mortar for plastering the walls for the frescoes in the Vatican palace. He came to the attention of a Florentine artist, B.C.Maturino, who

instructed him in the principles of painting; since no work remains from this early teacher and collaborator, his influence cannot be judged in Polidoro's paintings or drawings. The young student was so gifted that his work was brought to the attention of Raphael, and Polidoro soon joined the other young artists who constituted the Raphael "school" under the leadership of the equally youthful Giulio Romano. Ultimately, Polidoro's fame came to rest upon his decoration of the façades of several Roman palaces which artists, both Italian and foreign, copied in drawings and engravings. Most of these drawings have remained anonymous (cat. no.104).

Although he became well versed in Roman archaeology, a strong vein of realism and dramatic expressiveness pervades Polidoro's art, bringing it closer in style to Giulio Romano's work than to Raphael's. Influences from the emotionalized work of Rosso Fiorentino are also apparent. The charming drawing of the *Holy Family with St. Anne and the Infant St. John* (cat. no.103) is dated around 1520–25, a few years before the Sack of Rome which drove Polidoro to Naples. Later the artist went to Sicily where he was very active in Messina. Finally wishing to return to Rome after many years, Polidoro was, according to tradition, murdered by his servant for his money. Characteristics of the artist evident in the McCrindle *Holy Family* drawing are the deeply cut profiles and small delicate heads contrasting with voluminously draped bodies; Polidoro shared such deviations from the classical norms of the Renaissance with other painters of the Mannerist style.

Perino del Vaga's works had indeed prepared the way for the Mannerism, as seen in Polidoro da Caravaggio, which became the predominant style in Italy in the sixteenth century. Perino particularly influenced the early drawings of Taddeo Zuccaro (1529–1566) who, with his younger brother Federico (1540/41–1609), numbered among the important Mannerist artists working in Rome in the latter half of the century. Taddeo remained in Italy, working for the Duke of Urbino at Pesaro, in Rome for the popes, and also in the Villa Farnese at Caprarola. Federico, on the contrary, traveled extensively, working in France, the Netherlands, England, and Spain. Later he established the Academy of St. Luke in Rome, and toward the end of his life wrote an influential treatise, *L'idea de' scultori, pittori ed architetti*, which posited the existence of two types of *disegno*: the inner, which exists as a given idea of beauty in the artist's mind, and the exterior, which is the form the idea assumes when it is materialized.

What can generally be advanced as the most apparent difference between High Renaissance drawings and those of Mannerism is the break-up of forms and the departure from classical composition. The great self-contained geometric forms of Raphael, already loos-

ening in some of Giulio Romano's drawings, are re-cast in works by Perino del Vaga, yielding to a predominantly decorative quality which supplants the sculptural conception of Michelangelo and Raphael. The final dissolution of form appears in drawings by Taddeo Zuccaro, whose dynamic *Studies of a Woman Running Forward* (Uffizi), for example, abandons the High Renaissance in its use of centrifugally unraveling lines which paradoxically portray the simultaneous emergence and dissolution of form.

As John Gere's fundamental study of Taddeo's drawings has revealed, the artist had so many styles that his drawings have been confused with those of a great many artists of different schools and periods. At the same time, consistent within this variety are an energy and an individuality of line that make his work particularly expressive. These qualities are summed up in the double-sided *Sheet of Studies* (cat. no.113), a work not only beautiful in itself but a remarkable documentation of the artist's procedure in developing ideas for a fresco. The central figure, drawn with brush and red wash, is surrounded by five separate compositional sketches and several studies in brown ink and wash of individual figures, all struggling for definition and resolution. These peripheral figures are rough notes embodying the artist's spontaneous first thoughts, which are finally formulated in the central figure. Two of the thumbnail sketches at the bottom are preliminary ideas for the whole composition. In addition, the *verso* contains an early idea for the vault of the Frangipani Chapel in the church of San Marcello al Corso, Rome.

Federico Zuccaro, apparently lacking his brother's intensity, was more literal and rational in his approach to drawing. However, his use of color was innovative, for he is now recognized as the first Italian of his time to combine black with red chalk, a technique practiced earlier by portraitists like Holbein and the Clouets. The imposing Venetian scene (cat. no.114) dates from the 1580s, the period when Federico was banished from Rome for painting a large allegory intended to rebut criticism by Bolognese artists of one of his works. Both of the Zuccaro brothers were of central importance for the impact of their strongly anti-realistic art on Netherlandish Mannerism.

Mannerism flourished throughout Europe around the time of the Council of Trent (1545 –1563) which set the stage for the Counter Reformation, a movement seeking complete Roman Catholic dominion over Christendom. Among the first artists to communicate the Counter-Reformation psychology was Federico Barocci (1526/35–1612), who provided a bridge from Mannerism to the early Baroque and was a notable influence upon Rubens. One of Barocci's formal contributions as a painter was the compositional device of using a single figure to fill the major space of the canvas, thus stressing the individual's experience

of the religious ecstasy attained by practicing the *Spiritual Exercises* of St. Ignatius Loyola.*

Barocci lived most of his long but ailing life in his native Urbino. Although his corpus of paintings is not overly large, he was an indefatigable draftsman, and produced some thousand drawings, of which a great number were studies of individual details for his paintings. As appealing as his paintings, Barocci's drawings are enchanting for their variety of media as well as of styles. He was particularly a master in the use of colored chalks (*pastelli*), which he reputedly learned from examples by Correggio, an artist he profoundly admired. John Gere has suggested that Barocci's combining ink with wash and body color over chalk on blue paper was influenced by Taddeo Zuccaro's use of this technique. In turn Barocci's drawings must have inspired later artists who used colored chalks and pastel.

Two outstanding Barocci drawings are found in the present exhibition. The earlier one, *St. Francis Receiving the Stigmata* (cat. no.111), is a more painterly and free treatment of landscape in brown and black inks with pinkish white on blue paper; the later one, *Study for Aeneas' Flight from Troy* (cat. no.112) drawn in ink with chalk and yellow washes on gray green paper, is a more fully realized study for the painting of about 1589 in the Galleria Borghese, Rome. In using colored papers for his brilliant mixtures of media, Barocci seems to lead directly to the drawing techniques of many eighteenth-century French masters.

Annibale Carracci, his followers, and others of the Bolognese school contributed to the artistic activity of Rome during the seventeenth century. Carracci's return to the study of Raphael and the antique, and the classicism in the work of Domenichino rekindled the love of classical ideals among some artists in Rome. At the same time, Rome was dominated by a great sculptor, Gian Lorenzo Bernini (1598–1680) (cat. nos.118, 119), whose powerful Baroque form and emotive content were paralleled in the works of the most important painter of his period, Pietro da Cortona (1596–1669), and, somewhat later, in the works by Giovanni Battista Gaulli (1639–1709). Thus, the city was fairly divided between Baroque and classical directions. Classical concepts of simplicity, harmony, and purity opposed the mystic, passionate, free-spirited expression of the Baroque. Yet despite these conflicting forces, the drawings of the period generally manifest the large forms and bold movement of the Baroque style.

Such characteristics are clearly evident in the drawings by the master of the High Baroque, Pietro da Cortona. An early one (cat. no.116) is the only existing preparatory work

* More recently John Shearman has suggested the likelihood of influences of the Franciscan and Capuchin movements on Barocci ("Barocci at Bologna and Florence," *Burlington Magazine* 118 [Jan. 1976]:52).

for the fresco *The Age of Iron*, which the artist painted in 1640 in the Palazzo Pitti, Florence, one of several decorations he executed for that interior. In Cortona's operatic style, the movement of the drawing spins centrifugally from the powerful central figure of the soldier, and all the outlines are imposed with strong, decisive strokes. A preparatory study in ink and wash (cat. no.117) for the title page of a Roman missal exemplifies Cortona's dynamic energy, unabated with age. The engraving after this work by his pupil François Spierre (1643–1681) implies that the drawing may date from the late sixties. The extensive white highlighting of Cortona's drawing enhances the pictorial quality of a creation typical of this artist, whose works were unexcelled among contemporary productions for their brilliance and bravura. Characteristic of Cortona's style are monumental forms and classical heads with luxuriant masses of hair.

The Genoese Giovanni Battisti Gaulli (1639–1709), called Baciccio, spent most of his adult life in Rome, where he painted the celebrated ceiling fresco, *The Adoration of the Name of Jesus*, in the Church of the Gesù. Reflecting Bernini's drawing style much more than did Cortona, Gaulli was a particularly fluent draftsman. Deeply undulating folds with long hollows upon which the strokes and lines seem to float distinguish his drapery. Echoes of Bernini's sculpture can be seen in the *Allegory of the Mathematical Sciences* (cat. no.121) in which solid figures emerge from the light-flooded landscape.

After Gaulli the impact in Rome of the full-blooded Baroque was largely spent. The long-lived artist Carlo Maratti (1625–1713) reflected as well as helped to create the late international style of Baroque Classicism. Instead of portraying figures in impassioned movement, he designed them with dignified, heroic gestures and classical restraint, foreshadowing subsequent academic schools. Some of his red chalk drawings became so generalized that his autographic identity is virtually lost.

By the mid-eighteenth century Paris had largely supplanted Rome as the artistic center of Europe. Meanwhile, the close of the Baroque age also saw the development of a new approach to the purposes and uses of drawing; many artists rejected the long tradition of creating numerous preparatory studies for highly finished paintings, frescoes, and sculpture in favor of a spontaneity that was expressed directly in the final work. Thus, the Roman academic style of drawing by Maratti and others did not meet the requirements of the day, which were fulfilled in the lightness and wit, the grace and musicality of drawings by the masters of the French Rococo.

Catalog

102. BALDASSARE PERUZZI (Italian, 1481–1536)
An Allegory of Prudence
Brown ink and wash, heightened with white
on pink tinted paper, squared for transfer,
some losses
12½ x 7¼ in. (31.8 x 18.5 cm.)
Los Angeles County Museum of Art
Gift of the Bella Mabury Estate and of
Mr. and Mrs. Irving Stone

Collections: Sir Peter Lely; P. H. Lankrink;
Earl of Pembroke (Sale, London, Sotheby's,
July 9, 1917. no. 397/5 as School of Raphael);
Irma N. Straus (Sale, New York, Parke-Bernet,
Oct. 21, 1970, no. 7); H. Shickman
Literature: *The Irma N. Straus Collection of Old
Master Drawings*. Sale, New York, Parke-Bernet,
Oct. 21, 1970. no. 7, wrongly described as pub-
lished in S. A. Strong. *Reproductions in Facsimile
of Drawings by the Old Masters in the Collection
of the Earl of Pembroke....* London, 1900. and in
C. L. Frommel. *Baldassare Peruzzi als Maler und
Zeichner*, Munich, 1967–68.

Including the present work, there were five
Allegory drawings by Peruzzi in the Straus sale;
all had been sold at the Pembroke sale as School of
Raphael. In his book on Peruzzi, C. L. Frommel
reproduced two of the Pembroke Allegories,
Justice and *Liberality*, as well as a related one from
the Duke of Devonshire collection. Frommel at-
tributed these chiaroscuro drawings to Peruzzi
on the basis of the correspondence of their in-
scriptions to Peruzzi's handwriting and because
of the similarity of the figures to those in the art-
ist's frescoes in the Palazzo della Cancelleria,
Rome. He also compared the Allegory figures to
those in the Morgan Library drawing *Moses
Striking Water from the Rock* for showing the
same considerable heightening with white. From-
mel believed that Peruzzi had become interested
in the new chiaroscuro woodcut technique of Ugo
da Carpi, and made the series of Allegory draw-
ings with a view to reproducing them as prints,

an intention that was apparently never realized.
However, on the basis of the figure style, it is not
unreasonable to look rather toward Giulio Ro-
mano and his ambience for the possible source or
authorship of these drawings.

103. POLIDORO CALDARA, called Polidoro da
Caravaggio (Italian, 1490/1500–1543?)
Holy Family with St. Anne and the Infant St. John
Brown ink, brush and brown and grayish washes
over preliminary drawing in black chalk, height-
ened and corrected with white; squared with
brown ink in lower left and right
6¹⁵⁄₁₆ x 8¹⁵⁄₁₆ in. (17.7 x 22.8 cm.)
J. F. McCrindle

Collections: P. Crozat; P.–J. Mariette;
L. D. Lempereur; Count J. P. van Suchtelen;
unidentified collector's mark: CR
Literature: E. Pillsbury, J. Caldwell. *Sixteenth-
Century Italian Drawings: Form and Function.*
Yale University Art Gallery, May 7–June 30,
1974. no. 6, fig. 6.

104. POLIDORO CALDARA, called Polidoro da
Caravaggio, after (Italian, 1490/1500–1543?)
Sacrifice to Niobe
Brown ink, heightened with white
9⅜ x 16 in. (23.8 x 40.6 cm.)
Mr. and Mrs. Germain Seligman

Collection: A. Kann
Literature: Unpublished

Shortly before the Sack of Rome in 1527, Poli-
doro da Caravaggio completed his decoration of
the façade of the Palazzo Milesi in Rome. His
last work of this kind, it is the most renowned and
studied. The bottom frieze was devoted to the
story of Niobe, as can be seen from the engraving
made of the façade paintings at the end of the
nineteenth century when, thanks to restoration,
they were still extant (see A. Marabottini, *Poli-
doro da Caravaggio*, 2 vols. [Rome, 1969], vol. II,
pl. CXLVII). No preparatory drawings for the Pa-
lazzo Milesi façade paintings are known, but
many drawings and engravings were made after

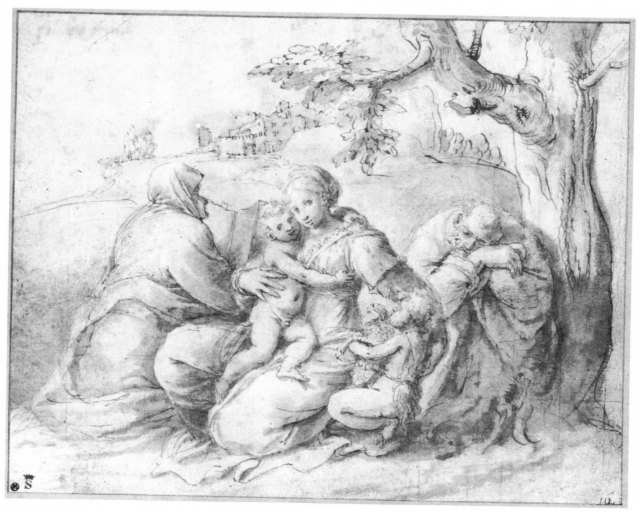

103

102

104

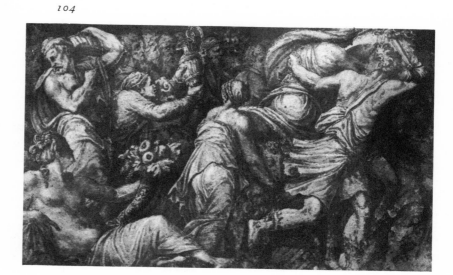

these grisaille decorations. The present drawing of the lower-left section of the frieze appears to be contemporary with the frieze; through its considerable white highlighting it captures the brilliant effect of the painting itself.

105. GIULIO ROMANO (Italian, 1499–1546)
Design for the Handle of a Mace
Pen and brown ink over black chalk. The lower segment of the stem was silhouetted for two inches by the artist and pasted on another sheet in which he continued the final section of the design, 16⁷⁄₁₆ x 3¾ in. (41.7 x 9.5 cm.)
The Pierpont Morgan Library

Collections: Unknown collector; Jonathan Richardson, Sr.; Sir Thomas Lawrence; Lord Francis Egerton, 1st Earl of Ellesmere and descendants (Sale, London, Sotheby's, Dec. 5, 1972, lot 10)
Literature: Unpublished

106. GIULIO ROMANO (Italian, 1499–1546)
Daedalus Warning Icarus against the Threat of the Sun
A: brown ink and wash, heightened with white over traces of black chalk
 10½ x 8³⁄₁₆ in. (26.7 x 20.8 cm.)
B: brown ink and wash, heightened with white; stylus under drawing
 13½ x 10⁷⁄₁₆ in. (34.3 x 26.5 cm.)
Anonymous

Collections: A–Count Bianconi; Jonathan Richardson, Sr.; T. Dimsdale; Sir Thomas Lawrence; Lord Francis Egerton, 1st Earl of Ellesmere (Sale, London, Sotheby's, Dec. 5, 1972, no. 61) B–Count Bianconi; T. Dimsdale; Sir Thomas Lawrence; Lord Francis Egerton, 1st Earl of Ellesmere (Sale, London, Sotheby's, Dec. 5, 1972. no. 61)
Literature, A and B: *Catalogue of the Ellesmere Collection of Drawings at Bridgewater House.* London, 1898. nos. 7, 117; P. A. Tomory. *The Ellesmere Collection of Old Master Drawings.* Leicester, 1954. no. 97, pl. XXIII (for drawing A

only); F. Hartt. *Giulio Romano.* New Haven, 1958. 1:278, 305, no. 297 (drawing A only); *The Ellesmere Collection, Part II, Drawings by Giulio Romano.* Sale, Sotheby's, London, Dec. 5, 1972. no. 61.

Giulio probably made drawing B from drawing A by dusting charcoal over the back of drawing A, which had been made on thin paper, then redrawing the *recto* with a stylus over another sheet, thus transferring the design. It appears he then went over the transferred design, drawing B, with ink, and finished it with ink wash and white heightening.

107. GIULIO ROMANO (Italian, 1499–1546)
St. Michael and the Devil
Brown ink
15³⁄₁₆ x 11³⁄₈ in. (38.6 x 29.0 cm.)
The National Gallery of Art, Washington, D.C.
Ailsa Mellon Bruce Fund

Collections: Dr. R. Mead; J. Barnard; Sir Thomas Lawrence; Lord Francis Egerton, 1st Earl of Ellesmere (Sale, London, Sotheby's, Dec. 5, 1972, no. 54); Y. Tan Bunzel
Literature: *Catalogue of the Ellesmere Collection of Drawings at Bridgewater House.* London, 1898. no. 13; H. Bodmer. "Drawings by the Carracci." *Old Master Drawings* 8 (Mar. 1934): 65, pl. 65; P. A. Tomory. *The Ellesmere Collection of Old Master Drawings.* Leicester, 1954. no. 94, pl. XXIII; *The Ellesmere Collection Part II, Drawings by Giulio Romano.* Sale, Sotheby's, London, Dec. 5, 1972. no. 54; *Recent Acquisitions and Promised Gifts.* National Gallery of Art, Washington, D.C., 1974. no. 15.

108. PIERO BUONACCORSI, called Perino del Vaga (Italian, 1501–1547)
The Presentation of the Virgin
Brown ink and wash, heightened with white, squared in black chalk, on brownish paper
8¹⁵⁄₁₆ x 10¹⁄₁₆ in. (22.7 x 25.5 cm.)
The Metropolitan Museum of Art
Rogers Fund

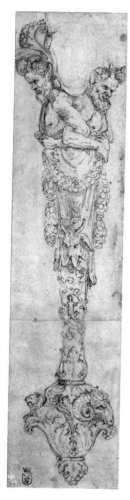

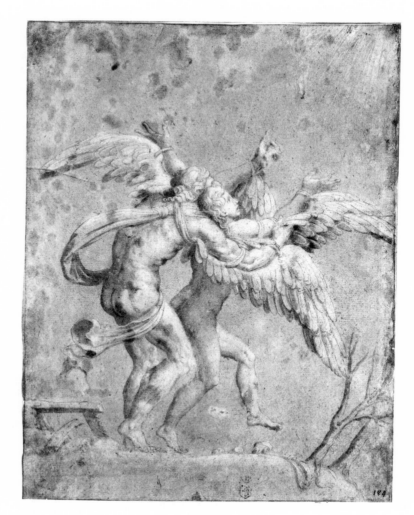

105

106

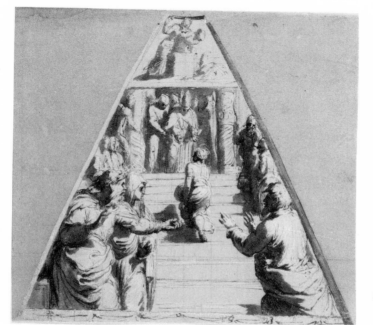

108

Collections: Prince Borghese; Sir Thomas Lawrence; Samuel Woodburn (Sale, London, Christie's, June 4-8, 1860, no. 981); (Sale, London, Sotheby's, Mar. 12, 1963, no. 20), Metropolitan Museum of Art purchase, 1963

Literature: B. Davidson. "Early Drawings by Perino del Vaga – I." *Master Drawings* I, no. 3 (1963): 16, pl. 7a; J. Bean. *100 European Drawings in The Metropolitan Museum of Art.* New York, 1964. no. 19; J. Bean, F. Stampfle. *Drawings from New York Collections I : The Italian Renaissance.* The Metropolitan Museum of Art and The Pierpont Morgan Library, New York, 1965. no. 84.

109. DANIELE DA VOLTERRA
(Italian, 1509–1566)
Nude Male Warrior with Sword and Plumed Helmet
Black chalk
12½ x 6¼ in. (31.7 x 15.9 cm.)
Inscribed in ink on the *verso*: Appartiene ad Alessandro Maggiori il quale lo compra a Roma nel 1809
Michael Hall, Esq.

Collection: Dr. L. P. (not in Lugt)
Literature: Unpublished

The Michelangelesque character of the drawing is evident. Unfortunately, the drawing has suffered several losses, with possible re-working, especially in the contouring of the figure's left arm.

110. PIRRO LIGORIO (Italian, 1513–1583)
Women at a Fountain in an Architectural Setting
Brown ink and wash
12 x 10 in. (30.5 x 25.4 cm.)
David E. Rust

Collections: Giorgio Vasari; J. C. Robinson; Sir Robert Mond; Stephen Spector
Literature: T. Borenius, R. Wittkower. *Catalogue of the Collection of Drawings by the Old Masters Formed by Sir Robert Mond.* London, n.d. no. 141, pl. XVI; O. Kurz. "Giorgio Vasari's 'Libro de' Disegni.'" *Old Master Drawings* 12, no. 47 (Dec. 1937): 41.

111. FEDERICO BAROCCI
(Italian, 1526/35–1612)
St. Francis Receiving the Stigmata
Brown and black ink with brown wash, heightened with pinkish white, on blue paper
14⁷⁄₁₆ x 10¹⁵⁄₁₆ in. (36.6 x 27.8 cm.)
The Janos Scholz Collection
The Pierpont Morgan Library

Collections: T. Bewick; R. Ford
Literature: *From Bruegel to Cézanne.* The Pierpont Morgan Library, New York, 1953. no. 11; *Drawings of the Renaissance from the Janos Scholz Collection.* Indiana University Art Center, Bloomington, 1958. no. 47; *Drawings from Tuscany and Umbria, 1350–1700.* Mills College Art Gallery, Oakland, 1961. no. 6; H. Olsen. *Federico Barocci.* Copenhagen, 1962. p. 161, no. 29; *Italienische Meisterzeichnungen von 14. bis 18. Jahrhundert aus amerikanischen Besitz: Die Sammlung Janos Scholz.* Hamburger Kunsthalle, 1963. no. 8; *Italian Drawings from the Collection of Janos Scholz.* Yale University Art Gallery, New Haven, 1964. no. 23; *Italian Drawings from the Collection of Janos Scholz.* London, Arts Council, 1968. no. 3; *Sixteenth Century Italian Drawings from the Collection of Janos Scholz.* National Gallery of Art, Washington, D.C., 1973. no. 17.

This composition of the drawing is based on Titian's woodcut *St. Jerome in the Wilderness.*

112. FEDERICO BAROCCI
(Italian, 1526/35–1612)
Study for Aeneas' Flight from Troy,
ca. 1587–1589
Brown and black ink, black chalk, and yellow wash on gray paper
10⅞ x 16¹³⁄₁₆ in. (27.6 x 42.6 cm.)
The Cleveland Museum of Art
L. E. Holden Fund

Literature: *Cleveland Museum of Art Bulletin* XLVII (Dec. 1960), no. 72, repr. p. 245; ibid. XLVIII (Apr. 1961): 63-65, repr.; H. Olsen. *Federico Barocci.* Copenhagen, 1962. p. 182, pl. 64.

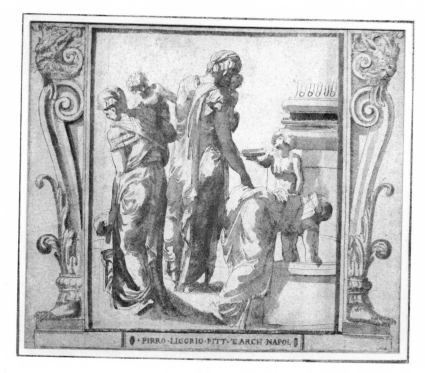

PIRRO·LIGORIO·PITT·E·ARCH·NAPOL

110

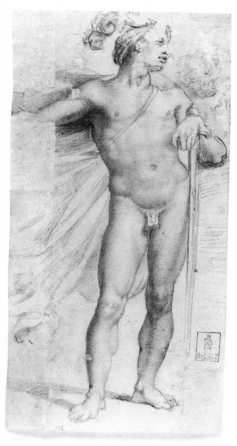

109

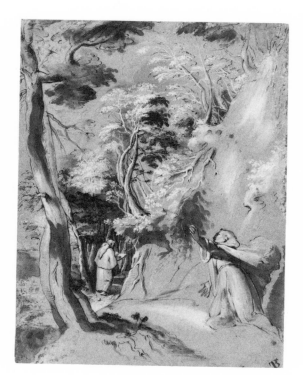

111

113. TADDEO ZUCCARO (Italian, 1529–1566)
*Sheet of Studies for the Blinding of Elymas and
for a Holy Family*
*Verso: Studies of the Same Subject and of Three
Men Supporting a Fourth*
Brush, red ink and wash, brown ink and wash
15 ¼ x 10¾ in. (38.7 x 27.4 cm.)
The Art Institute of Chicago
Gift of Robert B. Harshe

Collections: W.Y. Ottley; T. Philippe,
Sale, London, June 20, 1814, no. 1492; Sir
Thomas Lawrence; Sale, London, Christie's,
June 4, 1860, no. 108 (as Michelangelo)
Literature: J. A. Gere. *Taddeo Zuccaro, His
Development Studied in His Drawings.* London,
1969. pp. 73-74, 138, no. 22, pls. 94, 95; idem.
Il manierismo a Roma. I disegni dei maestri,
edited by W. Vitzthum. Milan, 1971. pp. 17, 83,
pl. XVII; W. Vitzthum. *A Selection of Italian
Drawings from North American Collections.* Nor-
man MacKenzie Art Gallery, Regina, Saskat-
chewan, and Montreal Museum of Fine Arts,
Quebec, 1970. no. 10; N. W. Nielson. *Italian
Drawings Selected from Mid-Western Collections.*
The St. Louis Art Museum, 1972. no. 12.

114. FEDERICO ZUCCARO
(Italian, 1540/41–1609)
*The Emperor Frederick Barbarossa
Submitting to Pope Alexander III in Front of
San Marco, Venice*
Brown ink and wash over black chalk
10½ x 8⅝ in. (26.6 x 21.4 cm.)
The Janos Scholz Collection
The Pierpont Morgan Library

Collections: Jonathan Richardson, Sr.;
T. Dimsdale; Sir Thomas Lawrence; S. Wood-
burn; Lawrence-Woodburn Sale, Christie's,
June 4-8, 1860, no. 1074; T. Phillips; T. Fitzroy
Philipps Fenwick; A. S. W. Rosenbach
Literature: M. Muraro. *Disegni veneti della colle-
zione Janos Scholz.* Venice, 1927. no. 25, fig. 25;
Venetian Drawings, 1400–1630. Mills College
Art Gallery, Oakland, 1959. no. 82, not repr.

115. PIETRO DA CORTONA
(Italian, 1596–1669)
Pietà, 1635
Brown ink and wash, heightened with white
9¹⁄₁₆ x 7⅞ in. (23.0 x 20.0 cm.)
Anonymous

Collections: Gigoux; R. M. Light
Literature: Unpublished
 This is a preliminary study for Cortona's fresco
over the altar in the former chapel of Urban VIII
in the Vatican. Giacinto Brandi (1623–1691)
later used the composition for an altarpiece he
painted in the Church of San Andrea al Quiri-
nale, Rome, in 1674–86 (repr. in E. K. Water-
house, *Baroque Painting in Rome* [Rome, 1937],
pl. XXXII, fig. 47). See G. Brigante, *Pietro da Cor-
tona* (Florence, 1962), p. 208, no. 56, fig. 156.

116. PIETRO DA CORTONA
(Italian, 1596–1669)
Study for "The Age of Iron"
Brown ink over red chalk
12¼ x 10³⁄₁₆ in. (31.1 x 25.9 cm.)
The Art Museum, Princeton University

Collections: W.Y. Ottley; D. F. Platt
Literature: D. R. Coffin. "A Drawing by Pietro
da Cortona for His Fresco of the Age of Iron."
Record of The Art Museum, Princeton University
XIII, no. 2 (1954): 33-37, fig. 1; M. Campbell,
M. Laskin, Jr. "A New Drawing for Pietro da
Cortona's 'Age of Bronze.'" *Burlington Maga-
zine* CIII (1961): 423-27, fig. 23; W. Vitzthum,
M. Campbell. Correspondence in *Burlington
Magazine* CIV (1962): 120-25; M. Campbell.
Gabinetto disegni e stampe degli Uffizi. XXI. *Mostra
di disegni di Pietro Berrettini da Cortona per gli
affreschi di Palazzo Pitti.* Florence, 1965. p. 17,
n.p. 24; J. Bean. *Italian Drawings in The Art Mu-
seum, Princeton University, 106 Selected
Examples.* Princeton, 1968. no. 50.

117. PIETRO DA CORTONA (Italian, 1596–1669)
The Vision of St. John the Evangelist
Brown ink and brush, black chalk,

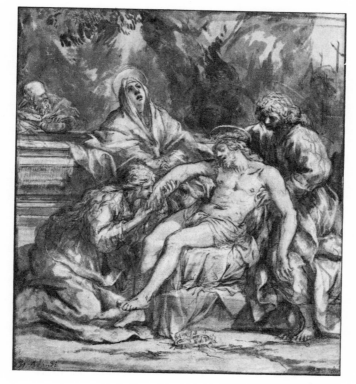

115

114

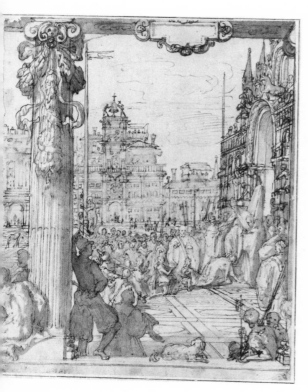

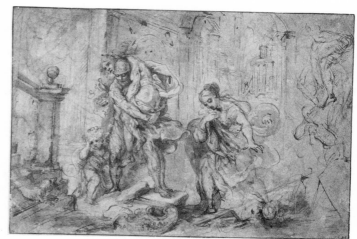

112

highlighted with white
17⅝₆ x 14¼ in. (45.5 x 36.0 cm.)
The Art Institute of Chicago
Gift of Tiffany and Margaret Day Blake

Collections: Viscount Churchill; The
Earl of Harewood (Sale, London, Christie's,
July 6, 1965, no. 122)
Literature: *Drawings Given to the Art Institute
of Chicago, 1944–1970, by Margaret Day Blake.*
Art Institute of Chicago, Apr. 28–June 7, 1970.
no. 7, repr. in color; N. W. Neilson. *Italian Draw-
ings Selected from Mid-Western Collections.*
St. Louis Art Museum, 1972. no. 40.

118. GIAN LORENZO BERNINI
(Italian, 1598–1680)
Portrait of a Youth (Self-Portrait?)
Black and red chalk, heightened with white
chalk, on buff paper
12⅞₆ x 9⅛₆ in. (31.6 x 23.0 cm.)
The National Gallery of Art, Washington, D.C.
Ailsa Mellon Bruce Fund

Collection: Mr. and Mrs. Lester Avnet
Literature: *Art News* LVII, no. 4 (1958), repr.;
F. Zeri. "Gian Lorenzo Bernini: *Un marmo di-
menticato e un disegno." Paragone* IX, no. 115
(1959): 63–64, pl. 42; J. Bean, F. Stampfle.
*Drawings from New York Collections II: The
Seventeenth Century in Italy.* The Metropolitan
Museum of Art and The Pierpont Morgan Li-
brary, New York, 1967. no. 67, repr.

119. GIAN LORENZO BERNINI
(Italian, 1598–1680)
Portrait of a Man (Self-Portrait?)
Red chalk on tan paper with extensive rework
with slightly darker red chalk
12⅛ x 10⅛ in. (30.8 x 25.7 cm.)
David Daniels

Collections: Colnaghi's, London;
Charles E. Slatkin
Literature: R. P. Wunder. *17th and 18th Century
European Drawings.* American Federation of
Arts, New York, 1966-67. no. 12; A. Mongan.

*Selections from the Drawing Collection of David
Daniels.* The Minneapolis Institute of Arts,
Feb. 22–Apr. 21, 1968. no. 7.

120. GIOVANNI FRANCESCO ROMANELLI
(Italian, *ca.* 1610–1662)
*Moses Driving the Shepherds from the
Daughters of Jethro*
Brown ink and wash, squared in chalk for transfer
5½ x 10¾ in. (13.9 x 27.3 cm.)
Los Angeles County Museum of Art
Gift of the Graphic Arts Council

Collection: Zeitlin and Ver Brugge
Literature: Unpublished
 The drawing seems unquestionably to be
a study for the painting of the same subject
in the Palace of Compiègne which is not,
unfortunately, in optimum condition. Since
Romanelli's drawings have not been fully stud-
ied, it is fairly difficult to assign the present work
to a certain time in his career. The format and
style link it to the drawing *The Judgment of Paris,*
reproduced in Charles Rogers' *Prints in Imitation
of Drawings,* vol. I, pl. 136.

121. GIOVANNI BATTISTA GAULLI, called
Baciccio (Italian, 1639–1709)
Allegory of the Mathematical Sciences,
ca. 1685–1690
Brown ink, brown and gray wash, over black chalk
11⅝ x 10¼ in. (29.5 x 26.0 cm.)
Robert L. and Bettina Suida Manning

Collection: Mr. and Mrs. E. Brandegee
Literature: R. Enggass. *The Painting of Baciccio,
Giovanni Battista Gaulli, 1639–1709.* University
Park, Pa., 1964. pp. 73, 113, no. 88; J. Bean,
F. Stampfle. *Drawings from New York Collec-
tions II: The Seventeenth Century in Italy.* The
Metropolitan Museum of Art and The Pierpont
Morgan Library, New York, 1967. no. 132, pl. 132.

122. PIER LEONE GHEZZI (Italian, 1674–1755)
The Famous Castrato Il Farinelli, 1724
Brown ink

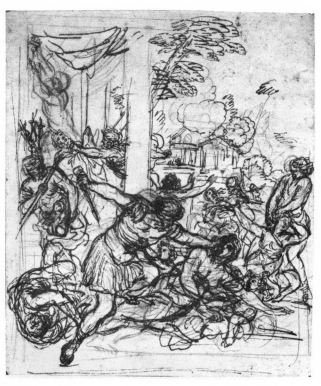

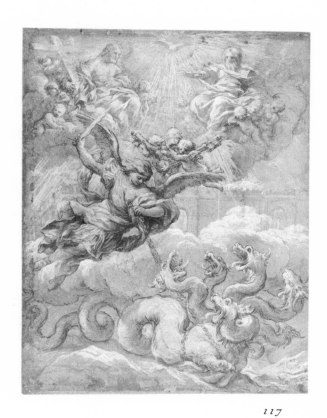

116

117

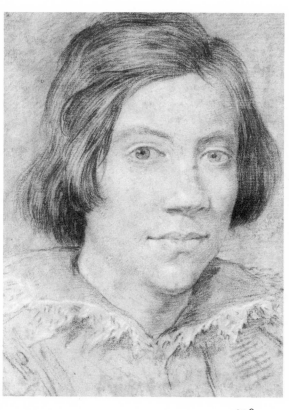

118

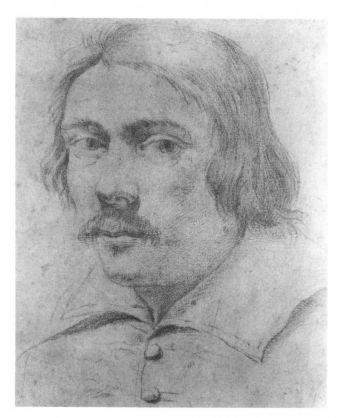

119

12 x 8⁵⁄₁₆ in. (30.5 x 20.3 cm.)
Janos Scholz

Collections: E. Goddard; M. A. Goldstein
Literature: R. Kirkpatrick. *Domenico Scarlatti.*
Princeton, 1953. fig. 30; *Italienische Meister-*
zeichnungen von 14. bis 18. Jahrhundert aus ameri-
kanischen Besitz: Die Sammlung Janos Scholz.
Hamburger Kunsthalle, 1963. no. 68, fig. 58;

American Federation of Arts. *17th and 18th Cen-*
tury Drawings. Washington, D.C., 1966-67.
no. 26, repr.; *Italian Drawings from the Collection*
of Janos Scholz. London Arts Council, 1968.
no. 42; J. Bean, F. Stampfle. *Drawings from New*
York Collections III: The Eighteenth Century.
The Metropolitan Museum of Art and The Pier-
pont Morgan Library, 1971. no. 20, fig. 20.

121 *122*

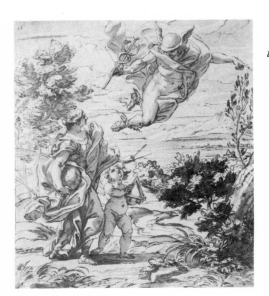

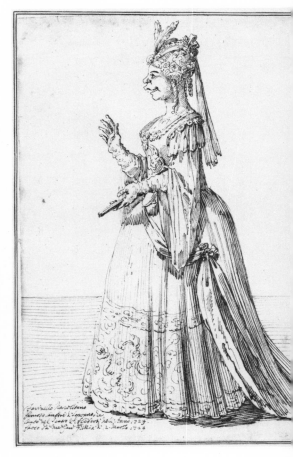

120

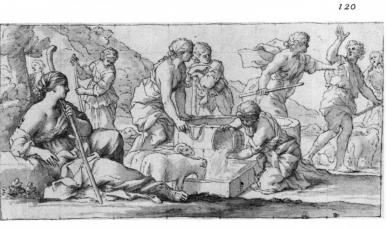

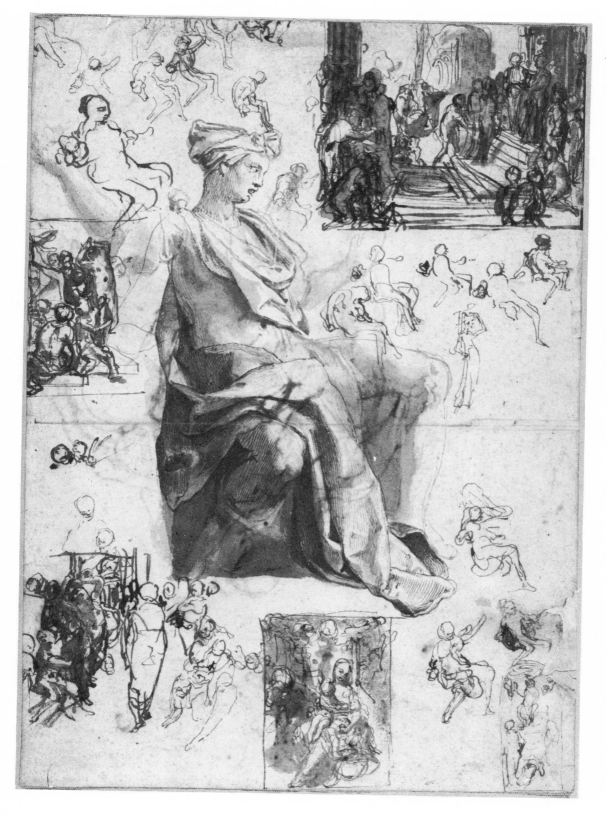

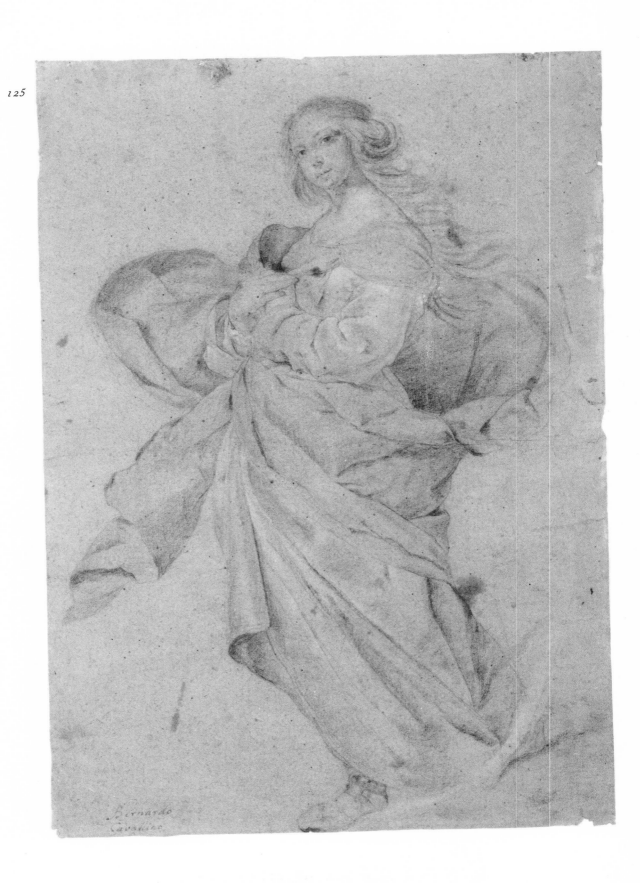

Bernardo
Cavallino

Naples

AS IN SOME other parts of Italy such as Piedmont and Liguria, the early art of Naples was largely dominated by foreign artists of little note. Since in the thirteenth century the city, as part of the Two Sicilies, had belonged to the Angevin line for over a century, there was a pervasive Franco-Flemish influence on the local art. Important Italian artists did work in Naples at various times, among them the Roman Pietro Cavallini in the late thirteenth century; later Giotto and Simone Martini; and, in 1448, Pisanello, who made many decorative designs while in service at the court of Alfonso V of Aragon, king of Sicily and Naples. The presence of these artists, however, did little to stimulate the formation of a Neapolitan school, which came into being only in the early seventeenth century. At that time, the handful of Neapolitan artists was strongly under the influence of Mannerism, although a few of them displayed individual drawing techniques, such as the Greek-born Belisario Corenzio (*ca.* 1560–1643), who used distinctive blue washes. The outstanding master among the Neapolitans of the period was Giovanni Battista Caracciolo (*ca.*1570–1637), who was also a major draftsman.

As in Rome, painters in Naples were influenced by the Bolognese artists of the seventeenth century. But to an even greater degree the painters and frescoists of this southern Italian school adopted Caravaggio's realism and chiaroscuro, which soon became almost constant features in their work. Strongly influenced by Bolognese art and by Caravaggio, Jusepe de Ribera, the leader of the Neapolitan school, practiced a vivid graphic style which is discussed in the Spanish section. This economical and staccato linear style was elaborated by the fiery and rebellious Neapolitan Salvator Rosa (1615–1673) into a dramatic *graphisme* characterized by free, bold washes and forms drawn with rapid, vital lines (cat. nos. 123, 124).

A striking contrast to the vehemence of Salvator's drawings is furnished by the classic naturalism of Bernardino Cavallino (1616–1654), whose drawings are exceedingly rare. Cavallino's Baroque expression is modulated by his lyrical interpretations, as can be seen in the graceful yet monumental black chalk drawing of the *Virgin Immaculate* (cat. no.125). Alfred Moir has offered the interesting suggestion that the youthful Cavallino might have come in contact with Velásquez when the latter came to Naples in 1630.

Among the most important Neapolitan draftsmen who lived into the eighteenth century were Luca Giordano (1632–1705) and Francesco Solimena (1657–1747). Extremely assim-

ilative, Giordano drew swiftly in a great many manners, sometimes even resembling Ribera. Solimena, represented here by two fine examples (cat. nos.126, 127), employed a more solidly constructed style for his large, ambitious subjects, as in his study for *Columbus Arriving in the New World* (cat. no.127), a preparatory drawing for one of three large paintings he executed between 1708 and 1728 for a ceiling in the Ducal Palace in Genoa; all three canvases were destroyed by fire in 1777.

Other notable Neapolitan draftsmen of the eighteenth century included Sebastiano Conca, Corrado Giaquinto, and Domenico Mondo, with whom the school may be said to have drawn to a close. As this brief essay indicates, Neapolitan drawings were neither so plentiful nor so revered as those produced in other parts of Italy. It is only in recent years that renewed study and research have yielded a greater knowledge, understanding, and appreciation of the character and quality of Neapolitan Baroque drawings.

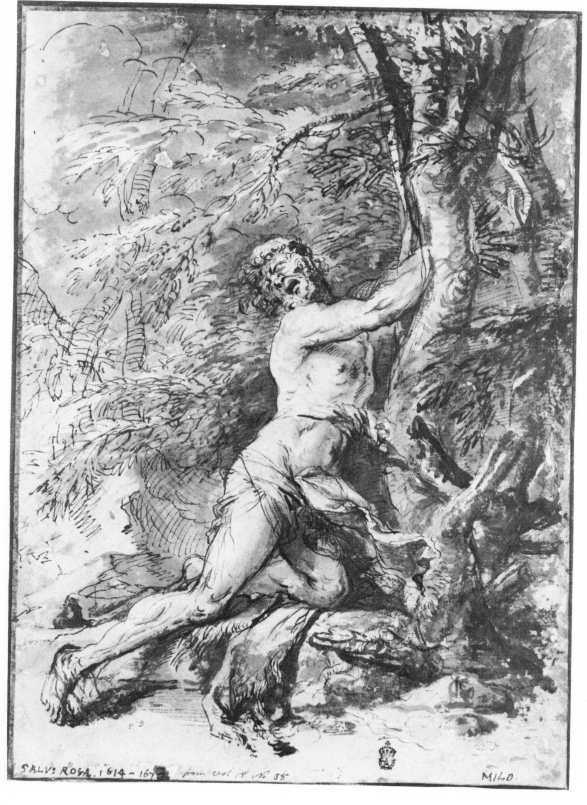

SALV: ROSA. 1614 - 167 from vol 14 No 38 MILO.

Catalog

123. SALVATOR ROSA (Italian, 1615–1673)
The Nurture of Jupiter
Brown ink and wash
12 x 7¹⁵⁄₁₆ in. (31.1 x 20.0 cm.)
Anonymous

Collection: Private collector, England
Literature: L. Salerno. *Salvator Rosa*. Milan, 1963. p. 130; W. Vitzthum. *A Selection of Italian Drawings from North American Collections*. Norman MacKenzie Art Gallery, Regina, Saskatchewan, and Montreal Museum of Art, Quebec, 1970. no. 45, repr. p. 149; idem. *Il Barocco a Napoli e Nell' Italia Meridionale*. Milan, 1971. p. 83, pl. xv; N. W. Neilson. *Italian Drawings Selected from Mid-Western Collections*. The St. Louis Art Museum, 1972. no. 39.

124. SALVATOR ROSA (Italian, 1615–1673)
Milo of Crotona
Quill pen, brown ink and wash
12¾ x 8¾ in. (32.4 x 22.2 cm.)
Anonymous

Collections: Earl of Pembroke (Sale, London, Sotheby's, July 1917, no. 516;) Archibald G. B. Russell; Sale, London, Sotheby's, May 22, 1928, no. 81, repr.
Literature: T. Borenius. "Drawings in the Collection of Mr. Archibald G. B. Russell." *Connoisseur*, May 1923. p. 8; A. Strong. *Drawings by the Old Masters at Wilton House*. n.p., 1900. pt. I, pl. 10; Burlington Fine Arts Club. London, 1925. p. xxxviii; M. Mahoney. "The Drawings of Salvator Rosa." Courtauld Institute of Art, London, 1965. unpub. diss., no. 79.6; F. W. Robinson. *One Hundred Master Drawings from New England Private Collections*. Wadsworth Atheneum, Hartford, 1973. no. 21, repr.

125. BERNARDINO CAVALLINO (Italian, 1616–1654)
The Virgin Immaculate
Black and white chalk on gray green paper
14¹⁵⁄₁₆ x 10¹¹⁄₁₆ in. (38.0 x 27.0 cm.)
Janos Scholz

Collections: Piancastelli; Brandegee
Literature: J. Scholz. "Sei- and Settecento Drawings in Venice: Notes on Two Exhibitions and a Publication." *Art Quarterly* XXIII (1960): 62, fig. 10; W. Vitzthum. "Neapolitan Seicento Drawings in Florida." *Burlington Magazine* 103 (1961): 314; O. Ferrari. "Seicento napoletano a Sarasota." *Napoli nobilissima* I (1961–62): 237; W. Vitzthum. "Drawings from the Scholz Collection in Germany." *Master Drawings* I, no. 4 (1963): 59; J. Bean, F. Stampfle. *Drawings from New York Collections II : The Seventeenth Century*. The Metropolitan Museum of Art, New York, and The Pierpont Morgan Library, 1967. no. 109; *Drawings by Seventeenth Century Masters from the Collection of Janos Scholz*. The Art Galleries, University of California at Santa Barbara, 1974. no. 29, fig. 29.

126. FRANCESCO SOLIMENA (Italian, 1657–1747)
An Allegory of Victory
Brown ink and gray wash over charcoal
17¼ x 10¼ in. (43.8 x 26.0 cm.)
Los Angeles County Museum of Art
Los Angeles County Funds

Collection: H. Voss
Literature: Unpublished

127. FRANCESCO SOLIMENA (Italian, 1657–1747)
Columbus Arriving in the New World, 1708–1728
Brown ink and gray wash
10⁵⁄₁₆ x 21⁵⁄₁₆ in. (26.3 x 54.2 cm.)
Cooper-Hewitt Museum of Decorative Arts and Design, Smithsonian Institution

Collection: James Hazen Hyde
Literature: R. P. Wunder. "Solimena Drawings at the Cooper Union Museum." *Art Quarterly* XXIV (1961): 151–64, figs. 1, 4; W. Vitzthum. *Disegni napoletani del sei- e settecento nel Museo di Capodimonte*. Naples, 1966. no. 33; J. Bean, F. Stampfle. *Drawings from New York Collections III : The Eighteenth Century in Italy*. The Metropolitan Museum of Art and The Pierpont Morgan Library, 1971. no. 1, fig. 1.

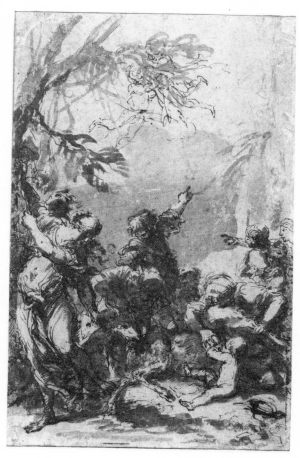

123

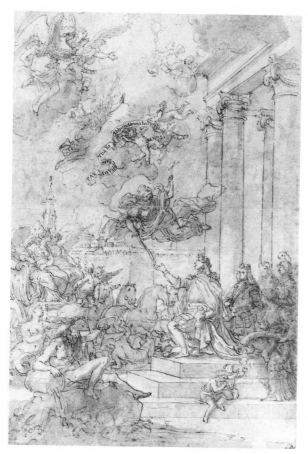

126

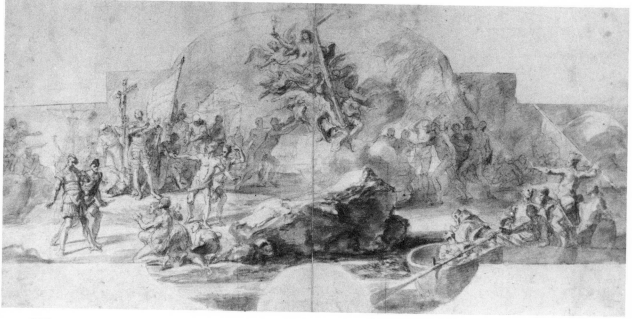

127

Genoa

L ARGELY dominated in its earlier periods by foreign artists, Genoese art assumed a native character in the work of Luca Cambiaso (1527–1585), the city's first important artist as well as one of the most distinctive Italian draftsmen. In 1544 the seventeen-year-old Cambiaso began the imposing frescoes in two rooms of the palace of Antonio Doria dell' Acquasola (later Spinola), now the site of the Prefecture in Genoa. The Los Angeles drawing (cat. no. 128) is related to one of the palace ceiling frescoes which depicts the ninth labor of Hercules; the hero is shown combating the Amazons for the girdle of their queen Hippolyta, which he later gave to Admete, daughter of King Eurytheus. The Hercules drawing is conceived in terms of broad, dynamic lineality, and its long, assured lines distinguish it from Cambiaso's later more architectonic drawings. Hercules' figure is formed through the linking, as it were, of the individual armorlike parts of his muscular anatomy. Blots of ink are employed to accent lines; other blots appear haphazardly. This unrestrained application of ink to produce a fluid, yet linear drawing structure is paralleled in other youthful designs by Luca Cambiaso.

One of the most individual and complex artists of the Italian seicento was Bernardo Strozzi (1581–1644). He absorbed influences from his native Genoa as well as from a number of other sources, including Rubens. Even more pertinent to Strozzi's development was the art of Federico Barocci and, inescapably, the realism of Caravaggio. Continually developing in his effort to slough off the patterns of late Mannerism, Strozzi found avenues to liberation in the art and ambience of Venice where, after his arrival in 1630, he spent the remainder of his life.

In his youthful Genoese period, Strozzi's style of drawing was essentially graphic in its lineality and crosshatching. His later work reflects the Mannerism of Luca Cambiaso, who had favored a more pictorial style of creating light and dark areas by means of spotting with ink and wash. Finally, in Venice, Strozzi's painterly figure studies assumed a more monumental character. A splendid drawing that demonstrates these qualities is Cleveland's preparatory black chalk study (cat. no. 130) for the painting of *Minerva* in that museum's collection. Both painting and drawing are imbued with the pathos and intimacy that formed the underlying character of the art of this vibrant and vital draftsman.

The leading Baroque artist of Genoa was Giovanni Benedetto Castiglione (1616–1670), who developed a particularly vigorous style overflowing with life and spirit. His composi-

tions are often crowded with figures and animals, filled with strong contrasts of light and shadow, and warmed by rich, glowing color. Like his Neapolitan contemporary Salvator Rosa, Castiglione favored fantastic, allegorical subjects with moralistic or philosophical meanings. In addition to producing numerous drawings that have an unusual directness and fluidity of execution, Castiglione invented the method of printing from freshly colored drawings onto paper, thus creating the first monotypes. Even more than Strozzi, he was influenced by those Flemings who worked in Genoa, and these foreign artists inspired the use of vigorous animal motifs by Castiglione, who was the finest Italian animal painter of his time. Often drawing with the brush and combining ink, watercolor, and paint, he formed brilliant colored drawings that were unique in his period and rank among the most painterly drawings in Italian history.

No outline of Genoese draftsmanship would be complete without reference to one of the most characteristic expressions of Genoese painting in the Baroque period, that of fresco decorations for the interiors of churches and palaces of that wealthy city. In connection with these wall and ceiling paintings, artists executed preparatory drawings, often of unusual complexity, which required specialized skills in linear perspective, foreshortening, and the devising of elaborate decorative motifs. For the greater part, however, these artists never attained the same status enjoyed by easel painters such as Strozzi, Castiglione, and Magnasco, and their decorative drawings are only now beginning to be studied and appreciated.

Though born in Genoa, Alessandro Magnasco, *Il Lissandrino* (1667–1749), spent the larger part of his artistic career in Milan. An artist of unusual character, he reputedly led a bohemian life, mingling with vagabonds, gypsies, soldiers, and others at the fringes of society. His art represents the final expression of the Italian picturesque style which had evolved from the earlier contributions of Callot and Salvator Rosa. The drawing from Chicago (cat. no. 131) is one of a pair and ranks with the most splendid examples of Magnasco's graphic art. In portraying itinerants who have paused to pay tribute at a religious shrine, he has imbued his humble subjects with a nobility and haunting pathos eloquent of his own spiritual fervor. The fluid rhythms, inflected strokes, and grandiose style of this drawing compel the viewer to grasp the special majesty inherent in this mundane wayside scene.

In addition to Alessandro Magnasco, Genoa produced outstanding draftsmen throughout the seventeenth century, including Giovanni Andrea de' Ferrari, Giovanni Battista Carlone, Valerio Castello, Domenico Piola, and Gregorio de' Ferrari. In the eighteenth century with Lorenzo de' Ferrari, Carlo Antonio Tavella, and Domenico Parodi, Genoa maintained the painterly tradition of drawing that had been inaugurated by Perino del Vaga.

Catalog

128. LUCA CAMBIASO (Italian, 1527–1585)
Hercules
Brown ink
14½ x 10 in. (36.8 x 25.4 cm.)
Los Angeles County Museum of Art
Los Angeles County Funds

Collection: Zeitlin and Ver Brugge
Literature: *Los Angeles County Museum Bulletin of the Art Division* XII, no. 1 (1960): 3–7, repr. on cover.

129. LUCA CAMBIASO (Italian, 1527–1585)
The Martyrdom of St. Sebastian, ca. 1555–1560
Brown ink and wash, over traces of black chalk
22¼ x 16½ in. (56.6 x 41.9 cm.)
Robert L. and Bettina Suida Manning

Collections: B. West; Colnaghi's, London
Literature: *Pontormo to Greco–The Age of Mannerism.* The John Herron Art Museum, Indianapolis, 1954. no. 47; B. Suida Manning, W. Suida. *Luca Cambiaso, la vita, e le opere.* Milan, 1958. p. 190, fig. 57; *Master Drawings of the Italian Renaissance.* Detroit Institute of Arts, 1960. no. 43; R. L. Manning, B. Suida Manning. *Genoese Masters: Cambiaso to Magnasco, 1550–1750.* Dayton Art Institute, John and Mable Ringling Museum of Art, Sarasota, and Wadsworth Atheneum, Hartford, 1962–63. no. 67; R. L. Manning. *Genoese Painters: Cambiaso to Magnasco, 1550–1750.* Finch College Museum of Art, New York, 1964–65. no. 12, repr.; J. Bean, F. Stampfle. *Drawings from New York Collections I : The Italian Renaissance.* The Metropolitan Museum of Art and The Pierpont Morgan Library, 1965. no. 120; P. Torriti. *Luca Cambiaso. Disegni.* Genoa, 1967. pl. VIII; R. L. Manning. *Luca Cambiaso Drawings.* Finch College Museum of Art, New York, 1967–68. no. 7, repr.; B. Suida Manning, R. L. Manning. *The Genoese Renaissance, Grace and Geometry: Paintings and Drawings by Luca Cambiaso from the Suida-Manning Collection.* The Museum of Fine Arts, Houston, 1974. no. 12, fig. 12.

130. BERNARDO STROZZI (Italian, 1581–1644)
Minerva
Black and red chalk, on buff pink paper, 14⅝ x 10⁵⁄₁₆ in. (37.1 x 26.2 cm.)
Cleveland Museum of Art
John L. Severance Fund

Literature: H. S. Francis. *Cleveland Museum of Art Bulletin* XLIII (1956) pp: 123–26; H. Comstock. *Connoisseur* (U.S. ed.) 138 (1956): 211ff; *Art in Italy, 1600–1700.* Detroit Institute of Arts, 1965. no. 204, repr. p. 177; L. Mortari. *Bernardo Strozzi.* Rome, 1966. p. 219, fig. 474.

This is a study for the painting in the Cleveland Museum of Art.

131. ALESSANDRO MAGNASCO (Italian, 1667–1749)
Ballad Singer with a Shrine to the Virgin
Brown wash, heightened with white, over black chalk on buff paper
18⅝ x 14⁹⁄₁₆ in. (46.6 x 37.0 cm.)
Art Institute of Chicago
The Helen Regenstein Collection

Collection: G. de Giuseppe; Dr. Wertheimer; Charles E. Slatkin
Literature: J. Scholz. "Drawings by Alessandro Magnasco." *Essays in the History of Art Presented to R. Wittkower.* London, 1957. p. 239; Sale, Paris, Galerie Charpentier. May 24, 1955. no. 131, repr.; *The Helen Regenstein Collection of European Drawings.* Art Institute of Chicago, 1974. no. 2, repr. p. 11.

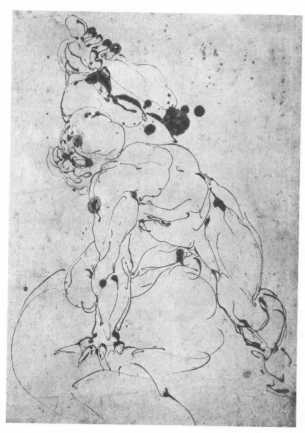

128

131

134

Milan

MILAN and the territory of Lombardy first attained importance as an art center in the Romanesque period, producing draftsmen of special note as early as the fourteenth century, including Giovanni de'Grassi (documented at Milan, 1389–1398) as well as Michelino da Besozzo (active 1394–1442). Foreign influences mingled with more native ones in Milan, partly because of the French and German architects and stone-masons who migrated there to work on the great cathedral. But it was not until the mid-fifteenth century that a truly independent Milanese school took form.

While the Brescian-born Vincenzo Foppa (*ca.*1427–after 1502) is considered to have been a leader in establishing the earlier Milanese style, strengthening its native characteristics against outside influences, it was Leonardo da Vinci who created a distinctive school in Lombardy. Working in Milan over a period of seventeen years, Leonardo's influence also extended into Piedmont where several native artists, including Gaudenzio Ferrari (*ca.* 1481–1546) and Giovanni Antonio Bazzi (1477–1549), called Il Sodoma, responded to it. In Milan itself, the outstanding contemporary of Leonardo was Bernardino Luini (*ca.*1475–1531/32) whose paintings and, to a lesser degree, drawings, reflect Leonardo's inspiration. Artists from the important center of Brescia were less susceptible to Leonardo's style and more amenable to that of the Venetian school. Brescia, originally a member of the Lombard League, came into the possession of Venice in the early fifteenth century, but at the beginning of the sixteenth was again a part of Lombardy. Thus, in his drawings Girolamo Romanino (*ca.* 1485–1559/61), a strong figure of the Brescian school, often unites his personal dramatic naturalism with the Venetian style of brush drawing (cat. no. 41).

In the seventeenth century, with the passing of Milan into Spanish possession following the extinction of the Sforza family, this Italian city became less influential as an art center. Still, several interesting artists appeared in Milan at this time: the short-lived Daniele Crespi (*ca.* 1598–1630) and the Bolognese Camillo Proccaccini (1551?–1629), a member of a thriving family of artists whose dates and activities have not yet been entirely sorted out.

Meanwhile, religious fervor was revived in the Milanese region by St. Charles Borromeo (1538–1584), the great Lombardian prelate and reformer. His remarkable spiritual impulse is reflected in the creation of one of the more extraordinary, yet probably least frequented churches in Lombardy, that of the Sacro Monte at Varallo in the hills north of Milan. Here, in the late sixteenth century, a church was constructed with forty-five chapels in which the

illusionism of the wall frescoes augments the strikingly painted, life-size terra-cotta figures that form vivid religious *tableaux-vivants*. This integration of painted and carved figures produced a theatrical realism then unparalleled in Italy. Two seventeenth-century artists, the brothers Giovanni and Antonio d'Errico, the latter better known as Tanzio da Varallo (*ca.*1575–1635), participated in this work. Giovanni provided the polychromed sculptures; Tanzio created the painted figures that furnish the illusionistic setting for the *tableaux-vivants*. The innate religious zeal of Tanzio's art was intensified by his encounter with the paintings by Caravaggio that he saw during an early trip to Rome. After the powerful realism and violently contrasted colors of Tanzio's paintings and frescoes, his rare drawings seem literal and restrained. The *Group of Soldiers with Pikes* (cat. no.132), which represents his draftsmanship at its height, displays a quasi-realism more suggestive of the later nineteenth century. In this drawing the rendering of details is sensitive, well modulated, and refined, and only the intensity of the first soldier's face affords any clue to Tanzio's more dramatic style of painting.

The finest achievements of the Milanese school of painting and draftsmanship were over before the mid-seventeenth century, several decades after the death of St. Charles Borromeo. Daniele Crespi died in the great plague of 1630 and symbolically the early Baroque, which had shown such dramatic intensity in the works of Milanese artists, came to an abrupt and, unfortunately, permanent end.

Catalog

132. ANTONIO D'ERRICO, called Tanzio da Varallo (Italian, *ca.* 1575–1635)
Group of Soldiers with Pikes
Red chalk, heightened with white, a few touches of black chalk, 16⅞ x 11⁵⁄₁₆ in. (42.9 x 28.7 cm.)
The Pierpont Morgan Library

Collections: B. H. Balfour; (Sale, London, Christie's, Mar. 29, 1966, no. 45, repr. as Sassoferrato) purchased by The Pierpont Morgan Library

Literature: G. Testor. "Una postilla e un inedito." *Paragone* XVII, no. 199 (1966): 55–56, pl. 51, as preparatory for Chapel XXVIII; J. Bean, F. Stampfle. *Drawings from New York Collections II : The Seventeenth Century in Italy*. The Metropolitan Museum and The Pierpont Morgan Library, New York, 1967. no. 22, fig. 22; F. Stampfle. *Drawings: Major Acquisitions of The Pierpont Morgan Library, 1924–1974.* New York, 1974. no. 10.

The French School

No.5 deborie

134

The French School

ASIDE from isolated works still remaining, such as the model books by Adémar de Chabannes and Villard de Honnecourt and the impressive late fourteenth-century brush drawing on vellum by the Master of the Parement de Narbonne, French drawing before the fifteenth century is to be found chiefly in the area of manuscript illumination. In the second half of the twelfth century, monastic art centers were gradually replaced as centers of learning and culture by increasing numbers of universities, including the renowned University of Paris. The scholars' need for diverse manuscripts could no longer be supplied entirely by the monasteries, and thus artists' workshops sprung up, devoting themselves to illuminating the romances, histories, didactic treatises, as well as books for private devotion, that were demanded by an ever-expanding clientele.

Very few early French drawings remain that were created as individual works rather than as parts of a manuscript. Outstanding among these independent drawings are the portraits by Jean Fouquet (*ca.* 1415/20–1480), court painter to Louis XI and one of the greatest of all French illuminators. In his profoundly observed portraits in metalpoint and in colored chalk, Fouquet was affected by the Florentine painters and the widely influential van Eycks; mingling elements from both of these sources with his own bourgeois naturalism, the French artist captured the forceful presence of his sitters.

In the following century Flemish influences lessened in France, and under the impress of the Italian Renaissance the art of portraiture changed character accordingly but continued as one of the genres most popular with the upper classes. The Renaissance influence was assimilated by Jean Clouet (*ca.* 1475–1541) and perpetuated by his son François.

Creating a style that was carried on with great success by François, Jean Clouet introduced the use of black and red chalk, alone or in combination, into the art of portraiture. The verism of his representations, an extension of the physiognomic realism of Italian artists such as Leonardo and Raphael, assured a considerable popularity for Clouet's drawing, which has never diminished. The French portrait tradition he founded continued in the latter half of the sixteenth century in the drawings of the Quesnels and the Dumonstier family, and its influence upon Hans Holbein the Younger is well known. In his portraits, François Clouet (before 1522–1572) intensified the sharp silhouetting favored by his father. Though bespeaking an earlier Flemish accuracy and realism, the younger Clouet's portraits remained distinctly French in their elegance of conception and execution, as in his

Portrait of Claude Gouffier de Boisy (cat. no.134) with its restraint, sobriety, and formidable melancholy *maestas*.

The earliest French drawing in the present exhibition and also one of the rarest is *The Holy Family with Joseph as Carpenter* (cat. no.133) by Jean de Gourmont (active 1506–1551) from whom a total of only three drawings are known. With Jean Duvet, Jean de Gourmont was the most important of the French sixteenth-century engravers. Both were natives of Lyon, but Gourmont began his career in Paris as a woodcut artist. The massive architectural background he chose as the setting for the sacred theme of the Morgan Library's spectacular drawing reflects his response to the Renaissance. The figures are subordinate to these imposing architectural surroundings, as they are in most of his small number of etchings. The deep perspective of the vista, a distinguishing feature of Gourmont's *oeuvre*, was possibly derived from his knowledge of work by the contemporary architect-engraver Jacques Androuet-Ducereau. The theatrical atmosphere of the drawing is heightened by the fantastic arrangement of the spiral staircases and loggias. The improbability of the architecture, the passages of untenanted space, and the dwarfed size of the participants create an effect that to a modern viewer may seem not unlike that sought centuries later by the Surrealists.

In the mid-fifteenth century the French king Francis I imported several Italian artists to decorate the royal residence of the Palace at Fontainebleau, thereby infusing a highly decorative, Mannerist style into French art. Since the three Italian artists who led the work at Fontainebleau had such influence on their French contemporaries, they must be included in a discussion of the French school. All three artists, Francesco Primaticcio, Nicolò dell' Abate, and Giovanni Battista di Jacopo (better known as Rosso Fiorentino), were stunning draftsmen whose work had a marked impact upon the French painters and engravers who constituted the First School of Fountainebleau.

Francesco Primaticcio (*ca.* 1504–1570), born in Bologna, studied with local masters before frequenting the studio of Giulio Romano in Mantua, where he acquired the classical manner. However, profiting from his study of Correggio and Parmigianino, he produced drawings more elegant and lyrical than his master's. At Fontainebleau, Primaticcio collaborated with Rosso Fiorentino (1494–1540), who had preceded him there, until dissension between them drove Primaticcio back to Italy. Later, after Rosso's premature death, he resumed work at Fontainebleau, where he was eventually joined by Nicolò dell'Abate (*ca.* 1509–1571). Born in Reggio Emilia, Nicolò had previously executed a considerable amount of decorative work in Bologna.

Strong diversities distinguish the drawings of these three important Italian artists. The most individualistic was Rosso, who generally ran counter to the classical tradition; particularly after his arrival in France his drawings evidence an eccentric wildness and distortion more northern than Italian. He often aimed at the grotesque rather than the graceful, yet his drawings could attain the nobility of the *Annunciation*, in the Albertina, as well as the wilful extravagance of *Pandora's Box*, in the Ecole des Beaux-Arts, Paris, and the relentlessly macabre quality of *Memento Mori*, in the Uffizi. John Shearman recently proposed that the simplified lineality of some of Rosso's figures derived from the discoveries at Arezzo of incised bronze works of Etruscan origin. The chief inspiration for Nicolò dell'Abate was Parmigianino, whose sinuous line he adopted to delineate forms that had a greater solidity more in conformity with the Bolognese tradition. Primaticcio's drawings, whether worked in pen with wash or watercolor, or in chalk, for the most part are fully realized compositions (cat. no.85) prepared for execution in fresco, generally by someone else. He used close, dense hatching to model form, and the shading added by wash gives his figures a startling corporeality. Nicolò's style of hatching is bolder, more dominant than Primaticcio's, at times even surpassing the intensely graphic drama of Parmigianino's works. By contrast, Rosso's drawings are often executed with open, continuous lines; strikingly silhouetted against the paper, his figures are modeled by a discreet use of wash.

Following the gracefully decorative, Italian-influenced style of the Fontainebleau School, characterized by its daintily mannered figures with elegantly small heads and tapering limbs, such as seen in the work (cat. no.211) of Ambroise Dubois (*ca.* 1543–1614), drawings by seventeenth-century French artists exhibited a classical clarity distinct from the styles of other schools. It is characteristic that in his paintings Poussin, for example, was unchanged by Caravaggio, eschewing the strong contrasts of chiaroscuro in favor of a more evenly graduated light. Similarly, although Simon Vouet lived in Italy for many years, he always used a light palette and pinkish skin tones that recalled the French style.

Characteristic French qualities of logic and order invested that country's art of the seventeenth century with attributes quite removed from the histrionics and rhetoric of the Roman Baroque. The strongest foreign influence on French art of this period came from the classicism of Bolognese artists such as Annibale Carracci, Domenichino, and Guido Reni, and from the refined, languid work by Cortona's assistant, Giovanni Francesco Romanelli (cat. no.120), who later worked in Paris.

Long eclipsed by the major names in seventeenth-century French painting, Simon Vouet and Claude Vignon have recently received a much delayed recognition. The prodigy Vouet

(1590–1649) was painting portraits in England at the age of fourteen, and was later in demand in Constantinople and cities throughout Italy. Although influenced by the Venetians and Caravaggio, his work remained incontestably French. The breadth and vigor of Vouet's draftsmanship is manifest in the flowing lines and solid construction of forms in his drawings. The contrast of Vouet's approach to that of his younger Italian contemporary Pietro da Cortona is evident in their drawings: grace and elegance on the part of the Frenchman, dynamic force and heroic movement on the part of the Roman.

The red chalk with brown wash drawing, *St. Helen with the True Cross* (cat. no.142), by Claude Vignon (1593–1670) also displays the classical restraint defining the French school of this period. The benignly countenanced saint confronts the spectator with the relic of Christ's sacrifice, while the religious drama of the scene is made incarnate in the brilliant red chalk which allows the cross to appear almost as if stained with blood. With its imaginative use of color and flickering lighting, this drawing by Vignon stands out as one of the most vivid and appealing single-figure French studies of the seventeenth century.

While artists like Vouet and Vignon have been somewhat neglected, the three major French draftsmen of the seventeenth century–Jacques Callot, Nicolas Poussin, and Claude Lorrain–have never fallen from favor.

Unlike the poetic landscapes of Claude and the epic classicism of Poussin, the graphic *oeuvre* of Jacques Callot (1592–1635) centered chiefly on the life and diversions of royal courts, first that of the Medici, later that of his native Nancy. His magnificent figure drawings, executed in ink with wash or in red chalk (cat. no.138), express a wit and assurance seldom encountered in work by his contemporaries; his finished, supple line and dramatic shadows seem never to have faltered, capturing form and movement unerringly (cat. nos. 137–141).

The landscapes of Claude (1600–1681) and Poussin (1594–1665), exemplified by their drawings, were unique in their time: atmosphere and perspective act purely as carriers of light and shade, and the vision extends limitlessly into space. Both artists used shimmering, translucent brown washes that dematerialized form in a manner unknown among their Italian contemporaries. Both artists, despite their long sojourns in Italy, maintained their essentially northern characters, and their "handwriting" remained un-Italianate. Echoing the works of Bartholomaus Breenbergh and Paul Bril, the rather static stolidity of Claude's figures is the visual antithesis of the more fluid Italian style.

Unlike the romantic silhouetting of forms against expanses of light that characterizes drawings by Claude (cat. no.145), the clarity of light itself, captured in blocklike, sculp-

tural forms, is the dominant element in Poussin's drawings (cat. nos.143, 144). They have the same measured and balanced composition, developed from the study of Roman sarcophagi, that is so evident in Poussin's paintings. Studies of individual motifs are rare in his *oeuvre*, for to Poussin the whole was of primary importance. More than any of his contemporaries, or even predecessors, he recaptured the classical world, but, paradoxically, his line was unclassical in the Italian sense; generally thin and summary, it was without that particular order of gracefulness and beauty sought in antiquity and the Renaissance.

Because of their uniquely individual drawing styles, the influence of both Poussin and Claude was naturally restricted. Poussin's chief follower was his brother-in-law, Gaspard Dughet (1615–1675), who lived his whole life in Italy. Claude's influence was particularly felt in England, first in the work of Richard Wilson, later in that of Turner. More austere and heroic in Poussin, and in Claude becoming a form of proto-Romantic subjectivity, the drawings of these two masters constitute an enduring testimony to the great tradition of French classicism.

By the eighteenth century, still-life painting had become almost extinct in Holland, previously its primary center. Yet, surprisingly, still-life and animal painting, both rare in the history of French art, flourished in eighteenth-century Paris through the work of Jean-Baptiste Oudry (1686–1755). A favorite of Louis XV, Oudry eventually became superintendent of the tapestry factories at Beauvais and the Gobelins. Inspired largely by Nicholas Berchem and other Dutch artists of the previous century, Oudry excelled in his intimate subject matter, uniting freedom of execution, harmonious line, and sensitive tonal effects, as evidenced in his black and white chalk drawing (cat. no.150).

In contradistinction to Oudry's highly specialized genre of drawing are the drawings by a trio of masters whose refined expression embodies the art of the French Regency and the Rococo: Jean Antoine Watteau, François Boucher, and Jean-Honoré Fragonard.

The great beauty of the best drawings by Jean Antoine Watteau (1684–1721) stems primarily from two factors: the sensitive precision of his line with its rich modulations, and the shimmering coloristic effects produced by his mixing black, red, and white crayons. Unlike many earlier French artists and most of his contemporaries, Watteau never went to Italy; however, he is known to have studied the work of the Venetians, especially Paolo Veronese, in Paris. A measure of the elegance and, indeed, the fineness of the features in his portraits is undoubtedly derived from this master.

The first of the two Watteau drawings in the exhibition is *Three Figures, One Playing a Cornemeuse* (cat. no.148). Characteristically, it records the artist's process of working out

motifs, in this case in preparation for another work: the two figures on the right reappear in the painting, *L'amour au Théâtre Français*, in Berlin. The drawing, dated to Watteau's youth, still shows some of the stiffness and angularity found in his earlier drawings influenced by Claude Gillot. One factor responsible for the subsequent development of Watteau's drawings to the full freedom and brilliance that make him the greatest French draftsman of his age was the influence of Rubens. By studying this master, Watteau learned to strengthen his line and to combine white chalk with black and red to produce the dazzling coloristic vibrancy of his drawings.

The second Watteau drawing is more typical of his mature style. The juxtaposition of unrelated, yet harmoniously arranged figures in the *Couple Seated on a Bank* (cat. no. 149) gives it a fresh spontaneity, heightened by the foreshortening and sketchiness of the man and the thoroughly detailed rendering of the girl.

As his great friend Count de Caylus recorded, Watteau did not ordinarily hire studio models; instead, he sketched the variety of people he encountered in daily life, preserving these drawings in numerous bound notebooks for future use. When he wished to paint a picture, he selected figures from his sketchbooks and formed them into groups which were appropriate to the background he had already prepared.

Evolving from many sources, Watteau's highly personal and intimate style of drawing epitomizes the perfection of the French draftsmanship of his era. A consummate master of the three-crayon method of sketching, which affords almost unlimited pictorial effects, Watteau always remained essentially a graphic draftsman: his works are predominantly linear in their structure whether he is portraying sensuous nudes, genre types, or the colorful figures from the contemporary stage whom he transformed into characters in amorous fairy tales.

François Boucher (1703–1770) made two to three drawings a day throughout his long career, producing a total of ten thousand known pieces that range from brief sketches to highly finished compositions. He initiated in France the practice of collecting drawings; previously many French artists had underestimated and neglected this aspect of their art. He was also the first French artist to sign his drawings and offer them to collectors for purchase. In consequence, *amateurs* hung decoratively framed drawings by Boucher and others in their rooms, treasuring them as choice expressions of the intimate "first ideas" of paintings which often offered a key to the fuller comprehension of contemporary art. *Three Heads of Roman Soldiers* (cat. no. 152), an early Boucher study, documents his youthful at-

tention to Roman art, for it was drawn from heads on Trajan's Column. But the other drawings by Boucher in the exhibition exemplify his most characteristic creations, namely the half-draped or nude figures (cat. no.154), which reveal a continuation, also evidenced by Watteau, of Rubens' influence.

Although Boucher is popularly identified with the depiction of the female nude, while teaching at the Académie Royale he made many studies of male nudes. The powerful chalk drawing of *Apollo* (cat. no.153) which preluded the figure in his painting of 1753, *The Rising of the Sun* (Wallace Collection, London), must rank with the academic figure classics of the century: it has been rarely equaled in terms of its presence and carriage. Regina Slatkin submits that it was done from a model, a premise supported by its lifelike character.

Some years later, in 1757, Boucher added red chalk to the customary black, or black and white, and drew one of his most celebrated female nudes, *Venus with a Dove* (cat. no.155). Its captivating, unself-conscious eroticism reflects one of the particular sentiments of the Rococo. The composition was so popular that not only was it much copied, but the engraver Louis Marin Bonnet reproduced it as an etching in the crayon manner.

When his powers as a draftsman were at their height, vitality and incisiveness filled Boucher's drawings. He generally employed deeply drawn, definite strokes to render the folds of draperies, often using heavy, sharply angular outlines rather than the variety and gradations of shading found in Watteau. Again contrasted to Watteau, Boucher's drawings have a linear quality that on the whole appears broader and more painterly in execution. In effect, Boucher's drawings, particularly his female nudes, are elegant and refined eighteenth-century counterparts to the solid, sensuous nudes by Peter Paul Rubens.

More versatile than his master, Boucher, Jean-Honoré Fragonard (1732–1806) considerably varied his use of drawing media. Overwhelmed by the work of Michelangelo and Raphael when he visited Italy, the young Fragonard was able to copy only those he called "second-raters like Pietro da Cortona and Giovanni Battista Tiepolo." While chalk had been the primary means employed by both Watteau and Boucher, Fragonard, influenced by Tiepolo, revived the technique of drawing with ink and wash. Only a thin boundary sometimes separates Fragonard's painting and drawing styles, as evidenced by some of his free oil sketches which are almost indistinguishable from his wash drawings.

Two beautiful Fragonard landscapes, one in brown ink and wash (cat. no.160), the other in red chalk (cat. no.161), contrast a finished treatment of the park at Tivoli with a freer, more sketchy handling of another view of the same subject. Both works reflect the new di-

rect approach to nature by French artists of the second half of the century; under the tutelage of Charles Natoire, director of the French Academy in Rome, they were inspired to make the Italian capital and its environs one of their favored subjects.

In a completely different vein, sometime after 1780 Fragonard made one hundred thirty-seven drawings as illustrations for Ariosto's poem, *Orlando Furioso*. Their truly Baroque quality is epitomized by the brilliant chalk and brown wash drawing of *Rinaldo astride Biardo Rides Off in Pursuit of Angelica* (cat. no.163). The Rubenist character of the dynamic galloping horse and rider spanning, if not literally "flying" through, the heavens has been pointed out by Roseline Bacou. In the forceful delineation as well as the interpenetration of the scene with light and aeriality, the work sums up the artist's dazzling poetic fantasy.

Among the many stars of the Rococo, Jean-Baptiste Greuze (1725–1805) was the first to fade and one of the last, it appears, whose light can hope to be re-kindled. His often deadly sentimentality evolved in the atmosphere engendered by the philosophy of Rousseau. Encouraged by the initial esteem and admiration of Diderot, who recognized the social value of Greuze's familial themes, the artist used such themes to convey the moralistic values of Neoclassicism. Today, Greuze's sentimentality is out of fashion, overshadowing his former popularity and renown. Yet while his paintings have been pointedly neglected, drawings such as his portraits have in no way suffered the same fate. What today may seem painful or even risible in some of Greuze's canvases is often admirable in preliminary drawings. The study of the *Head of the Paralyzed Father* (cat. no.158) for Greuze's painting, *Le paralytique secournu par ses enfants* (Hermitage), dating from 1761, must surely rank with the artist's most vivid and expressive pieces of drawing. Even Diderot commented on this work as a head of rare beauty. The spiritualized suffering in this study could be that of a saint or martyr, and it is in considerable contrast to the more melodramatic friezelike chalk and ink drawing of the *Family Reconciliation* (cat. no.159) considered to have been executed some ten to twenty years later. A painting of this subject does not appear to exist, but the theme is believed by Anita Brookner to mirror Greuze's own troubles with his beautiful, inconstant wife.

French pastel drawing had originated in the crayon drawings of the late fifteenth century and developed in the work of portrait artists such as Fouquet and the Clouets. The portraitist Joseph Vivien (1657–1735), who was originally an oil painter, later adopted the pastel medium with great success. In the eighteenth century the use of pastels gained new popularity and stimulation through the presence in Paris of the celebrated Venetian pastellist Rosalba Carriera.

A high point of achievement in pastel drawing was reached in eighteenth-century France. Artists like Chardin, Quentin de Latour, and Boucher excelled in this medium which was generally reserved for portraiture. Another master in pastels was Jean-Baptiste Perroneau (1715–1783), who is represented here by a portrait of an unidentified man (cat. no.156) whose personality has been captured with an astounding degree of verisimilitude and immediacy. The sense of presence that confronts us in this concentrated, resolute face is made even more emphatic by the use of superbly blended chalks that communicates the sitter's character more forcefully than another graphic medium might have done.

Continuing the French tradition of the classically inspired landscape was Hubert Robert (1733–1808), whose *View with Classical Ruins and Obelisk* (cat. no.165) is among the most beautiful watercolor drawings of Roman scenes produced by his hand. The artist projected a great feeling of melancholy into this scene, evoking a brooding silence and a sense of vast space. Two figures anachronistically transmuted into classical "shades" are introduced in deep shadow at the top of the broad stairway; their presence intensifies the height of the towering, ruined loggia above the fountains at the right. Deserted except for the *staffage* which emphasizes its emptiness, the wide terrace is dominated by the obelisk. The mood conveyed by this single drawing amply demonstrates that among eighteenth-century French artists there were few interpreters of romantically picturesque antiquity more eloquent than Hubert Robert, last genius in the reign of French landscape drawing which began with Poussin and Claude Lorrain.

Catalog

133. JEAN DE GOURMONT (French,
active 1506–1551)
The Holy Family with Joseph as Carpenter
Brown ink and wash
6 x 8⁷⁄₁₆ in. (15.2 x 21.4 cm.)
The Pierpont Morgan Library

Collection: André de Hevesy, Brussels
Literature: P. Lavallée. *Le dessin français du
XIII au XVI siècle*. Paris, 1930. p. 91; F. Stam-
pfle. *Drawings: Major Acquisitions of The Pier-
pont Morgan Library, 1924-1974*. New York,
1974. no. 22.

134. FRANÇOIS CLOUET (French,
before 1522–1572)
Portrait of Claude Gouffier de Boisy
Black and red chalk on ivory paper
12⅝ x 9¹⁄₁₆ in. (32.0 x 23.0 cm.)
Watermark: Small crown (not in Briquet)
Inscribed in the upper left in the hand of one of
Catherine de' Medici's secretaries *debosie*;
numbered 5, in Ignatius Hugford's hand
Fogg Art Museum
Gift of Paul J. Sachs

Collections: Catherine de' Medici; Christine of
Lorraine, Grand Duchess of Tuscany; Ignatius
Hugford; Marquis de Biron; Alphonse Kann;
Paul J. Sachs, 1918
Literature: E. Moreau-Nelaton. *Les Clouets et
leurs émules*. Paris, 1924. II : 96, no. 3, fig. 357;
*Master Drawings Selected from the Museums and
Private Collections of America*. Buffalo Fine Arts
Gallery, 1935. no. 33, fig. 33; A. Mongan,
P. Sachs. *Drawings in the Fogg Museum of Art*.
3 vols. Cambridge, 1940. no. 569, fig. 284;
R. Shoolman, C. E. Slatkin. *Six Centuries of
French Master Drawings in America*. New York,
1950. pl. 8; P. J. Sachs. *The Pocket Book of Great
Drawings*. New York, 1951. p. 78, pl. 50; J. Wa-
trous. *The Craft of Old Master Drawings*. Madi-
son, Wis., 1957. p. 104; M. W. Alpakov. *Geschichte

der Kunst*. Dresden, 1964. II : 145; *Memorial
Exhibition: Works of Art from the Collection of
Paul J. Sachs (1878-1965) Given and Bequeathed
to the Fogg Art Museum*. Cambridge and New
York, 1966-67. no. 15, repr.; B. D. Francis.
The Humanities in Retrospect. Iowa, 1974.
p. 97, repr.

135. JEAN COUSIN THE YOUNGER
(French, 1522–1594)
*The Virgin, Christ Child, and Angels with
SS. John and Luke*
Brown ink and wash
14⅜ x 12⁵⁄₁₆ in. (36.5 x 31.4 cm.)
Mr. and Mrs. Julius S. Held

Collections: Dr. G. L. Laporte; Paul J. Sachs
(as Niklaus Manuel Deutsch)
Literature: *Selections from the Drawing Collec-
tion of Mr. and Mrs. Julius S. Held*. University
Art Gallery, State University of New York at
Binghamton. Jan. 5-28, 1970. no. 59.

136. SCHOOL OF FONTAINEBLEAU
(French, *ca.* 1570)
Head of a Horse with a Plume and a Tassel
Pen and brown ink, colored washes on prepared
rose paper, heightened with white
6⁹⁄₁₆ x 3½ in. (16.7 x 89.0 cm.)
Woodner Family Collection

Literature: *Woodner Collection II : Old Master
Drawings from the XV to the XVIII Century*.
New York, 1973. no. 86.

137. JACQUES CALLOT,
attributed (French, 1592–1635)
Surrender of a City(?)
Sanguine
14¹⁵⁄₁₆ x 10⅜ in. (37.9 x 26.4 cm.)
Michael Hall, Esq.

Literature: Unpublished
The *verso* of the old mount of this drawing
bears a passage on the life of Antonio Tempesta
from Pilkington's *Dictionary of Painters*; appar-
ently the work was once considered to be by

135

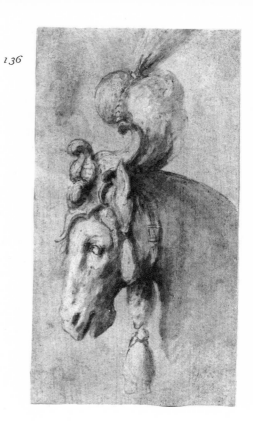

136

133

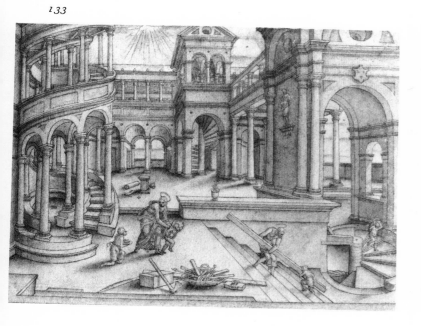

138

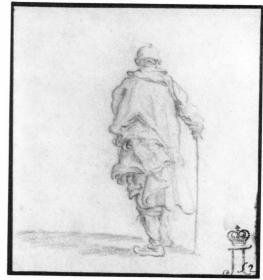

Tempesta. However, drawings in red chalk and with the characteristics of this drawing are not known from this artist's little-studied graphic *oeuvre*. The features that stand out from the draftsmanship, especially the extremely mannered stances and the tiny horsemen galloping at upper left, are those familiar from the work of Jacques Callot. Thus the suggestion that this may be one of Callot's earliest drawings does not seem unreasonable. The premise would be that it dates from around the time of the artist's engravings of the *Battles and Victories of Ferdinando de' Medici*, 1619–20. These prints were done after drawings by Florentine artists, including Tempesta, but in some instances Callot made changes in the engravings. The full modeling of the figures would suggest they were worked after another design. They are, for example, dissimilar to the freedom of the black chalk sketches on the *verso* of *The Enrollment of the Troups*, a drawing in the Uffizi that Ternois published as possibly among Callot's earliest known drawings. The identity of the supplicants emerging from the gate in the present work is not, as yet, forthcoming.

138. JACQUES CALLOT (French, 1592–1635)
Standing Figure
Red chalk
6 x 6 in. (15.2 x 15.2 cm.)
Stephen Spector

Collections: Medici; Count Cobenzl; Catherine II; Paul I; Hermitage; Boerner's, Leipzig
Literature: L. Zahn. *Die Handzeichnungen des Jacques Callot*. Munich, 1923. p. 115, fig. 1; *Handzeichnungen alter Meister aus der Eremitage*, *Leningrad*. Boerner's, Leipzig, Apr. 29, 1931. no. 3, not repr.

According to Zahn, this is a preparatory figure for the *Fair at Impruneta* or the *Varie Figure*.

139. JACQUES CALLOT (French, 1592–1635)
Admiral Inghirami Presenting Barbary Prisoners to King Ferdinand I of Tuscany, 1618–1620

Brown ink and wash over charcoal
7¾ x 12 in. (19.4 x 30.3 cm.)
Detroit Institute of Arts
John S. Newberry Bequest

Collections: H. M. Calmann (Sale, London, June 1949); acquired by John S. Newberry
Literature: D. Ternois. *Jacques Callot, catalogue complet de son oeuvre dessiné*. Paris, 1961. p. 92, no. 542, pl. 542; *Jacques Callot*. Museum of Art, Rhode Island School of Design, Providence, 1969. no. 61, fig. 61.

140. JACQUES CALLOT (French, 1592–1635)
Miracle of St. Mansuetas, 1621
Brown ink and wash over traces of black chalk
9⁷⁄₁₆ x 7¹⁄₁₆ in. (24.0 x 18.0 cm.)
Mr. and Mrs. Germain Seligman

Collections: Jhr. J. van Frankenstein (1722–1785) and his son (1756–1821); Lord Delamere Sale, London, Sotheby's, Apr. 13, 1926, no. 362; H. S. Reitlinger Sale, London, Sotheby's, Apr. 14, 1954, no. 294
Literature: A. B. Freedberg. "A Fourth Century Miracle Drawn by a Seventeenth Century Artist." *Boston Museum of Fine Arts Bulletin* 55 (Summer 1957): 38–43; D. Ternois. *Jacques Callot, catalogue complet de son oeuvre dessiné*. Paris, 1961. p.98, no. 571, pl. 571.

According to Ternois, who followed the chronology of Anne Freedberg, this is the second of four versions of the subject; the three others are in the Museum of Nancy, France; the Museum of Fine Arts, Boston; and the Nationalmuseum, Stockholm.

141. JACQUES CALLOT (French, 1592–1635)
Study for the Martyrdom of St. Sebastian, 1623
Black chalk and brown wash
8¼ x 13¾ in. (20.4 x 34.4 cm.)
E. B. Crocker Art Gallery

Collections: Dalbertos (De Julienne Sale, Paris, 1767); E. B. Crocker
Literature: N. S. Trivas. "Callot's Martyrdom of S. Sebastian." *Art Quarterly*. Summer 1941,

141

140

137

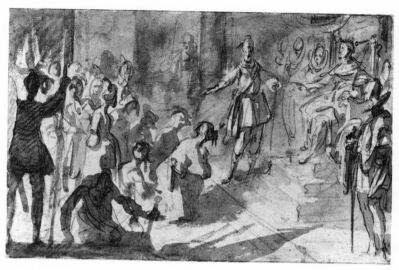

139

p. 205 ff.; *Jacques Callot Prints and Drawings*. Los Angeles County Museum, 1957. no. 354; D. Ternois. *Jacques Callot, catalogue complet de son oeuvre dessiné*. Paris, 1961. no. 1174; *Jacques Callot*. Museum of Art, Rhode Island School of Design, Providence, 1969. no. 75.

142. CLAUDE VIGNON (French, 1593–1670)
St. Helen with the True Cross
Brown ink, red chalk, and bister wash
12 5/16 x 8 1/16 in. (31.4 x 20.5 cm.)
Signed at lower left: Vignon in^t f.
Mr. and Mrs. Germain Seligman

Collection: Art market, Paris
Literature: P. Rosenberg. "Some Drawings by Claude Vignon." *Master Drawings* IV, no. 3 (1966): 289–93, pl. 25; idem. *French Master Drawings of the 17th and 18th Centuries in North American Collections*. National Gallery of Canada, Ottawa, 1972. no. 145, color pl. I.

143. NICOLAS POUSSIN (French, 1594–1665)
Christ's Charge to Peter
Brown ink and wash
7 5/16 x 10 in. (18.7 x 25.5 cm.)
The Pierpont Morgan Library

Collections: G. M. Marchetti; Robinson; C. Fairfax Murray
Literature: C. Fairfax Murray. *Drawings by the Old Masters: Collection of J. Pierpont Morgan*. 4 vols. London, 1905–12. vol. III, no. 70; A. Blunt. *The French Drawings at Windsor Castle*. London, 1945. p. 51, no. 260; H. Tietze. *European Master Drawings in the United States*. New York, 1947. p. 118, no. 59; W. Friedländer, A. Blunt. *The Drawings of Nicolas Poussin*. 5 vols. The Warburg Institute, London, 1953. I: 46, no. 98, pl. 98, v: 89, under the title, *Ordination*; A. Blunt. *Nicolas Poussin*. New York, 1967. pp. 196, 198–99, fig. 163.

144. NICOLAS POUSSIN (French, 1594–1665)
The Triumph of Bacchus
Brown ink
6 3/16 x 9 in. (15.7 x 22.8 cm.)

The William Rockhill Nelson Gallery and Atkins Museum of Fine Arts
Nelson Fund

Collection: Marignane
Literature: W. Friedländer, A. Blunt. *The Drawings of Nicolas Poussin, catalogue raisonné*. 5 vols. The Warburg Institute, London, 1953. III: 23, v: 106, no. 436, pl. 312.

This is a drawing for the painting of the same subject in the Nelson Gallery-Atkins Museum, formerly at Castle Howard (see O. Grautoff, *Nicolas Poussin, sein Werk und sein Leben* [Munich and Leipzig, 1914], no. 86). The Kansas City painting is one of only two paintings of Bacchanals that remain from the series Poussin painted for Cardinal Richelieu in the mid-1630s.

145. CLAUDE GELLÉE, called Claude Lorrain (French, 1600–1681)
Landscape with Jacob, Laban and His Daughters, 1661
Brown ink, gray wash, and black chalk
7 3/4 x 11 3/4 in. (19.7 x 29.8 cm.)
Signed: Claudio. I. V. Romae 1661
Anonymous

Collections: Colnaghi's, London; Lord Harewood
Literature: T. Borenius. *Apollo* I (1925): 194, repr.; idem. *Catalogue…Harewood House*. London, 1936. no. 9; M. Rothlisberger. *Claude Lorrain, the Paintings*. 2 vols. New Haven, 1961. I: 323; idem. *Claude Lorrain, the Drawings*. 2 vols. Berkeley and Los Angeles, 1968. vol. I, no. 834; vol. II, fig. 834.

146. JEAN JOUVENET (French, 1644–1717)
Phaethon Driving the Chariot of the Sun, ca. 1680
Brown ink and brush and gray ink and wash, heightened with white, over black chalk on gray prepared paper
16 7/16 x 13 3/4 in. (46.8 x 34.8 cm.)
Yale University Art Gallery

Collection: R. W. Weir, West Point
Literature: Yale University. *Bulletin of the Asso-*

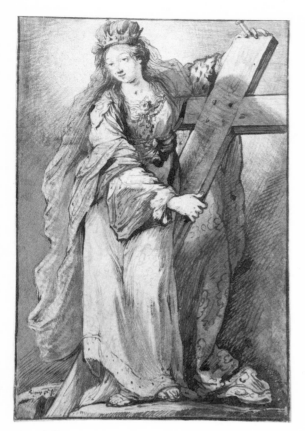

142

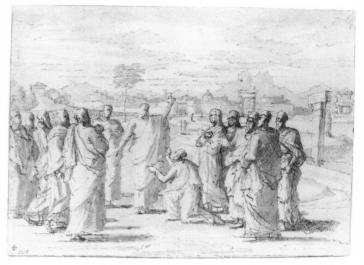

143

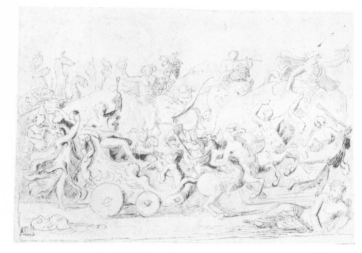

144

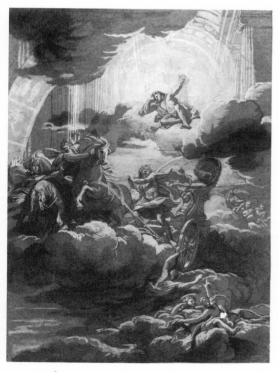

146

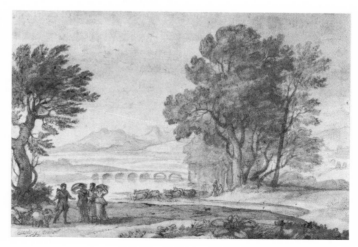

145

ciation of Fine Arts. 1931. 5 : 39 (as Charles Le Brun); A. Schnapper. *J. Jouvenet.* Rouen, 1966. no. 2; P. Rosenberg. *Tableaux français du XVIIe siècle et italiens des XVIIe et XVIIIe au Musée des Beaux-Arts, Rouen.* Paris, 1966. p. 48, no. 25; idem. "'Les compositions' of Jean Jouvenet." *Master Drawings* v, no. 2 (1967): 135–43, pl. 2; E. Haverkamp-Begemann, A. M. S. Logan. *European Drawings and Watercolors in the Yale University Art Gallery.* New Haven and London, 1970. no. 6, pl. 18; P. Rosenberg. *French Master Drawings of the 17th and 18th Centuries in North American Collections.* National Gallery of Canada, Ottawa, 1972. no. 63, pl. 57.

147. HYACINTHE RIGAUD
(French, 1659–1743)
Portrait of Samuel Bernard, 1727
Black chalk and white chalk with highlights on blue paper
22 x 12¼ in. (55.9 x 31.2 cm.)
The William Rockhill Nelson Gallery and Atkins Museum of Fine Arts
Nelson Fund

Collections: Johann von und zu Liechtenstein in Feldsberg; Rothschild; Rosenberg and Steibel
Literature: J. Roman. *Le livre de raison de Rigaud.* Paris, 1919. 201 (footnote); *Art Quarterly.* 1966. p. 168, pl. on p. 185; P. Rosenberg. *French Master Drawings of the 17th and 18th Centuries in North American Collections.* National Gallery of Canada, Ottawa, 1972. no. 122, fig. 63.

148. JEAN ANTOINE WATTEAU
(French, 1684–1721)
Three Figures, One Playing a Cornemeuse
Red, black, and white chalk
8⅛ x 6⁷⁄₁₆ in. (20.6 x 16.3 cm.)
Anonymous

Collections: Unidentified English collection; R. Owen, London
Literature: K. T. Parker, J. Mathey. *Catalogue de l'oeuvre dessiné d'Antoine Watteau.* 2 vols. Paris, 1957. vol. I, no. 88; *French Draw-*

ings from American Collections, Clouet to Matisse. The Metropolitan Museum of Art, New York, 1959. no. 84, pl. 30.

149. JEAN ANTOINE WATTEAU
(French, 1684–1721)
Couple Seated on a Bank
Red, black, and white chalk on buff paper
9½ x 13¾ in. (24.1 x 34.9 cm.)
Armand Hammer Foundation

Collections: Anonymous Sale, Paris, 1892, no. 72; Lallemand (Sale, Paris, May 2, 1894); Léon-Michel-Levy (Sale, Paris, Galerie Georges Petit, June 17-18, 1925, no. 106); G. Blumenthal; Mrs. Jesse I. Straus (Sale, Parke-Bernet, Oct. 21, 1970, no. 20)
Literature: *Les maîtres du dessin.* Paris, 1911. vol. III, pl. 136; K. T. Parker. *The Drawings of Antoine Watteau.* London, 1931. pl. 92; *Commemorative Catalogue of the London Exhibition of French Art, 1200–1900.* London, 1933. no. 780; K. T. Parker, J. Mathey. *Catalogue de l'oeuvre dessiné d'Antoine Watteau.* 2 vols. Paris, 1957. no. 665, p. 326, pl. 665; *The Irma N. Straus Collection of Master Drawings,* Parke-Bernet, New York, Oct. 21, 1970. no. 20, p. 34; *The Armand Hammer Collection.* Los Angeles, 1971. no. 65; *Recent Acquisitions and Promised Gifts.* National Gallery of Art, Washington, D.C., 1974. no. 71.

150. JEAN-BAPTISTE OUDRY
(French, 1686–1755)
Still Life with Rabbit and Duck
Black and white chalk on blue paper
15¹⁄₁₆ x 8⅞ in. (40.0 x 27.0 cm.)
Stephen Spector

Collections: E. and J. de Goncourt; G. Bourgarel; P. W. Josten; private collector
Literature: P. de Chennevières. *Les dessins de maîtres anciens.* Paris, 1880. p. 99; E. de Goncourt. *La maison d'un artiste.* Paris, 1881. p. 131; J. Locquin. "Catalogue raisonné de l'oeuvre de Jean-Baptiste Oudry." *Bulletin de la Société de l'Histoire de l'Art Français,* 1912. no. 577; J. Ver-

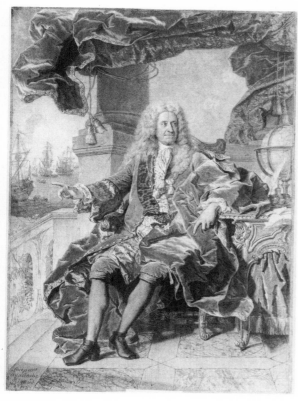

147

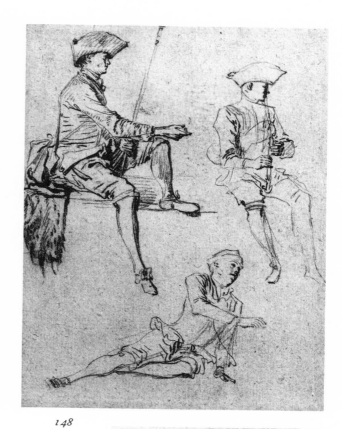

148

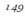
149

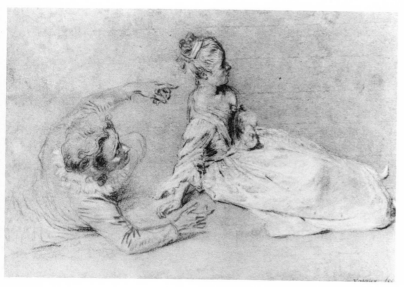

150

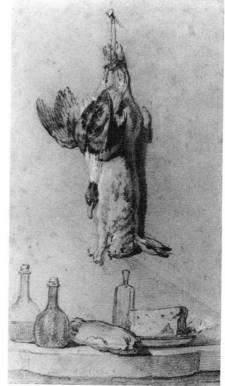

gnet-Ruiz. "Oudry." in L. Dimier. *Les peintres français au XVIIIe siècle.* Paris and Brussels, 1930. II :180, no. 125; F. Boucher, P. Jacottet. *Le dessin français au XVIIIe siècle.* Lausanne, 1952. p. 175, pl. 33; E. van Schaack. *Master Drawings in Private Collections.* New York, 1962. pp. 80-81, pl. 40; P. Rosenberg. *French Master Drawings of the 17th and 18th Centuries in North American Collections.* National Gallery of Canada, Ottawa, 1972. no. 102, p. 189, pl. 79.

151. CHARLES NATOIRE (French, 1700–1777)
Bacchanal
Black and red chalk, wash, and highlights in various gouaches
14¹⁵⁄₁₆ x 22⅞ in. (38.0 x 50.8 cm.)
Fogg Art Museum
Gift of Charles E. Dunlap

Collections: C. Natoire (Sale, Dec. 14, 1778, no. 90); M. de Clesle sale, Paris, Jan. 2, 1804, no. 18
Literature: *Catalogue de tableaux et dessins originaux...qui composent le cabinet de feu Charles Natoire....* Hôtel d'Aligre, Paris, Dec. 14, 1778. no. 90; *Catalogues de ventes et livrets de salons illustrés par Gabriel de Saint-Aubin.* Emile Dacier, Paris, 1913. vol. VIII, pp. 49, 63, n. 3, Saint-Aubin illustration of this gouache facsimile, p. 20; *The Eighteenth Century.* University Gallery, University of Minnesota, Minneapolis, Jan. 24 –Mar. 7, 1961, no. 26; P. Rosenberg. *French Master Drawings of the 17th and 18th Centuries in North American Collections.* National Gallery of Canada, Ottawa, 1972. no. 98, p. 186, pl. XI.

152. FRANÇOIS BOUCHER (French, 1703–1770)
Three Heads of Roman Soldiers
Black chalk, heightened with white on buff paper, 8¹⁵⁄₁₆ x 12 in. (22.8 x 30.5 cm.)
Michael Hall, Esq.

Literature: R. S. Slatkin. *François Boucher in North American Collections, 100 Drawings,* National Gallery of Art, Washington, D.C., Dec. 23, 1973–Mar. 17, 1974, and The Art Institute of Chicago, Apr. 4–May 12, 1974, no. 19.

153. FRANÇOIS BOUCHER (French, 1703–1770)
Apollo
Black and white chalk on greenish gray paper
21³⁄₈ x 14³⁄₈ in. (54.3 x 36.5 cm.)
David Daniels

Collections: Ecole Académique de Dessins, Orléans; Ryaux
Literature: *Figures nues d'école française.* Hotel Charpentier, Paris, 1953. no. 20; *Drawings, Paintings and Sculpture from Three Private Collections.* Minneapolis Institute of Arts, 1960. no. 9; *Drawings from the Daniels Collection.* Minneapolis Institute of Arts, The Art Institute of Chicago, Nelson Gallery–Atkins Museum, Kansas City, and Fogg Art Museum, 1969. no. 22; *The Male Nude.* Emily Lowe Gallery, Hofstra University, New York, Nov. 1–Dec. 12, 1973. no. 29, pl. 29; R. S. Slatkin. *François Boucher in North American Collections, 100 Drawings.* National Gallery of Art, Washington, D.C., Dec. 23, 1973–Mar. 17, 1974, and The Art Institute of Chicago, Apr. 4–May 12, 1974. no. 68.

154. FRANÇOIS BOUCHER (French, 1703–1770)
Nymphs and Cupids
Black chalk, partially stumped and heightened with white chalk
13¹⁄₁₆ x 9⅛ in. (32.2 x 23.2 cm.)
The Metropolitan Museum of Art
Robert Lehman Collection

Collections: Harcourt (?); S. Courtauld; Lady Aberconway; Sir R. Abdy; Robert Lehman
Literature: L. Soulie, C. Masson. *Catalogue raisonné de l'oeuvre peint et dessiné de François Boucher.* Paris, n.d. no. 235 (?), no. 574; D. Cooper. *The Courtauld Collection.* London, 1954. no. 253; E. van Schaack. *Master Drawings in Private Collections.* New York, 1962. no. 70, fig. 70.

155. FRANÇOIS BOUCHER (French, 1703–1770)
Venus with a Dove, 1757
Red, black, and white chalk on buff paper
10⅞ x 15 in. (27.6 x 38.0 cm.)

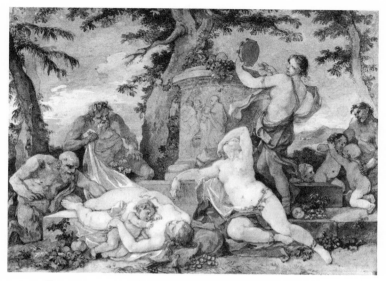

151

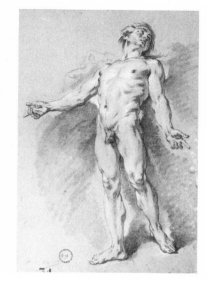

153

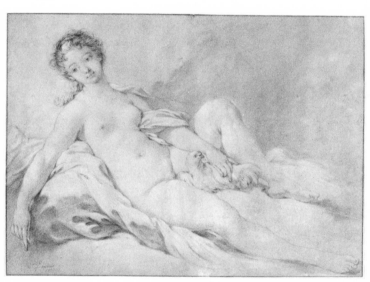

155

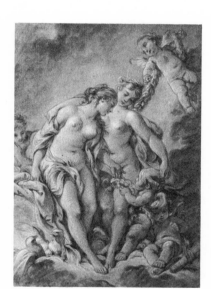

154

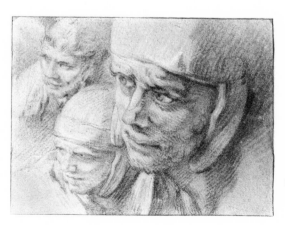

152

Signed lower left: F. Boucher 1757
National Gallery of Canada, Ottawa

Collections: Anonymous Sale, Paris, Apr. 1, 1776, no. 80, with marginal illustration by Gabriel de Saint-Aubin as "Une femme couchée"; Anonymous Sale, Paris, Feb. 19, 1869, as *Vénus mollement étendue et tenant une colombe*"; C. Ephrussi; bought from Charles E. Slatkin Galleries, New York, in 1957
Literature: A. Michel. *François Boucher, catalogue raisonné de l'oeuvre peint et dessiné.* n.p., n.d.; A. E. Popham, K. M. Fenwick. *European Drawings in the Collection of the National Gallery of Canada.* Toronto, 1965. p. 127, no. 222, repr.; A. Ananoff. *L'oeuvre dessiné de François Boucher.* Paris, 1966. vol. I., no. 771; R. S. Slatkin. "Some Boucher Drawings and Related Prints." *Master Drawings* X, no. 3 (1972): 264 ff., pl. 30; idem. *François Boucher in North American Collections, 100 Drawings.* National Gallery of Art, Washington, D.C., Dec. 23, 1973–Mar. 17, 1974, and The Art Institute of Chicago, Apr. 4–May 12, 1974. p. 97, no. 75, repr.

156. JEAN-BAPTISTE PERRONEAU
(French, 1715–1783)
Portrait of a Young Man
Pastel
21½ x 17⁵⁄₁₆ in. (54.5 x 44.0 cm.)
Woodner Family Collection
Literature: *Woodner Collection II : Old Master Drawings from the XV to XVIII Century.* New York, 1973. no. 105.

157. PIERRE-ANTOINE BAUDOUIN
(French, 1723–1769)
La modele honnête, 1769
Gouache
15¾ x 13⅝ in. (40.0 x 34.5 cm.)
Woodner Family Collection

Literature: E. Bocher. *Pierre-Antoine Baudouin, catalogue raisonné.* Paris, 1875. p. 36, no. 34; *Woodner Collection II : Old Master Drawings from the XV to the XVIII Century.* New York, 1973. cat. no. 106, repr. in color.

158. JEAN-BAPTISTE GREUZE
(French, 1725–1805)
The Head of the Paralyzed Father, 1761
Red and black chalk, heightened with white
18⁵⁄₁₆ x 14¹³⁄₁₆ in. (46.6 x 37.6 cm.)
Woodner Family Collection

Collections: D. David-Weill; Cranbrook Academy of Art, Bloomfield Hill, Michigan
Literature: G. Henriot. *Collection David-Weill Dessins.* Paris, 1928. vol. III, pt. I, p. 213; Wildenstein. *French Pastels and Drawings from Clouet to Degas.* New York, Feb.–March 1944. no. 45; *Woodner Collection II : Old Master Drawings from the XV to the XVIII Century.* New York, 1973. no. 110.

159. JEAN-BAPTISTE GREUZE
(French, 1725–1805)
The Family Reconciliation, ca. 1770–1780
Black chalk and india ink
19 x 24¾ in. (48.3 x 62.7 cm.)
The Arizona Art Museum, Phoenix
Gift of Mr. and Mrs. Randall Barton in memory of Bruce Barton, Jr.

Collections: H. Walferdin Sale, May 18, 1860, no. 76; Marquis de V[alori], Sale, Nov. 25-26, 1907, no. 118 (?); Wildenstein, New York
Literature: C. Mauclair. *Jean-Baptiste Greuze.* Paris, 1908. p. 26, no. 357; *Phoenix Art Museum Catalogue.* 1965. p. 50; *Art Quarterly.* 1965. p. 109; P. Rosenberg. *French Master Drawings of the 17th and 18th Centuries in North American Collections.* National Gallery of Canada, Ottawa, 1972. no. 60, fig. 108.

160. JEAN-HONORÉ FRAGONARD
(French, 1732–1806)
Corner of the Park at Tivoli
Brown ink and wash
13⅜ x 16⅞ in. (34.0 x 43.0 cm.)
Stephen Spector

Collections: Rahir; Mme. X., Dijon; S. Higgons
Literature: *Collectionneurs et chercheurs de curiosités.* Paris, Dec. 13, 1957. repr. p. 90.; A. Ananoff. *L'oeuvre dessiné de J.-H. Fragonard.* 4 vols. Paris, 1961. vol. I, no. 370, fig. 130.

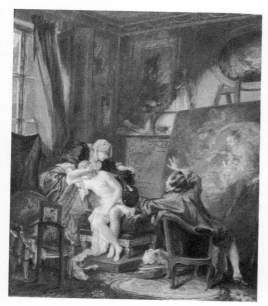

157

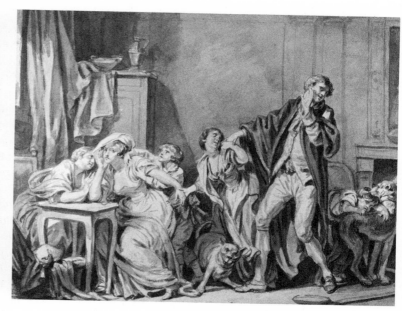

159

160

158

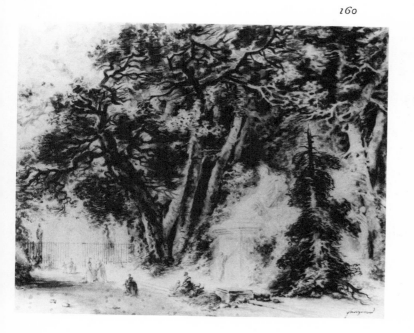

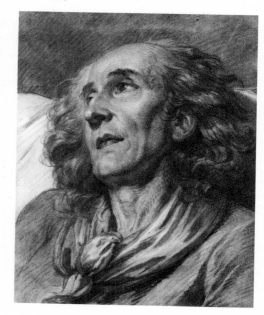

161. JEAN-HONORÉ FRAGONARD
(French, 1732–1806)
*Landscape with Curving Stairs and Cypresses
and Three Women*
Red chalk
12¼ x 17¼ in. (31.1 x 43.8 cm.)
Signed at lower right: Frago
Stephen Spector

Collections: Wildenstein; Hallsborough, London
Literature: Unpublished

162. JEAN-HONORÉ FRAGONARD
(French, 1732–1806)
Young Woman Seated
Verso: Light Sketch of a Female Head
Red chalk
10 x 7 in. (25.4 x 17.8 cm.)
Los Angeles County Museum of Art
The Mr. and Mrs. Allan C. Balch Collection

Collections: R. Owen, London; D. Hatfield,
Los Angeles
Literature: Unpublished
 The Museum acquired the drawing as a
Le Prince, but the preponderant opinion of many
scholars has been that it is actually by Fragonard.

163. JEAN-HONORÉ FRAGONARD
(French, 1732–1806)
*Rinaldo astride Biardo Rides Off in Pursuit of
Angelica, ca.* 1795
Black crayon and brown ink
15⅜ x 10⅛ in. (39.1 x 26.1 cm.)
The National Gallery of Art, Washington, D.C.
Rosenwald Collection

Collections: H. Walferdin; J. Doucet; L. Roederer

Literature: H. Cohen, S. Ricci. *Guide de l'amateur
de livres à gravures....*Paris, 1912, 6th ed.; S. Ricci.
*The Roederer Library of French Books....*Phila-
delphia, 1923; E. Mongan. *Selections from the
Rosenwald Collection.* National Gallery of Art,
Washington, D.C., 1943. p. 97, repr. p. 96;
E. Mongan, P. Hofer, J. Seznec. *Fragonard:
Drawings for Ariosto.* New York, 1945. no. 11,
repr.; R. W. Kennedy. "Fragonard Drawings
for Ariosto." *Art in America* XXXIV (July 1946):
163–64; idem. "Fragonard Drawings for Ariosto."
Burlington Magazine 88 (July 1946):180;
R. Shoolman, C.E. Slatkin. *Six Centuries of French
Master Drawings in America.* New York, 1950.
p. 94, pl. 52; *French Drawings from American
Collections.* The Metropolitan Museum of Art,
New York, 1959. no. 56, fig. 68.

164. JEAN-BAPTISTE LE PRINCE
(French, 1734–1781)
Une Sultane
Red chalk
19⁷⁄₁₆ x 16⅛ in. (49.5 x 41.0 cm.)
Anonymous

Collections: M. Strolin; Galerie Strolin and
Bayser, Paris
Literature: Unpublished

165. HUBERT ROBERT (French, 1733–1808)
View with Classical Ruins and Obelisk
Watercolor
12½ x 20 in. (31.7 x 50.8 cm.)
Stephen Spector

Collection: Hirschl and Adler
Literature: Unpublished

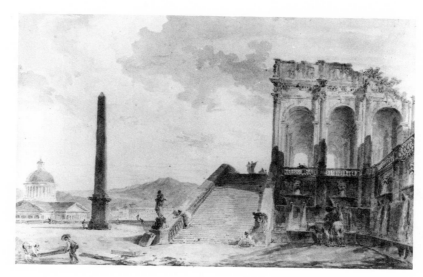

165

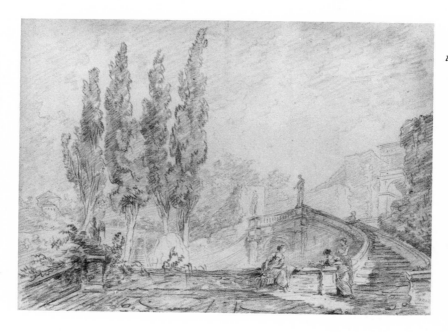

161

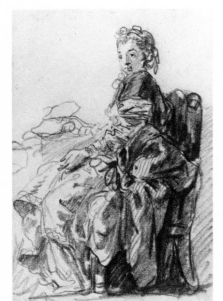

162

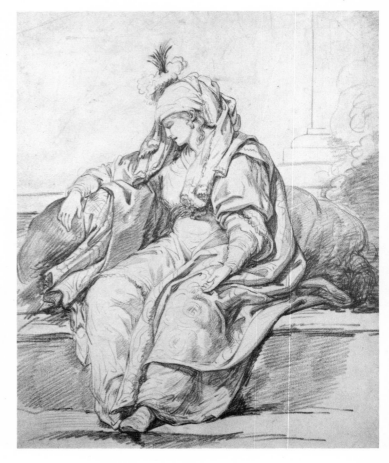

164

163

The German School

The German School

IN GERMANY, as in other European countries, manuscript illustrations (often executed in colored inks) and drawings made for model books supplied the main foundations for the development of draftsmanship. Throughout the Middle Ages anonymous copies prevailed and an individual artist's identity was considered of little significance; he was esteemed more for his craftsmanship and ability to perpetuate tradition than for his powers of innovation.

Of the several anonymous German works in the exhibition, the earliest is a mid-fourteenth-century double-sided leaf from a manuscript of the *Biblia Pauperum* (cat. no. 166). Appearing first in manuscript form and later in block books (printed from woodblocks containing both text and illustration), the *Biblia Pauperum*, a brief picture book of the life and passion of Christ in approximately forty to fifty leaves, was intended for use by the poorer clergy who could not afford more elaborately decorated works for their teaching. In such picture books, scenes from the life of Christ were juxtaposed with Old Testament parallels, and these illustrations were accompanied by predictions of the Prophets. The present sheet is executed in pen and ink with watercolor on vellum. The central subject of the *recto* is the *Betrayal of Christ*, that of the *verso*, *Christ before Pilate*, in which the artist neglected to inscribe the scroll held by Jezebel. The arrangement of the drawings and text was apparently inspired by contemporary illuminated manuscripts, most likely those produced in Upper Germany and Austria. A later example of a German provincial manuscript drawing with watercolor is the fifteenth-century Alsatian work, *God Crowning the Daughter of Zion* (cat. no. 167) which immediately delights the eye with its vivid intensity of expression and brilliant color.

Still another aspect of late Gothic drawing in Germany is found in the fine sheet of *Studies of a Madonna and Female Saints* (cat. no. 168), from the end of the fifteenth century ascribed by Jacob Rosenberg to the Middle Rhenish artist called Master of the Coburg Roundels. (The drapery studies on the *verso* of the sheet are by another hand.) According to Tietze's suggestion, the work was made by an artist to provide himself with figure and drapery models for use by himself or his shop. The drawing is therefore a guide sheet from a model book which offered various patterns for the artist to follow in preparing a composition. Since such model or pattern books were used extensively by the workshops of the Middle Ages, it is difficult when confronted with a drawing such as this to be certain if the models originated with the man who drew them or are merely his copies of a prototype.

In the early fifteenth century German art was marked by two influences: the graceful curvilinear International Gothic style and the forceful realism of the Flemish school of painters, which had become even more pronounced by the time the first major German engraver, the Master E. S. (active *ca.* 1450–1467), appeared. Aware of work by Rogier van der Weyden, the Master E. S. was also influenced by south German artists and, as pointed out by L. Fischel and Alan Shestack, by the sculpture of Nicolaus Gerhaert van Leyden as well.

With the Master E. S., engraving became a very important medium for German artists. Their activity in that field is responsible for the relative paucity of designs surviving from that period, for drawings used in printmaking were often consumed by the process. Thus only two drawings are known by the Master E. S., one in Berlin, the other in the Louvre. They are models of delicate, careful, almost stippled patterns, with the fine hatching reminiscent of manuscript illumination. This style is also found in some of the artist's earliest engravings.

Small as it is, the corpus of drawings by Martin Schongauer (*ca.* 1450–1491) exceeds that of the Master E. S. by about a dozen works. Although Schongauer's drawings, made in connection with paintings or engravings, resemble his prints in technique, his drawings are understandably freer in execution because the pen is less restrictive than is the burin required for engraving. An example of the intensity and vitality Schongauer could achieve in his drawings is offered by the beautiful study of the *Annunciate Angel*, in Berlin, a work belonging to the best period of his youth. Schongauer's drawings incorporate the delicacy and grace of the International Gothic style while also revealing knowledge of the Flemings Rogier van der Weyden, Dirk Bouts, and Hugo van der Goes. Such influences may explain how Schongauer was able to infuse a new humanity into forms and faces that in the work of E. S., his predecessor, had still been medieval, half-schematized, half-caricatural. In the purity and reedlike delicacy of his line, combined with the ripe beauty of his figures with their rich curls and their intricate drapery patterns, Schongauer stands alone. His graphic work consistently displays an idealized naturalism and nobility which subsequent German engravers and draftsmen, superior in dramatic strength and expression, studied but could never achieve.

An approach completely different from that of Schongauer is presented in the drawings of the unidentified artist known as the Master of the Housebook (active *ca.* 1475–1500), whose lines are free and discontinuous, the modeling sketchy within bold, energetic forms. All the traces of the International Gothic style have vanished from the work of this inde-

pendent master of drypoint engraving, who is sometimes regarded as a distant forerunner of Rembrandt.

A transitional figure between the Gothic and Renaissance worlds, and a contemporary of Dürer and Grünewald, was Bernhard Strigel (1460/61–1528), an important Swabian painter in the service of the emperor Maximilian. His works are striking in their rich color contrasts and his portraits especially were in constant demand. Unlike his two fellow artists, Strigel did not visit Italy and had no opportunity to experience at first hand the new styles and aesthetics of the Renaissance. Because he encountered Renaissance ideals only through the works of German artists who returned from Italy, late Gothic characteristics are more prevalent in his drawings than the Italian influence. His beautiful *Two Lovers* (cat. no. 170) presents a theme that began to be very popular in the northern schools in the fifteenth century and later appeared in sixteenth-century Venice. The drawing was dated by K. T. Parker

147

to the end of the last decade of the fifteenth century; its broad treatment, especially in the garments of the figures, reflects Italy's influence, then on the rise in German art.

A quarter-century after the birth of Bernhard Strigel, the region of Swabia saw the appearance of Hans Baldung Grien (1484/85–1545), the most important artist of the Dürer circle. Baldung studied with Dürer in Nuremberg but unlike his master never felt impelled to go to Italy; for most of his life he lived and worked in Strasbourg. While Baldung's pen drawings surely show the influence of Dürer, on the whole his strokes were sketchier, less regular and dense. In addition, Baldung was less concerned with modeling and more summary in his treatment of form. His most unforgettable drawings are those in the chiaroscuro manner: on green and reddish brown papers he created imaginative visions of witches' sabbaths, and other macabre as well as realistic studies, with white highlights shimmering against the intense, unrealistic colors of the backgrounds. It was from his frequent use of green that he derived his nickname, Grien.

While remarkable artists like the Master of the Housebook and Strigel could develop without any direct influences from outside their native regions, their great contemporary Albrecht Dürer could not resist the attraction of the Italian Renaissance. Still, many other German artists of the sixteenth century were content to work exclusively at home, never living outside Germany or Austria. Confining their activities primarily to the region near the Danube River, a number of these artists are broadly labeled the Danube School. Although inspired by Dürer's technical innovations in woodcut, etching, and engraving, the Danube School artists remained quite unlike Dürer in their aesthetic expression, being less concerned with the analytical order and clarity of composition, according to Italian Renaissance canons, than with their own personal vision and interpretation of nature.

One of the artists represented in the exhibition, the Master of Muhldorf, worked chiefly in Austria and southern Bavaria where he was influenced by the Tyrolean painter Michael Pacher and by one of the outstanding representatives of the Danube School, Albrecht Altdorfer (1480–1528). The 1514 drawing of *The Annunciation* by the Master of Muhldorf (cat. no. 178) with its massive interior; deep, angular perspective; dramatic, dancelike posture of the angel; and white highlighting of the vivid brick red background, creates an unusual setting for the traditional theme. It also recalls Altdorfer's woodcut of the same subject, executed a year earlier, in which a towering angel dominates the scene as though to enforce the message of the Annunciation. With their markedly oblique perspective, disproportionate figures, and heightened emotionalism these two works contrast strongly with Dürer's three *meisterstiche: Knight, Death and Devil*, 1513; *Melencolia*, 1514; and *St. Jerome*

in His Cell, 1514. This contrast makes it clear that the artists of the Danube School had continued an essentially Gothic stylistic approach to art at a time when Dürer was uniting both the Gothic and Renaissance spirits in his graphic production.

Also linked to the Danube School is Lucas Cranach (1472–1553) who influenced its artists with his vigorous, tapestried style unconcerned with symmetry or perspective, when he worked in Vienna, *ca.* 1500–05. Aside from the Venetian artist Jacopo de' Barbari, whose work he knew in Wittenberg, Cranach's awareness of Italian art and the classical canons came mainly through the Netherlandish Renaissance Mannerists whom he met during a visit to Antwerp in 1508. Like other Germans whose contact with the Italian Renaissance was either distant, indirect, or non-existent, Cranach produced compositions with an energetic rhythm and a concept of landscape not bound to classical ideals of balance, proportion, and linear perspective. Rather, his response to nature was a spontaneous, intimate one, as can be seen in the drawing of *St. Eustache* (cat. no. 176), which has a freshness and freedom not unlike the lilt of an eighteenth-century Venetian like Guardi. Although their stature has always been secondary to Dürer's, the artists of the Danube School helped create a picturesque, highly expressive art, particularly in the field of landscape. Here, nature does not reflect an order imposed on it by the human mind; instead, man himself is represented as an integral, organic element of nature.

Drawings by some members of the Danube School were enhanced by the use of colored papers. (German woodcut artists simulated this technique through the means of chiaroscuro woodcuts generally printed in two tones.) Colored papers had originated in Italy in the thirteenth century but German artists only adopted them in the early sixteenth century. These newly employed blue, brown, green, and brick red papers provided backgrounds for drawings that were so finished they resembled paintings. However, the use of a single hue for both background and image gave a tonal unity to chiaroscuro drawings that set them apart from contemporaneous paintings. Often brilliantly highlighted with white, such drawings by both German and Swiss artists including Albrecht Altdorfer, Wolf Huber, Hans Leu, Urs Graf, and Niklaus Manuel Deutsch have an eerie, spectral quality for modern viewers, although the artists themselves had been chiefly seeking to heighten the illusionism of their work.

The three supreme German draftsmen of the sixteenth century—Dürer (1471–1528), Grünewald (*ca.* 1475–1528), and Holbein (1497/98–1543)—represent distinct styles: Dürer, the grafting of Italian Renaissance ideals onto the German late Gothic; Grünewald, the full expression of the native German spirit in a monumental form largely untouched by

the Italian Renaissance; and Holbein, the restraint, repose, and objectivity of a true classic German Renaissance master.

Dürer's drawings, executed in practically every technique and medium and ranging from slight sketches to finished watercolors, represent one of the greatest bodies of graphic art in the world. Freed from Schongauer's tighter, more Gothic linearity, Dürer's calligraphic line assumed a distinctive rhythmic character at once fine, sure, supple, and strong. The vital quality of Dürer's highly individual draftsmanship identifies it as the expression of an intense and probing personality. Placing Dürer apart from other graphic artists was his ability to outline and model purely by line, including some of the most varied crosshatching ever seen. The descriptive realism of German art, first seen in developed form in the portraits of Hans Holbein the Elder (1460/70–1524), could never be entirely subordinated to the generalized beauty presented by the Italians, and in Dürer's work this realism crystalized into an almost photographic vision of clarity and detail, particularly in his nature studies and landscape views.

The sampling of Dürer drawings in the exhibition covers two decades. The earliest work (1493) is his *Self-Portrait, Hand, and Pillow* (cat. no. 171); its magnificent *verso* is *Six Pillows*, in which one can find "hidden" faces in the configurations of the folds. The masterly strength and freedom of the artist's line are fully apparent as it curves and swings with the contours of the forms. Dürer's drawing of the hand, as well as another sheet of his hand studies in the Albertina, should be compared to the elder Holbein's *Studies of a Hand* in the Basel Museum in order to appreciate the varied, yet compelling, expressions of realism in the graphic work of these two artists.

In *Nude Woman with Herald's Wand* (cat. no. 172), one of Dürer's earliest studies of a female nude, he attempts to delineate this subject in accordance with Italian standards; despite his efforts, however, his characterization remains fundamentally northern. The heavily muscled shoulders portrayed in this work also appear in other Dürer nudes of the period, for example, the *Fortuna*, in the Lehman collection, and the two left-hand figures in *Four Naked Women*, an engraving of 1497, although in the latter the musculature is less pronounced. In the *Nude Woman with a Staff*, of about 1501–03 (cat. no. 173), the shoulders are already drawn with sloping lines like those in the Morgan Library's drawing of *Adam and Eve* and in the two 1507 paintings of the same subject in the Prado.

In the *Madonna and Child*, dated 1512–14 (cat. no. 174), the lines on the lower front part of the Madonna's drapery are drawn with a regularity rather unusual for Dürer. This sharp passage of parallel strokes is almost blocklike, a configuration further emphasized by the

two long, straight, and closely placed lines at the right. Like the *Madonna on a Chair* in the Accademia, Venice, and other Dürer sketches of the Madonna this sheet was apparently begun as a study of drapery. This accounts for the difference in treatment between the detail of the drapery and the Madonna's unshaded mantle, which was added to complete the image. The Seattle drawing shares with that in Venice the apparent fur trim at the hem of the drapery.

During the period of 1512–14 Dürer used a broader, more simplified drawing style, utilizing straight, repeated parallel lines whose economical, abstracting effect is strikingly apparent in the Metropolitan's *Holy Family in a Trellis*. In 1513 Dürer began drawing a series of overlapping profiles, of which *Four Heads in Profile* (cat. no.175) is the most outstanding example. Generally the artist began with a normal male head from which he developed a frieze of ugly or grotesque profiles. Five female profiles of varying aspect appear on a sheet in the Szépmüvészeti Múzeum, Budapest. Although Leonardo's drawings of abnormal faces undoubtedly stimulated these studies, it has also been suggested that another inspiration came from a book published by Pomponio Gaurico in 1504, *De Sculptura*, which contained a chapter entitled, "De Physiognomia."

Schoenberger wrote aptly that while Dürer's drawings lived on in his paintings, Grünewald's paintings already lived in his drawings. Compared to the over one thousand extant drawings by Dürer, the extremely small number by Grünewald, who was not an engraver, proves they were less central to his artistic activity. But with their powerful mystical realism, Grünewald's drawings have an individuality that cannot be likened to any work preceding them. It can be said that the expressiveness and emotionalism of the Baroque, which was probably the true continuation of the Gothic spirit rather than that of the Renaissance, is already manifest in Grünewald, whereas Dürer remained tied to the doctrines of the Italian Renaissance, trying to rectify, according to Italian values, the errors he perceived in his native art. Grünewald bypassed the Italian rationalistic controls to portray forms, not according to the classical canons of sculpture and proportion, but as the embodiments of spiritual states: the language of the soul revealed by the movements of the body.

Mathis Neithardt Gothardt, called Grünewald, worked as painter and architect of the court of the Archbishop of Mainz from 1510 to 1525. Although he may have made numerous drawings in this medium, only one work in pen is known by Grünewald, and of his thirty-six known drawings only one (cat. no. 177) is in the United States. The structure of this remarkable drapery study has defied explanation and perplexed interpreters for years, since it covers the underlying figure so completely that it conceals its exact position. Schoen-

berger linked the drawing study with a figure in Grünewald's lost painting of *The Transfiguration*, most likely that of St. Peter; a study for the saint's figure is in the Print Room of the Dresden Museum. In that wildly expressive work St. Peter's body is sharply defined beneath the voluminous cloak with its broadly rendered folds. The Smith College drawing may possibly have been a preliminary essay in the arrangement of a flowing robe which was not resolved and completed, since the triangular overlap in the center of the drapery is not as finished as the rest of the drawing. It may even be that the position of the body changed in the artist's mind while he was drawing, a possibility that could explain the difficulty in deciphering its pose under the enveloping garment. Heir to the great Germanic genius for patterning drapery which had culminated in Schongauer, Grünewald drew weighty, plastic folds and rippling, radiating pleats in his favorite medium of black chalk, which gives a full range of tonal contrasts. Variously heightened and modulated for pictorial effect, in their highly perfected form his drapery studies convey a palpable reality with almost irresistible persuasiveness.

Hans Holbein the Younger (*ca.*1497/98–1543) is best known as a draftsman for the two major collections of his drawings at Basel and Windsor Castle. The first contains a great variety of Holbein's drawings; the second is almost exclusively comprised of his English portraits, over eighty of them, dating from 1527 to 1540, portraying most of the personages from the court of Henry VIII. An international man of the courts himself, somewhat like Rubens, Holbein was an artist of considerable diversity: not only a portraitist, historical painter, miniaturist, and muralist, but also a designer of stained glass and woodcuts. To some extent the character of his art was formed and influenced by his early life in Basel, then a humanist center of the book trade, as well as by his travel into Lombardy where he was obviously influenced by Leonardo, and, not least, by his study in France of drawings by the Clouets. He also continued the keen realism of his father, Hans Holbein the Elder.

Many of Holbein's chalk drawings have suffered the stresses of time and various degrees of restoration (cat. no.179). Retouching is also discernible in a drawing (cat. no.180), ascribed variously to Holbein's second Basel period, after his return from France in 1524, and to his first return to Switzerland from England in 1528. K.T. Parker pointed out that sometime between 1528 and 1530 Holbein gave up using a natural white paper in favor of a colored background. This signified a "revival," as it were, of his earlier use (1520–1521) of vividly colored papers. Rather than the brick reds of his youthful period, however, he later employed a variety of pinks to tone the backgrounds of his English portraits which convey a mood that is generally restrained and reticent.

Germany did not have an important period of Mannerist art, nor was the second half of the sixteenth century rich in outstanding masters. Thus the recent assignment to the sixteenth-century German school of a striking drawing previously held by Winkler to be Flemish offers a rare impressive example of German Mannerism. In terms of the relationship of figures to setting, *The Judgment of Solomon* (cat. no.181) by the so-called Liechtenstein Master provides a striking contrast to the possibly contemporary *Holy Family with Joseph as Carpenter* by Jean de Gourmont (cat. no. 133). Whereas the French artist used a few unobtrusive figures in his large perspective view, the Liechtenstein Master peopled his studied architectural interior with many figures who express the drama of the artist's theme with broad, outwardly flung gestures that add to the bold movement of the scene. Even though the sun is placed quite high in the French drawing, the lighting is subdued and the shadows delicate, while in the German work light and shadow contrast sharply in the interior setting, with the source of light chiefly from the right. Undoubtedly influenced by Netherlandish Mannerists, the Master of Liechtenstein translated these influences into the terms of his own characteristic German expressiveness; this expressiveness, as can be seen in some of his other drawings, at times inclined in its intensity towards the grotesque.

In the seventeenth century the development of art and culture in Germany was arrested by the bitter struggle of the Thirty Years' War; not until the beginning of the eighteenth century had the country sufficiently recovered to again cultivate art. German draftsmen of the 1700s mirrored the prevalent styles of the Baroque and Rococo without attaining the strength and individuality of their French and Italian contemporaries. Actually, not until the latter nineteenth century with Menzel and Liebl, the Impressionist Lovis Corinth, and finally in the twentieth with the Expressionists, did the native German graphic art regain the aesthetic force that had placed its drawings of the fifteenth and early sixteenth centuries among the most distinctive in Europe.

Catalog

166. GERMAN, mid-14th century
Typological Scenes, "Biblia Pauperum"
Recto: Betrayal of Christ
Verso: Christ before Pilate
Ink and watercolor on vellum
10¼ x 7⅛ in. (25.5 x 18.2 cm.)
Mark Lansburgh

Collection: Swiss Collection, 1964
Literature: M. Lansburgh. "Medieval and
Renaissance Manuscripts and Graphic Arts at
Colorado College." *Colorado College Magazine*
2 (Summer 1967), no. 3; idem. "The Illumi-
nated Manuscript Collection at Colorado
College." *Art Journal* XXVIII (Fall 1968), no. 1.

167. ALSATIAN, 15th century
God Crowning the Daughter of Zion
Watercolor, 6½ x 6⅛ in. (16.5 x 15.5 cm.)
Los Angeles County Museum of Art
Gift of the Graphic Arts Council

Collections: Siegfried Laemmle; W. Laemmle
Literature: *Medieval and Renaissance
Illuminated Manuscripts.*
Los Angeles County Museum,
1953-54. no. 87.

168. MASTER OF THE COBURG ROUNDELS
(German, active late 15th century)
Studies of a Madonna and Female Saints
Verso: Drapery Studies
Brown ink
11¼ x 8¼ in. (28.8 x 21.1 cm.)
E. B. Crocker Art Gallery

Literature: H. Tietze. *European Master
Drawings in the United States.* New York, 1947.
no. 10, repr.; *Master Drawings from Sacramento.*
E. B. Crocker Art Gallery, Sacramento, 1971.
no. 5, repr.

169. GERMAN, late 15th century
Standing Madonna with Nursing Child
White ink on prepared brown paper
7⅜ x 4⅞ in. (18.7 x 12.2 cm.)

Los Angeles County Museum of Art
Los Angeles County Funds

Collection: Schaeffer Galleries
Literature: *Illustrated Handbook.* Los Angeles
County Museum of Art, 1965. repr. p. 120.

Dr. Ernst Buchner originally attributed
this drawing to Sigmund Holbein (*ca.* 1470-
1540), but Dr. Fritz Grossman considers the
work earlier than Holbein. The theme is ob-
viously based on that by the Master of Flémalle.

170. BERNHARD STRIGEL
(German, *ca.* 1460/61-1528)
Two Lovers
India ink, heightened with white, on red paper
7¹¹⁄₁₆ x 6¹¹⁄₁₆ in. (19.5 x 17.0 cm.)
The Pierpont Morgan Library

Collections: Jonathan Richardson, Sr.;
Jonathan Richardson, Jr.; Charles (?) Rogers;
Sir Thomas Lawrence; William Russell; Sir John
Charles Robinson; Charles Fairfax Murray
Literature: C. Fairfax Murray. *Drawings by the
Old Masters: Collection of J. Pierpont Morgan.*
4 vols. London, 1905-12. vol. I, no. 250; K. T.
Parker, W. Hugelshofer. "Bernard Strigel als
Zeichner." *Belvedere*, 1925. vol. 8, fig. 8,
pp. 27-44, pl. 12, repr.; S. J. Freedberg. *Fogg
Museum Bulletin.* Harvard University, 1938.
vol. VIII, no. 1, p. 20, fig. 5; R. Shoolman and
C. E. Slatkin. *The Enjoyment of Art in America.*
New York, 1942. pl. 446; G. Otto. *Bernhard
Strigel.* Munich, 1964. p. 30, cat. no. 96,
p. 108, pl. 162.

171. ALBRECHT DÜRER (German, 1471-1528)
Self-Portrait, Hand, and Pillow, 1493
Verso: Six Pillows
Brown ink
11¹⁵⁄₁₆ x 7¹⁵⁄₁₆ in. (27.8 x 20.2 cm.)
The monogram, an early form of Dürer's signa-
ture, is by another hand, but the date on the *verso*
of the drawing, 1493, is autographic.
Watermark: Coat of arms with three fleurs-de-lis
with cross (Briquet 1749 [?] or 1799)
The Metropolitan Museum of Art
Robert Lehman Collection

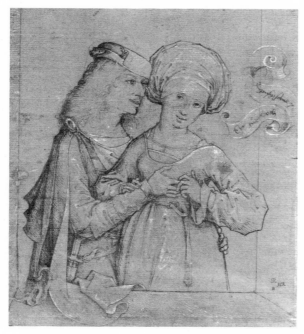

170

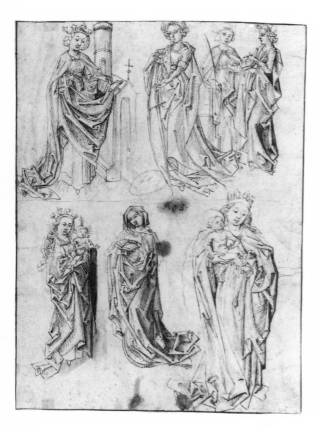

168

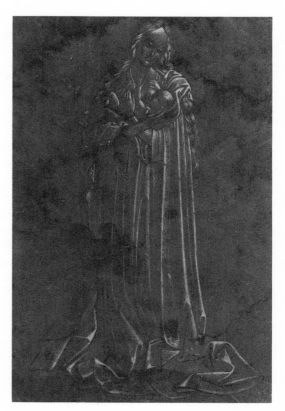

169

Collection: Lemberg, Lubomirski Museum
Literature: H. S. Reitlinger. "An Unknown Collection of Dürer Drawings." *Burlington Magazine* 50 (1927): 154; H. Höhn. *Albrecht Dürer und seine frankische Heimat.* Nuremberg, 1928. pl. 14; M. Gebarowicz, H. Tietze. *Albrecht Dürers Zeichnungen im Lubomirski Museum im Lemberg.* Vienna, 1929. p. 15; H. Kehrer. *Dürers Selbstbildnisse und die Dürer-Bildnesse.* Berlin, 1934. p. 31; F. Winkler. *Die Zeichnungen Albrecht Dürers.* 4 vols. Berlin, 1936–39. pp. 36–37, pl. 4; E. Panofsky. *Albrecht Dürer.* 2 vols. Princeton, 1943–45. I : 25; H. Tietze. *Dürer als Zeichner und Aquarellist.* Vienna, 1951. p. 37; E. Buchner. *Das deutsche Bildnis der Spätgothik und der frühen Dürerzeit.* Berlin, 1953. p. 147, no. 168; J. Jahn. *Albrecht Dürer.* Berlin, 1954. p. 122; *Exposition de la Collection Lehman.* Galerie de l'Orangerie, Paris, 1957. p. 67, no. 92, pl. LVIII; *The Lehman Collection.* Cincinnati Art Museum, 1959. p. 27, no. 250, fig. 250; H. Ladendorf. "Zur Frage der kunstlerischen Phantasie." *Museion: Studien aus Kunst und Geschichte fur Otto H. Förster.* Cologne, 1960. p. 21; *Dürer in America, His Graphic Work.* Washington, D.C., 1971. p. 24, no. I, pl. I; H. G. Evers. *Dürer bei Memling.* Munich, 1972. p. 48; R. F. Timken-Zinkann. *Ein Mensch namens Dürer.* Berlin, 1972. p. 96; W. L. Strauss. *The Complete Drawings of Albrecht Dürer.* 6 vols. New York, 1974. pp. 146–49.

172. ALBRECHT DÜRER (German, 1471–1528)
Nude Woman with Herald's Wand, 1498
Brown ink
12¼ x 8¼ in. (31.0 x 20.9 cm.)
E. B. Crocker Art Gallery

Literature: H. Tietze, E. Tietze-Conrat. *Kritisches verzeichnis der Werke Albrecht Dürers.* 2 vols. Basel and Leipzig, 1937. vol. II, no. 127A; H. N. Pratt. "The E. B. Crocker Collection of Old Master Drawings." *Prints* 8 (Oct. 1937): 27, 30; A. Neumeyer. "Albrecht Dürer, Study of a Nude Female Figure." *Old Master Drawings* 13 (June 1938): 16–17, pl. 15; F. Stampfle. *Drawings and Prints by Albrecht Dürer.* The Pierpont Morgan Library, New York, 1955. pp. 3–4; *Dürer in America, His Graphic Work.* Washington, D.C., 1971. no. V, repr.; W. L. Strauss. *The Complete Drawings of Albrecht Dürer.* 6 vols. New York, 1974. I : 466.

173. ALBRECHT DÜRER (German, 1471–1528)
Nude Woman with a Staff, ca. 1501–1503
Pen with brown ink and brown wash
9¼ x 3¾ in. (23.5 x 9.6 cm.)
National Gallery of Canada, Ottawa

Collections: Prince George Lubomirski, formerly deposited in the museum at Lemberg (or Lwow), Poland; Colnaghi's, London; presented by Joseph Hirshhorn and a group of his friends and associates.
Literature: H. S. Reitlinger. "An Unknown Collection of Dürer Drawings." *Burlington Magazine* 50 (1927): 159, pl. 110; M. Gebarowicz, H. Tietze. *Albrecht Dürers Zeichnungen im Lubomirski Museum im Lemberg.* Vienna, 1929. no 12, pp. 18, 19, pl. XIV; F. Lippmann. *Zeichnungen von Albrecht Dürer in Nachbildungen.* 7 vols. (vols. 6 and 7 by F. Winkler). Berlin, 1883–1929. vol. VII, no. 751; E. Flechsig. *Albrecht Dürer.* Berlin, 1931. II : 150, 183, 185, no. 265, repr.; F. Winkler. *Die Zeichnungen Albrecht Dürers.* 4 vols. Berlin, 1936–39. no. 265; H. Tietze, E. Tietze-Conrat. *Kritisches verzeichnis der Werke Albrecht Dürers.* Basel and Leipzig, 1937. II : 17, no. 251a, repr. p. 174; E. Panofsky. *Albrecht Dürer.* 2 vols. Princeton, 1943–45. II : 118, no. 1185; K. M. Fenwick. "A Gift of a Notable Dürer." *Canadian Art* XIII (1956): 331, repr.; *Colnaghi's, 1760–1960.* London, 1960. no. 71, repr.; I. Moskowitz, ed. *Great Drawings of All Time.* 4 vols. New York, 1962. vol. II, no. 342, repr. (entry by O. Benesch); K. M. Fenwick. "The Collection of Drawings." *The National Gallery of Canada Bulletin* II, no. 2 (1964): 2, 6, fig. 5; A. Emery. "The Nude in Art." *Canadian Art* XXII (Jan.–Feb. 1965): 41; A. E. Popham, K. M. Fenwick. *European Drawings in the Collection of the National Gallery of Canada.*

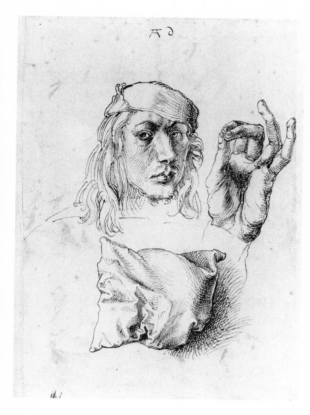

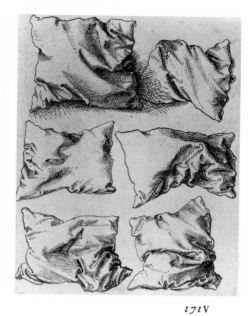

171R

171V

172

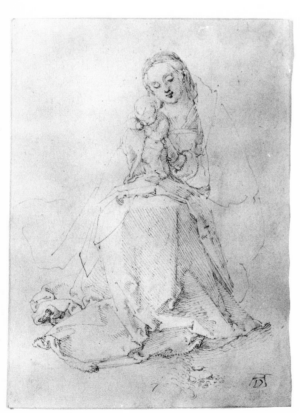

174

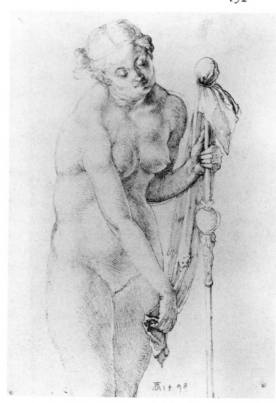

Toronto, 1965. p. 127, no. 183; *Dürer in America, His Graphic Work*. Washington, D.C., 1971. no. VIII, repr.; W. L. Strauss. *The Complete Drawings of Albrecht Dürer*. 6 vols. New York, 1974. vol. 2, repr. p. 556, dated 1500.

174. ALBRECHT DÜRER (German, 1471–1528)
Madonna and Child, 1512–1514
Brown ink
7 3/16 x 5 3/16 in. (18.2 x 13.0 cm.)
The Dürer monogram at lower right is by another hand.
The Seattle Art Museum
Leroy M. Backus Collection

Collections: Sir Thomas Lawrence (Sale, Christie's, London, 1830, no. 12); C. S. Bale (Sale, Christie's, London, 1881, pt. VI, no. 2279); W. Mitchell (Sale, P. A. C. Prestel, Frankfurt/M, 1890, no. 18); K. Alexander, Grand Duke of Weimar; L. V. Randall; Leroy M. Backus
Literature: *Albrecht Dürer and Lucas van Leyden*. Burlington Fine Arts Club, London, 1869. no. 135; C. Ephrussi. *Albrecht Dürer et ses dessins*. Paris, 1882. pp. 189–90; F. Lippmann. *Zeichnungen von Albrecht Dürer in Nachbildungen*. 7 vols. (vols. 6 and 7 by F. Winkler). Berlin,1883 –1929. I:17, no. 77, pl. 77; E. Heidrich. *Geschichte des Dürerschen Marienbildes*. Leipzig, 1906. p. 29; E. Flechsig. *Albrecht Dürer: Sein Leben und seine kunstlerische Entwicklung*. 2 vols. Berlin, 1928, 1931. II:286, no. 846; F. Winkler. *Die Zeichnungen Albrecht Dürers*. 4 vols. Berlin, 1936–39. III:21-22, no. 548; H. Tietze, E. Tietze-Conrat. *Kritisches verzeichnis der Werke Albrecht Dürers*. 2 vols. Basel, 1937. II:100, pt. 1, no. 602, pl. 252; E. Panofsky. *The Life and Art of Albrecht Dürer*. 3rd ed., 2 vols. Princeton, 1948 (4th ed., 1955, text, illustrations, and revision without handlist; same pagination as 3rd ed., vol. I). vol. II, no. 674; *Bulletin of the Schaeffer Gallery*. New York, Nov. 1948. no. 6; *LeRoy M. Backus Memorial Collection*. Seattle Art Museum, 1952. no. 8; W. M. Conway. *The Writings of Albrecht Dürer*. New York, 1958. no. 580; C. W. Talbot, G. F.

Ravenel, J. A. Levenson. *Dürer in America, His Graphic Work*. National Gallery of Art, Washington, D.C., 1971. pp. 68–70, figs. XIX and XIXa (*verso*); E. Gunter Troche. *Albrecht Dürer, Graphic Master*. Achenbach Foundation of Graphic Arts, California Palace of the Legion of Honor, San Francisco, 1971. not repr.; W. L. Strauss. *The Complete Drawings of Albrecht Dürer*. 6 vols. New York, 1974. vol. 3, repr. p.1412.

175. ALBRECHT DÜRER (German, 1471–1528)
Four Heads in Profile, ca. 1513
Brown ink
8 1/4 x 7 7/8 in. (21.0 x 20.0 cm.)
The William Rockhill Nelson Gallery and the Atkins Museum of Fine Arts
Nelson Fund

Collections: Willibald Imhoff; A. F. Andréossy; Sir Thomas Lawrence; Defer-Dumesnil
Literature: J. Heller. *Das Leben und die Werke Albrecht Dürers*. Bamberg, 1827. p. 84; C. Ephrussi. *Albrecht Dürer et ses dessins*. Paris, 1882. repr. p. 127; F. Lippmann. *Zeichnungen von Albrecht Dürer in Nachbildungen*. 7 vols. Berlin, 1883–1929. 4:11; H. Knackfuss. *Albrecht Dürer*. London, 1900. p. 149, fig. 133; R. Bruck. *Das Skizzenbuch von Albrecht Dürer in der Konglichen Offentlichen Bibliothek zu Dresden*. Strasbourg, 1905. pl. 122; E. Flechsig. *Albrecht Dürer: Sein Leben und seine kunstlerische Entwicklung*. 2 vols. Berlin, 1928, 1931. 2:343–44; E. Panofsky. *The Life and Art of Albrecht Dürer*. 3rd ed., 2 vols. Princeton, 1948. p. 269; W. Waetzoldt. *Dürer and His Times*. London, 1950. p. 110; *Die Weltkunst* 24 (1954): 6, no. 10; H. Rupprich. *Dürer, Schriftlicher Nachlass*. 3 vols. Berlin, 1956–69. 2:442; F. Winkler. *Albrecht Dürer, Leben und Werke*. Berlin, 1957. p. 264; *Nelson Gallery and Atkins Museum Bulletin* 1 (Dec.1958): 11; J. Bialostocki. "Opus Quinque Dierum: Dürer's 'Christ among the Doctors' and Its Sources." *Journal of the Warburg Institute* 22 (1959): 23-25; C. White. "A Recently Discovered Drawing by Dürer." *Burlington Magazine*

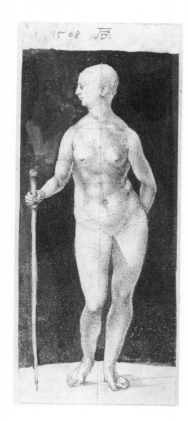

173

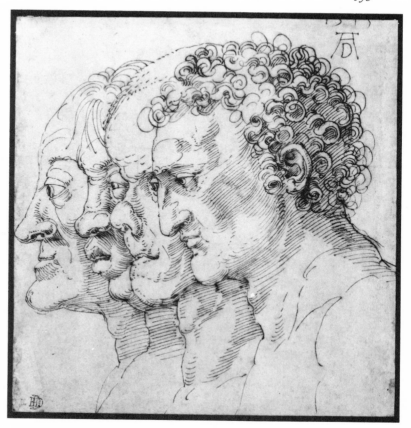

175

103 (1961): 20–23, fig. 33; *Dürer in America, His Graphic Work*. National Gallery of Art, Washington, D.C., 1971. no. xx, repr.; D. Posner. *Annibale Carracci*.... London, 1971. 1:68, fig. 63.; W. L. Strauss. *The Complete Drawings of Albrecht Dürer*. 6 vols. New York, 1974. 3:1344, repr.

176. LUCAS CRANACH (German, 1472–1553)
St. Eustache
Brown ink and wash
10 x 7½ in. (25.4 x 19.0 cm.)
Museum of Fine Arts, Boston

Collection: W. Esdaile
Literature: J. Rosenberg. "A Drawing by Lucas Cranach the Elder." *Art Quarterly*, Autumn 1954. pp. 281–85, fig. 1; *Old Master Drawings*. The Newark Museum, 1960. no. 16, repr.

177. MATHIS NEITHARDT GOTHARDT, called Grünewald (German. *ca.* 1475–1528)
Study of Drapery
Black chalk on buff paper
5⅛ x 7³⁄₁₆ in. (13.1 x 18.2 cm.)
Inscribed by a later hand at lower right: A. Dürer
Smith College Museum of Art

Collections: L. Grassi; Henry Oppenheimer (Sale, Christie's, London, July 10–14, 1936, no. 377); H. Eisemann; L. Rosenthal; Schaeffer Galleries; L. Backus; E. H. L. Sexton
Literature: M. J. Friedländer. *Die Zeichnungen von Matthias Grünewald*. Berlin, 1927. no. 1, pl.1; H. Feurstein. *Mathias Grünewald*. Bonn, 1930. pl. 64; A. Burkhard. *Matthias Grünewald, Personality and Accomplishment*. Cambridge, Mass., 1936. no. 24, repr. pl. 82, mentioned p. 70; *Catalogue of the Famous Collection of Old Master Drawings Formed by the late Henry Oppenheimer, Esq.* Christie's, London, July 10–14, 1936. no. 377, repr. pl. 86; W. K. Zulch. *Der Historische Grünewald. Mathis Gothardt Neithardt*. Munich, 1938. no. 6, repr. fig. 173; *Master Drawings*. California Palace of the Legion of Honor, San Francisco, no. 51, repr.; H. Tietze. *European Master Drawings in the United States*. New York,

1947. no. 33, described p. 66, repr. p. 67; G. Schoenberger, ed. *The Drawings of Mathis Gothart Nithart Called Gruenewald*. New York, 1948. no. 13, repr.; *Five Centuries of Drawings*. Montreal Museum of Fine Arts, Quebec, 1953. no. 88, repr.; Dr. L. Behling. *Die Handzeichnungen des Mathis Gothart Nithart gennant Grünewald*. Herman Böhlaus Nachfolger, Weimar, 1955. no. 4, not repr.; N. Pevsner, M. Meier. *Grünewald*. New York, 1958. mentioned p. 26, no. 7, repr. p. 31, fig. 7; *Check List, European Drawings*. Smith College Museum of Art, Spring 1958. no. 34; *Smith College Museum of Art Bulletin*. no. 38 (1958), repr. fig. 13; "Accessions of American and Canadian Museums Jan.–Mar., 1958." *Art Quarterly* XXI, no. 2 (Summer 1958), listed p. 220, repr. p. 236; *Old Master Drawings*. Newark Museum, 1960. no. 14, repr.; A. Weixlgärtner. *Grünewald*. Vienna, 1962. no. 6, repr.; W. Hutt. *Mathias Gothardt-Neithardt, genannt Grünewald*. Leipzig, 1968. no. 74, repr., text, p. 184; C. Chetham. "The Smith College Museum of Art." *Antiques* XCVI, no. 5 (Nov. 1969): 774–75, repr. p. 775; E. Ruhmer. *Grünewald Zeichnungen*. Cologne, 1970. no. 3, repr., text, pp. 22, 80; P. Bianconi. *L'opera completa di Grünewald*. Milan, 1972. no. 42; F. Baumgart. *Grünewald, tutti i disegni*. Florence, 1974. no. 18, repr.; "Lost Painting Turns Up in U.S.," *San Francisco Chronicle*, Sept. 18, 1974.

178. MASTER OF MUHLDORF (German, active *ca.* 1505–1520)
The Annunciation, 1514
Brown ink and wash, heightened with white on red prepared paper
8¾ x 6¼ in. (21.5 x 15.5 cm.)
E. B. Crocker Art Gallery

Collections: Count Franz Joseph Sternberg, Prague; E. B. Crocker
Literature: *Old Master Drawings from the E. B. Crocker Collection: The German Masters, 15th to 19th Centuries*. Sacramento, 1939. group one, no. 11; F. Winzinger. *Albrecht Altdorfer Graphik*.

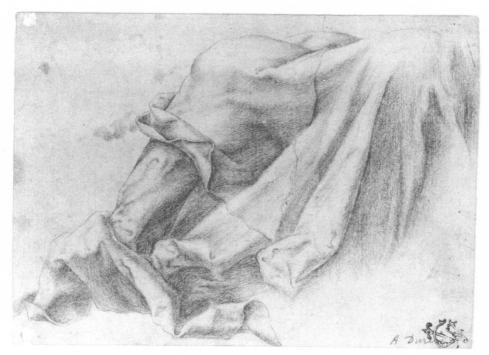

177

176

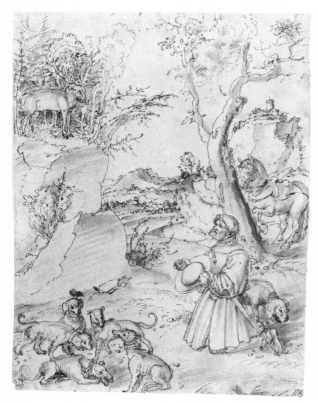

178

Munich, 1963. p. 18; *Master Drawings from California Collections.* University Art Museum, Berkeley, 1968. no. 24, 102; *The Danube School.* Yale University Art Gallery, 1969. no. 75; *Master Drawings from Sacramento.* E. B. Crocker Gallery, Sacramento, 1971. no. 11, repr.

179. HANS HOLBEIN THE YOUNGER
(German, 1497/98–1543)
Head of a Young Man
Natural red and black chalks, quill pen and carbon black ink, with washes of ochre on a laid paper, on a woven paper support
8⅛ x 6 in. (20.5 x 15.2 cm.)
Dated at upper edge in chalk: 1523. Inscribed on the *verso* by Wilhelm Koller: *Portrat U. von Hütten in seinem Todesjahr.*
Fogg Art Museum
Gift of Paul J. Sachs

Collections: W. Koller; Freiherr von Lanna; M. Bonn; Colnaghi's, London; Paul J. Sachs, 1922
Literature: A. Woltmann. *Holbein und sein Zeit.* Leipzig. II:149–50; *Master Drawings Selected from the Museums and Private Collections in America.* Buffalo Fine Arts Academy, 1935. no. 32, repr.; A. Mongan, P. Sachs. *Drawings in the Fogg Museum of Art.* 3 vols. Cambridge, 1940. no. 386, fig. 196; H. Tietze. *European Master Drawings in the United States.* New York, 1947. p. 74, no. 39, repr.; J. Watrous. *The Craft of Old Master Drawings.* Madison, Wis., 1957. pp. 106, 110, repr. p. 111; I. Moskowitz, ed. *Great Drawings of All Time.* 4 vols. New York, 1962. vol. II, pl. 437; *Memorial Exhibition: Works of Art from the Collection of Paul J. Sachs (1878–1965) Given and Bequeathed to the Fogg Art Museum.* Cambridge and New York, 1966–67. no. 13.

Although this drawing has long been held to be the portrait of a leper, modern medical opinion has diagnosed the young man's condition as "a case of *impetigo contagioso.*" (See *Memorial Exhibition...Paul J. Sachs....*above.)

180. HANS HOLBEIN THE YOUNGER
(German, 1497/98–1543)
Bust of a Young Man, Three-Quarters to the Left
Black, yellow, and red chalk
11 13/16 x 7⅞ in. (30.0 x 20.0 cm.)
Woodner Family Collection

Collections: E. Jabach; J. C. Ritter von Klinkosch; Baron Liebig; Baron H. Thyssen-Bornemisza
Literature: P. Ganz. *Les dessins de Hans Holbein le jeune.* Geneva, 1939. no. 465; R. Heinemann. *The Baron H. Thyssen-Bornemisza Collection.* Lugano, 1949 (other editions, 1952, 1958). no. 198, pl. 29; *Woodner Collection I: A Selection of Old Master Drawings before 1700.* New York, 1971. no. 53, repr.

181. MASTER OF THE LIECHTENSTEIN ADORATION (German, 16th century)
The Judgment of Solomon
Brown ink and wash, heightened with white on prepared pink paper
8½ x 12¼ in. (21.6 x 31.8 cm.)
Mr. and Mrs. Julius S. Held

Collection: Duke of Liechtenstein
Literature: F. Winkler. "The Anonymous Liechtenstein Master." *Master Drawings* I, no. 2 (1963): 34, pl. 31; *Selections from the Drawing Collection of Mr. and Mrs. Julius S. Held.* University Art Gallery, State University of New York at Binghamton, Jan. 5–28, 1970. no. 88.

182. CHRISTOPH MURER (Swiss, 1558–1614)
The Virgin and Child with Pope and Bishop Saint
Black ink with blue gray wash
10⅞ x 8⅛ in. (27.6 x 20.7 cm.)
Inscribed in pencil by a later hand: CM 1595
Los Angeles County Museum of Art
Gift of the Graphic Arts Council in memory of Kate Steinitz

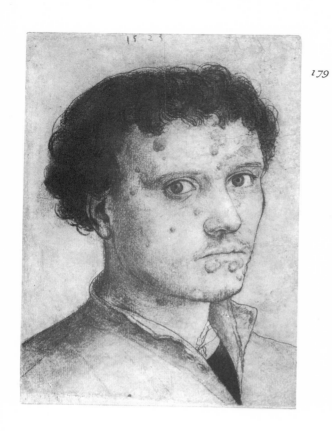

179

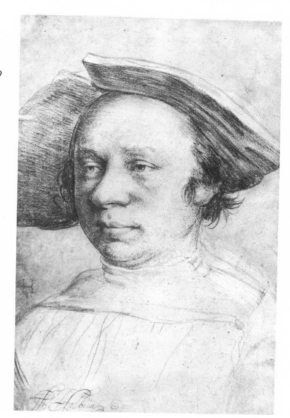

180

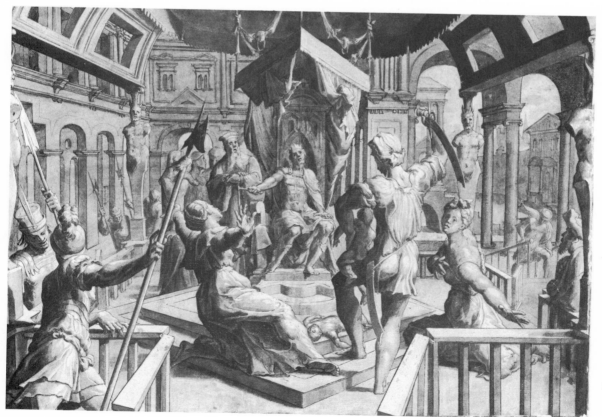

181

Literature: Unpublished

Although Murer is considered the chief stained-glass painter of the latter sixteenth-century Swiss school, his drawings have not been systematically studied. He was the pupil of his father, the glass painter Joss Murer, and was also influenced by Tobias Stimmer. He is recorded as having frequented Stimmer's studio in Schaffhauen and in Strasbourg. At one time Murer also lived in Basel, where he came in contact with followers of Hans Holbein the Younger.

The present drawing appears to belong to Murer's middle period, as the penciled date suggests. The bishop saint's tonsure is drawn in a manner not unlike Stimmer's rendering of hair, while the hatching on the Virgin's face and mantle corresponds to Murer's entirely linear drawing of the *Death of Lucretia*, 1588, in the Basel Museum. These features tend to confirm the drawing as a work in which traces of both Stimmer's influence and Murer's earlier style are present.

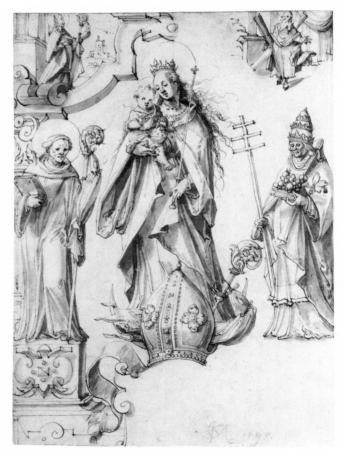

182

The Dutch School

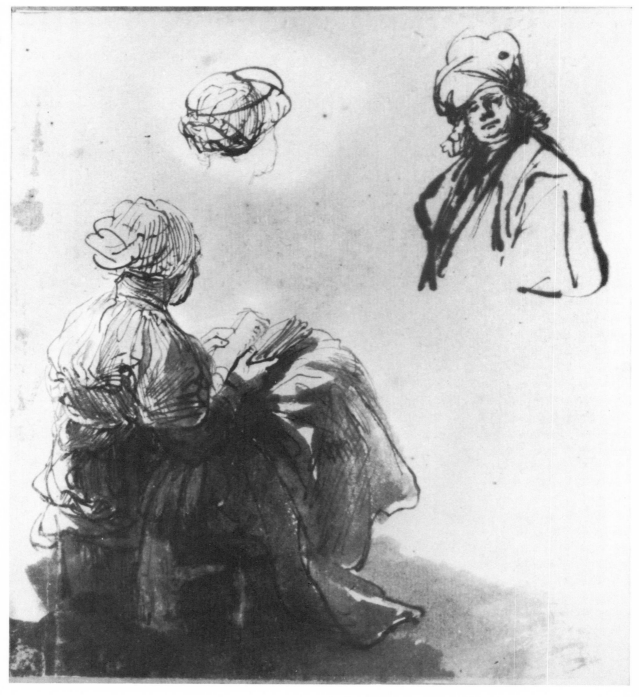

The Dutch School

THROUGHOUT the fifteenth century there was more or less common ground for aesthetic expression in both the northern and southern regions of the Low Countries. Under the leadership of the dukes of Burgundy, the southern area made a special contribution to European art during this period; with their late Gothic realism and detail, the works of the great Flemish primitives were as important and successful as those of the Italian masters of the early Renaissance. In contrast, the north produced artists at a much slower rate, and for the most part they mirrored the accomplishments of their southern compatriots. Eventually, in the late sixteenth century a decisive break split the Low Countries: the predominately Protestant north seceded and became the independent Dutch Republic, while the Catholic south, called Flanders, remained under Spain's dominion. When the northern region (modern Holland) broke away from Spain, it established the religious and political freedoms that have since been identified with the Dutch land and its people. Artists, too, felt an easing of constraint as the world seemed to open up to their vision, and in the wake of this new liberty their works reveal a sense of harmonious well being.

At the time that Lucas van Leyden (1489/94–1533) emerged as an important painter there was still no readily identifiable Dutch tradition in art. However, his native qualities of restraint and quiet humanity were strong enough to find expression in his art, even when the powerful influence of Dürer was evident. Lucas was the first Dutch artist to break away from the late Gothic style and was also the first draftsman in Holland to employ the medium of chalk. Historically he is considered more important as an engraver and a designer of woodcuts than as a draftsman, if only because so few of his drawings exist compared to his more numerous engravings. Influenced by the engravings of Marcantonio Raimondi, Lucas' graphic work tended to become more classical, which diminished his native characteristics of intimacy and naturalism.

Like Lucas van Leyden, the Dutch Mannerists of the latter sixteenth century followed the examples of foreign artists. Thus, Dutch Mannerism was a response to the art of the School of Fontainebleau which had in turn been formed principally by the Italians Rosso Fiorentino, Francesco Primaticcio, and Nicolò dell'Abate. Out of the courtly, highly decorative work at Fontainebleau there evolved a Dutch style in which figures were fluid yet energetically charged and dramatically positioned, as in drawings by the noted Flemish Mannerist Bartholomaus Spranger (1546–*ca.*1638). *Odysseus and Tiresias* (cat. no.189),

once attributed to Spranger as well as to Cornelis van Haarlem, now seems more likely to be the work of the little-known artist Gerrit Pietersz. Sweelink (1566–1628?), who was the teacher of Pieter Lastman. Adding to the theatrical quality of the work is the remarkable unit of male nudes kneeling in the foreground; they reflect the influence of Cornelis van Haarlem who popularized the violent foreshortening of muscular nudes in late Dutch Mannerism. Generally executed with long, flowing lines; broad treatment of details; and modeling through wash, the drawings of Spranger, Cornelis van Haarlem, and Sweelink are also characterized by artificial poses and disproportionate, heavy appendages. Nevertheless, the works by these forceful "Baroque" Mannerists were popular enough to be translated into numerous engravings whose dispersal widely disseminated their style.

Among the Dutch Mannerists, the most prolific and successful was the virtuoso draftsman and engraver, Hendrik Goltzius (1558–1617), who early in his career was influenced by Spranger. Goltzius first traveled to Italy in 1590–91 and the work he saw there caused him to subdue some of the more fantastic features found in his earlier *oeuvre*. His later drawings with their classical aspects summed up the best and most influential elements of the Dutch Mannerist school, and his landscape drawings established the precedent for subsequent Dutch scenic views. Goltzius and his pupil Jacob de Gheyn II (1565–1629) are represented in the exhibition by remarkable landscape drawings (cat. nos. 184, 186). Early in his career Dürer had used similar landscape motifs as backgrounds for some of his engravings, and Goltzius seems to repeat the German artist's swinging strokes, animating the landscape with stressed, accentuating lines that enliven the composition with an organic vitality. In Jacob de Gheyn's landscape (cat. no. 186) the linear movements become more rhythmic and flowing, suggesting the intensely emotional response to nature that is so acute in the work of the greatest Dutch draftsman after Rembrandt, Vincent van Gogh.

Born one year before Jacob de Gheyn, Abraham Bloemaert (1564–1651) lived considerably longer, dying at the age of eighty-seven. His influence was widespread, prolonged through engraved reproductions well into the eighteenth century in France. Bloemaert was one of the early proponents of Dutch Mannerism who was affected by the strongly Italianized Dutch and Flemish painters of his time, by the French School of Fontainebleau, and by the works of Caravaggio. On the whole, Bloemaert's drawings have a remarkable consistency, especially in their wavy, strongly rhythmic lines, which makes it difficult to sort them chronologically. The artist's distinctive silhouette patterning was used to achieve picturesque effects, particularly in landscape elements. This silhouetting is often evident in his treatment of sprawling trees and in his foreground positioning of figures as foils to

elements in the middle plane and background. Because of the mythological subject and the mannerist, foreshortened figure in the foreground, the charming drawing *Meleager Killing the Caledonian Boar* (cat. no. 185) may be a work belonging to the artist's early period.

Like his stepfather, Goltzius, whose designs he often engraved, Jacob Matham (1571–1631) is known chiefly as an engraver. In this exhibition he is represented by a strikingly realistic study of a man's head (cat. no. 190) that was later inscribed with the monogram of his celebrated stepfather. The relentless verism of this work can be traced to Dürer's drawings of the very old or ugly and to similar, still earlier studies by Leonardo.

It has been said that all of nature presented itself as a portrait to the northern schools. Notably with the Dutch the particular rather than the general or idealized features of a subject became the essential component of nearly all their pictorial art. This was especially evident in the seventeenth century, when the full native expression of Dutch artists matured and gave form to an art rooted in a vigorous, bourgeois society concerned primarily with the things of this world.

Portraiture, still life, landscape, and genre were all categories in which Dutch artists excelled. To suggest the broad versatility of Jan van Goyen (1596–1656), perhaps one of the most characteristic of seventeenth-century Dutch landscapists, he is represented here by a genre scene (cat. no. 191) rather than by one of his more typical landscape drawings. In the category of peasant genre, the works of Pieter Bruegel the Elder (1525/30–1569) introduced themes that were not fully developed in Dutch art until the first quarter of the seventeenth century. Two outstanding pupils of Frans Hals (1580–1666), who himself depicted low life scenes with a full appreciation of their merriment and robust energy, were Adriaen Brouwer (1605/6–1638) and Adriaen van Ostade (1610–1685). Brouwer, whose example stimulated genre subjects among Dutch artists, was born near the Dutch border and lived most of his life in Flanders; he is discussed in the Flemish section.

Originally influenced by Brouwer, Adriaen van Ostade produced drawings of two general types. In his earlier period, he drew rugged individuals in ink with strong, sharp lines and brought them into relief by broad areas of wash. In his second period, the artist composed large, highly finished peasant and tavern scenes carefully developed in watercolor as preliminary studies for paintings. On occasion he also drew with chalk, as in cat. no. 199. Often drawing from life, van Ostade captured almost perfectly the spirited liveliness of the daily activities of his peasant subjects. And while some of the stocky, rounded figures appear to be distantly reminiscent of Bruegel, unlike his great predecessor van Ostade was neither a moralist nor a social critic. Van Ostade's chief followers, after his brother Isaack,

included the vigorous etcher Cornelis Pietersz. Bega (1620/31/32–1664) and van Ostade's assistant, Cornelis Dusart (1660–1704).

Bega's masterful study, *Seated Woman* (cat. no. 200), has been described as being of the same model who appears in Gerrit Berckhyde's black chalk drawing, *Standing Woman*, in the Rijksmuseum. Much in Berckhyde's style is a red chalk study, *Standing Woman* (Städelsches Kunstinstitut, Frankfurt); it is attributed to Bega, but opens up the still unresolved question of attributions of works to these artists. The broader conception of the red chalk drawing, with its more regular parallel hatching and more summary treatment of the hands and feet than are generally found in Bega's drawings, suggests that it may be Berckhyde rather than Bega.

In his scenes of *kermesses* (carnivals), taverns, and other popular amusements, Cornelis Dusart tended to satiric caricature of peasant types, in contrast to van Ostade's good-natured, more literal portrayals. But Dusart's individual figure studies, whether in chalk or watercolor, give the strong impression of having been drawn from life in their immediacy and ability to capture a natural pose. In the *Seated Man* (cat. no. 204) with the extravagant bonnet and ribboned jacket, the freshness of the portrayal is heightened by the lively combination of red, blue, and black chalks that preserves the image of the model with his whole body twisted in the effort of very intently observing something on the floor.

Nephew of Willem van de Velde II the Younger (1633–1707), the foremost Dutch painter and designer of marine subjects (cat. no. 202), Adriaen van de Velde (1636–1672) was one of the principal animal and landscape painters in seventeenth-century Holland. Because of the emphasis on such subjects and since the portrayal of the nude played a comparatively minor role in contemporary Dutch art, it is doubly surprising to find exquisite drawings of the female nude among Adriaen's graphic *oeuvre*. This may be explained, however, by the fact that the artist possibly had first-hand contact with classical art. His studies, often drawn in red chalk with long, continuous strokes, had a precedent in nudes drawn by Rembrandt's pupil, Jacob Adriaensz Backer (1608–1651). Some nudes by van de Velde, like the two in the Boymans-van Beuningen Museum, appear less finished than others, while examples in Cleveland, Hamburg, and Los Angeles are more solidly modeled. In the one from Los Angeles (cat. no. 203), van de Velde has combined a sculptural treatment of the model's flesh with a fine sensitivity and delicacy of finish that seem to anticipate works by Watteau.

Although landscape painting was one of the leading categories of seventeenth-century Dutch art, Rembrandt produced comparatively few paintings in this genre. On the other

hand, he left a large number of landscape drawings which bespeak his love for Holland's countryside. Among his numerous pupils and followers, it was chiefly Philips Koninck and Lambert Doomer (1623–1700) who were active as landscape painters. Doomer, in fact, confined his efforts exclusively to this field. One of Doomer's earliest drawings (Institut Néerlandais, Paris) is a copy of the Lehman collection's Rembrandt drawing, *Cottage near the Entrance to a Wood* (cat. no. 196). Compared to his master's often flamboyant, always individualistic style of draftsmanship, Doomer's drawings seem restrained and often exquisitely rendered, as in his *View of Orléans on the Loire* (cat. no. 201), one of the many drawings he made during a trip to France in 1645–46. Painterly both in concept and execution, this drawing carefully subordinates the linear elements of the composition to the general emphasis on subtle, carefully modulated tonal ranges, suggesting an expansive mood of stillness and an almost palpable atmosphere.

With Rembrandt van Rijn (1606–1669) the essence of creative originality was embodied in an artistic personality so strong that it absorbed whatever it needed from others while at the same time possessing its own wealth of aesthetic resources. This process produced such a powerful creativity that Rembrandt's art now seems almost self-generating. The dramatic vigor and depth of his spiritual expressiveness is unsurpassable, whether one examines his paintings, prints, or drawings. It is characteristic that Rembrandt maintained his profound individuality in the face of the strong attraction of Italian art that pervaded northern schools during the seventeenth century.

Leaving over a thousand drawings as evidence of his preoccupation with this form of expression, Rembrandt was among the first major European artists to sketch regularly for his own private enjoyment. As a result, we have a visual diary of Rembrandt's observations, imagination, and creativity which provides an intimate insight into his art. Drawing with chalk in his earlier period, he later employed pen and brush, usually with a brown ink called bistre. He used either quill or reed pens, the latter for broad and blunt strokes, the former for approximating the fluidity and varying widths of line associated with writing. Often mixing several pens to create a single work, Rembrandt was able to achieve rich contrasts of line, to which he added washes applied by brush. His drawings suggest total spontaneity, unlike the often complex structures of his prints, partly because their more immediate creation did not require the numerous stages of development needed to make an etching.

The Rembrandt drawings in the exhibition span the mid-1630s to the early 1660s. The earliest, *Joseph Telling the Dreams of the Butler and the Baker* (cat. no. 192), already evidences Rembrandt's facility for dramatic composition. The three figures form a perfect

diagonal across the upper part of the picture. At the same time, the figure of Joseph, drawn with forceful angular strokes, is liberated from the sketchy background architecture to stand suffused with light. With an eloquent gesture, his left arm projects into free space, as if into the future. The baker, more calmly portrayed in his blocklike seated position, listens intently, a foil to the impassioned butler who forms the dramatic center of the scene. In contrast to the two other men, Joseph is drawn broadly, abstractly, as though to symbolize his spiritual role as divine prophet. *Studies of a Woman Reading, and an Oriental* (cat. no. 193) is a preparatory work for Rembrandt's etching of 1638, *Joseph Telling His Dreams* (Hind 160, ill. no. 1). As is usual, the figures are reversed in the print; however, the light and shade effects are the same in both etching and drawing. The seated woman seen from three-quarter view was most likely drawn from life.

The largest of all Rembrandt's landscape drawings, *Cottage near the Entrance to a Wood* of 1644 (cat. no. 196), is truly exceptional in its large size and, particularly, in its grand conception. Combining a planar structure created by finely graduated layers of wash with a masterly use of the white, uncovered paper, this work is one of the marvels of Rembrandt's landscape studies. The luminism of the left foreground mounds is contrasted with the deep vibrancy of the shadow that falls on the trees and house and appears to be moving with the change of day. Rembrandt's special stillness and sense of atmosphere seem to envelop the figure who rests on the Dutch door of the cottage. Employing a complex yet broadly executed structure of lines and washes to create an organic unity resembling that found in nature, this drawing is also infused with a visual monumentality that is more often associated with painting. Thus in this single work Rembrandt demonstrates his consummate draftsmanship, particularly in his unparalleled mastery of the washes. In contrast, the artist's *Farm Buildings at the "Dijk"* (cat. no. 197), created around 1648, is more abbreviated, an economical sketch. In this work Rembrandt's directness and fidelity to nature are exemplary; each stroke of the drawing shapes the scene and reveals the artist's unnerving ability to extract the essential character of a natural view.

Dated by Benesch to about 1647, Rembrandt's *The Publican and the Pharisee* (cat. no. 194) unites an amplitude of space with the artist's characteristic emphasis upon a solitary figure. The self-abasing, kneeling Publican is spotlighted and set off in the foreground against the self-exalting Pharisee placed in the middle ground—an arrangement that seems almost operatic. One can easily imagine these two figures on stage, their rising voices contending for the mercy of God.

Isaac and Rebecca Spied Upon by Abimelech (cat. no. 198), a late drawing in Rembrandt's

oeuvre, is related to the painting *The Jewish Bride* in the Rijksmuseum. The drawing is based on Raphael's composition of the same subject in the Logge of the Vatican, which Rembrandt is believed to have known through an engraving. Rendered by almost wholly linear and sketchy means, the figures in Rembrandt's drawing possess a vitality that projects them away from the broad expanse of white paper. Thus, Rembrandt demonstrated the power of relatively few lines to capture the salient elements of mood and character.

As is well known, Rembrandt had a large group of followers, including Ferdinand Bol, Gebrandt van den Eeckhout, Nicolaes Maes, Samuel van Hoogstraten, and Philips Koninck, whose drawings on occasion have been confused with those of the master. In the early eighteenth century, Aert de Gelder, Rembrandt's last important pupil, still carried on his master's style. But close study reveals that although many of these draftsmen emulated Rembrandt's manner, they were nevertheless unable to equal his highly individual genius. To this day Rembrandt remains the most noted artistic personality of the seventeenth century. His drawings occupy a special place, not only as representative of the Dutch school at its very best, but in the larger context of the history of European drawing.

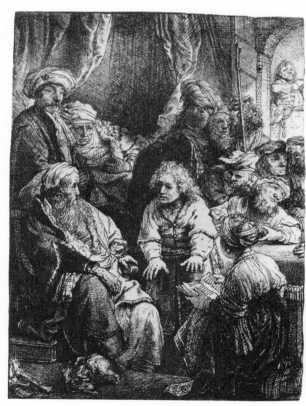

Rembrandt van Rijn
(Dutch, 1606–1669)
Joseph Telling His Dreams, 1638
Etching, third state
(11.0 x 8.3 cm.)
Engel Family Collection

Catalog

183. HENDRIK GOLTZIUS
(Dutch, 1558–1617)
Portrait of a Man, 1591
Black and red chalk with gray washes
14 x 10¹¹⁄₁₆ in. (35.1 x 26.8 cm.)
Abrams Collection, Boston, Massachusetts

Collection: B. Houthakker, 1966
Literature: *Things of This World, A Selection
of Dutch Drawings from the Collection of Maida
and George Abrams.* Williamstown, Mass.,
1972–73. no. 11, repr. p. 30.

The bust itself has been cut out and laid down
on another sheet of paper.

184. HENDRIK GOLTZIUS (Dutch, 1558–1617)
Mountainous Coastal Landscape
Brown ink over black chalk
9¼ x 15¹⁄₁₆ in. (23.6 x 38.4 cm.)
The Pierpont Morgan Library
Purchased as the gift of the Fellows with the
Special Assistance of The Lore and Rudolf
Heinemann Foundation, 1971

Collections: Count K. Lanckoronska, Vienna;
Countess A. Lanckoronska; Sale, London,
Christie's, Mar. 30, 1971, no. 97
Literature: J. Schönbrunner, J. Meder. *Hand-
zeichnungen aus der Albertina.* Vienna, 1893–
1908, no. 666; J. G. van Gelder. *Jan van de Velde.*
Amsterdam, 1933. p. 20; J. Q. van Regteren
Altena. *Jacques de Gheyn.* Amsterdam, 1935.
p. 88; *Kunstgeschiednis der Nederlandern.* 1936,
pp. 179, 181, pl. 21 (pl. 22 in editions of 1946 and
1954); E. K. J. Reznicek. *Hendrik Goltzius
Zeichnungen.* Utrecht, 1961, pp. 110, 433, no. 408,
fig. 253; *Christie's Review of the Year,* 1970–71,
p. 85; "International Saleroom." *Connoisseur*
CLXXVII (1971): 233, no. 17, repr.; F. Stampfle.
*Drawings: Major Acquisitions of the Pierpont
Morgan Library, 1924–1974.* New York, 1974.
no. 38.

185. ABRAHAM BLOEMAERT
(Dutch, 1564–1651)
Meleager Killing the Caledonian Boar
Brown ink and washes
8 x 12 in. (20.3 cm. x 30.5 cm.)
Abrams Collection, Boston, Massachusetts

Collection: C. R. Rudolf
Literature: Unpublished

Although Meleager killed the Caledonian
Boar with a spear (Ovid's *Metamorphoses,*
Book VIII) Bloemaert shows him here shooting
an arrow at the animal. In the myth, it is Atalanta
who holds the bow and arrow, and she is thus
represented in Giulio Romano's drawing of the
subject in the British Museum.

186. JACOB DE GHEYN II (Dutch, 1565–1629)
Landscape with Sleeping Peasants
Brown ink on buff paper
10⅛ x 15½ in. (25.7 x 38.7 cm.)
Anonymous

Collections: Kaienann, Brussels; A. P. E. Gasc,
C. Gasc, *ca.* 1850, with his attribution to Els-
heimer on the *verso,* and the inscription, "Dessin
acheté à Paris 11, 774 le Juillet 1860"; H. Schick-
man Gallery
Literature: *Recent Acquisitions and Promised
Gifts.* National Gallery of Art, Washington, D.C.,
1974, no. 75.

187. JACOB DE GHEYN II (Dutch, 1565–1629)
Witches' Sabbath
Brown ink and wash, on brownish paper
9¼ x 14⁷⁄₁₆ in. (23.5 x 36.7 cm.)
The Metropolitan Museum of Art
Purchase, Joseph Pulitzer Bequest

Collections: H. S. Squire; Metropolitan Muse-
um purchase, 1962
Literature: J. Bean. *100 European Drawings in
The Metropolitan Museum of Art.* New York,
1964. no. 85.

183

185

184

186

187

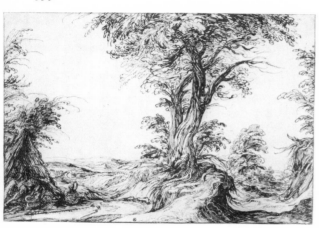

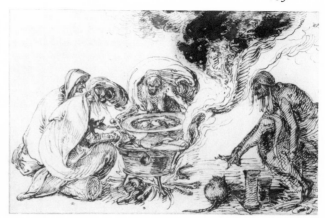

188. JACOB DE GHEYN II (Dutch, 1565–1629)
Design for a Garden Grotto
Brown ink and gray wash, over slight indications in black chalk
7⅛ x 11⅞ in. (18.1 x 30.1 cm.)
The Pierpont Morgan Library
Gift of Walter C. Baker

Literature: F. Stampfle. "A Design for a Garden Grotto by Jacques de Gheyn II. " *Master Drawings* III, no. 4 (1966): 381–83, pl. 27; J. R. Judson. *The Drawings of Jacob de Gheyn II*. New York, 1973. pl. 111.

189. GERRIT PIETERSZ. SWEELINK
(Dutch, 1566–1628?)
Odysseus and Tiresias
Brown ink and reddish brown wash, heightened with white
9⅝ x 16⅜ in. (24.6 x 41.6 cm.)
Signed indistinctly: Cornelisz van Haarlem
David E. Rust

Collections: J. Skippe; Sale, London, Christie's, Nov. 20–21, 1958, no. 283B (as B. Spranger); H. M. Calmann (as Cornelis van Haarlem)
Literature: Unpublished
 Identification of artist and the subject was made by Pieter J. J. van Thiel, Rijksmuseum. A drawing attributed to G. P. Sweelink is in the Yale University Art Gallery (E. Haverkamp-Begemann, A. M. Logan, *European Drawings and Watercolors in the Yale University Art Gallery*, 1970, no. 333, pl. 179).

190. JACOB MATHAM (Dutch, 1571–1631)
Jan Govertsen
Black chalk, quill pen in brown ink, touches of brown wash, gray washes (later additions?)
11½ x 8½ in. (29.2 x 21.6 cm.)
Watermark: Foolscap, with a hanging 4 and three balls (close to Churchill 355 without ID)
Abrams Collection, Boston, Massachusetts

Collection: B. Houthakker
Literature: F. W. Robinson. *One Hundred Master Drawings from New England Private Col-*

lections. Wadsworth Atheneum, Hartford, 1973. p. 36, no. 11, repr.

191. JAN VAN GOYEN (Dutch, 1596–1656)
Scene with Peasants, Inn and Draw-Well, 1653
Black chalk and gray wash
8 x 12 in. (21.0 x 30.5 cm.)
Signed with the monogram and dated 1654 at lower left
Watermark: Crowned shield with fleur-de-lis
Anonymous

Collections: J. A. Repelaer; Sale, The Hague, Nov. 7, 1967; A. Brod; Sale, London, Sotheby's, July 7, 1972, no. 5, acquired by present owner
Literature: H.-U. Beck. *Jan van Goyen, Ein Oeuvreverzeichnis*. Amsterdam, 1972. vol. I, no. 434, fig. 434.

192. REMBRANDT VAN RIJN
(Dutch, 1606–1669)
Joseph Telling the Dreams of the Butler and the Baker
Quill and reed pens, brown ink and wash
6¹⁄₁₆ x 7 ³⁄₁₆ in. (15.5 x 18.0 cm.)
Watermark: Long, doubleheaded eagle, each head crowned (Heawood 1302–1303)
Mrs. Edwin Garvin Fischer

Collections: J. von Bergmann, Storkel-Kauffung, Silesia; A. S. Drey, Munich
Literature: W. R. Valentiner. *Rembrandt, des Meisters Handzeichnungen*. Stuttgart and Berlin. vol. I, no. 104, dated *ca.* 1633; H. Kaufmann. "Zur Kritik der Rembrandtzeichnungen." *Repertorium für Kunstwissenschaft* XLVII (1926): 174, dated *ca.* 1633–34; O. Benesch. *Rembrandt, Werk und Forschung*. Vienna, 1935. p. 21, dated 1634–35; J. Rosenberg. *Rembrandt*. Cambridge, Mass., 1948. p. 129, fig. 175, dated *ca.* 1633; O. Benesch. *The Drawings of Rembrandt*. London, 1954–57. vol. I, no. 109, fig. 124, dated *ca.* 1635; W. R. Valentiner. "Drawings by Bol." *Art Quarterly* XIV (1957): 56, dated 1634–35; *Harvard Alumni Bulletin*. Apr. 16, 1960; H-M. Rotermund. *Rembrandts Handzeichnungen und*

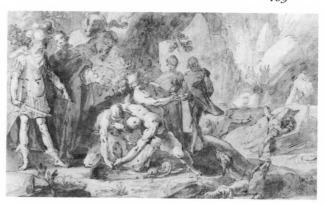

Radierungen zur Bibel. Stuttgart, 1963. fig. 64; W. Sumowski. "Zwei Rembrandt–Originale." *Pantheon* XXII (1964): 30, no. 4; J. Rosenberg. *Rembrandt, Life and Work*. 2nd ed. London and New York, 1964. p. 208, fig. 174, dated *ca*. 1633; *Rembrandt after Three Hundred Years*. Art Institute of Chicago, 1969 (E. Haverkamp-Begemann, A. M. S. Logan, section on drawings, no. 104, repr. p. 206, dated *ca*. 1634–36); F. W. Robinson. *One Hundred Master Drawings from New England Private Collections*. Wadsworth Atheneum, Hartford, 1973. no. 18, repr.; O. Benesch. *The Drawings of Rembrandt*. Enlarged and edited by E. Benesch. London, 1973. vol. I, no. 109, fig. 127.

193. REMBRANDT VAN RIJN
(Dutch, 1606–1669)
Studies of a Woman Reading, and an Oriental, *ca*. 1637–1638
Brown ink and wash, slightly corrected with white, 5½ x 5 in. (13.9 x 12.5 cm.)
Anonymous

Collections: T. Dimsdale, Hamian, Rev. S. Brooke (Sale, London, May 28, 1924, no. 75); C. Hofstede de Groot (Sale, Leipzig, Nov. 4, 1931, no. 163)
Literature: O. Benesch. *Rembrandt, Selected Drawings*. London and New York, 1947. no. 97; L. Munz. *A Critical Catalogue of Rembrandt's Etchings*. London, 1952. vol. II, no. 175; O. Benesch. *The Drawings of Rembrandt*. 6 vols. London, 1954–57. vol. I, no. 168, fig. 186; E. Haverkamp-Begemann. review of "Otto Benesch, The Drawings of Rembrandt." *Kunstchronik* XIV (1961): 51-52; *Rembrandt after Three Hundred Years*. Art Institute of Chicago, 1969 (E. Haverkamp-Begemann, A. M. S. Logan, section on drawings, p. 164, no. 110, repr. p. 212); O. Benesch. *The Drawings of Rembrandt*. Enlarged and edited by E. Benesch. London, 1973. vol. I, no. 168, fig. 186.

194. REMBRANDT VAN RIJN
(Dutch, 1606–1669)
The Publican and the Pharisee, 1640s

Brown ink and wash, heightened with white
8⅛ x 7⁷⁄₁₆ in. (20.6 x 18.7 cm.)
Woodner Family Collection

Collections: Jonathan Richardson, Sr.; T. Hudson; Mrs. Symonds
Literature: O. Benesch. *The Drawings of Rembrandt*. 6 vols. London, 1954–57. no. 587A; idem. "Nuentdeckte Zeichnungen von Rembrandt." *Jahrbuch der Berliner Museen* VI (1964): 127-29; *Woodner Collection I : A Selection of Master Drawings before 1700*. New York, 1971. no. 64, repr.

195. REMBRANDT VAN RIJN (?)
(Dutch, 1606–1669)
Allegory of Art Criticism, 1644
Brown ink
6⅛ x 7¹⁵⁄₁₆ in. (15.6 x 20.0 cm.)
The Metropolitan Museum of Art
Robert Lehman Collection

Collections: Baron D. Vivant-Denon; Friedrich August II of Saxony; L. H. Silver; Robert Lehman
Literature: C. Hofstede de Groot. *Die Handzeichnungen Rembrandts*. Haarlem, 1906. no. 303; K. Freise, H. Wichmann. *Rembrandts Handzeichnungen*. Parchim, 1925. vol. III, no. III (as not Rembrandt); W. R. Valentiner. *Die Handzeichnungen Rembrandts*. 2 vols. New York, 1925–34. vol. II, no. 619 (as Rembrandt); O. Benesch. *The Drawings of Rembrandt, A Critical and Chronological Catalogue*. 6 vols. London, 1954–57. vol. IV, no. A35a, fig. 1037 (as apparently the work of a pupil; inscription *den tyt 1644* by Rembrandt); J. Rosenberg. *Art Bulletin* XLI (1959): 116 (could well be by Rembrandt); J. G. van Gelder. "Dencwerk" *Bundel opstellen in 1959 Prof. Dr. D. T. Enklaar te Utrecht aangeboden*, 1959. p. 308 (mentioned as by Rembrandt); *Rembrandt Drawings from American Collections*. The Pierpont Morgan Library and Fogg Art Museum, 1960. no. 41 (as Rembrandt); O. Benesch. *The Drawings of Rembrandt*. Enlarged and edited by E. Benesch. 6 vols. London, 1973. vol. IV, no. A35a, fig. 1096 (as apparently the work of a pupil).

198

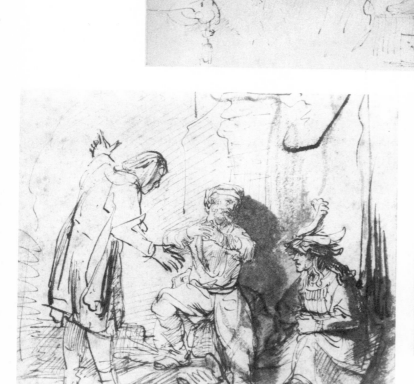

192

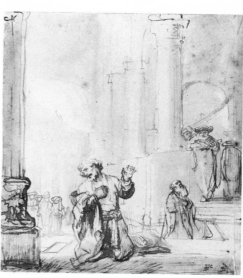

194

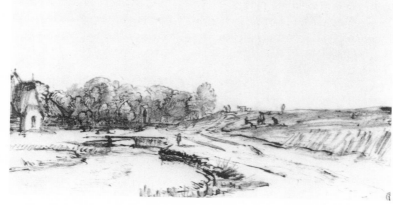

197

196. REMBRANDT VAN RIJN
(Dutch, 1606–1669)
Cottage near the Entrance to a Wood, 1644
Brown ink and wash and some black chalk
11¹¹⁄₁₆ x 17¹³⁄₁₆ in. (29.8 x 45.2 cm.)
The Metropolitan Museum of Art
Robert Lehman Collection

Collections: Jonathan Richardson, Sr.; A. Pond;
J. Barnard; Benjamin West; W. Esdaile; Sir
Thomas Lawrence; B. Grahame; J. P. Hesel-
tine; F. Muller; O. Gutekunst; J. Hirsch
Literature: F. Lippman, C. Hofstede de Groot.
Original Drawings by Rembrandt. Reproduced
in the Colours of the Originals, series I–IV.
Berlin and The Hague, 1888–1911. no. 186;
C. Hofstede de Groot. *Die Handzeichnungen
Rembrandts*. Haarlem, 1906. no. 1049; J. P.
Heseltine. *Original Drawings by Rembrandt in
The Collection of J. P. H. Heseltine*. London,1907;
C. Neumann. *Rembrandts Handzeichnungen*.
Munich, 1919. no. 64; O. Benesch. *Rembrandt,
Werk und Forschung*. Vienna, 1935. p. 36; C. de
Tolnay. *History and Technique of Old Master
Drawings*. New York, 1943. no. 197; O. Benesch.
Rembrandt, Selected Drawings. London and
New York, 1947. no. 134; J. Q. van Regteren
Altena. in *Mostra di incisione e disegni di Rem-
brandt*. Rome and Florence, 1951. no. 77; O.
Benesch. *The Drawings of Rembrandt*. 6 vols.
London, 1954–57. vol. IV, no. 815, fig. 965;
Rembrandt Drawings from American Collections.
The Pierpont Morgan Library and Fogg Art
Museum, 1960. p. 32, no. 40, pl. 34; S. Slive.
Drawings of Rembrandt. 2 vols. New York, 1965.
vol. I, no. 199; H. Dattenberg. *Niederrheinani-
sichten hollandischer Künstler des 17. Jahrhun-
derts*. Düsseldorf, 1967. p. 83; H. Gerson. *Rem-
brandt Paintings*. Amsterdam, 1968. pp. 96–352,
fig. a, p. 353; *Rembrandt after Three Hundred
Years*. Art Institute of Chicago, 1969 (E. Hav-
erkamp-Begemann, A. M. Logan, section on
drawings, no. 117, repr. p. 216); O. Benesch.
The Drawings of Rembrandt. Enlarged and edited
by E. Benesch. London, 1973. vol. IV, no. 815,
fig. 965.

197. REMBRANDT VAN RIJN
(Dutch, 1606–1669)
Farm Buildings at the "Dijk," ca. 1648
Verso: Trees near a Fence or Bridge
Brown ink and wash
5¾ x 10¼ in. (14.6 x 26.0 cm.)
Museum of Art, Rhode Island School of Design
Jesse Metcalf and Mary B. Jackson Funds

Collection: Friedrich August II of Saxony
Literature: F. Lippman, C. Hofstede de Groot.
Original Drawings by Rembrandt. Reproduced in
the Colours of the Originals, Series I–IV. Berlin
and The Hague, 1888–1911. vol. IV, no. 21;
W. von Seidlitz. *Repertorium für Kunstwissen-
schaft* XVII (1894): 125; C. Hofstede de
Groot. *Die Handzeichnungen Rembrandts*. Haar-
lem, 1906. no. 322; F. Lugt. *Mit Rembrandt in
Amsterdam*. Berlin, 1920. pp. 141-42, fig. 89 (as
not by Rembrandt); K. Freise, H. Wichmann.
Rembrandts Handzeichnungen. Parchim, 1925.
vol. III, no. 130, dated *ca.* 1650–60; O. Benesch.
Rembrandt, Werk und Forschung. Vienna, 1935.
p. 41, dated *ca.* 1647–50; H. Schwarz. "A Draw-
ing by Rembrandt." *Museum Notes* (Museum of
Art, Providence) VII (Nov. 1949), no. 2, dated
ca. 1645–50, closer to 1650; O. Benesch. *The
Drawings of Rembrandt, A Critical and Chrono-
logical Catalogue*. 6 vols. London, 1954–57.
vol. IV, no. 831, figs. 982, 983, dated *ca.* 1648;
Rembrandt Drawings from American Collections.
The Pierpont Morgan Library and Fogg Art
Museum, 1960. p. 36, no. 46, pl. 40; S. Slive.
*The Drawings of Rembrandt with a Selection of
Drawings by His Pupils and Followers*. 2 vols.
New York, 1965. vol. II, no. 464, dated *ca.*1648;
Rembrandt after Three Hundred Years Art Insti-
tute of Chicago, 1969 (E. Haverkamp-Begemann,
A. M. S. Logan, section on drawings, no. 120,
repr. p. 218).

Two drawings exist of the great dike which
protects Amsterdam from the Zuidersee. One is
in the British Museum (Ben. I, 115), the other
is the present work (Ben. IV, 21). Both represent
different views of the scene. Slive considers both
drawings to be by Rembrandt.

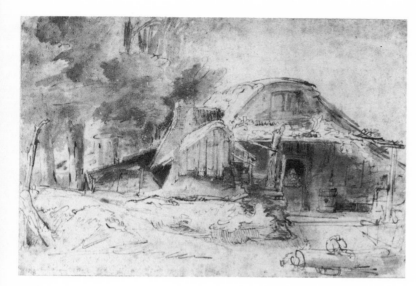

196

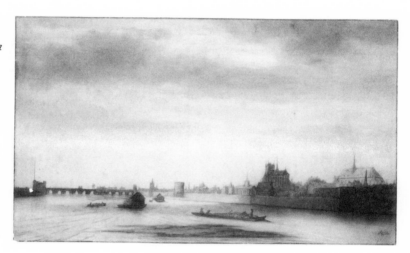

201

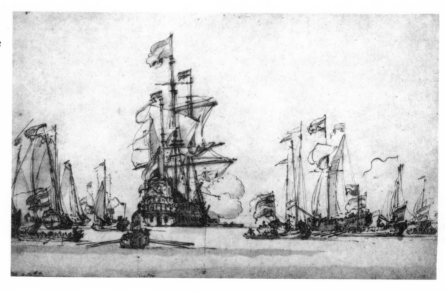

202

198. REMBRANDT VAN RIJN
(Dutch, 1606–1669)
Isaac and Rebecca Spied Upon by Abimelech,
early 1660s (?)
Brown ink, corrected with black (partly oxi-
dized), 5¹¹⁄₁₆ x 7³⁄₁₆ in. (14.5 x 18.5 cm.)
Anonymous

Collections: L. Richter; E. Cichorius (Sale,
Leipzig, May 5, 1908, no. 581); O. Huldschin-
sky; W. R Valentiner (Sale, Amsterdam, Oct.
25, 1932, no. 11)
Literature: W. R. Valentiner. *Kunst und Kunst-
ler*. n.p., 1924. XXII:18, as Tobias and Sarah; H.
Swarzenski, E. Shilling. *Handzeichnungen alter
Meister aus deutschem Privatbesitz*. Frankfurt,
1924. no. 47; W. R. Valentiner. *Die Handzeich-
nungen Rembrandts*. New York, 1925–34. vol. 1,
no. 243, *ca.* 1667, as Isaac and Rebecca(?); H.
Kaufmann. *Repertorium für Kunstwissenschaft*
XLVII (1925–26): 158, as Isaac and Rebecca;
H. Hell. "Die spaten Handzeichnungen Rem-
brandts." *Repertorium für Kunstwissenschaft* LI
(1930): 131; O. Benesch. *Rembrandt, Werk und
Forschung*. Vienna, 1935. pp.56, 68 (*ca.* 1653–55);
H. Tietze. *European Master Drawings in the
United States*. New York, 1947. no. 70, p. 140;
J. Rosenberg. *Rembrandt*. Cambridge, 1948.
I:67–68, vol. II, fig. 114, early fifties, as Isaac and
Rebecca, couple in painting portrayed as Jacob
and Rachel; J. R[osenberg] in A. Mongan. *One
Hundred Master Drawings*. Cambridge, Mass.,
1949. p. 80; O. Benesch. *The Drawings of Rem-
brandt*. 6 vols. London, 1954–57, vol. v, no. 988,
fig. 1202, *ca.* 1655–56; W. Sumowski. "Nacht-
räge zum Rembrandtjahr 1956." *Wissenschaft-
liche Zeitschift der Humboldt—Universitat zu
Berlin, Gesellschafts-und sprachwissenschafti-
liche Reihe* VII (1957–58): 225–26, dating in six-
ties more likely; comparable in pen lines to
Benesch 1057.

199. ADRIAEN VAN OSTADE
(Dutch, 1610–1685)
Peasants outside an Inn
Brown ink and wash over black chalk and graph-
ite, 6¾ x 8⅝ in. (17.2 x 22.0 cm.)
Signed in pen lower left: Ostade
Abrams Collection, Boston, Massachusetts

Collections: Miss James, the Misses Alexander,
London
Literature: *Selections from the Collection of
Dutch Drawings of Maida and George Abrams*.
Wellesley College Museum, 1969. no. 25, repr.

200. CORNELIS PIETERSZ. BEGA
(Dutch, 1620/31/32–1664)
Seated Woman
Black chalk
10⅝ x 7 in. (27.2 x 18.0 cm.)
Watermark: F D or E D
Abrams Collection, Boston, Massachusetts

Collection: J. A. van Dongen
Literature: S. H. Levie. *Schilderinjen, teken-
ingen, en beelhouwwkern 16e—20e eeuv uit de ver-
zamelingen van Dr. J. A. van Dongen*. Amster-
dam, 1968. no. 26; Singer Museum, Laren.
no. 15; *Things of This World: A Selection of
Dutch Drawings from the Collection of Maida and
George Abrams*. The Sterling and Francine
Clark Art Institute, Williamstown, Mass., 1972–
73. no. 3, pl. 21, repr. p. 34.

201. LAMBERT DOOMER
(Dutch, 1623–1700)
View of Orléans on the Loire
Brown ink, brown and gray washes
9⅜ x 16³⁄₁₆ in. (23.7 x 41.0 cm.)
The Cleveland Museum of Art
Delia E. Holden Fund

Collections: J. Tonneman; W. van Zon;
B. Houthakker; H. E. ten Cate
Literature: *Handbook*. Cleveland Museum
of Art, 1966. p. 122.

202. WILLEM VAN DE VELDE II
THE YOUNGER (Dutch, 1633–1707)
Shipping on the Y before Amsterdam
Brown ink and gray wash
11⅛ x 17⅜ in. (28.3 x 44.1 cm.)

200

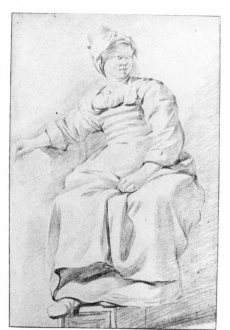

204

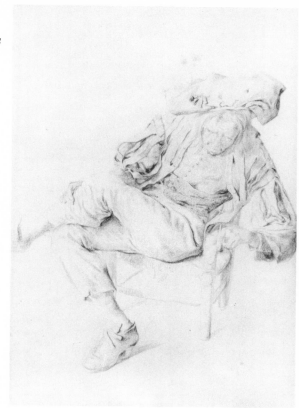

191

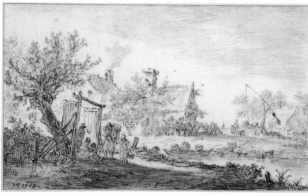

203

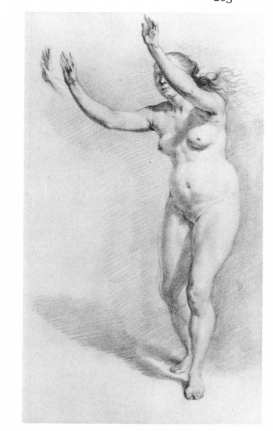

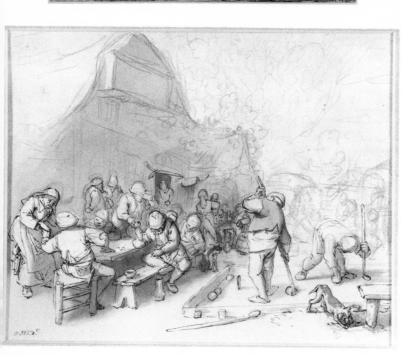

199

Signed with the artist's initials and inscribed:
Lager
Anonymous

Collection: Lord Brownlow (Sale, London,
Sotheby's, July 14, 1926, no. 49)
Literature: Unpublished

This is a study for the large oil painting of the
same subject in the Rijksmuseum. The full title
of the painting is *Shipping on the Y before Am-
sterdam Including the Flag Ship Golden Lion
Commanded by Admiral Cornelis Tromp.*

203. ADRIAEN VAN DE VELDE
(Dutch, 1636–1672)
Standing Nude Woman with Upraised Arms
Red chalk
11¾ x 7 in. (29.8 x 17.8 cm.)

Los Angeles County Museum of Art
Los Angeles County Funds

Collection: R. S. Davis
Literature: *Drawings in the Collection of the Los
Angeles County Museum of Art.* Alhambra, 1970.

204. CORNELIS DUSART (Dutch, 1660–1704)
Seated Man with Crossed Legs (An Actor?)
Red, blue, and black chalk
12¼ x 8¾ in. (31.1 x 22.2 cm.)
Abrams Collection, Boston, Massachusetts

Collections: Prince Hoehnzollern-Hechingen
(Sale, 1892, no. 137); Dr. M. Schubart (Sale,
Munich, Oct. 26-27, 1899, no. 274)
Literature: *Selections from the Collection of
Dutch Drawings of Maida and George Abrams.*
Wellesley College Museum, 1969. no. 20.

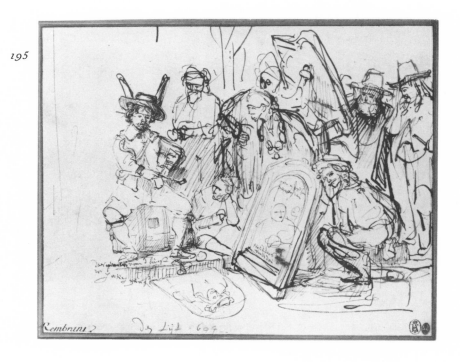

195

The Flemish School

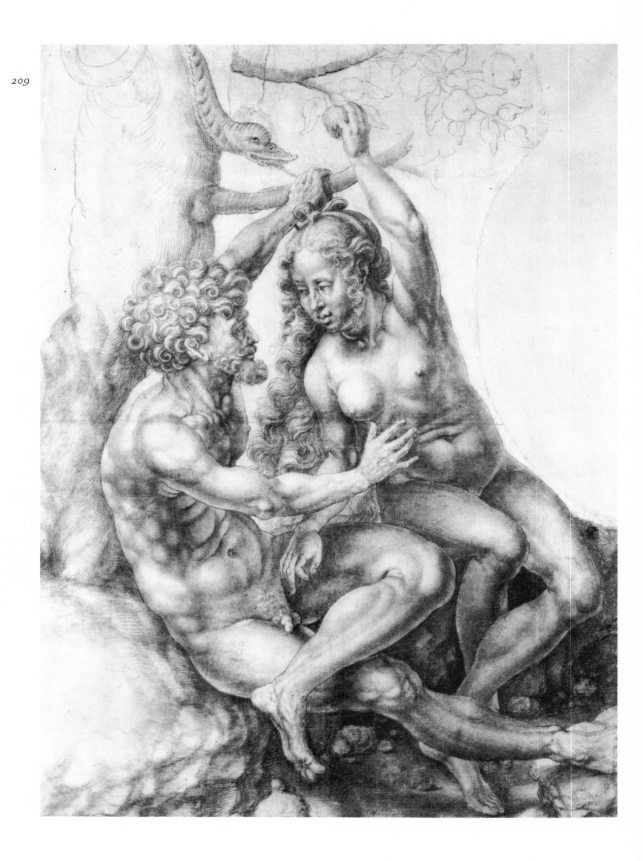

The Flemish School

As in other countries, Flemish drawings evolved from the earlier tradition of manuscript illumination. In accordance with universal medieval practice, the drawing technique prevailing in fourteenth-century Flanders was metalpoint, in which various styluses made of silver, gold, tin, or combined metals were used to draw on specially prepared grounds. The medieval tradition of craftsmanlike precision, inspired in part by this technique, which produced delicate, threadlike lines, continued well into the next century.

From the very great Flemish masters of the early fifteenth century, including Jan van Eyck of the school of Bruges, the Master of Flémalle (Robert Campin), and Rogier van der Weyden of Brabant, only a scant few drawings have survived. Outstanding among them is the *grisaille* drawing on panel by van Eyck, *St. Barbara*, in the Musée Royale des Beaux Arts, Antwerp. Evidently intended for over-painting but never completed, it presents a contemplative spiritual conception and a pronounced refinement of execution and finish not encountered in the contemporary Italian drawings on paper. Portrayed in the background of this remarkable composition are the labors of the common man, a theme later depicted with such careful realism in the drawings of Pieter Bruegel the Elder. The fact that so few Flemish drawings dating prior to the sixteenth century have survived suggests that either this art was less common than painting or that many early drawings were executed on panels preparatory to painting and thus were absorbed by the finished work.

Even when artists eventually replaced the medieval stylus with a quill pen and ink, miniaturist detail still remained a hallmark of Flemish drawing. This detailing is clearly seen in the extremely fine modeling of the late fifteenth-century study, *St. James Minor* (cat. no. 206), executed with brush on vellum and enlivened by touches of gold, red, and flesh tone. However, other late fifteenth-century Flemish drawings by such masters as Rogier van der Weyden, Hugo van der Goes, Hans Memling, and their studios, present a broader style which departs from the earlier miniaturelike conception. *Men Shovelling Stools* (cat. no. 205), attributed to van der Weyden, already prefigures the style and thematic approach of Pieter Bruegel the Elder. The stately metalpoint drawing by, or possibly after, Hans Memling (cat. no. 207) is related to the wing of a small diptych in the Munich Museum. Recalling the monumentality earlier found in Jan van Eyck's study of *St. Barbara*, Memling's handling of the drapery in the Ottawa drawing shows a considerable modification of the abstract Gothic style in favor of a more naturalistic representation.

While the Italians strove to portray lifelike yet classical forms in their drawings of the late fifteenth century, the so-called Flemish primitives (including those artists mentioned above) continued to work within their aesthetic and geographic confines, choosing to preserve the highly perfected naturalistic detail and intricate religious symbolism of their own pictorial tradition. By the early sixteenth century Italian art was at its apogee, and the country had become the art center of Europe. Consequently, the more traditional, even medieval, world of Flanders, as yet largely untouched by the discovery of the antique, no longer sufficed as a place for artists to experience current aesthetic developments as it had under the inspiration of the van Eycks, whose art dominated northern Europe for nearly a century. As a result, artists like Jan Gossaert, called Mabuse (*ca.* 1478–1533/36), had to travel to Rome. There Mabuse encountered antique art as well as the Renaissance aesthetic and was among the very first to bring these influences, principles, and directions back to his native land. He spent only a few months in the Italian capital in 1509, but his study there considerably affected the development of his style. At that time Michelangelo was at work on the Sistine ceiling and it seems reasonable, as Heinrich Schwarz suggested, that Mabuse would have been allowed to see it. Thus, Michelangelo's heroic manner was probably among the many influences of Mabuse's Italian travels that were later reflected in both his paintings and drawings.

Of the three known drawings by Mabuse on the theme of Adam and Eve, the black chalk version in the exhibition (cat. no. 209) is the largest. The other two, in the Chatsworth collection and the Albertina, are drawn in ink. The latter is especially lively, not only in composition but in style; although obviously based on Dürer's method of hatching, Mabuse's line in this instance is freer and more varied than the German master's. In contrast, the Chatsworth drawing, which Schwarz considered the earliest of the three *Adam and Eve* studies, is highly finished, the figures defined by continuous lines, the modeling densely hatched with white, generally parallel lines against the green paper. The Chatsworth work seems definitely inspired by Hans Baldung Grien's woodcut of the same subject, dated 1519.

The Rhode Island *Adam and Eve* is the most erotic of the three, reflecting not only the new realism in the art of the period, but possibly (according to Schwarz) a hedonistic aspect of Gossaert's own temperament as described by the Dutch Vasari, Carel van Mander. The rather thin contour lines that define the figures in this drawing contrast with the marked naturalism and sculptural tonalities of the interior modeling, especially as seen in the emphatic musculature of Adam. Enhancing the striking composition are the individualized faces of Adam and Eve. It has been proposed that Mabuse used his own features for the

former, the stylized curls no doubt inspired by the classical portraits he would have seen in Rome. Together with the half-turned body of Eve, the accentuated curve of Adam's back forms an oval or elliptical composition in which variation is created by the arrangement of the couple's legs. Schwarz relates that the treatment of Adam's legs was derived from two sources: the outstretched one from Michelangelo's Adam of the Sistine ceiling, the crossed one from the famous Roman bronze, *Il Spinario*, in the Museo Capitolino, Rome. The position of Eve's legs has been shown to be very similar to that of the figure Dejanira in Mabuse's painting *Hercules and Dejanira* of 1517, in Birmingham. In contrast to Mabuse's fully detailed treatment of the figures and the rocky terrain upon which they are seated, the upper part of the drawing, including the fruit of the tree, is more lightly sketched. For this reason Meder interpreted the work as a cartoon for a painting. While Schwarz was unresolved as to whether it was a *modello* for a patron or a *ricordo* drawing of a finished painting made to preserve the composition for Gossaert's shop, more recent opinion has concurred with Meder's conclusion.

Mabuse's attention to the Renaissance emphasis upon classical themes, the nude, and ornamental motifs contributed to the development of a new classicism in sixteenth-century Flemish art. This influence was intensified by the arrival of Raphael's tapestry cartoons in Brussels which added to the diffusion of this great Italian master's style and subjects among numerous artists, notably Pieter Coecke van Aelst, the future father-in-law of Pieter Bruegel the Elder.

The spirit of eroticism which the Romanized work of Mabuse introduced into Flemish art was continued by the leading Flemish Mannerist, Bartholomaus Spranger (1546–1611). The amatory component in Spranger's pen drawing of *Adam and Eve*, in the Museum at Schwerin, exceeds that in Mabuse's drawings of the subject. Born in Antwerp and widely traveled in Europe, Spranger absorbed influences from many artists, of whom Parmigianino is possibly the most discernible. Spranger worked for many years in Prague at the court of Rudolph II, Holy Roman Emperor from 1576 to 1612. Religiously intolerant and oppressive, Rudolph was nevertheless fascinated by astrology, the occult sciences, and the search for the Philosopher's Stone. It was also at his court that the international Mannerist style flourished, with Spranger as its chief exponent. Surprisingly, Spranger's graphic work, including the engravings after his paintings which had a great impact on the Dutch Mannerists, has not yet been the subject of a monograph. His highly personal drawings display a fluidity of line and movement that seems to herald the sparkling drawings produced in eighteenth-century Venice by Giovanni Antonio Pellegrini and Gaspare Diziani. Spranger

was, in fact, a precursor of the northern Rococo. Frederick Antal regarded his drawings as so similar to those of the Florentines Jacopo Zucchi and Maso da San Friano as to be indistinguishable.

Emperor Rudolph's enjoyment of the dramatic flourishes and exaggerated poses of the Mannerists did not prevent his appreciating the more naturalistic and thematically rich paintings of Pieter Bruegel the Elder (1525/30–1569), which he collected in considerable numbers. Despite the predominance of Flemish Mannerism, Bruegel's work remained completely independent; complex in personality as well as in his art, he was always closer in spirit to his great forerunner, Bosch, than to the Romanist Flemish artists of his time. More than any of his contemporaries, he preserved and conveyed in his work the often earthy, robustly satirical nature of his countrymen.

Bruegel's drawings show a microscopic attention to detail and a selflessness in execution reminiscent of Flemish manuscript illuminations. Although they have been described as influenced by the landscapes of Titian, Bruegel's landscape drawings have, nevertheless, a totally different character. His panoramic vistas recall Leonardo's "bird's eye" view drawing of the Italian coast, which is almost topographical in its sweep and relief. Testimony to Bruegel's patience are the endless clumps of trees that dot his large Alpine views, all drawn in the same feathered manner yet completely avoiding the nearly static repetitiveness of landscape drawings by a later Fleming he influenced, Tobias Verhaecht (1561–1631) (cat. no. 212).

The exclusively linear patterning of the sixteenth-century Flemish drawing style appears in drawings by both Bosch (cat. no. 208) and Bruegel (cat. no. 210). In conformity with their native tradition, these artists used continuous outlines to delineate their forms. But whereas in the *Group of Ten Spectators*, Bosch shades with straight, parallel strokes and uses crosshatching only in limited areas, Bruegel crosshatches more emphatically to actually model the forms. In the remarkable Woodner *Bagpipe Player*, Bruegel demonstrates the height of control in his grasp of figure drawing and the portrayal of individual character.

In contrast to Bruegel's frequent veiled criticism of contemporary religious intolerance and the rigidly dogmatic program and practices of the Counter Reformation, the work of Peter Paul Rubens (1577–1640) not only accorded with, but also served the aims of the Roman Catholic Church during its struggles to re-establish a position of dominance. No moralistic, didactic, satirical, or erotic images issued from Rubens' hand; in regard to the latter, it is revealing to compare his drawing of *Adam and Eve* in Leipzig with those of the same subject, previously mentioned, by Mabuse and Spranger.

Although Rubens absorbed influences as wide ranging as those of any painter in European history, his genius was grand and individual enough to assimilate them all without the slightest sign of eclecticism. He easily converted all that was useful to him, regardless of the period from which it came. Few artists who have drawn from so many sources have left such an unmistakable stamp of individuality upon their work, and in turn have influenced so many other painters and engravers.

Rubens' drawings, which parallel the achievement of his painting in their rhythmic flow and in the vigorous rapidity of their delineation, occupy several categories. First, he was an avid copyist of works that were interesting or useful to him, from antique art (cat. no. 216) to that of his contemporaries, though Michelangelo, Caravaggio, and, above all, the Venetians, were the most influential upon his style. Next, when preparing for his paintings, Rubens made compositional studies as well as individual sketches that were neither exploratory nor tentative, for he was an artist who conceptualized his work in his mind rather than on paper. Then, in collaborating with his assistants, Rubens would provide a small oil sketch as a model, eventually enlarging this composition in still another drawing for them to follow. A further category of drawings in which Rubens was involved was that connected with the reproduction of his paintings: on occasion, his assistants, including van Dyck, would make reduced copies of Rubens' paintings, and often these drawings were retouched by the master prior to being engraved. In addition, Rubens himself supplied designs which were engraved for books published by the famous Antwerp printers, Plantin and Moretus. The master was also involved with restoring, retouching, and "improving" drawings he collected from various periods. Finally, there are the highly prized drawings that Rubens made entirely by his own hand for special reasons, including those required for commissions and those which he made for personal pleasure of his family and of the countryside, especially around his great estate of Steen.

There was little in Flemish art to predict the phenomenon of Rubens, who brought Flemish painting and drawing to a height it never surpassed. Studying the Italian masters of the Renaissance and the early seventeenth century taught Rubens to draw monumental forms and to use the soft chalk that was admirable for expressing plasticity and pictoriality. From the Venetians he adopted the electric zigzag pattern of broken highlights. But all that Rubens learned he infused with a torrential energy unmatched in European art. Dominating all his drawing styles—from the most finished and painterly to the working pen sketches in which he sought "short-cuts" to the image—is a throbbing graphic vitality. With his powerful, unique dynamism and the clarity and rich warmth of his color, Rubens transcended

the classicizing current of the Renaissance to become the greatest Flemish Baroque artist.

As herculean vitality was the paramount characteristic of Rubens, so intensity was that of his close associate and collaborator, Anthony van Dyck (1599–1641). This factor is possibly even more apparent in van Dyck's drawings than in his paintings. Unlike the solidly constructed forms and balanced compositions of Rubens' painting style, van Dyck's pictoriality took the form of heavily washed, broadly drawn figures with faces sometimes almost medievally distorted. Flamelike, expressive lighting and agitated gestures endowed such drawings with a dramatic character too rarely encountered in van Dyck's paintings. At other times, his drawings could be more abstract than Rubens', and more romantic, as shown by comparing the pen and wash drawing of the *Duke of Lerma on Horseback* by Rubens, in the Louvre, with the brush and wash drawing of a *Field Marshal on Horseback* by van Dyck, in the Kunsthalle, Bremen.

Van Dyck's chalk portraits for his projected etched series of illustrious men can scarcely be matched for psychological penetration and truthfulness of rendering. As is sometimes true of Rubens, there are sketches and studies by van Dyck that startle by their harsh awkwardness of expression; these drawings are notes thrown off in the first flush of inspiration, conflicting with the qualities of elegance and grace that have come, above all, to be associated with van Dyck's work.

Although in the Flemish school van Dyck has always been regarded as second in stature only to Rubens, just one exhibition of his work has ever been held in the United States (in conjunction with one of Rubens), at the Los Angeles County Museum in 1946. A comprehensive assembling of his paintings, drawings, and etchings could contribute much in this country toward a new study and appreciation of this master's many contributions.

Unlike Rubens and van Dyck, the third major artist of seventeenth-century Flanders, Jacob Jordaens (1593–1678), never studied or worked in Italy. Nevertheless, in his native Antwerp he was able to copy paintings by Titian and Veronese, the masters who had so notably affected the style of his great predecessors. But the most important influence upon Jordaens was Rubens, whose work inspired the largeness of Jordaens' forms and his ebullient realism. This realism, however, was untempered by the idealizing effects achieved by Rubens, who molded his heroic forms to resemble Italian concepts of antique beauty. In Jordaens, the portrayal of native Flemish types and character was unrestrained, particularly in his roistering groups of peasants or burghers. Compared to the noble art of Rubens, Jordaens' version of life is rather pedestrian; yet his accurate, unidealized images express a depth of emotion—as seen, for example, in his painting of the *Evangelists*, in the Louvre— not always found in Rubens' more externalized art.

Jordaens was an outstandingly individual, vigorous, and monumental draftsman who used color in a novel manner, distinct from that of Rubens and van Dyck. Beginning his career as a watercolor artist, Jordaens furnished designs for tapestries; he also painted imitation tapestries in watercolor. He often combined chalk with watercolor, a mixture which he developed in complexity, eventually producing brilliantly hued drawings that approached the character of paintings. Some of these works, like the oil sketches of Rubens, were *modelli* for paintings; others were drawn for Jordaens' own pleasure.

It is also the character of his line that differentiates Jordaens from Rubens and van Dyck. His stroke was generally straight and formed angular patterns that were closer to the distant tradition of the Gothic than to the flowing curves of the Baroque. His simplified, more abstract line, as well as the compelling naturalism of his portrait drawings, make his graphic art appealing to modern taste. With time the striking angularity of his drawing became more pronounced, as can be seen in a characteristic treatment of drapery in the relatively late *Study of a Seated Man* (cat. no. 219) which is comparable in its cubistic patterning to his black chalk drawing of a *Seated Woman*, in the Print Room of Dresden. A comparison of Jordaens' dramatic *Conversion of St. Paul* (cat. no. 217) with his copy after Rubens' *Fall of the Damned* (cat. no. 218) also reveals the difference between Jordaens' reduction of modeling and Rubens' powerful depiction of bodily structure.

A host of excellent artists flourished in the wake of Rubens and van Dyck—pupils, followers, and independents, as well as noted masters of genre. Of the last, the most outstanding were Adriaen Brouwer (1606–1638) and David Teniers the Younger (1610–1690). The short-lived Brouwer produced sketches of peasant life that in their own way recall the wit and movement of Callot; as mentioned in the Dutch section, Brouwer was the pupil of Frans Hals, and his works were the prototype for the early period of Adriaen van Ostade.

In the eighteenth century, Flemish painting, like that of the Dutch, suffered a decline. At the same time, however, Flanders provided the ground for the appearance of the most original genius of French Rococo painting and drawing: Jean Antoine Watteau, who was born in Valenciennes only a few years after this originally Flemish city was made part of France.

Catalog

205. ROGIER VAN DER WEYDEN, attributed
(Flemish, 1399/1400–1464)
Men Shovelling Stools
Brown ink over black chalk on buff paper
11¼ x 16¾ in. (29.8 x 42.5 cm.)
The Metropolitan Museum of Art
Robert Lehman Collection

Literature: A. Mongan. *One Hundred Master
Drawings.* Cambridge, Mass., 1949. no. 8;
J. Adhémar. *Bulletin de la Société des Antiquaires
de France,* 1952–53. p. 142; L. Lebeer. *Bruxelles
au XVᵉ siècle.* Brussels, 1953. pp. 193–95;
Exposition de la collection Lehman de New York.
Galerie de l'Orangerie, Paris, 1957. no. 109,
pl. LIII; *Great Master Drawings of Seven Cen-
turies.* M. Knoedler & Co., New York, 1959.
no. 19, pl. XVIII.

 This great and unusual drawing has been
identified as a model for a stone capital, pre-
served in the Musée Communal in Brussels, that
was originally part of an arcade of the Town Hall.
In the fifteenth century, on the site of this ar-
cade, there had stood a house called "De Scup-
stoel," a name combining "shovel" and "stool."
It was thus called after its instrument for pun-
ishing criminals, a stool onto which the culprit
was strapped, pulled up into the air, and then
suddenly dropped, into mud or worse.

 According to explanations by Panofsky and
Adhémar, the subject of the drawing is related to
the "frequent revolts of the lower classes of
Flanders...for civil rights." The overturning
and piling of the stools, etc., symbolized revolu-
tion, and the shovels referred to the complaints
of underpaid labor.

206. FLEMISH SCHOOL, 15th century
St. James Minor
Brush with colors and gold on vellum
5¼ x 3⅜ in. (13.4 x 8.6 cm.)
The Pierpont Morgan Library

Collections: William Russell; C. Fairfax Murray

Literature: C. Fairfax Murray. *Drawings by the
Old Masters: Collection of J. Pierpont Morgan.*
4 vols. London, 1905–12. vol. I, no. 225;
F. Winkler. "Über verschollene Bilder der Brü-
der Van Eyck." *Jahrbuch der Königlich Preussi-
schen Kunstsammlungen.* Berlin, 1916. p. 297,
footnote; M. J. Friedländer. *Die altniederländi-
sche Malerei.* Berlin, 1924. I : 126, footnote; O.
Benesch. *Die Zeichnungen der niederländischen
Schulen des XV und XVI Jahrhunderts, beschrei-
bender Katalog der Handzeichnungen in der
graphischen Sammlung Albertina.* Vienna, 1928.
II : 1, no. 7; L. Baldass. *Jan van Eyck.* London
and New York, 1952. p. 284; *Flanders in the 15th
Century: Art and Civilization.* Detroit Institute
of Arts, 1960. p. 227 ff., no. 67; M. J. Friedländer.
The van Eycks–Petrus Christus. Leyden and
Brussels, 1967. p. 74, no. 12, pl. 68D.

207. HANS MEMLING, attributed (Flemish,
ca. 1430/40–1494)
The Virgin and Child with Four Angel Musicians
Metalpoint on prepared cream-colored paper
9⅞ x 7½ in. (25.4 x 19.0 cm.)
National Gallery of Canada, Ottawa

Collections: Richard Philipps, Baron Milford
(1744–1823); Sir John Philipps, Bart.; Auction
98, *L'art ancien,* S. Z. Zurich, June 16, 1960;
H. M. Calmann; Colnaghi's, London, 1961
Literature: *Drawings by Old Masters.* Royal
Academy, London, 1953. no. 238; Colnaghi
exhibition. June–July 1961. no. 11; *Annual
Report by the Trustees of the National Gallery of
Canada,* 1961–62, repr.; "La Chronique des
Arts." no. 1129, p. 14, no. 63, repr., supplement
to the *Gazette des Beaux-Arts* LXI (Feb. 1963);
A. E. Popham, K. M. Fenwick. *European Draw-
ings in the Collection of the National Gallery of
Canada.* Toronto, 1965. p. 87, no. 125, repr. p. 86.

208. HIERONYMUS BOSCH (Flemish,
ca. 1450–1516)
Group of Ten Spectators
Brown ink, 4⅞ x 4¹⁵⁄₁₆ in. (12.4 x 12.6 cm.)
The Pierpont Morgan Library

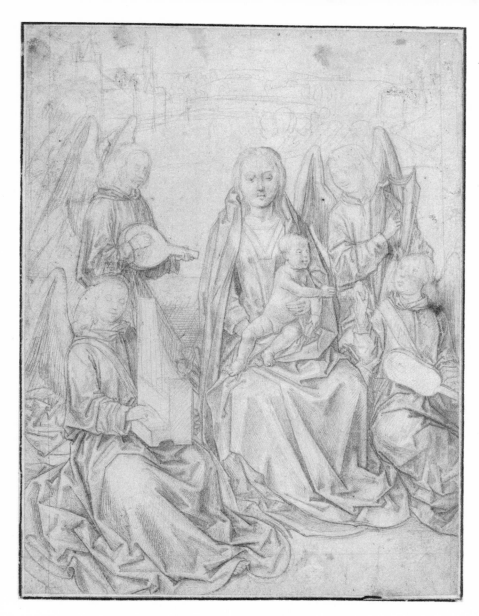

207

205

206

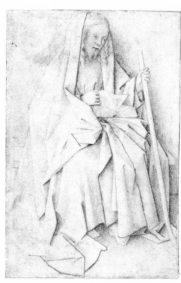

Collections: Rymsdyk; Tighe; C. Fairfax Murray
Literature: C. Fairfax Murray. *Drawings by the Old Masters: Collection of J. Pierpont Morgan.* 4 vols. London, 1905-12. vol. I, no. 112; W. Cohen. "Hieronymus Bosch." in Thieme-Becker, *Kunstlerlexikon*, 1910. IV: 390; L. Baldass. "Betrachtungen zum Werke des Hieronymus Bosch." *Jahrbuch der kunsthistorischen Sammlung in Wien.* n.p., 1926. pp. 109, III; M. J. Friedländer. *Die altniederländische Malerei.* Berlin, 1927. V:126, no. 17 (rev. English ed., *Early Netherlandish Painting*, 1969. V:68-69, pl. 128b); M. D. Henkel. *Le dessin hollandais.* n.p., 1931. p. 9; L. Baldass. "Die Zeichnung im Schaffen des Hieronymus Bosch und der Frühholländers." *Graphischen Künste*, N. F., Vienna II (1937): 24, no. 1, repr.; C. de Tolnay. *Hieronymus Bosch.* Bâle, 1937. p. 109, pl. 99 (right); J. Combe. *Jerome Bosch.* Paris, 1946. p 96, no. III, pl. 127; H. Swarzenski. "An Unknown Bosch." *Bulletin of the Museum of Fine Arts, Boston* LIII (Feb. 1955): 5, fig. 4; C. de Tolnay. *Hieronymus Bosch.* Baden-Baden, 1965. repr. I: 317, no. 1, repr. II: 387, no. 1; G. Lemmens, E. Taverne. "Hieronymous Bosch Naar Aanleiding van de Expositie in s'Hertogenbosch." *Simiolus.* Kunsthistorisch Tijdschrift, 1967-68. II: 83, no. 2; *Pieter Bruegel d. Ä. als Zeichner.* Staatliche Museen Preussischer Kulturbesitz, Berlin, 1975. no. 9, pl. 4.

209. JAN GOSSAERT, called Mabuse (Flemish, *ca.* 1478-1533/36)
Adam and Eve
Black chalk
24¾ x 18 in. (62.8 x 46.0 cm.)
Museum of Art, Rhode Island School of Design
Walter H. Kimball Fund

Collections: Albertina, Vienna; Archduke · Friedrich; Czeczowicka; Oskar C. Bondy; Mrs. E. Bondy
Literature: J. Meder. *Die Handzeichnung.* Vienna, 1923. pp. 390, 533, fig. 247 (detail); M. J. Friedländer. *Die altniederländische Malerei.*

Berlin, 1930. VIII: 64, no. 4; W. Kronig. *Der italienische Einfluss in der flamischen Malerei im ersten Drittel des 16. Jahrhunderts.* Wurzburg, 1936. pp. 75-76, pl. 2; H. Schwarz. "Jan Gossaert's Adam and Eve Drawings." *Gazette des Beaux-Arts*, series 6, XLII (1953): 45-68; *Great Master Drawings of Seven Centuries.* M. Knoedler & Co., New York, 1959. no. 22, pl. XXI: *Jean Gossaert dit Mabuse.* Museum Boymans-van Beuningen, Rotterdam, May 15-June 27, 1965. no. 62, repr. pp. 311-312.

210. PIETER BRUEGEL THE ELDER (Flemish, 1525/30-1569)
The Bagpipe Player, *ca.* 1565-1568
Brown ink, 8⅛⁶ x 5¹¹⁄₁₆ in. (20.5 x 14.4 cm.)
Woodner Family Collection

Collection: Sale, Hôtel Drouot, Paris, May 20, 1966
Literature: C. de Tolnay. "A Contribution to Pieter Bruegel the Elder as Draughtsman." *Miscellanea for J. Q. van Regteren Altena.* Amsterdam, 1969. pp. 62-63, figs. 10-11; *Woodner Collection I: A Selection of Old Master Drawings before 1700.* New York, 1971. no. 61, repr.

This drawing was dated to around 1565-68 by Tolnay, who also proposed that it might have been "a first, still caricatured version of the bagpipe player in a more classical pose, in the *Peasant Dance*, Vienna...."

211. AMBROISE DUBOIS (Flemish, *ca.* 1543-1614)
The Miraculous Draught of Fishes
Brown ink, heightened with white
7⅝ x 12¼ in. (19.3 x 31.1 cm.)
Mr. and Mrs. Germain Seligman

Collections: P. J. Mariette (1694-1774); J. A. Duval le Camus
Literature: S. Beguin. "Dessins d'Ambroise Dubois." *L'Oeil*, Mar. 1966. p. 67, no. 4; idem. "Quelques nouveaux dessins d'Ambroise Dubois." *Revue de l'Art*, no. 14 (1971), p. 38, no. 35.

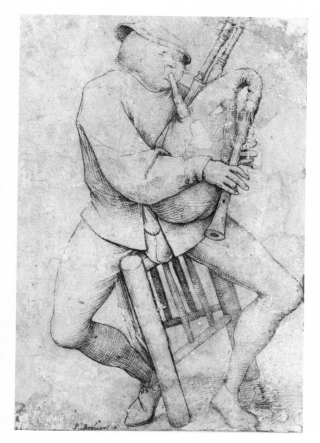

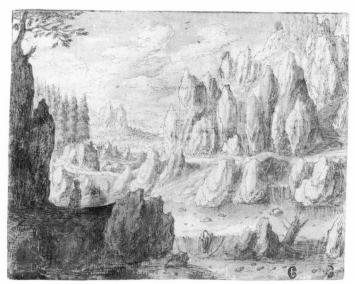

212

210

211

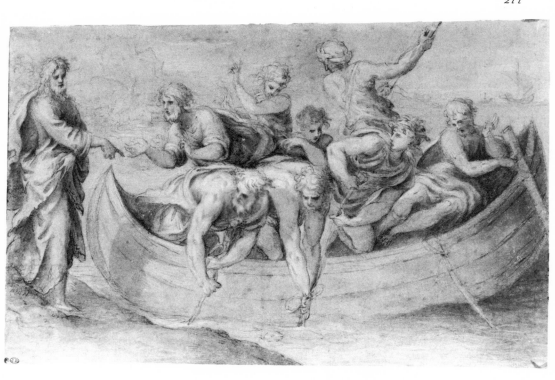

Flemish-born Ambrosius Bosschaert (who Gallicized his name to Ambroise Dubois) spent his whole life, from the age of twenty-five till his death at seventy-two, in France, working principally in the palace at Fontainebleau. Although Flemish traits are discernible enough in his drawings to have confused him at times with Abraham Bloemaert, French and Italian influences predominate. S. Beguin has assigned the present drawing to Dubois' early period, and she has also compared it to a drawing on the *verso* of the artist's drawing *Théagène et Chariclée dans l'île des Pâtres*, in the Louvre.

212. TOBIAS VERHAECHT
(Flemish, 1561–1631)
View of a Rocky Landscape
Brown ink, with brown, blue, green, and pink washes, 6½ x 8½ in. (16.5 x 21.6 cm.)
Los Angeles County Museum of Art
Graphic Arts Council Funds

Collection: Crozat; E. Weyhe
Literature: Unpublished

Although this drawing was originally considered to be by Matthias Brill, the name of Verhaecht was advanced as its author by the late Wolfgang Stechow. J. Muller-Hofstede called it close to Verhaecht. The work seems to be by the same hand as the Tobias Verhaecht in the sale at Christie's, July 10, 1973, no. 26. At the same time, the drawing should be judged against the work of Verhaecht's pupil, Pieter van Hoeck, who, according to Lugt, worked completely in his master's style. In 1929 Stechow published the only known drawing by van Hoeck ("Peeter van Hoeck," *Old Master Drawings* 15 [Dec. 1929]: 45, pl. 45). Stechow's last article establishes van Hoeck's drawing as a copy of Verhaecht ("Verhaecht and Hoeck, Teacher and Pupil," *Master Drawings* XIII, no. 2 (1975): 146.) Recently, a drawing in Budapest has been suggested as possibly a work by van Hoeck after his master (T. Gerszi, *Netherlandish Drawings in the Budapest Museum: XVI Century Drawings*, Amsterdam, 1971, I: 96, no. 293, vol. II, fig. 293).

213. JOOSE DE MOMPER (Flemish, 1564–1635)
Winter Landscape
Brown ink and watercolor
6½ x 10½ in. (16.5 x 26.6 cm.)
Los Angeles County Museum of Art
Los Angeles County Funds

Collection: R. S. Davis
Literature: *Drawings in the Collection of the Los Angeles County Museum of Art.* Alhambra, 1970.

214. FREDERICK VAN VALCKENBORCH
(Flemish, *ca.* 1570–1629)
Landscape with Three Foreground Trees
Brown ink and gray wash
8¼ x 11⅛ in. (21.0 x 29.2 cm.)
Watermark: Double eagle
Los Angeles County Museum of Art
Los Angeles County Funds

Collections: Dr. A. Welcker; N. Chaikin
Literature: *Drawings in the Collection of the Los Angeles County Museum of Art.* Alhambra, 1970.

The drawing is close in composition to the *Landscape* by Valckenborch in the Musée Plantin-Moretus, Antwerp (A. J. J. Delen, *Catalogue des Dessins Anciens* [École Flamande et Hollande], Antwerp, 1938, no. 129, pl. XXII), drawn on paper with the same watermark as the present work. The Los Angeles landscape is also similar to a drawing by Valckenborch that was at Boerner's in 1966 (Lagerliste 44, no. 100).

215. ROELANT SAVERY (Flemish, 1576–1639)
Mountainous Landscape with Castles and Waterfalls
Black crayon heightened with reddish, yellowish, and blue chalks on grayish green paper
13⅞ x 19½ in. (35.2 x 49.5 cm.)
Woodner Family Collection

Literature: *Woodner Collection II: Old Master Drawings from the XV to the XVIII Century.* New York, 1973. no. 80.

216. PETER PAUL RUBENS
(Flemish, 1577–1640)

213

214

215

Bust of "Seneca," ca. 1615
Brown ink over a light sketch of black ink and
wash, 10¾ x 7 in. (27.3 x 17.8 cm.)
The Metropolitan Museum of Art
Robert Lehman Collection

Collection: Earl of Warwick
Literature: M. Rooses. *L'oeuvre de P. P. Rubens.*
5 vols. Antwerp, 1886–92. vol. v, no. 1218;
J. A. Goris, J. S. Held. *Rubens in America.* New
York, 1947. p. 43, no. III, pl. 101; *Drawings and
Oil Sketches by P. P. Rubens from American Col-
lections.* Fogg Art Museum and The Pierpont
Morgan Library, 1956. p. 18, no. 13, pl. XVII;
Exposition de la collection Lehman de New York.
Galerie de l'Orangerie, Paris, 1957. p. 91,
no. 125, pl. LXIII.

W. Prinz has discussed the subject of the
Seneca bust and reproduced the engraving by
Cornelis Galle I of Rubens' *Seneca* in his article
"*The Four Philosophers* by Rubens and the
Pseudo-Seneca in Seventeenth Century Paint-
ing," *Art Bulletin* LV, no. 3 (Sept. 1973): 410–428.

217. JACOB JORDAENS (Flemish, 1593–1678)
*The Conversion of St. Paul with Horseman and
Banner, ca.* 1645–1647
Watercolor and body color over red and black
chalks, 12⅞ x 7¾ in. (32.9 x 19.9 cm.)
The Cleveland Museum of Art
Delia E. and L. E. Holden Funds

Collections: A. von Sachsen-Teschen; Alber-
tina, Vienna; O. Burchard
Literature: R. A. d'Hulst. *De Tekeningen van
Jakob Jordaens.* Brussels, 1956. no. 129, pp. 249,
373, fig. 166; H. S. Francis. "The Conversion of
S. Paul by Jacob Jordaens: Two Drawings in
Washes and Chalks." *The Bulletin of the Cleve-
land Museum of Art*, Feb. 1957. pp. 19-22;
M. Jaffé. *Jacob Jordaens, 1593–1678.* National
Gallery of Canada, Ottawa, Nov. 9, 1968–Jan.
5, 1969. pp. 204, 368, no. 228, fig. 228.

218. JACOB JORDAENS (Flemish, 1593–1678)
The Fall of the Damned (copy after Rubens)
Black and red chalks, brush and brown inks
28 x 18¾ in. (71.2 x 47.6 cm.)
National Gallery of Canada, Ottawa

Collection: T. Agnew and Sons
Literature: M. Jaffé. *Jacob Jordaens, 1593–1678.*
National Gallery of Canada, Ottawa, Nov. 9,
1968–Jan. 5, 1969. p. 204, no. 229, fig. 229.

Assigned by Jaffé to around 1650, this is one
of four sheets by Jordaens after Rubens' draw-
ings that are now in the British Museum. The
present drawing is after Rubens' study for the
upper right portion of the celebrated painting in
the Pinacothek, Munich. In contrast to the me-
dia used by Rubens, which included watercolor
and body color in addition to red and black
chalks, Jordaens combined the two chalks with brush
and brown ink.

219. JACOB JORDAENS (Flemish, 1593–1678)
Study of a Seated Man
Verso: Study of an Elderly Woman's Left Hand
Brush with brown, gray, and blue watercolor
over black chalk, with some heightening with
white (*verso*: red chalk)
11¼ x 10½ in. (28.5 x 26.6 cm.)
Los Angeles County Museum of Art
Los Angeles County Funds

Collection: R. Stora
Literature: I. Moskowitz, ed. *Great Master
Drawings of All Time.* 4 vols. New York, 1962.
II: 560; *European Master Drawings.* Santa Bar-
bara Museum of Art, 1964. no. 12; C. Eisler.
Great Flemish Drawings. New York, 1964. p. 50;
M. Jaffé. *Jacob Jordaens, 1593–1678.* National
Gallery of Canada, Ottawa, Nov. 9, 1968–Jan. 5,
1969. p. 209, no. 238, fig. 238 (dated by Jaffé to
the 1650s or early 1660s).

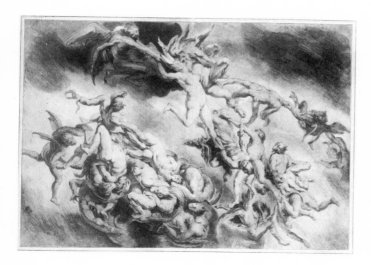

218

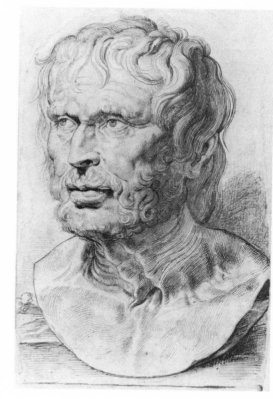

216

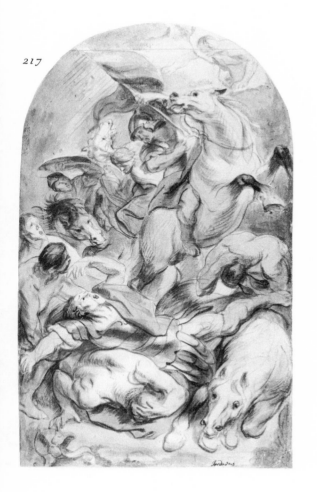

217

219

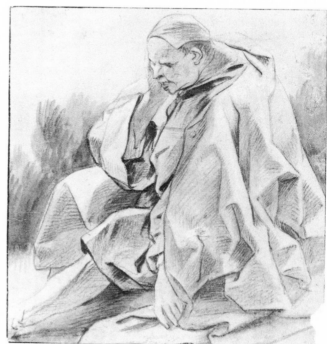

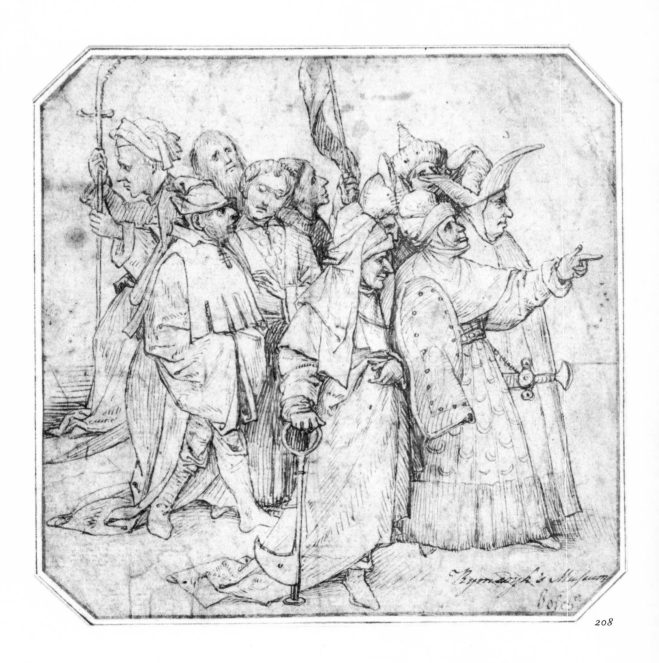

208

The Spanish School

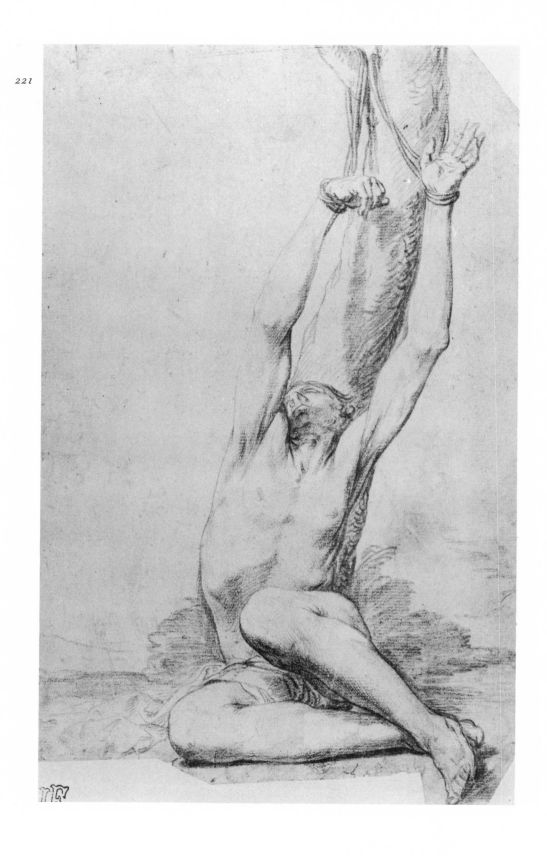

The Spanish School

RAWINGS were rarely collected in Spain before the seventeenth century, when the most illustrious collector was Don Gaspar de Haro y Guzman, Marquis of Carpio and Heliche (1629–1687), who lived in Naples as vice-regent. Most of his large collection was from the Neapolitan school, possibly because at that time Spanish drawings were not only fewer in number but also seemingly less original than Italian ones. This lack of innovation was partly caused by the influx of Netherlandish engravings into Spain during the sixteenth century; Spanish artists used the engravings as studies for motifs rather than making numerous preparatory drawings for each painting. Also decreasing the number of surviving Spanish drawings was the prolonged indifference of Spaniards to collecting and preserving their native graphic art, as well as the repeated re-use of drawings in the studios and workshops, which ultimately destroyed many of them. Unfortunately, these negative factors have circumscribed our knowledge of the graphic styles of many important Spanish artists, including painters and sculptors. With the exception of the many drawings by Goya that are principally in East Coast collections, the Spanish school is inadequately represented in America; fortunately, we are nevertheless able to include in this exhibition twelve Spanish drawings that suggest the varied and characteristic styles of this interesting school which produced so many distinctive draftsmen, particularly during the seventeenth and eighteenth centuries.

Numerous waves of foreign conquerors caused Spain to emerge in Romanesque times as a nation permeated by intercultural influences which were manifested most strikingly in Spanish mysticism. The most fervent of all forms of European mysticism, it left a vivid imprint upon Mozarabic illuminated manuscripts and continued to be a factor in subsequent Spanish painting, which was distinguished by an unusual melding of impassioned spirituality and tangible realism.

The earliest extant Spanish drawings belong to the art of manuscript illumination, which reached its height in the Romanesque period. From the Romanesque and early Gothic periods to the High Renaissance, when painting was in the ascendancy throughout Europe, there was less of note in the development of Spanish drawing than in that of Italy and France. In the sixteenth century Spanish artists, like artists of other countries, were following the lead of the Italians. Spaniards such as the youthful sculptor from Castille, Alonso Berruguete (1486–1560), went to Italy, which was then the center of modern art. In Rome, Ber-

ruguete was taken under the protection of Michelangelo, and in Florence he was allowed to see the Italian master's famous cartoon of the *Battle of Cascina*. Later, in 1533, Titian was appointed court portraitist by Charles V of Spain; he influenced, but never dominated, the native school. Despite Italian influences, however, much in Spanish painting and drawing revealed the anti-classical deflections that are typified by the work of Spain's first great artist, the Greek-born, Italian-trained El Greco (1540–1614). Surrendering himself equally to his Byzantine heritage and to the intense mysticism of his adopted Spain, El Greco transmuted Italian influences into a new, highly personal, emotionally charged vision and produced numerous paintings that occupy a singular position in the history of Spanish art.

Although the prestige and influence of Spanish painters began to increase after the first quarter of the seventeenth century, of the major artists of this period only Ribera, Murillo, and Alonso Cano are now represented by any sizable number of drawings in international collections. Few drawings can be attributed to Velásquez, the greatest Spanish artist of this time, and none to Zurbarán.

Jusepe de Ribera (1591–1652) was the first-born artist of Spain's "Golden Age" of painting, and he is possibly the draftsman best represented in American collections. Opinion is divided as to whether this native of Valencia was influenced in his formative years by the work of the Spanish master Francesco Ribalta (1551–1628), but it is known that after leaving Spain the young Ribera went first to Lombardy where he studied the works of Correggio in Parma. He then journeyed to Rome in 1615–16, where he came under the influence of Raphael, Caravaggio, and Bolognese painters. Finally he settled in Naples and became the leader of that school.

Generally executed either in red chalk or brown ink, his drawings are characteristically unclassical in composition, revealing the Spanish penchant for extreme realism, religious piety, and a marked strain of irony. Affected by Caravaggio's naturalism, Ribera only occasionally drew highly finished, fully modeled figures; he preferred a freer sketching style, often exploring a figure's position, movement, and emotional expressiveness, as in his numerous studies of martyrdom (cat. nos. 221, 223). Ribera's highly dramatic, individual style which employed economical and staccato patterns of line (cat. no. 222) had a great influence on Neapolitan artists, particularly Salvator Rosa and Luca Giordano. Thus under Ribera's hand Spain had a strong effect on Italian art, thereby reversing the earlier direction of influence.

Compared with Ribera's successful career in Naples, Alonso Cano's life (1601–1667) was dramatically checkered. Sculptor and architect as well as painter, he was born in Gra-

nada and early in his career worked first in Seville and then in Madrid. Arrested and tortured for allegedly murdering his young wife, Cano took refuge in a monastery before returning to Madrid where he was finally ordained as a sub-deacon. Ranking with the finest Spanish draftsmen of the Baroque period, Cano inclined toward the classical ideals of balance and symmetry, his works suggesting the influence of the Italian Renaissance masters, including Titian. Cano's drawings exhibit a variety of styles ranging from the classically sculptural delineation of his study (Real Academia de Bellas Artes de San Fernando, Madrid) for the painting *Christ in Limbo* (Los Angeles County Museum of Art) to the vividly pictorial treatment of *The Miracle of the Loaves and Fishes* (cat. no. 224) characterized by an angular linearity and a painterly use of wash. Venetian influence is manifest in both the asymmetry of the composition and the positioning of the figures. Like other major Spanish artists of the seventeenth century, Cano often depended on prints as sources for his compositions, thus continuing a custom that had begun a century earlier.

Once more famous than Cano and much more popular than Ribera, Bartolomé Esteban Murillo (1617–1682) has, at times, been ranked among the greatest European masters. In recent years, as the pendulum of taste has swung away from Murillo's devotional themes, his paintings have suffered a lack of attention; yet his drawings have risen in the general estimation, their energetic freedom presenting a contrast to the usually smooth brushwork and refined sentimentality of his canvases.

The two drawings by Murillo in this exhibition afford an excellent opportunity to view distinct aspects of his graphic style. The brilliant *Virgin and Child* (cat. no. 226), a study for the painting of about 1670 in the Metropolitan Museum, is an example of Murillo's most dynamic expression. The bold calligraphy of the pen strokes stands out dramatically against the wash which is broken by patches of light that just suggest two heads in relief. The spontaneity and intensity of this drawing recalls works by Salvator Rosa, while stylistically it closely resembles Murillo's own drawing of the *Immaculate Conception*, in the collection of Lord Clark. In contrast to the *Virgin and Child*, Murillo's *Christ on the Cross* (cat. no. 227) is more conservative, its conception possibly derived from Rubens. Unlike the former drawing, this one was first delineated in black chalk, to which ink lines and luminous washes were added to heighten the suggestion of relief and atmosphere. The restrained, yet intense religious emotion and shimmering visions of miracles evoked by *Christ on the Cross* correspond to the better-known, more popular view of Murillo's art.

Spanish individuality and originality can be said to have reached full fruition with Francisco Goya (1746–1828). In his *oeuvre*, which often presents an acerbic, almost misanthropic

analysis of society that contrasts sharply with works by earlier Hispanic artists, he seems to burst out from the centuries of repression by superstition and the Inquisition. He was, for example, the first Spaniard to paint an unabashedly frontal picture of a female nude—the great *Maja Desnuda* in the Prado.

Of his several self-portraits, the present one (cat. no. 229) ranks among the most indelible. Apparently drawn soon after the discovery of his permanent deafness, Goya's face, as noted by Hyatt Mayor, reflects profound shock in the gaze of the downcast, inward-searching eyes. Henceforth cut off from the world of sound, Goya produced drawings with a passion that approached ferocity. In works registering the Inquisition, the wars, and the social turmoil of his period, the figures seem often to cower under the threat of destruction. His vitriolic pictures (cat. nos. 230, 231) take savage, relentless revenge on the manners and morals of his age and, by extension, on mankind itself.

Goya's graphic skills were many; he displayed virtuosity in numerous techniques including pen, brush, wash, chalk, tempera, and, as Eleanor Sayre has shown, paint on ivory. He preferred chalk and rich, brushed washes, for they accommodated his need for freedom and helped communicate his perception of life's high dramatic contrasts. Undoubtedly among the most painterly in European history, Goya's drawings in their use of light and shade seem the rightful heir to the work of masters such as Rembrandt, Callot, Claude, and Tiepolo; yet they retain stylistic elements and methods characteristic of Spain. Few of Goya's more than one thousand known drawings are purely linear, as befits the artist who first pronounced that nature contains no lines. Abandoning old traditions and themes, Goya moved the art of Europe, as Napoleon moved its politics, into the modern world of the nineteenth century.

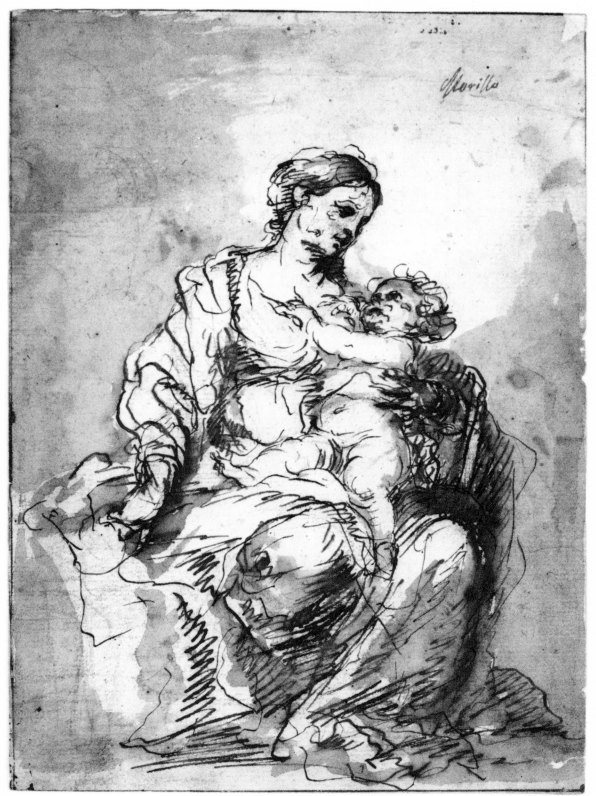

Catalog

220. FRANCESCO ROMULO CINCINATO
(Spanish, 1585–1635)
The Entry of Christ into Jerusalem, 1629
Brown ink and wash on cream paper
8 x 12⅛ in. (20.3 x 30.7 cm.)
University of Michigan Museum of Art
Gift through the Estate of Edward Sonnenschein

Collections: Mr. Rosenheim (Sale, London);
E. Parsons; Edward Sonnenschein
Literature: M. C. Taylor. *European Drawings
from the Sonnenschein Collection...in the Collec-
tion of the University of Michigan Museum of Art.*
Ann Arbor, 1974. no. 16, fig. 16; G. M. Smith.
*Spanish Baroque Drawings in North American
Collections.* University of Kansas Museum of
Art, Lawrence, Oct. 19–Nov. 24, 1974.
no. 17, fig. 17.

221. JUSEPE DE RIBERA (Spanish, 1591–1652)
Saint Sebastian, ca. 1626
Red chalk on brown paper
10⅟₁₆ x 6½ in. (25.5 x 16.5 cm.)
The Indiana University Museum of Art
William Lowe Bryan Memorial

Collections: Unidentified "LF"; Schaeffer
Galleries
Literature: *Old Master Drawings.* The Newark
Museum, 1960. no. 36, repr.; I. Moskowitz, ed.
Great Drawings of All Time. 4 vols. New York, 1962.
vol. IV, no. 931; F. J. Sánchez Cantón. *Drawings
of the Masters, Spanish Drawings from the 10th to
the 19th Century.* New York, 1964. pl. 19; *Cento
disegni napoletani.* Uffizi, 1967. no. 32; A. E.
Pérez Sánchez. *I disegni dei maestri. Gli spagnoli
da El Greco a Goya.* Milan, 1970. pp. 88–89, fig.
9; J. Brown. "Notes on Princeton Drawings:
Jusepe de Ribera." *Record of the Art Museum,
Princeton University* XXXI, no. 2 (1972): 7, no. 1;
idem. *Jusepe de Ribera Prints and Drawings.*
Princeton, 1973. no. 10, fig. 37; G. M. Smith.
*Spanish Baroque Drawings in North American
Collections.* University of Kansas Museum of
Art, Lawrence, Oct. 19–Nov. 24, 1974. p. 60.

222. JUSEPE DE RIBERA (Spanish, 1591–1652)
An Orator
Pen and black ink on cream paper
7⅟₁₆ x 5½ in. (19.5 x 14.0 cm.)
The Achenbach Foundation for Graphic Arts,
California Palace of the Legion of Honor

Collections: Joseph Green Cogswell; M.L.
Schiff; M.S. Achenbach
Literature: G.S. Hellman. *Original Drawings by
the Old Masters: The Collection Formed by Joseph
Green Cogswell, 1786–1871.* New York, 1915.
no. 255; D. Fitz Darby. "Ribera and the Wise
Men." *The Art Bulletin* XLIV (1962): 279–307;
J. Brown. *Jusepe de Ribera Prints and Drawings.*
Princeton, 1973. no. 16, fig. 43.

223. JUSEPE DE RIBERA (Spanish, 1591–1652)
Man (Martyr) Hung and Bound to Stake
Pen and brown ink with brown ink wash on tan
washed paper
8⅟₁₆ x 6⅝₁₆ in. (21.5 x 16.0 cm.)
The Achenbach Foundation for Graphic Arts,
California Palace of the Legion of Honor

Collections: Joseph Green Cogswell (no. 172);
M.L. Schiff; M.S. Achenbach
Literature: G.S. Hellman. *Original Drawings by
the Old Masters: The Collection Formed by Joseph
Green Cogswell.* New York, 1915. no. 256, pl.
LXI; W. Vitzthum. "Disegni inediti di Ribera."
Arte Illustrata IV (1971): 79, fig. 7; J. Brown.
Jusepe de Ribera Prints and Drawings. Princeton,
1973. no. 36, pl. 63.

224. ALONSO CANO (Spanish, 1601–1667)
The Miracle of the Loaves and Fishes
Brown ink and wash over traces of black chalk
13⅟₅₁₆ x 7⅝ in. (19.3 x 35.4 cm.)
The University of Michigan Museum of Art

Collections: Mlle. Kalebdijan; Mme. E.
Zarnowska
Literature: "Bibliografia." *Archivo Español de
Arte* XXV, no. 100 (1952): 364–65, nos. 73–74, pl.
VII; H. Wethey. "Alonso Cano's Drawings."
The Art Bulletin XXXIV (1952): 220, 230, no. V,
fig. 9; idem. "A Drawing by Alonso Cano."

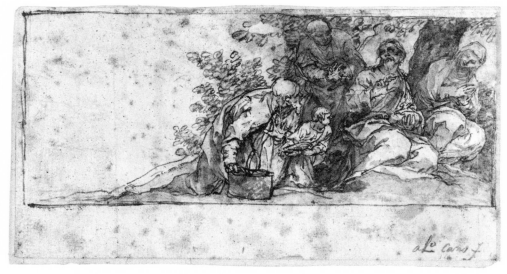

224

225

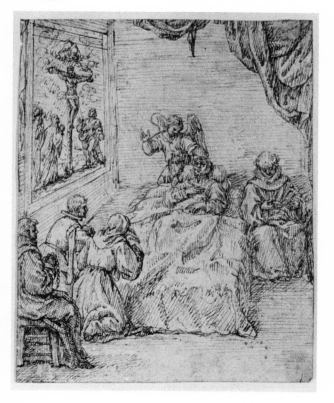

228

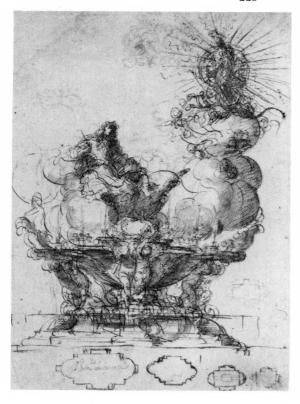

Bulletin of the University of Michigan Museum of Art. Ann Arbor, 1952. pp. 2–4, fig. 1; idem. *Alonso Cano, Painter, Sculptor, Architect.* Princeton, 1955. p. 9, fig. 3; E. Orozco Diaz. *Esposición Alonso Cano y su escuela.* Granada, 1969. pp. 31–32; M. C. Taylor. *European Drawings from the Sonnenschein Collection...in the Collection of the University of Michigan Museum of Art.* Ann Arbor, 1974. no. 61; G. M. Smith. *Spanish Baroque Drawings in North American Collections.* University of Kansas Museum of Art, Lawrence, Oct. 19–Nov. 24, 1974. no. 4, pl. 4.

225. ANTONIO DE PEREDA
(Spanish, 1608–1678)
Death of a Franciscan Saint (San Diego de Alcala)
Brown ink on tan paper
7⁵⁄₁₆ x 6 in. (18.6 x 15.2 cm.)
Chrysler Museum at Norfolk
Museum Purchase, 1950

Literature: F. J. Sánchez Cantón. *Drawings of the Masters: Spanish Drawings from the 10th to the 19th Century.* New York, 1964. pl. 49.

Published originally by Sánchez Cantón as Juan Valdès Leal, the drawing has been re-attributed by Alfonso Pérez Sánchez to Antonio de Pereda, an opinion supported by Jonathan Brown (review, "Spanish Baroque Drawings in North American Collections," *Master Drawings* XIII, no. 1 [1975]: 61).

226. BARTOLOMÉ ESTEBÁN MURILLO
(Spanish, 1617–1682)
Virgin and Child, ca. 1670
Brown ink and light brown wash over black chalk with traces of red chalk
8⁷⁄₁₆ x 6¹⁄₁₆ in. (21.4 x 15.4 cm.)
The Cleveland Museum of Art
Mr. and Mrs. Charles G. Prasse Collection

Collections: J. de Mons; F. Mont
Literature: L. S. Richards. "Bartolomé Estebán Murillo: A Drawing Study for a Virgin and Child." *Bulletin of the Cleveland Museum of Art* LV (1968): 235–39; G. M. Smith. *Spanish Baroque*

Drawings in North American Collections. University of Kansas Museum of Art, Lawrence, Oct. 19–Nov. 24, 1974. no. 26, fig. 26.

227. BARTOLOMÉ ESTEBÁN MURILLO
(Spanish, 1617–1682)
Christ on the Cross
Brown ink and wash over black chalk
13³⁄₁₆ x 9⁵⁄₁₆ in. (33.5 x 23.6 cm.)
The Art Museum, Princeton University
Laura P. Hall Memorial Collection

Collections: Lord Northwick (Sale, London, Sotheby's, Nov. 1–4, 1920, no. 318); Sir B. Ingram
Literature: J. Brown. "Notes on Princeton Drawings: Bartolomé Estebán Murillo." *Record of the Art Museum, Princeton University* XXXII, no. 2 (1973): 28–33; G. M. Smith. *Spanish Baroque Drawings in North American Collections.* University of Kansas Museum of Art, Lawrence, Oct. 19–Nov. 24, 1974. no. 30.

228. FRANCESCO HERRERA EL MOZO
(Spanish, 1622–1685)
The Vision of St. John on Patmos
Brown ink and wash over preliminary indications in graphite
10¾ x 7¹³⁄₁₆ in. (27.3 x 18.3 cm.)
The Pierpont Morgan Library

Literature: I. Moskowitz, ed. *Great Drawings of All Time.* 4 vols. New York, 1962. vol. IV, no. 945, repr.; F. Stampfle. *Drawings: Major Acquisitions of The Pierpont Morgan Library, 1924–1974.* New York, 1974. no. 31; J. Brown. "Pen Drawings by Herrera the Younger." *Hortus Imaginum Essays in Western Art.* Edited by R. E. Enggass, M. Stokstad. Lawrence, Kansas, 1974. p. 138; idem. "Drawings by Herrera the Younger and a Follower." *Master Drawings* XIII (1975), no. 3.

229. FRANCISCO DE GOYA
(Spanish, 1746–1828)
Self-Portrait
Point of brush and gray wash

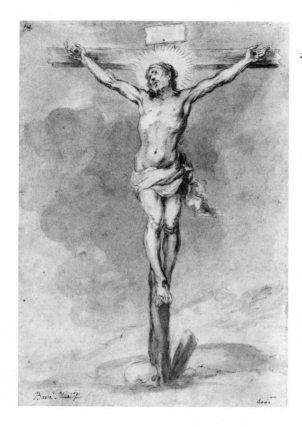

227

223

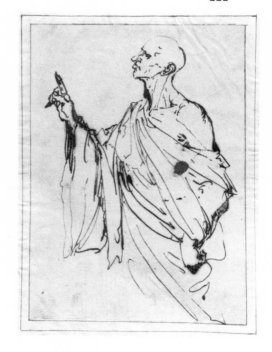

222

6 x 3⁹⁄₁₆ in. (15.3 x 9.1 cm.)
The Metropolitan Museum of Art
Harris Brisbane Dick Fund

Collections: V. Carderera; F. de Madrazo;
Mariano Fortuny y Madrazo; purchased by the
Metropolitan Museum in Paris in 1935
Literature: V. Carderera. "François Goya."
Gazette des Beaux-Arts VII (1860): 222–27;
V. von Loga. "Drei Briefe Goyas." *Kunst und
Kunstler* V (1908): 65, repr.; H. Wehle. *Fifty
Drawings by Goya*. New York, 1938. p. 7, repr.
frontispiece; P. Gassier, J. Wilson. *Goya: His
Life and Work*. London, 1971. repr. p. 114;
A. Hyatt Mayor. *Goya: 67 Drawings*. New York,
1974. no. 23, repr.

230. FRANCISCO DE GOYA
(Spanish, 1746–1828)
You'll See Later
Brush and brown ink
10½ x 7⁹⁄₁₆ in. (26.6 x 18.7 cm.)
The Metropolitan Museum of Art
Harris Brisbane Dick Fund

Collections: J. Goya; M. Goya; V. Carderera;

F. de Madrazo; M. Fortuny y Madrazo
Literature: H. B. Wehle. *Fifty Drawings by Goya*.
New York, 1938. p. 11; P. Gassier. *Francisco
Goya, Drawings, The Complete Albums*. New York,
1973. p. 214, no. E. 24, repr. p. 183; A. Hyatt
Mayor. *Goya: 67 Drawings*. New York, 1974.
no. 30, repr.

231. FRANCISCO DE GOYA
(Spanish, 1746–1828)
The Nightmare
Brush and brown wash
9³⁄₁₆ x 5¹¹⁄₁₆ in. (23.4 x 14.5 cm.)
The Metropolitan Museum of Art
Rogers Fund

Collections: P. Lebas; Anonymous Public Sale,
Paris; E. Féral; E. Rodriguez; purchased by the
Metropolitan Museum, 1919
Literature: H. B. Wehle. *Fifty Drawings by Goya*.
New York, 1938. fig. 10; P. Gassier. *Francisco
Goya, Drawings, The Complete Albums*. New
York, 1973. p. 162, no. D. 20, repr. p. 151;
A. Hyatt Mayor. *Goya: 67 Drawings*. New York,
1974. no. 27, repr.

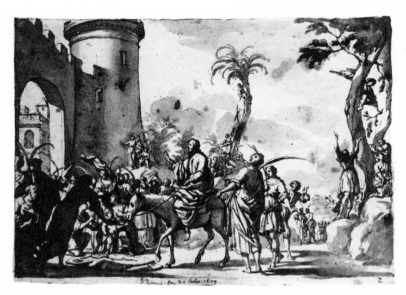

220

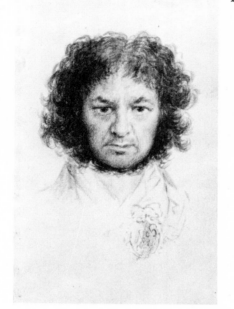

229

231

20 22.

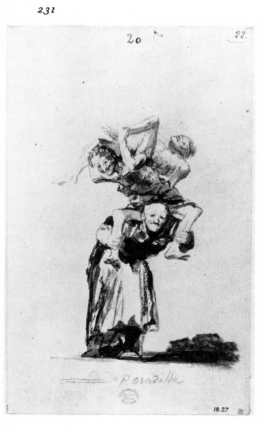

Pesadilla

19.27

230

24 18.

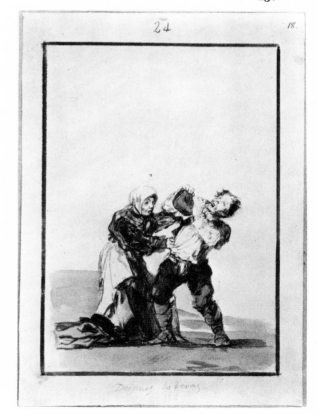

Despues lo veras

The English School

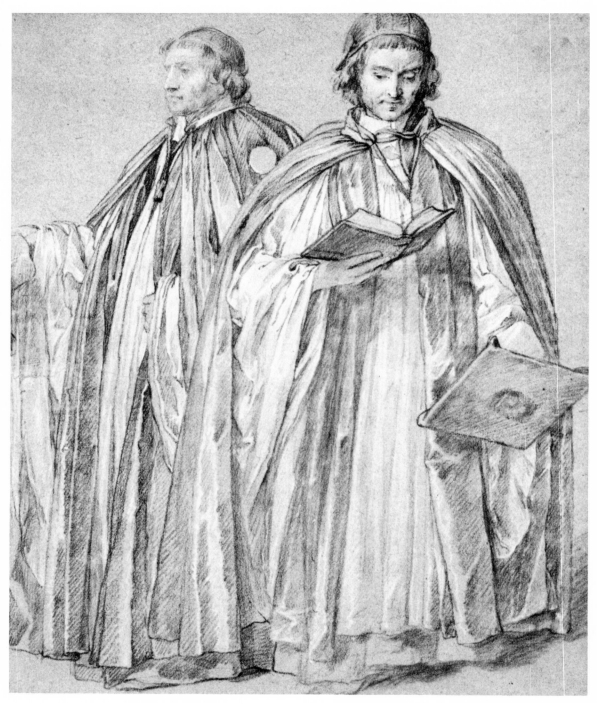

The English School

FLOURISHING in the early eighth and ninth centuries, the city of Canterbury appears to have been the first center of illustrated book production in southern England. Still, not until the tenth century did a drawing style develop that was truly English. With the Winchester School as its main center, this style was to a degree a renaissance of the Greco-Roman and Continental narrative tradition, which it restated in a fresh and delicate new form. English drawings of the tenth century were often outlined in brown ink and lightly tinted with colored washes or executed in pen and colored inks. Conventional treatment of features and coloring, fluttering drapery, large hands, and extravagant gestures were characteristic of this English style, so closely related to manuscript illumination, which lasted until the Norman Conquest of 1066.

Following the Norman Conquest, in the twelfth century English and Norman styles intermingled at Winchester and Canterbury. The Crusades introduced such Byzantine influences as gold paint and rich color, which were fully absorbed into the English style by the third decade of the twelfth century. Subsequent developments include the emergence of two distinct schools in the thirteenth and fourteenth centuries, one almost exactly resembling the French; the other, the East Anglican school, continuing traditional motifs and ornamentation.

In the middle of the fourteenth century the English drawing tradition which had existed for four hundred years abruptly ended, possibly due to the plague of 1348–49. During the fifteenth century when French manuscript illumination attained its zenith in such works as *Les très riches heures du Duc de Berry*, native British manuscript drawing and illumination reached their nadir. Most of the fifteenth-century illuminated books executed in England were the work of French artists or of English artists who imitated foreign models, and during the reign of Edward IV (1461–1483) this fashion gave way to a similar enthusiasm for Flemish painting.

Until the beginning of the eighteenth century, England, for a variety of historical reasons, gave little encouragement to her native artists, and they had neither the means for training nor the benefit of great art collections for study and inspiration. Thus, in the sixteenth century English art fell far behind stylistically. The German Hans Holbein the Younger dominated the English scene until his death in 1543, and he left no strong successors in England except the miniaturists Nicholas Hilliard and Isaac Oliver. Oliver was born in France and his English works definitely reflect the influence of Parmigianino as well as the School of Fontainebleau.

In the seventeenth century the Flemish artists Rubens and van Dyck were the major artists working in England. The one outstanding English draftsman of the early seventeenth century was the influential architect and stage designer Inigo Jones (1573–1652) who received his training in Italy. His style in everything was Italianate, from his Palladian architectural principles to his costume designs reminiscent of drawings by the little-known Florentine draftsman Mirabello di Antonio Cavalori (*ca.* 1510/20–after 1572). But the looseness of his line, grounded in a tradition of linear freedom going back to the Winchester School, characterizes his drawing as English.

Apparently Inigo Jones was the first Englishman to acquire drawings, thus setting the precedent for the great bevy of old master drawing collections in the seventeenth century. Among the earliest collections formed was that of Sir Peter Lely (1618–1680) who succeeded van Dyck as portrait painter to the king. Born Pieter van der Faes in Westphalia, Lely studied in Haarlem before coming to England in 1641, following the death of van Dyck. Between 1663 and 1671, he executed numerous chalk drawings on blue paper of members of the Order of the Garter. Presumably these studies were for a painting, but there is no record of the work having ever been carried out. These drawings are considered his finest achievement as a draftsman, and the study of *Two Noble Clergymen* (cat. no. 232), which belongs to the series, well represents the strength and freshness of Lely's drawing style, not found in his more official, mannered paintings.

The last principal artist in seventeenth-century England was, like most of the painters working there, of foreign birth. Sir Godfrey Kneller (1646–1723), a well-traveled and cultivated German portraitist, came to England as a young man and achieved great reputation and wealth. Few of his drawings are known, possibly because his skill and rapidity in portraiture precluded a need for preliminary sketching. Kneller contributed to the burgeoning art life in England by heading the newly formed Art Academy which began teaching life drawing. The second governor of the academy, named in 1711, was the English-born ceiling painter and draftsman James Thornhill (1675–1734), whose academic Baroque style was formed largely upon the model of Italian ceiling decorators.

With the birth of William Hogarth in 1697 (d. 1764), English art entered a new era. Hogarth was revolutionary in the sense that he gave visual form to the native literary genius for portraying character, breaking from the nearly slavish attachment to foreign artists that had marked English artists in the past. As an internationally successful engraver, he was the first major representative of this popular graphic art in England. In contrast to the vivid, highly detailed quality of his prints, some of Hogarth's drawings have a surprising gener-

ality; yet in others there appears an intense, repetitive calligraphy which parallels Daumier's drawings.

In freeing his expression from foreign influences, Hogarth was a forerunner of England's first outstanding landscape painter, Richard Wilson (1714–1782). Although Wilson studied in Italy and inevitably came under the sway of Claude Lorrain, he was individual enough to allow the native English character of openness and looseness of line to emerge in his drawings, immediately distinguishing them as belonging to the English tradition rather than the more disciplined classical Italian school of drawing.

With Thomas Gainsborough (1727–1788) we come to the first major landscape painter in England. His landscape drawings reflect the atmospheric qualities found in his paintings. Often he developed these drawings in soft-ground etchings in order to popularize his landscape work. Although he originally studied with the French engraver Hubert Gravelot, who had been a pupil of Watteau, Gainsborough formed his landscape style independently, preferring melancholy scenes in faint or evening light, mysterious forest shades, or rough and broken country sites with clouded skies. His predilection for landscape paintings was so strong that he continued producing them even though they were rarely sold.

The three landscape drawings shown here represent diverse styles from different periods. *Horseman by a Stile* from Toledo (cat. no. 233) dates, according to John Hayes, from the early to mid-1760s when Gainsborough was working in watercolor. The detailed rendition of nature evidences a Dutch influence. The *Landscape with Buildings* (cat. no. 234) is classically composed, restful, restrained. By means of complex media, the artist achieved strong contrasts of light and dark areas as well as multiple gradations of tone. The work dates from around 1770 when Gainsborough introduced varnish into his drawings to give them the appearance of paintings. The *Landscape with Cattle Drinking at a Pond* (cat. no. 235) is in the artist's later, sketchier manner, in which forms diffuse into insubstantiality.

As Gainsborough's work can be said to have paralleled the gentle lyricism of Thomas Gray, the drawings of George Romney (1734–1802) anticipated the extravagant, half-tragic emotionalism of Byron. While Romney's portrait paintings were affected by artists as diverse as Titian and Greuze, his drawings have also a strange parallel to Blake's in their boldly dramatic, flowing execution. The drawings in the exhibition illustrate the rapidity, breadth, and freedom of Romney's use of ink and wash, whether with pen or brush. In *Howard Visiting a Prison* (cat. no. 236) the figures are drawn with great simplicity and little modeling. The limp, almost boneless woman in the foreground is delineated by broad patches of wash; stylistically she could hardly seem more "modern" due to the artist's economy of

graphic means. In the landscape view (cat. no. 237) the flattening of the forms and the blotting of the wash create a sketch that heralds the approach of the Impressionists. Comparing Romney's drawings with those by two of his contemporaries we find that they lack Fuseli's extravagance and refinement of finish, or Blake's visionary content. Nevertheless, through the high pitch of their emotional intensity Romney's drawings convey the lyrical, romantic spirit of his age.

The last "English" artist represented in the exhibition is Benjamin West (1738–1820). Born in Pennsylvania of Quaker parents, at twenty-two he went to Italy to study and in Rome came under the influence of Winckelmann, who was advocating a return to "moral" painting based on classical art and universal values. Studying for a time under Mengs, West remained in Italy for three years, enjoying great success and achieving membership in several academies. In 1763 he proceeded to England, then still the "mother country," where he eventually became court painter and one of the founders of the Royal Academy, which he later served as president.

West is represented here by two drawings. The earlier one appears to be the study of a woman's head (cat. no. 238); the influence of Guercino suggests the work was done by West during his Italian sojourn, in the early sixties. The generously proportioned *Hagar and Ishmael* (17½ x 20¼ in.) (cat. no. 239), dated 1780 or 1789(?), may be related to the painting of the same subject in the Metropolitan Museum, a work which West began in 1776 and later repainted in 1803. The angel in *Hagar and Ishmael* with its upturned arm, streaming locks of hair, and flowing garments seems much akin to the angel appearing in West's painting *Isaiah's Lips Annointed with Fire* of 1784 (Bob Jones University) from his "Revealed Religion" series. In the painting, however, the angel's position is reversed, and the garment differs slightly, particularly in the sleeves which seem shorter than in the drawing.

Spending the remainder of his life in England, West enjoyed wide acclaim until his death in 1820. He was instrumental in forming European as well as American aesthetics, pioneering as an innovator in both Neoclassical and Romantic works which earned him an international reputation. Equal, if not more important, was his influence as a teacher. He taught painting to both English and American students (the latter include Copley, Stuart, Trumbell, Allston, Morse, Sully, and numerous others who subsequently became well known in their native land) at a time when the Royal Academy taught only drawing and there was no formal painting instruction. Thus, Benjamin West has rightly been claimed not only as the "father" of American art, but as a major contributor to English art as well.

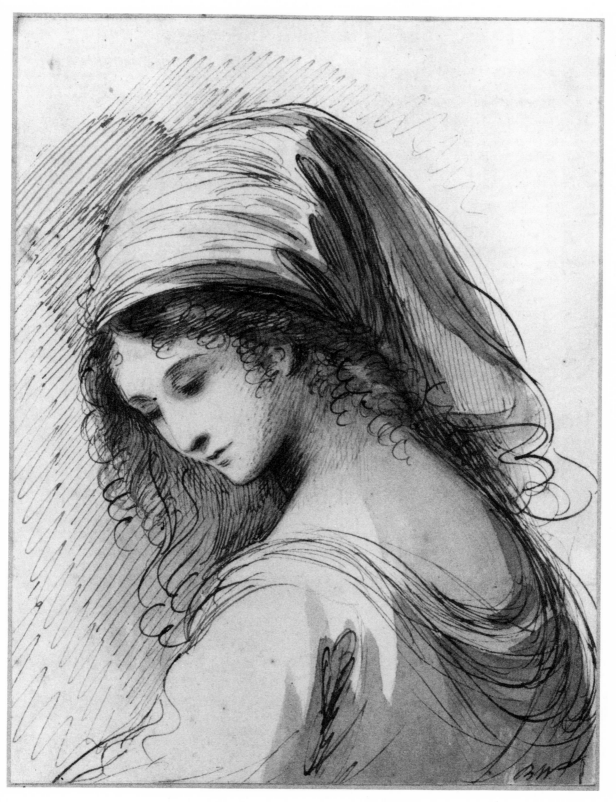

Catalog

232. SIR PETER LELY (English, 1618–1680)
Two Noble Clergymen
Black and white chalk on blue paper
19⅛ x 16⁵⁄₁₆ in. (48.5 x 41.4 cm.)
E. B. Crocker Art Gallery

Collections: Dabeth; R. Weigel; E. B. Crocker
Literature: *Master Drawings from Sacramento.*
E. B. Crocker Art Gallery, Sacramento, 1971.
no. 64, fig. 64.

233. THOMAS GAINSBOROUGH
(English, 1727–1788)
Horseman by a Stile, ca. 1760–1765
Pencil, watercolor, and gouache
9⁷⁄₁₆ x 12³⁄₁₆ in. (24.0 x 30.9 cm.)
Watermark: Fragment of fleur-de-lis in crowned
escutcheon
The Toledo Museum of Art

Collections: G. Richmond; Sale, London,
Christie's, Apr. 29, 1897, no. 164; W. Richmond
Literature: J. Hayes. "The Gainsborough
Drawings from Barton Grange." *Connoisseur,*
Feb. 1966. p. 91 ff.; idem. *The Drawings of
Thomas Gainsborough.* London, 1970. pp. 59,
173, no. 277, pl. 271.

234. THOMAS GAINSBOROUGH
(English, 1727–1788)
Landscape with Buildings
Black chalk, watercolor, and oil in shades of
blue, rose, opaque white, brown, and green on
tan antique paper, the surface varnished
8¾ x 12 in. (22.2 x 30.5 cm.)
Anonymous

Collections: H. J. Pfungst; Sale, London,
Christie's, June 15, 1917, no. 3; Colnaghi's, 1929
Literature: M. Woodall. *Gainsborough's Land-
scape Drawings.* London, 1939. no. 441; J. Hayes.
The Drawings of Thomas Gainsborough. New
Haven and London, 1970. I: 191, no. 355; F. W.
Robinson. *One Hundred Master Drawings from
New England Private Collections.* Wadsworth
Atheneum, Hartford, 1973. no. 33, repr.

235. THOMAS GAINSBOROUGH
(English, 1727–1788)
Landscape with Cattle Drinking at a Pond
Charcoal and wash
10⁵⁄₁₆ x 13¼ in. (28.0 x 33.5 cm.)
Anonymous

Collections: Gainsborough Dupont (the artist's
nephew); G. Donaldson; H. Schiewind
Literature: *Landscape: The Artist's View.* The
Grunwald Graphic Arts Foundation, Los
Angeles, 1968. no. 15, fig. 15.

The drawing, apparently unknown to John
Hayes, was not included in either his article,
"The Drawings of Gainsborough Dupont,"
Master Drawings III, no. 3 (1965): 243–56, or his
catalog, *The Drawings of Thomas Gainsborough,*
New Haven and London, 1971.

236. GEORGE ROMNEY (English, 1734–1802)
Howard Visiting a Prison, ca. 1790–1794
Black ink, ink and watercolor in shades of gray,
over pencil
14 x 21 in. (35.6 x 53.3 cm.)
Yale University Art Gallery
Gift of Mr. and Mrs. J. Richardson Dilworth

Collection: Xavier Haas
Literature: *The Drawings of George Romney.*
Smith College Museum of Art, Northampton,
Mass., May–Sept. 1962. no. 81, not repr.

This is one of Romney's nine studies for the
one or two large works he intended to paint on
contemporary prison conditions, but which he
never carried out. John Howard, High Sheriff of
Bedfordshire in 1773, visited prisons all over
Europe and Russia, where he finally died of jail
fever in 1790. By his travels Howard focused
attention on the intolerable conditions and
became a national hero.

237. GEORGE ROMNEY (English, 1734–1802)
Glade in a Forest
Brush with gray watercolor over pencil
15¾ x 21½ in. (40.0 x 54.9 cm.)
Yale University Art Gallery
Gift of Mr. and Mrs. J. Richardson Dilworth

234

235

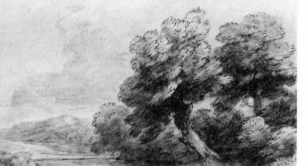

233

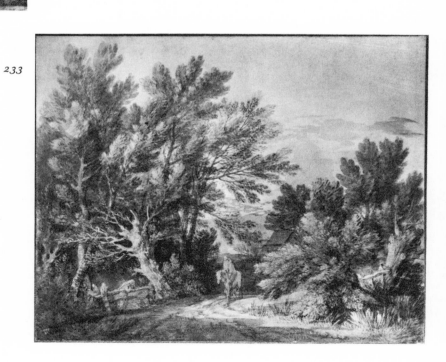

Collection: Xavier Haas
Literature: *The Drawings of George Romney*.
Smith College Museum of Art, Northampton,
Mass., May–Sept. 1962. no. 63, pl. XIII.

238. BENJAMIN WEST (American, 1738–1820)
Woman with Draped Head, Looking Down
Brown ink and wash
8¼ x 6⅛ in. (20.9 x 15.5 cm.)
Los Angeles County Museum of Art
Los Angeles County Funds

Collection: Private collector, Bologna
Literature: Unpublished

239. BENJAMIN WEST (American, 1738–1820)
Hagar and Ishmael
Brown ink and blue wash
17½ x 20¼ in. (44.4 x 51.4 cm.)
Signed and dated: 1780 (1789?)
Addison Gallery of American Art,
Phillips Academy

Collection: Unrecorded; acquired by the
Addison Gallery in 1953
Literature: *Old Master Drawings*. The Newark
Museum, Mar. 17–May 22, 1960. no. 57; E. E.
Gerdts, W. H. Gerdts. *The Hand and the Spirit:
Religious Art in America, 1700–1900*. University
Art Museum, Berkeley, 1973. no. 11, not repr.

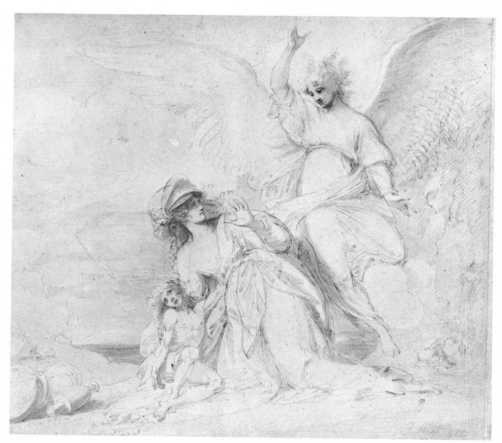

239

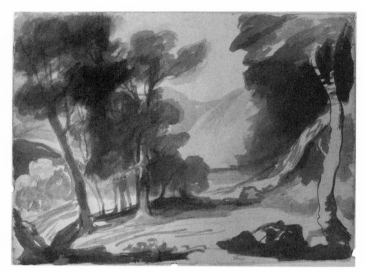

237

236

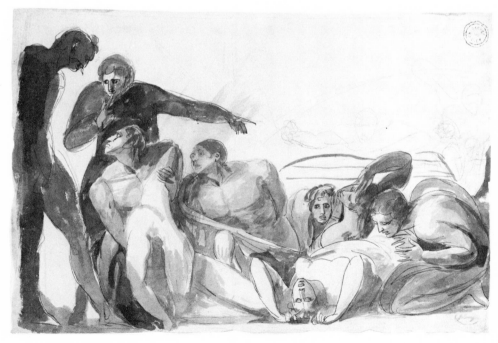

BIBLIOGRAPHY

References are limited principally to general books and catalogs on drawings. Those works dealing with individual draftsmen are omitted in the interests of space and also because many are found under Literature in the catalog entries.

Adhémar, J. *Le dessin français au XVI^e siècle*. Lausanne, 1954.

——. *French Drawings of the XVI Century*. New York, 1955.

American Federation of Arts. *Old Master Drawings from the Collection of Mr. and Mrs. Lester Francis Avnet*. New York, 1968.

Ames, W. *Drawings of the Masters: Italian Drawings from the 15th to the 19th Century*. New York, 1963.

Andrews, K. *National Gallery of Scotland, Italian Drawings*. 2 vols. Edinburgh, 1968.

The Art Galleries. *Drawings by Seventeenth Century Italian Masters from the Collection of Janos Scholz*. University of California, Santa Barbara, 1974.

Art Institute of Chicago. *Drawings Given to the Art Institute of Chicago, 1944–1970, by Margaret Day Blake*. Chicago, 1970.

Bacou, R. *Great Drawings of the Louvre Museum: The German, Flemish and Dutch Drawings*. New York, 1968.

——. *Great Italian Drawings of the Louvre Museum*. New York, 1968.

——. *Il Settecento francese*. I disegni dei maestri, Edited by W. Vitzthum. Milan, 1971.

Bean, J. *One Hundred European Drawings in The Metropolitan Museum of Art*. New York, 1964.

——. *Italian Drawings in the Art Museum, Princeton University: 106 Selected Examples*. Princeton, 1968.

Bean, J., and Stampfle, F. *Drawings from New York Collections I: The Italian Renaissance*. The Metropolitan Museum of Art and The Pierpont Morgan Library, New York, 1965.

——. *Drawings from New York Collections II: The Seventeenth Century in Italy*. The Metropolitan Museum of Art and The Pierpont Morgan Library, New York, 1967.

——. *Drawings from New York Collections III: The Eighteenth Century in Italy*. The Metropolitan Museum of Art and The Pierpont Morgan Library, New York, 1971.

Beguin, S. *Il cinquecento francese*. I disegni dei maestri, Edited by W. Vitzthum. Milan, 1970.

Benesch, O. *Venetian Drawings of the Eighteenth Century in America*. New York, 1947.

Berenson, B. *The Drawings of the Florentine Painters*. 2 vols. London, 1903.

——. *The Drawings of the Florentine Painters*, amplified ed., 3 vols. Chicago, 1938.

——. *I disegni dei pittori fiorentini*, 3 vols. Milan, 1961.

Berliner, R. "Two Contributions to Criticism of Drawings Related to Decorative Art-II." *Art Bulletin* XXXIII (1951): 53–55.

Bernt, W. *Die niederlandischen Zeichner des 17. Jahrhunderts*. 2 vols. Munich, 1957.

Bertini, A. *I disegni italiana della Biblioteca Reale di Torino*. Rome, 1958.

Bertram, A. *1,000 Years of Drawing*. (paperback), New York, 1966.

Blunt, A. *The French Drawings at Windsor Castle*. London, 1945.

Blunt, A., and Croft-Murray, E. *Venetian Drawings at Windsor Castle*. London, 1957.

Blunt, A., and Cooke, H. L. *The Roman Drawings of the XVII and XVIII Centuries ... at Windsor Castle*. London, 1960.

Bock, E. *Die deutschen Meister*. Berlin, 1921.

Borenius, T., and Wittkower, R. *Catalogue of the Collection of Drawings by the Old Masters Formed by Sir Robert Mond*. London, n.d.

Bostico, S., and Gardini, G. "Drawing in Antiquity and the Middle Ages." *Encyclopedia of World Art.* vol. IV, New York, 1963.

Boucher, F., and Jacottet, P. *Le dessin français au XVIII^e siècle.* Lausanne, 1952.

Briegar, L. *Das Pastell.* Berlin, n.d.

British Museum. *The Art of Drawing.* London, 1972.

The Buffalo Fine Arts Academy. *Master Drawings Selected from the Museums and Private Collections of America.* Buffalo, 1935.

Le cabinet d'un grand amateur, P. J. Mariette (1694–1774): Dessins du XV^e au XVIII^e siècle. Paris, 1967.

Catalogue of the Ellesmere Collection of Drawings at Bridgewater House. London, 1898.

Cennini, C. *The Craftsman's Handbook.* Translated by D.V. Thompson, Jr. New York (paperback) and New Haven, 1933.

Chatelet, A. "Notes on Old and Modern Master Drawings from the Janos Scholz Collection at the Cini Foundation." *Art Quarterly* XXI (1958): 193.

Chennevières, P. de. *Les dessins de maîtres anciens.* Paris, 1880.

Chiarini, M. *I disegni italiani di Paesaggio dal 1600 al 1700.* Treviso, 1972.

The Sterling and Francine Clark Art Institute. *Things of This World: A Selection of Dutch Drawings from the Collection of Maida and George Abrams.* Williamstown, Mass., 1972–73.

Colnaghi's, London. *Drawings by Old Masters from the Collection of Dr. and Mrs. Springell.* New York, 1959.

Columbia Museum of Art and Science. *Italian Baroque Drawings from the Janos Scholz Collection.* Columbia, S.C., n.d.

Degenhart, B. "Zur Graphologie der Handzeichnungen. Die Strichbildung als stetige Erscheinung innerhalb der italienischen Kunstkreise." *Kunstgeschictliches Jahrbuch der Bibliothek Hertziana.* vol. I. Leipzig, 1937.

Degenhart, B., and Schmitt, A. "Methoden Vasaris bei der Gestaltung seines 'Libro.'" *Studien zur toskanischen Kunst, Festschrift für L. H. Heydenreich.* Munich, 1964.

———. *Corpus der italienischen Zeichnungen, 1300–1450.* 4 vols. Berlin, 1968.

Delbrüch, R. *Die Consulardiptychen.* Berlin, 1929.

Delen, A. J. J. *The Seventeenth Century.* New York, 1950.

Ede, H. S. *Florentine Drawings of the Quattrocento.* London, 1926.

Eisler, C. *Drawings of the Masters: Flemish and Dutch Drawings.* New York, 1963.

Evans, M. W. *Medieval Drawings.* London, New York, Sydney, Toronto, 1969.

Fenyo, I. *North Italian Drawings from ... the Budapest Museum of Fine Arts.* Budapest, 1965.

Fogg Art Museum. *Memorial Exhibition: Works of Art from the Collection of Paul J. Sachs (1878–1965) Given and Bequeathed to the Fogg Art Museum.* Cambridge, 1966–67.

Forlani, A. *I disegni italiani del cinquecènto.* Venice, n.d.

Galerie de l'Orangerie. *Exposition de la collection Lehman de New York.* Paris, 1957.

Ganz, P. *Handzeichnungen schweizerischen Meister des XV–XVIII Jahrhunderts.* vol. III. Berlin, 1904.

Gelder, J. G. van. *Dutch Drawings and Prints.* New York, 1959.

Gere, J. A. *Il Manierismo a Roma.* I disegni dei maestri, Edited by W. Vitzthum. Milan, 1971.

Gerszi, T. *Capolavori del rinascimento tedesco.* I disegni dei maestri, Edited by W. Vitzthum. Milan, 1970.

——. *Netherlandish Drawings in the Budapest Museum.* Amsterdam, 1971.

Gradmann, E. *Bildhauer-Zeichnungen.* Basel, 1943.

Grand Palais. *L'école de Fontainebleau.* Paris, 1973.

Grassi, L. *Il disegno italiano dal trecento al seicento.* Rome, 1956.

Groschwitz, G. von. *The Lehman Collection.* Cincinnati, 1957.

Grotanelli, V. L. "Drawings in Primitive Cultures." *Encyclopedia of World Art.* vol. IV. New York, 1963.

Hadeln, D. van. *Venezianische Zeichnungen des Quattrocento.* Berlin, 1925.

——. *Venezianische Zeichnungen der Hochrenaissance.* Berlin, 1925.

——. *Venezianische Zeichnungen der Spätrenaissance.* Berlin, 1926.

Halm, P.; Degenhart, B.; and Wegner, W. *Hundert Meisterzeichnungen aus der staatlichen graphischen Sammlung Munchen.* Munich, 1958.

Haverkamp-Begemann, E. *Drawings from the Clark Institute.* 2 vols. New Haven, 1964.

Haverkamp-Begemann, E., and Logan, A. M. S. *European Drawings and Watercolors in the Yale University Art Gallery.* New Haven and London, 1970.

Haverkamp-Begemann, E., and Sharp, E. *Italian Drawings from the Collection of Janos Scholz.* Yale University Art Gallery, New Haven, 1964.

Hellman, G. S. *Original Drawings by the Old Masters: The Collection Formed by Joseph Green Cogswell, 1786–1871.* New York, 1915.

Henkel, M.-D. *Le dessin hollandais des origines au XVII^e siècle.* Paris, 1931.

Henle, A. *Master Drawings: An Exhibition of Drawings from American Museums and Private Collections.* San Francisco; Palace of Fine Arts, Golden Gate International Exposition, 1940.

Hind, A. M., and Popham, A. E. *Catalogue of Drawings by Dutch and Flemish Artists...in the British Museum.* 5 vols. London, 1915–32.

Hofer, P.; Bean, J.; and Peterdi, G. *Approaches to Drawings.* New York, 1963.

Hoff, U. "Meditations in Solitude." *Journal of the Warburg Institute* I (1937–38).

Hofstra University, The Emily Lowe Gallery. *The Male Nude.* Hempstead, N. Y., Nov. 1–Dec. 2, 1973.

Hutter, H. *Drawing, History and Technique.* New York and Toronto, 1968.

Indiana University Art Center. *Drawings of the Renaissance from the Janos Scholz Collection.* Bloomington, 1958.

Italian Drawings Exhibited at the Royal Academy Burlington House. London, 1930.

Italian 17th Century Drawings from British Private Collections. Edinburgh, 1972.

Ivanoff, N. *I disegni italiani del seicento.* Venice, n.d.

James, M. R. *An English Medieval Sketchbook.* vol. XIII. London, 1924–25.

Joachim, H. *Master Drawings from the Art Institute of Chicago.* Chicago, 1963.

——. "The Intimacy of Drawings." *Apollo*, Sept. 1966, pp. 226–32.

——. *A Quarter Century of Collecting....* Art Institute of Chicago, 1970.

——. *The Helen Regenstein Collection of European Drawings.* Art Institute of Chicago, 1974.

Jombert, J. *Méthode pour apprendre le dessin.* Paris, 1755.

Johnston, C. *Il seicento e il settecento a Bologna.* I disegni dei maestri, Edited by W. Vitzthum. Milan, 1971.

Kenin, R. *The Art of Drawing*. New York, 1974.

M. Knoedler & Co. *Great Master Drawings of Seven Centuries*. New York, 1959.

Koschatsky, W.; Oberhuber, K.; and Knab, E. *Italian Drawings in the Albertina*. New York, 1971.

Kurz, O. "Giorgio Vasari's 'Libro de' Disegni.'" *Old Master Drawings* 11, no. 45 (1937).

——. *Bolognese Drawings of the XVII and XVIII Centuries*. Windsor Castle Series. London, 1955.

Kutznetsov, J. *Capolavori fiamminghi e olandesi*. I disegni dei maestri, Edited by W. Vitzthum. Milan, 1970.

Lairesse, G. de. *Les principes du dessin*. Amsterdam, 1719.

Lavallée, P. *Le dessin français du XIIIe au XVIe siècle*. Paris, 1930.

——. *Les techniques du dessin, leur évolution dans les différentes écoles de l'Europe*. 2nd ed. Paris, 1949.

Leclerc, A. *Flemish Drawings, XV–XVI Centuries*. New York, 1949.

Lees, F. *The Art of the Great Masters*. London, 1913.

Leporini, H. *Die Stilentwicklung der Handzeichnung XIV bis XVIII Jahrhundert*. Vienna, 1925.

——. *Die Kunstlersammlung*. Berlin, 1945.

——. *Die Kunstlerzeichnung*. Braunschweig, 1955.

Levenson, J. A.; Oberhuber, K.; and Sheehan, J. L. *Early Italian Engravings: From the National Gallery of Art*. Washington, D. C., 1973.

Los Angeles County Museum of Art. *Tuscan and Venetian Drawings of the Quattrocento from the Collection of Janos Scholz*. Los Angeles, 1967.

——. *The Armand Hammer Collection*. Los Angeles, 1971.

Marks, C. *From the Sketchbooks of the Great Artists*. New York, 1972.

Master Drawings (quarterly publication). The Pierpont Morgan Library, New York, from 1963.

Mayer, A. L. *Dibujos originales de maestros españoles*. 2 vols. Leipzig, 1920.

Meder, J. *Handzeichnungen französicher Meister des XVI–XVIII Jahrhunderts*. Vienna, 1922.

——. *Die Handzeichnung: Ihre Technik und Entwicklung*. 2nd. ed. Vienna, 1923.

Mellaart, J. H. J. *Drawings of the Seventeenth Century*. London, 1926.

Mendelowitz, D. *Drawing*. New York, 1967.

The Metropolitan Museum of Art. *European Drawings from the Collection of The Metropolitan Museum of Art*. New York, 1943.

——. *French Drawings from American Collections: Clouet to Matisse*. New York, 1959.

——. *The Great Age of Fresco, Giotto to Pontormo: An Exhibition of Mural Paintings and Monumental Drawings*. New York, 1968.

Mills College Art Gallery. *Drawings from Bologna, 1520–1800*. Oakland, 1957.

Minneapolis Institute of Arts. *Drawings, Paintings and Sculpture from Three Private Collections*. Minneapolis, 1960.

——. *Drawings and Watercolors from Minnesota Private Collections*. Minneapolis, 1971.

Miotti, T. *Il collezionista di disegni*. Venice, 1962.

Monbeig-Goguel, C. *Il manierismo fiorentino*. I disegni maestri, Edited by W. Vitzthum. Milan, 1971.

Mongan, A. *100 Master Drawings*. Fogg Art Museum, Cambridge, 1949.

——. *Selections from the Drawing Collection of David Daniels*. The Minneapolis Institute of Arts, 1968.

Mongan, A., and Sachs, P. J. *Drawings in the Fogg Museum of Art*. 3 vols. Cambridge, 1940.

Mongan, E. *Selections from the Rosenwald Collection*. National Gallery of Art, Washington, D. C., 1943.

The Pierpont Morgan Library. *Fifth Fellows Report*. New York, 1954.

Moskowitz, I., ed. *Great Drawings of All Time*. 4 vols. New York, 1962.

Muchall-Viebrook, T. W. *Flemish Drawings of the Seventeenth Century*. London, 1926.

Murray, C. Fairfax. *Drawings by the Old Masters: Collection of J. Pierpont Morgan*. 4 vols. London, 1905-12.

Musée du Louvre. *Inventaire général des dessins du Musée du Louvre et du Musée de Versailles: Ecole française*. vol. I, 1907 (2nd ed., 1933); vol. II, 1908; vol. III, 1909; vol. IV, 1909; vol. V, 1910; vol. VI, 1911; vol. VII, 1912; vol. VIII, 1913; vol. IX, 1921, by J. Guiffrey and P. Marcel; vol. X, 1928, by J. Guiffrey, P. Marcel, and G. Rouchès; vol. XI, 1938, by G. Rouchès and R. Huyghe. Paris.

——. *Inventaire général des dessins des écoles du nord: Ecole hollandaise*. By F. Lugt. vol. I, 1929; vol. II, 1931; vol. III, 1933. Paris.

——. *Inventaire général des dessins des écoles du nord: Ecoles allemande et suisse*. By L. Demonts. vol. I, 1937; vol. II, 1938. Paris.

——. *Inventaire général des dessins des écoles du nord: Ecole flamande*. By F. Lugt. 2 vols. Paris, 1949.

National Gallery of Art. *Recent Acquisitions and Promised Gifts*. Washington, D. C., 1974.

Neumeyer, A. *Drawings from Tuscany and Umbria, 1350-1700*. Mills College Art Gallery. Oakland, 1961.

The Newark Museum. *Old Master Drawings*. Newark, N. J., 1960.

Nielson, N. W. *Italian Drawings Selected from Mid-Western Collections*. The St. Louis Art Museum, 1972.

Newcome, M. *Genoese Baroque Drawings*. University Art Gallery, State University of New York at Binghamton, 1972.

Nismes, G. de. *L'art de laver*. Paris, 1687.

Oertel, R. *Die Frühzeit der italienischen Malerei*. Stuttgart, 1953. 2nd. ed., Stuttgart and Berlin, 1966.

Old Master Drawings: A Quarterly Magazine for Students and Collectors. 14 vols. London, 1926-40.

Panofsky, E. *Memory and the Visual Arts*. New York, 1955.

Parke-Bernet. *The Irma N. Straus Collection of Master Drawings* (sale catalog). New York, Oct. 21, 1970.

Parker, K. T. *Drawings of the Early German School*. London, 1926.

——. *North Italian Drawings of the Quattrocento*. London, 1927.

——. *Catalogue of Drawings in the Ashmolean Museum*. 2 vols. Oxford, 1938.

Pérez Sánchez, A. E. *Gli spagnoli da El Greco a Goya*. I disegni dei maestri, Edited by W. Vitzthum. Milan, 1970.

Philadelphia Museum of Art. *Drawings by the Bibiena Family*. Philadelphia, 1968.

Pignatti, T. *I disegni veneziani del settecento*. n.p., n.d.

——. *La scuola veneta*. I disegni dei maestri, Edited by W. Vitzthum. Milan, 1970.

——. *Venetian Drawings from American Collections*. National Gallery of Art, Washington, D. C., 1974.

Pillsbury, E., and Caldwell, J. E. *Sixteenth Century Italian Drawings, Form and Function*. Yale University Art Gallery, New Haven, 1974.

Popham, A. E. *Drawings of the Early Flemish School*. London, 1926.

——. *Italian Drawings Exhibited at the Royal Academy*. London, 1930.

——. *Catalogue of Drawings in the Collection…of…T. Fitzroy Phillipps Fenwick*. privately printed, 1935.

——. *Selected Drawings from Windsor Castle, Raphael and Michelangelo*. London, 1954.

Popham, A. E., and Fenwick, K. M. *European Drawings in the Collection of the National Gallery of Canada*. Toronto, 1965.

Popham, A. E., and Pouncey, P. *Italian Drawings in the Department of Prints and Drawings in the British Museum*. 2 vols. British Museum, London, 1950.

Popham, A. E., and Wilde, J. *Italian Drawings of the XV and XVI Centuries at Windsor Castle*. London, 1949.

Pouncey, P., and Gere, J. A. *Raphael and His Circle*. British Museum, London, 1962.

Procacci, U. *La tecnica degli antichi affreschi e il loro distacco e restauro*. Florence, 1958.

——. *Sinopie e affreschi*. Florence, 1961.

Prouté, P. et Fils. *Grand Siècle* (sale catalog). Paris, 1965.

Puyvelde, L. van. *Flemish Drawings at Windsor Castle*. New York, 1942.

——. *Dutch Drawings at Windsor Castle*. London, 1952.

Regteren Altena, J. Q. van. *Hollaendishe Meisterzeichnungen*. Basel, 1948.

Reitlinger, H. S. *Old Master Drawings*. New York, 1922.

Reynolds, G. *English Drawings and Watercolors, 1550–1850, in the Collection of Mr. and Mrs. Paul Mellon*. The Pierpont Morgan Library, New York, 1972.

Richardson, J. *An Account of the Statues, Bas-Reliefs, Drawings and Pictures in Italy, France, etc. with Remarks by Mr. Richardson, Sen. and Jun.* 2nd. ed. London, 1954.

Robinson, F. W. *One Hundred Master Drawings from New England Private Collections*. Wadsworth Atheneum, Hartford, Conn., 1973.

Roli, R. *I disegni italiani del seicento*. Treviso, 1969.

Rosenberg, J. *Great Draughtsmen*. Cambridge, Mass., 1959.

Rosenberg, P. *Il seicento francese*. I disegni dei maestri, Edited by W. Vitzthum. Milan, 1970.

——. *French Master Drawings of the 17th and 18th Centuries in North American Collections*. National Gallery of Canada, Ottawa, 1972.

Ross, M. C. *Medieval and Renaissance Illuminated Manuscripts*. Los Angeles County Museum of Art, 1953–54.

Rowland, B., Jr. *Drawings of the Masters: Cave to Renaissance*. New York, 1965.

Royal Academy. *Drawings by Old Masters*. London, 1953.

Sachs, P. J. *The Master Pocket Book of Great Drawings*. New York, 1951.

Salvani, R. "Medieval Europe [Drawing]." *Encyclopedia of World Art*. vol. IV. New York, 1963.

Sánchez Cantón, F. J. *Drawings of the Masters: Spanish Drawings to the 19th Century*. New York, 1964.

Santa Barbara Museum of Art. *European Master Drawings*. Santa Barbara, Calif., 1964.

Schaack, E. van. *Master Drawings in Private Collections*. New York, 1962.

William H. Schab Gallery, Inc. *Woodner Collection I: A Selection of Old Master Drawings before 1700*. New York, 1971.

——. *Woodner Collection II: A Selection of Old Master Drawings from the XV to the XVIII Century*. New York, 1973.

Scharf, A. "The Exhibition of Old Master Drawings at the Royal Academy." (review) *Burlington Magazine* 95 (1953): 352.

Scheller, R. W. "Uomini famosi." *Bulletin van het Rijksmuseum*, 1962.

——. *A Survey of Medieval Model Books.* Haarlem, 1963.

Schendel, A. van. *Le dessin en Lombardie.* Brussels, 1938.

Schilling, E. *German Drawings at Windsor Castle and Supplements to the Catalogues of the Italian and French Drawings by A. Blunt.* London and New York, 1973.

Schmidt, D. F. *Dessins hollandais de Jerome Bosch à Rembrandt.* Brussels, 1937–38.

Scholz, J. "Sei- and Settecento Drawings in Venice: Notes on Two Exhibitions and a Publication." (review) *Art Quarterly* XXIII (1960): 62.

Schuler, J. E. *Great Drawings of the Masters.* New York, 1963.

Shoolman, R., and Slatkin, C. E. *Six Centuries of French Master Drawings in America.* New York, 1951.

Sicre, J. *Spanish Drawings XV–XIX Centuries.* New York, 1949.

Siren, O. *Italienska handtechnigar.* Stockholm, 1917.

Smith College Museum of Art. *Italian Drawings: 1330–1780.* Northampton, Mass., 1941.

Smith, G. M. *Spanish Baroque Drawings in North American Collections.* University of Kansas Museum of Art, Lawrence, Oct. 19–Nov. 24, 1974.

Smithsonian Institution. *Old Master Drawings from Chatsworth.* Washington, D. C., 1962–63.

Stampfle, F. *Landscape Drawings and Watercolors: Bruegel to Cézanne.* The Pierpont Morgan Library, New York, 1953.

——. *Drawings: Major Acquisitions of The Pierpont Morgan Library, 1924–1974.* New York, 1974.

Stampfle, F., and Denison, C. D. *Drawings from the Heineman Collection.* New York, 1973.

Sterling, C. *Exposition de la Collection Lehman de New York.* Galerie de l'Orangerie, Paris, 1957.

Stix, A., and Frohlich-Bum, L. *Die Zeichnungen der venezianischen Schule.* Vienna, 1926.

Stix, A., and Spitzmuller, A. *Die Schulen von Ferrara, Bologna, Parma und Modena, der Lombardei, Genuas, Neapels un Sizilien. . . .* Vienna, 1941.

Strong, S. A. *Reproductions in Facsimile of Drawings by the Old Masters in the Collection of the Earl of Pembroke. . . .* London, 1900.

Stubbe, W. *Italienische Meisterzeichnungen von 14. bis 18. Jahrhundert aus amerikanischen Besitz: Die Sammlung Janos Scholz.* Hamburger Kunsthalle, 1963.

Sutton, D. *French Drawings of the Eighteenth Century.* London, 1949.

Taylor, M. C. *European Drawings from the Sonnenschein Collection . . . in the Collection of the University of Michigan Museum of Art.* Ann Arbor, 1974.

Tempesti, A. F. *Capolavori del Rinascimento.* I disegni dei maestri, Edited by W. Vitzthum. Milan, 1970.

Tietze, H. *European Master Drawings in the United States.* London, 1947.

——. "Nuovi disegni veneti del cinquecento in collezioni americane." *Arte Veneta*, 1948, pp. 56–66.

Tietze, H., and Tietze-Conrat, E. *The Drawings of the Venetian Painters of the 15th and 16th Centuries.* New York, 1944.

Tintori, L., and Meiss, M. *The Painting of the Life of St. Francis in Assisi.* New York, 1962, 1967 (paperback).

Todorow, M. F. *L'Italia dalle origini a Pisanello.* I disegni dei maestri, Edited by W. Vitzthum. Milan, 1970.

Toesca, I. "Gli uomini famosi, della Biblioteca Cockrell." *Paragone* XXV (1952).

Tolnay, C. de. *History and Technique of Old Master Drawings.* New York, 1943.

Tomory, P. A. *The Ellesmere Collection of Old Master Drawings.* Leicester, 1954.

Trinity College. *Thirty Italian Drawings from the Collection of Janos Scholz.* Hartford, Conn., 1969–70.

Ueberwasser, W. *Drawings by European Masters from the Albertina.* New York, 1963.

University Art Gallery. *Selections from the Drawing Collection of Mr. and Mrs. Julius S. Held.* State University of New York at Binghamton, 1970.

University Art Museum. *Master Drawings from California Collections.* University of California, Berkeley, 1968.

Vasari on Technique. Translated by L. S. Maclehose. (paperback) New York, 1960.

The Vasari Society for the Reproduction of Drawings by Old Masters. London, 1905–15 (first series), 1920–35 and continuing (second series).

Virch, C. *Master Drawings in the Collection of Walter C. Baker.* New York, 1962.

Vitzthum, W. *Disegni napoletani del sei- e settecento nel Museo di Capodimonte.* Naples, 1966.

——. *Il Barocco a Napoli e nell'Italia Meridionale.* I disegni dei maestri, Edited by W. Vitzthum. Milan, 1970.

——. *A Selection of Italian Drawings from North American Collections.* Norman Mackenzie Art Gallery, Regina, Saskatchewan, and Montreal Museum of Fine Arts, Quebec, 1970.

Vivant-Denon, D., and Duval, A. ed. *Monuments des arts du dessin chez les peuples tant anciens que modernes, receueillis par le baron Vivant Denon...décrits et expliqués par A. Duval.* 4 vols. Paris, 1829.

Watrous, J. *The Craft of Old Master Drawings.* Madison, Wis., 1957.

Weitzmann, K. *Illustrations in Roll and Codex.* Princeton, 1937.

Wellesley College Museum. *Dutch Drawings from the Abrams Collection.* Wellesley, Mass., 1969.

White, C. "The Armand Hammer Collection: Drawings." *Apollo* LXXXXV (1972): 457.

White, J. "Paragone: Aspects of the Relationship between Sculpture and Painting." In *Art, Science and History in the Renaissance,* Edited by C. S. Singleton, pp. 43–108. Baltimore, 1967.

Wildenstein, *French Pastels and Drawings from Clouet to Degas.* New York, Mar.–Feb. 1944.

Winkler, F. *Vlaemische Zeichnungen.* Berlin, 1948.

Wittkower, R. *Carracci Drawings at Windsor Castle.* London, 1952.

Woodward, J. *Tudor and Stuart Drawings.* London, 1951.

Wormald, F. *English Drawings of the Tenth and Eleventh Centuries.* London, 1952.

Wunder, R. *Extravagant Drawings of the Eighteenth Century from the Collection of the Cooper Union Museum.* New York, 1962.

——. *17th and 18th Century European Drawings.* American Federation of the Arts, New York, 1966–67.

——. *Architectural, Ornament, Landscape and Figure Drawings.* Middlebury, Vt., 1975.

Yale University Art Gallery. *Italian Drawings from the Collection of Janos Scholz.* New Haven, 1965.

——. *Prints and Drawings of the Danube School.* New Haven, 1969.

Zink, F. *Die deutschen Handzeichnungen, die Handzeichnungen bis nur des 16. Jahrhunderts.* Nuremberg, 1968.

INDEX OF ARTISTS

Typography: Lillian Marks,
The Plantin Press
Printing: Joseph Simon,
Anderson, Ritchie & Simon